# THE IMPACT OF
# MODERNISM 1900–1920

# THE IMPACT OF MODERNISM 1900–1920

*Early Modernism and the Arts and Crafts Movement in Edwardian England*

S. K. Tillyard

ROUTLEDGE
LONDON AND NEW YORK

First published in 1988 by
Routledge
11 New Fetter Lane, London EC4P 4EE

Published in the USA by
Routledge, Chapman & Hall, Inc.
29 West 35th Street, New York, NY 10001

Set in Linotron Ehrhardt
by Input Typesetting Ltd, London
and printed in Great Britain
by T J Press (Padstow) Ltd
Padstow, Cornwall

Library of Congress Cataloging in Publication Data

Tillyard, S. K.
The impact of modernism, 1900–1920 / S.K. Tillyard.
    p.   cm.
Bibliography: p.
Includes index.
1. Modernism (Art)—Great Britain.   2. Art. British.   3. Art
Modern—20th century—Great Britain.   4. Post-impressionism—
Influence.   I. Title.
N6768.5.M63T54   1988
709'.42—dc19

British Library CIP Data also available
ISBN 0-415-00281-8

*This book is dedicated to my Parents*
*Stephen and Margot Tillyard*

# CONTENTS

# ILLUSTRATIONS

# ACKNOWLEDGMENTS

I wish to acknowledge the help of the staffs of the Bodleian Library, the British Library, the British Newspaper Library at Colindale and the William Morris Gallery in Walthamstow. I would also like to thank the staff of the National Art Library and Dr Michael Halls of King's College Cambridge.

My thanks are also due to Christopher Butler, Mike Weaver, Tim Hilton, Seth Koven, Sally Laird and John Brewer.

I would also like to thank the following: the William Morris Gallery for permission to quote from Mackmurdo's *History of the Arts and Crafts Movement*; Mrs O. B. Taber and the Estate of Roger Fry for permission to quote from the correspondence of Roger Fry; the Estate of Clive Bell, Chatto & Windus: The Hogarth Press, and The Putnam Publishing Group for permission to quote from *Art* by Clive Bell; New Directions Publishing Corporation and Faber & Faber Ltd for permission to quote from *The Cantos of Ezra Pound*, copyright 1934, 1939 by Ezra Pound: *Pavannes and Divisions*, Copyright © 1958 by Ezra Pound: *The Spirit of Romance*, Copyright © 1968 by Ezra Pound. Every effort has been made to find the copyright holders of the works of art reproduced in this book, and credit is given in the appropriate captions.

# INTRODUCTION

This book explains the change of taste that prompted the introduction and accompanied the establishment of Post-Impressionism, and the early Modernism of which Post-Impressionism was a part, in England between 1910 and 1914. In it I have sought to understand how the London audience and press made sense of the paintings, drawings and sculpture with which they were confronted at the First Post-Impressionist Show in 1910, and how they construed the aesthetic which accompanied them. I have also sought to understand how Roger Fry and his associates made the French paintings which they called Post-Impressionist intelligible to an audience largely unfamiliar with theory and practice in France.

The exploration of these problems not only explains Post-Impressionism's success. It also shows how and why Fry assumed such an important role in the events which followed the First Post-Impressionist Show, and it explains why individual painters and groups who refused to co-operate with Fry and his circle failed to establish alternative aesthetics or styles.

In one sense, what unfolds is the story of the gradual increase in prominence of Roger Fry as a critic of modern art, of the painters he patronised and of the aesthetic – that is, the version of the history of art and the means of description and evaluation – which he and his associates promoted. This story begins in November 1910, when the First Post-Impressionist Show opened in the Grafton Galleries. But, clearly, Fry's own history had a prerequisite, an audience willing to accept the aesthetic and style which he

propounded. So another story unfolds. That is the story of the audience for early English Modernism in general, and for Post-Impressionism in particular, and of the beliefs, allegiances and associations which they brought to bear upon what they saw. That story begins much earlier, in the last tumultuous twenty years of the nineteenth century, when both Fry and his audience were reaching maturity.

Guided – indeed lectured – by Fry, MacCarthy, Bell and their critical cortège, the Post-Impressionist audience applied parts of an aesthetic which they already held to the work on display at the 1910 Grafton Galleries show. That meant that the French painting and sculpture which they saw was rendered significant by the application of English ideas.[1] Fry and MacCarthy did not ask their audience simply to look at Post-Impressionist painting, although it would have been eminently consistent with their aesthetic had they allowed the works to be their own explanations. Like other late Victorians, they were charged with the need to explain, to educate, to direct, to convert. So, along with the paintings, drawings and sculpture, they also supplied a language in which Post-Impressionist works could be described and a set of criteria by which they could be judged. Much of the language and some of the criteria had already been used to describe and evaluate the products of the Arts and Crafts Movement.

The use of this language by writers favourable to the new painting had two consequences. First, some of those involved in the Arts and Crafts Movement were attracted to Post-Impressionism because Fry and MacCarthy described and judged Post-Impressionist works in ways that were familiar. Second, because the audience evaluated Post-Impressionism using Arts and Crafts criteria, Post-Impressionism came to have for them some of the meanings and associations which informed Arts and Crafts practices.

This audience was a vital component in the acceptance of Post-Impressionism, and we obviously need to bring them into our understanding of its success. The means by which we can do so, however, are fraught with methodological difficulties. We need to reconstruct the views of the nebulous participants in Post-Impressionism's acceptance who made up the bulk of the thousands of visitors at shows of new painting. But beyond the records of a few self-conscious individuals – often actors close to the stage

like Desmond MacCarthy or professional self-memorialisers like Arnold Bennett and Wilfred Scawen Blunt – we cannot know what the audience of Manet and the Post-Impressionists felt about Post-Impressionism. The morphology of such a group has thus perforce to be built upon the unreliable bed of Fleet Street. Methodological flaws notwithstanding, both the constituencies and the theory of the Arts and Crafts Movement and early Modernism can be shown to be similar and overlapping. They were quite obviously not the same, and cannot be exactly matched. While we stress the movements' similarities in shape, presentation and tenor, we should not pass over the important distinctions between them.

This book is not an attempt to provide a new ancestry for early Modernism. Rather, it suggests that early Modernism's roots are more subtle, more complex and more interesting than its apologists have argued. When I emphasise the complexities of early Modernism's late Victorian roots I have two connected concerns. The first is to get away from a model of change which is essentially linear. The second is to abandon a taxonomy of late Victorian thought which creates a polarity between the Arts and Crafts Movement and aestheticism in its various forms. This manichean division, combined with a linear model of change, tends towards thinking about early Modernism as either the child of aestheticism or the child of the Arts and Crafts Movement.

When the early Modernist aesthetic is placed within a linear framework, it is generally regarded as a development of continental symbolist and aesthetic theory. Whistler and Pater provide its Anglo-Saxon ancestry. This 'line' is unsatisfactory because, as I show, aestheticism is not a discrete theoretical or practical entity. If we cease to regard aestheticism as a discrete category of theory and practice then the notion of linear change is itself oversimplified. Clearly, if there is no discrete entity there is no definable spot from which to draw the line. In other words, we need a new model of change. We could see the aesthetics of one generation as a sheet woven from many different ideas. When the sheet becomes worn out, old or useless, it can be turned sides to middle, patched with new fabric, restitched and reconstituted into an entirely new garment. In a less domestic vein – and more in keeping with some early Modernists' brief flirtation with scientific terminology – we can use a molecular model for aesthetic change. Each aesthetic theory, each cluster of attitudes, practices and assumptions can be

seen as a molecule whose constituent parts are held together in a dynamic relationship. When several different molecules are caused to rub up against one another, some of their constituent elements will become detached. Eventually some of them will band together to form a completely new whole, a new aesthetic theory.

Such images or metaphors may help us to see the shortcomings of a linear view of change. As I mentioned, such a view is inadequate because it is based on an oversimplified understanding of the different strands of late Victorian thought. Victorian aesthetics have commonly been divided into camps which are regarded as mutually exclusive. The Arts and Crafts Movement is pitched successively against the Aesthetic Movement and art nouveau. Art nouveau, in keeping with the linear model of change, is thus seen as the decadent child of aestheticism. That means that Ruskin and Morris are made to stand as representatives of the Arts and Crafts Movement against the aesthete Pater and the decadents Beardsley and Wilde. I do not want to break down these distinctions completely. Morris and Wilde did have very different casts of mind, and the movements they stand for did have very different aspirations and complexions. Moreover, we have to retain some means of generalisation. But I do want to suggest that we should place the two movements in a graduated relationship to one another and thus regard Morris and Wilde as occupying the extreme ends of a spectrum of ideas. So if they had little in common, especially by the eighteen-nineties, there was a middle ground between them where ideas and impulses from both movements were fused or held in active tension.

Once we reject a manichean approach to late Victorian aesthetics, the logic of a linear theory of change is destroyed. By pointing out some of the similarities between the Arts and Crafts Movement and early Modernism I want not so much to suggest a new 'line of influence' as to encourage a more generous and catholic approach to the upheaval in British art in the four years before the First World War.

This study ends with the acrimonious finale to the excitement Manet and the Post-Impressionists ushered in: a discussion of the debates and disagreements between early Modernism's principal protagonists. But it begins harmoniously. In the course of the first chapter, I discuss the beliefs which the disputants of 1914 shared

with the theorists of the Arts and Crafts Movement, and the common language they used to describe their products. I have not established these bonds simply by concentrating on the major figures of the movement – Morris or Crane, for example – but have suggested the variousness of the movement and its departures from the professional fountainhead by using a very wide range of the literature which was available to both professional and dilettante craftworkers. Along with such well-known volumes as *Arts and Crafts Essays*, I have incorporated many manuals for amateurs and aspirant professionals and the accompanying justificatory material: books on the crafts of earlier times or the histories of particular skills.

It is with the Arts and Crafts Movement that the story of the early Modernist audience began. For it was by means of Arts and Crafts language and precepts that both critics and audience were enabled to understand Fry's exhibition in 1910. It is therefore here that I have tried to identify the 'audience' or 'consumers' of the Arts and Crafts Movement with some precision, because it was from amongst these people that much of the early enthusiasm for Post-Impressionism came. In order to construct this profile of those involved with Arts and Crafts, I have examined a large amount of neglected periodical literature. It is here also that I have discussed the resonances of the language in which Arts and Crafts was described, for these same resonances – qualitative, formal and ethical – were to be found in the language of early Modernism in England.

In the first chapter I have also made distinctions, as far as present scholarship allows us and in keeping with the idea of a spectrum of theory just outlined, between the Arts and Crafts Movement, the Aesthetic Movement, and art nouveau and the decadence. The distinctions are important because I maintain that while early Modernists share some attitudes with the critics of the 'nineties in particular, their intentions, their 'tone' and their language were far closer to those of the Arts and Crafts Movement.

The similarity in tenor between the Arts and Crafts Movement, early Modernism in general and Post-Impressionism in particular provides an invaluable key to their success. Both movements were 'religious', fervent, and crusading. They both used similar religious language and their supporters were also 'converts' who joined a 'cause'. This religiosity illuminates two aspects of Post-

Impressionism. First, since religiosity, ways of living, and therefore ethics were regarded as connected, the religiosity of Post-Impressionism helps to explain why some of its supporters attached a moral dimension to Fry's aesthetic. Second, the use of religious language and the ferment of religiosity that Post-Impressionism aroused throws light on the new movement's hostile reception in 1910. For this religious language recalled the religious language of the Arts and Crafts Movement, and the religiosity of the Arts and Crafts Movement was also the religiosity of the early socialist organisations of the 1880s and early 1890s. Arts and Crafts, socialism and this crusading, sometimes overtly Christian spirituality were briefly one and the same thing. The use of Arts and Crafts language, both formal and religious, by Post-Impressionist critics in 1910 carried with it, in consequence, an echo of the heady socialism of twenty years before. It is in this context, as chapter two shows, that the limited 'politicisation' of Post-Impressionism in England should be seen. Hostile critics, many of them of an age to remember the 1880s, were responding to the threat of socialism as it had been constituted twenty years previously, not as it presented itself or was perceived in the gradualist, materialist climate of the pre-war years.

In the first chapter I also examine the decorative arts ventures of the early Modernists. Fry's Omega Workshops, Lewis's Rebel Art Centre and Pound's projected College of Arts were, in their very conception, quintessentially late Victorian enterprises, although those involved in them preferred to stress their debts to French initiatives rather than to the English Arts and Crafts Movement. Looking at these ventures in an English rather than a French context not only adjusts our view of them, it also serves to introduce the complex problem of the nature and degree of continental influence upon early Modernism as a whole.

In chapter three the examination of the relationship between Arts and Crafts language, theory and practice and early Modernism is extended to the field of sculpture. There, the production, reception and aesthetic of avant-garde sculpture between 1908 and 1914 are examined in the light of the Arts and Crafts beliefs outlined earlier. Again, I have made extensive use of neglected contemporary literature to forge links between the two aesthetics and modes of production.

Chapter two discusses the First Post-Impressionist Show. That

is, the moment at which Fry and his audience came together. If it marked the beginning of Fry's prominence as a critic of modern painting, it was, of course, by no means the beginning of the story of his audience. This serves to remind us that although 'Post-Impressionism' in England began in 1910, when Fry coined the phrase, staged the show and put forward an accompanying aesthetic, it had what might be termed a 'pre-history', or a past, which was a signal factor in its success. Examination of the many reviews of 'Manet and the Post-Impressionists', as Fry called his show, reveals how important is the 'recovery' of that past in the assessment of Post-Impressionism.

Discussion of the First Post-Impressionist Show also serves to demonstrate the reactive quality of Post-Impressionist theory. It was in part the rejection of prevalent academic styles and standards that made Post-Impressionism so successful. Post-Impressionism derived both strength and adherents by virtue of the fact that it represented an opposition and an alternative not only to Impressionism but also to the thoroughgoing academic painters who made up the most vociferous group of its detractors. The vigorous dialogue between academic and Post-Impressionist spokesmen and the grounds for academic dislike of the First Post-Impressionist Show need serious consideration. Academic standards and precepts are bound up with the character of early Modernism and it is for this reason that the writings of academic artists and critics have been given fuller treatment in this study than in previous work on 'Manet and the Post-Impressionists'.

By 1912 and the Second Post-Impressionist Show, the critical climate had changed considerably. Most critics now accepted and publicised Post-Impressionist precepts and language and had come closer into line with Fry's incipient formalism. In the final chapter I discuss the ways in which Post-Impressionist theory developed after 1910, its presentation in the Second Post-Impressionist Show and the repercussions of the critical acceptance of the exhibition. Although the Second Post-Impressionist Show has received little scholarly attention, it was important as a bench-mark in the development of Post-Impressionist theory and the adoption of various Post-Impressionist styles by British painters, and it represented a recognition of the movement's social and critical acceptance. That it caused no scandal similar to the first show merely indicates the size of Fry's victory.

Although some critics opposed the second Grafton Galleries show, the majority of artists and spokesmen who had been so vociferous in 1910 had bowed out of direct confrontation with Fry by 1912. That meant that they separated themselves from painters and critics who regarded themselves as avant-garde, although, of course, their presence was a vital foil to avant-garde aesthetics and production. It is possible to say, then, that by early 1913, when the second show closed, there was an avant-garde in England which was separate and self-regarding in a way that no group had been two years before, and that that avant-garde was enabled to flourish because of an audience which subscribed to its aesthetic. But, in part because of that support and the possibilities for patronage that it promised, at the very moment of its crystallisation, the group which considered itself avant-garde began to fragment. From the end of the second show onwards it was to be splinter groups within the avant-garde itself which produced written opposition to Post-Impressionism. In the closing pages of my study, I examine the quarrels between these various avant-garde groupings and individuals. I discuss the ostensibly 'private' but necessarily 'public' nature of these disputes, and demonstrate that they refer constantly to the issues raised at the two Post-Impressionist Shows when the audience became apparent. But it was during these last two years, as well, that the axes and emphases of early Modernist theory began to change and shift away from its earlier reference points. Chapter four charts the shift from self expression to self-suppression, expressionism to classicism and from the assertion of individuality to the elevation of tradition not only within Post-Impressionist theory but within early Modernism as a whole. Finally I show why no avant-garde group was able to dislodge Fry and his circle from their dominant position.

It is partly in this very short-term context that I call Post-Impressionism a success. The rivals of Fry and his circle failed to establish any alternative aesthetic and style. Post-Impressionism captured more press attention over a longer period of time than any other aesthetic. This went along with a widespread and more than metropolitan grasp of its tenets. The combination ensured that while the Futurists, for example, became briefly fashionable, Post-Impressionism was garnering enduring support.

The success of Post-Impressionism was not just short term.

Until the end of 1914 members of rival groupings had a strong sense, and one that needs to be emphasised, that they were in competition with Post-Impressionism and that art might develop along any one of a number of channels. Before the war destroyed artistic activity, Fauvism, Futurism, Russian and German abstraction, even Vorticism seemed possible alternatives to the Post-Impressionism that Fry put forward. The establishment of Post-Impressionism meant that these alternatives were cast into the shade. On a broader level it also meant that French rather than German art became the model for ensuing generations and in England that Matisse rather than Picasso became the master. In the critical accounts that accompanied practical activity French art became the stepping stone from the nineteenth century to the present. This version of the history of art affected not just artists and patrons but also a much wider public. Another consequence of the success of Post-Impressionism was that this version of the past, with variations, was enshrined in the collections of national institutions in the English-speaking world, where the story of modern art is still dominated by events in France, and where the German contribution is only now being given its due weight.

Throughout this thesis I have tried to maintain a strict sense of chronology. I have done this not only in my discussions of disputes within the avant-garde, where a sense of chronology is important to a proper understanding of the content and context of any statement, but also in my nomenclature. Adherence to the nomenclature used at the time is imperative because of the resonances which language held. Except in situations which are indicated in the text, I have called all practitioners by the titles given to them or taken by them at the time of which I am writing. Wyndham Lewis, for instance, allowed himself to be called a Post-Impressionist painter until October 1913. In June 1914, he called himself a Vorticist, but he could not have been a Vorticist any earlier because Vorticism did not exist.

I have, however, employed some terminology which was not in use at the time of which I am writing. For the purposes of generalisation I have referred to particular painters and critics as 'early Modernist', by which I mean that their work displayed characteristics which have been identified as hallmarks of an aesthetic and production which were later called 'Modernist'. Modernism is a construction (that is, a selective version of the past and its reper-

cussions), which constantly changes. It is a construction which is the 'aggregate' of the styles and aesthetics which are at any moment selected by artists, critics and art historians for inclusion within it. So the writing of Fry and Bell, and to a lesser extent of Hulme, Lewis, Pound and Gaudier were subsequently synthesised and dubbed Modernist by Read, Greenberg and other critics. Following these critics I have called Fry, Bell, Hulme, Lewis, Pound and Gaudier, as well as the artists with whom they were closely associated before the First World War, 'early Modernist'.

All these critics and painters thought of themselves, and were thought of, as 'modern'. Painters like Ginner and Gilman also regarded themselves and were widely regarded as 'modern' – that is, contributing to developments and innovations in art – although neither their work nor their aesthetic have characteristics which are at present thought of as Modernist. But I have included them in the company of the early Modernists because they – with the approval of contemporaries – placed themselves there. Their contribution, moreover, is important to any adequate understanding of aesthetics and production in England before the First World War.

For the same reason, although with more uneasiness, I have talked of these painters as part of an 'avant-garde'. I have used this phrase in the way that contemporaries did, to mean a group in the forefront of change and a group that was ahead of others. The artists I have called 'modern' were therefore a 'group' which, as I point out, was, by 1913, self-referential and separated from other artistic activity.

I am aware that this usage of the term is not shared by all theorists of the avant-garde, most notably by Peter Bürger, who sees the key to the definition of the avant-garde in an attitude of confrontation between the artist and society.[2] If we applied this test to early Modernism in England it is unlikely that any artist, with the exception of Lewis, would pass. Similarly, if we regard an aggressive attitude towards the past as being a condition of avant-gardism then only the pronouncements of Lewis in *Blast*, Nevinson in the 1914 Futurist manifesto that he wrote with Marinetti, and Hulme in his last essays would pass muster. Both definitions separate out Lewis, Nevinson and the Hulme of the 1914 *New Age* essays from their pre-war associates and enemies. This may satisfy the theory of the avant-garde but it makes no sense of what was happening at the time. As I show, Lewis, Hulme and, to a lesser

extent, Nevinson were closely bound up with the enterprises, practices and ideologies of other groupings before the First World War. Since it is part of my purpose to unravel these connections I have not used terminology which implies a dissociation which cannot be substantiated.

On the other hand, I am acutely aware of the linguistic famine that rages in this area. Such linguistic nicety as I am employing does little to satisfy a hunger for a more extensive vocabulary with which to describe and discriminate between artists and critics working not in the cloudy realm of theory, but in the practical, contingent and limited world of London in 1910. As the readers progress to the body of my text they will become aware that rather than indulging in a burst of potentially incomprehensible linguistic procreation, I am making the best of a bad job.

## NOTES

1 I do not wish to suggest here that the meaning of a work of art is defined solely by the different reactions of different audiences. I would argue, rather, that the creation of meaning is an immensely complex and dynamic process involving an interaction between the work of art, the conditions under which it is created, displayed and seen, and the perceptions and preconceptions of the viewer. Moreover, I do not want to preclude either the possibility of some inherent meaning in the work of art or the possibility of a connection between that inherent meaning and both 'authorial intention' and audience response.
2 Peter Bürger, *Theory of the Avant-Garde*, translation from the German by Michael Shaw, Foreword by Jochen Scutte-Sasse (Manchester: Manchester University Press, 1984).

# 1

## THE STRUCTURE AND INSTITUTIONS OF THE ARTS AND CRAFTS MOVEMENT

The aesthetic of the Arts and Crafts Movement was seen by its advocates as a radical response to the parlous state of mid-Victorian design. Arts and Crafts theorists proposed to reunite the arts by bringing back together the artist and the craftsman. The designer of an object and the man who made it would be the same person. The craftsman would once again become the artist, and the artist the craftsman. The former would gain in dignity, while the latter would find a new humility. The craftsman's consequent pleasure in creation would produce the good work necessary to halt the decline of the fine and decorative arts alike. This prescription was the common denominator of a movement that was very broadly based. It was made up of professionals, semi-professionals, amateurs, and consumers. In each of these groups a wide variety of aesthetic and political opinion was to be found.

The Arts and Crafts Movement was launched on a commercial footing with the foundation of Morris, Marshall, Faulkner and Company in April 1861. According to Dante Gabriel Rossetti it began one evening when 'a lot of us were together, and we got talking about the way in which artists did all kinds of things in olden times, designed every kind of furniture, and someone suggested – as a joke more than anything else – that we could each put down five pounds and form a company. We had no idea of commercial success, but it succeeded almost in our own despite.'[1]

Rossetti's account is interesting because it contains in embryonic form many of the social and aesthetic ideals which were central to

the Arts and Crafts Movement. It was *fellowship*, 'a lot of us . . . together', which initiated the scheme. The belief in corporate endeavour and what Mackmurdo called 'the brotherhood of man' lay behind the Arts and Crafts attack on class strife and the division of labour.[2] For Arts and Crafts theorists, corporate endeavour was associated with a putative golden age when the arts were one, when artists, or craftworkers in guilds 'designed every kind of decoration and most kinds of furniture'. Rossetti's deliberate archaism suggests that the source of that golden age was primarily derived from literature, while his deference to the past points to the stylistic revivalism which characterised so much Arts and Crafts production.

Associated with the past was the notion of spontaneity. 'Someone suggested', said Rosetti, 'that we could . . . form a company'. To Morris and others, spontaneity was the outcome of naturalness, a lack of affectation, and was contrasted with the sterility, formality and mechanical inhumanity of the society around them. Spontaneity was the product of the age before the machine captured a man's hand, and the critic his head, and in which form was the result of tradition and pleasure in creation and not the result of an aesthetic.

For all its idealism, the firm was a commercial venture. Its foundation marked the moment when the consumer became necessary to the producer, and when producers recognised that there was a potential public to buy their products and accept their ideals. The formation of Morris and Company began the long association between producers and consumers which sustained the movement's ideals, and for this reason it heralded the beginning of the Arts and Crafts Movement.

The rise and decline of the professional movement can be traced through the fortunes of other commercial and corporate bodies. As we shall see, the two most important professional institutions were the Art Workers' Guild and the Arts and Crafts Exhibition Society. The Art Workers' Guild was established in 1884 to bring together architects, designers and craftsmen. It was not a commercial body but it became a most important meeting place, a forum for the discussion of theory and an agent in the dissemination of information and ideas. Many of its members made contributions to the practical and theoretical literature of the Arts and Crafts Movement, and many rose to positions of power within educational institutions.[3]

The Art Workers' Guild provided the nucleus of the Arts and

Crafts Exhibition Society, which was founded in 1886 for the purposes of showing and selling the products of its members. The formation of the society had tremendous symbolic significance in the history of the Arts and Crafts Movement, because it marked the moment when, for many, previously anonymous endeavour gave way to the display and sale of the signed work of individuals. The craftsman was, in effect, demanding the same status as the contemporary fine artist, and his product would then cease to be a purely utilitarian object. Instead it would become an art object, something for show rather than for use.

The establishment of the Arts and Crafts Exhibition Society and the exhibitions it held made overt a contradiction between theory and practice that had been inherent in the Arts and Crafts Movement since the beginnings of Morris and Company. On the one hand, the movement was dedicated to the production of 'the well-made thing', while on the other, stress laid upon self expression, and the demands of the market, prompted creation of exhibition pieces and luxury goods. The period of greatest prosperity and expansion of the Arts and Crafts Movement occured when the contradictory imperatives of reform and fashion were working to one another's advantage, when the desire and market for the art object prompted the production of the 'well-made thing' and provided the working capital for experiments in social reconstruction. This system of mutual advantage operated between 1890 and 1905. After this, both professional success and amateur interest declined rapidly. Ashbee's Guild of Handicraft, set up in 1888, folded in 1907. It was the last large-scale surviving corporate body dedicated to social reform, and its bankruptcy marked the end of the professional attempt to create working exemplars of aesthetic, social and industrial ideals.

During the period when Arts and Crafts flourished, however, professional and fashionable elements worked together to create a various and broadly based yet none the less definable movement. To understand the extent and character of that movement, the means by which its precepts and practices were disseminated need to be examined. Two of the most important were the development of educational institutions and the publication of a substantial body of Arts and Crafts literature. Study of these provides evidence of a high degree of amateur involvement in the Arts and Crafts Movement and of the variety and extent of the audience.

From the 1880s onwards a range of institutions, both public and private, provided training for professional and semi-professional craftsmen as well as for fashionable dilettantes. Professional craftsmen received instruction at the Royal College of Art, reorganised under the direction of Walter Crane between 1899 and 1901, or were trained at the Central School of Arts and Crafts founded in 1896 and headed by W. R. Lethaby.[4] But these were only the most prestigious of many institutions – ten London County Council colleges in the metropolitan area by 1916, as well as schools in Birmingham, Leeds, Liverpool, Edinburgh, Glasgow, Manchester, Derby, Bradford, and Brighton by the early twenties – which continued to train both professionals and amateurs long after the collapse of both the Arts and Crafts market and the movement for the regeneration of society.

Besides the London County Schools, there were schools like Ashbee's School of the Guild of Handicraft and Mackmurdo's Home Arts and Industries Association which were founded in a spirit of idealism, and which initiated amateurs, sometimes alongside professionals, into the joy and dignity of labour. Ashbee's operation only taught about 100 people. But Mackmurdo presided over a vast nationwide network which had '450 classes, about 100 branches, about 1000 teachers and about 5000 students' in 1899.[5]

A rather different sort of institution was the Royal School of Art Needlework founded by Princess Christian in 1873. The college, which earned warm praise from the periodicals designed for the upper end of the female market, rode on the wave of fashion and royal patronage that carried the fashionable market for Arts and Crafts. In 1878, indeed, the Queen herself had proposed to set up a tapestry and stained glass factory.[6]

The many different people who benefited from these institutions could have supplemented their knowledge with works from a large corpus of literature devoted to Arts and Crafts. This literature may be divided into four overlapping categories which reflect the major preoccupations of the movement. The first was theoretical and aesthetic. In this category were collections like *Arts and Crafts Essays* (1893),[7] treatises like Day's *Some Principles of Everyday Art* (1886),[8] and Crane's *The Claims of Decorative Art* (1892).[9] The second category was historical. These books provided the necessary support, sometimes scholarly, to theory. This was the function of Lethaby's *Mediaeval Art* (1904),[10] H. Dolmetsch's vast *Historic Styles*

*of Ornament* (1898)[11] and Julia de Wolf Addison's *Arts and Crafts in the Middle Ages* (1908).[12] The third category was utopian and idealist. Such visionary work was exemplified by Ashbee's various dramatised debates on Arts and Crafts theory, and his fictional searches for the good citizen and the just society, such as *The Building of Thelema* (1910),[13] and *From Whitechapel to Camelot* (1892).[14] The fourth category of literature was technical and practical. It included manuals of instruction for the aspirant craftsman like Richard Lunn's *Pottery* (1903),[15] or Douglas Cockerell's *A Note on Bookbinding* (1904).[16] It also included practical instructions for eager amateurs. These could be found in Sanford's *The Art Crafts for Beginners* (1906),[17] Mabel Priestman's *Handicrafts in the Home* (1910),[18] Snowden Ward's *Profitable Hobbies* (1907),[19] or Emily J. Skeaping's *The Art of Dainty Decoration* (1914).[20]

For information on any one of these preoccupations, however, participants in the movement could have turned to the chief kind of Arts and Crafts publication, the periodical press. Arts and Crafts periodicals were put out for utopian professionals, their supporters and professional craftsmen who produced goods for the fashionable market, but the majority were sustained by amateur enthusiasts.

Magazines produced by and for those who placed a utopian construction on their endeavour included *The Century Guild Hobby Horse*, later called the *Hobby Horse* (1884, 1886–92), the *Quest* (1884–96), the *Bond* (1906–7), and the *Imprint* (1912–13). These were intended not only to educate their readers in Arts and Crafts beliefs and practices but also, very often, to embody those principles in their production, to be models of craftsmanship in their own right. As Mackmurdo said of the *Hobby Horse*, these magazines could be the 'means of reinforcing from season to season the claims of art'.[21]

Among trade magazines were the *Ladies' Cutter* (1899), the *Furnisher* (1899), the *Carver and Gilder* (1901), the *Bookbinder* (1902) and the *Caxton Magazine* (1901). Although these magazines may have disseminated Arts and Crafts practices and discussed Arts and Crafts products, they did so not to edify or instruct, but to make money. They thus helped to promote the Arts and Crafts Movement as a commercial enterprise producing fashionable goods.

The substantial number of magazines for amateurs supplied the needs of two different groups. In the first were the collector and

the connoisseur, those whose interests in Arts and Crafts lay not so much in the products of their own day but in the products of the past which members of the Arts and Crafts Movement held in such high regard. Many Arts and Crafts magazines contained articles on the applied arts of the past, but the *Collector and Art Furnisher* (1886), the *Poster and Art Collector* (1895), the *Print Seller and Collector* (1903–5), *Collecting* (1907), the *Expert* (1907) and the *Magazine of Taste* (1909) were directed explicitly at those who wanted to acquire them.

The second group of amateurs were those who actually practised craft work and who needed practical instruction. A range of amateur taste was satisfied. *Arts and Crafts* (1890) and *Arts and Crafts Magazine* (1904–8) mixed their instructions with more general articles and described themselves as magazines for professional and amateur alike. They were addressed to amateurs who saw their craftwork as more than a fashionable diversion, who subscribed to many Arts and Crafts precepts, and who aspired, perhaps, to semi-professional status. *Art Work* (1879), the *Spinning Wheel* (1893–9), the *Needle* (1903–10), the *Ladies Fancy Work Magazine* (1907), and *Home Handicrafts* (1907–17) had few pretensions to the wider connotations of the movement. They were devoted solely to Arts and Crafts in the home and provided technical instructions largely divested of aesthetic or social prescriptions.

Without exception these magazines were for women. They point to the vital role which women played in the Arts and Crafts Movement. Women were the Arts and Crafts Movement's most dedicated and numerous amateur practitioners and they sustained the movement's fashionable and commercial side. For the first time women were practically involved in large numbers in a major artistic movement. There were to be profound implications for early Modernism in their participation. When Arts and Crafts terminology was used to describe Post-Impressionist painting the ethical and aesthetic overtones it carried were in a language which women understood, a language which they had already used, read and heard. The number of women who responded to Post-Impressionism took men by surprise. The reviews and satirical sketches of male journalists and critics testify to their amazement and shock at this feminine invasion of a hitherto almost exclusively masculine domain. Like Arts and Crafts, then, Post-Impressionism had a very large female contingent among its followers. But this

did not mean that it was only the audience for fine art which was changing. The active presence of women and women painters in the Post-Impressionist camp (albeit women working within a 'masculine' institution) drew a sharp reaction from those who turned away from Post-Impressionism. When Wyndham Lewis ✗ broke away from Post-Impressionism and created Vorticism, he gave it a very anti-feminist cast. The aggressively masculine Vorticist aesthetic should thus be seen not only against the development of feminism in the larger environment, but also against the increasing feminisation of the institution of art itself.

Although there was no major female Arts and Crafts theorist, and although the Art Workers' Guild was closed to professional craftswomen, women were involved in the movement at all other levels. The ideology of women craftworkers mirrored the ideological structure of the movement as a whole. Women craftworkers ran all the way from utopian socialists, through professional but not idealist craftworkers, to semi-professionals and amateurs.[22]

There were few female groups which were both professional and visionary, but one such was the Haslemere Handweaving Industry. The Haslemere experiment was not only a scheme of social and moral regeneration, but was also specifically concerned with female emancipation. The women who ran the industry, which was the subject of an approving article in the socialist magazine *Women's Employment* in 1902, regarded a change in the moral basis of society as necessary not only to elevate craft, but also to elevate women. A concern for female management and economic independence was grafted on to the more familiar preoccupation with hand production, small workshops and the rural environment.[23]

More typical of women in the Arts and Crafts Movement was the Guild of Women Binders. Founded in 1898, the Guild was perhaps the largest and certainly the best-known umbrella organisation for professional craftswomen in the Arts and Crafts Movement. In 1899 it had 67 members and a depot in Charing Cross Road which served as an outlet for several provincial groups. Messrs Karslake, who ran the depot, also acted as agents for the Hampstead bindery, a workshop which was closely linked to the Guild and which had 40 full-time members in 1901.

The Guild shared many of the aims of the Haslemere Handweavers. As a commentator noted, it stood for hand production against machine and factory. The women binders, he said, 'carry

us back beyond the whirr of mill-bands, the crash of meeting blades, the guillotine and the stitching machine, and all the adjuncts of the factory – back to the days when a man's work grew under his hand'.[24] But the Guild neither carried out these principles by establishing a country workshop nor elaborated them into a more general desire for social reconstruction and female emancipation. It saw itself, indeed, as 'essentially a business institution, extending women's work into a new and attractive field'.[25]

This half-way house was occupied by the majority of professional and semi-professional women craftworkers. Women were encouraged to think of Arts and Crafts as a suitable field of employment, but not as vehicle for radicalism. Thus the *Spinning Wheel*, 'A Magazine for English Wives, Mothers and Daughters', placed home decorating alongside poultry farming, librarianship and drawing for the press as a possible source of income for women. But it included Arts and Crafts not because they would change women's social position, but because 'there is no occupation to which woman is more adapted than anything which has for its basis the decoration of the home'.[26] Similarly, *Woman* magazine encouraged remunerative employment for women, but it did not regard any political prescription as attendant upon it. Thus while the object of the exhibition it organised at Westminster Town Hall in February 1891 was 'to encourage the most novel, profitable, and commercially important forms of women's work in the British Isles, the colonies and British India', its proceeds went to 'the Irish Distressed Ladies Fund and to a charitable institution for the benefit of women'.[27]

Most women involved in Arts and Crafts were concerned not with female emancipation or economic independence but with fashion. They were the amateurs, the producers and consumers who made up the backbone of the movement as a whole. They were, as has been seen, sufficiently numerous to be provided with several magazines devoted exclusively to Arts and Crafts in the home. But, apart from these specialised publications, Arts and Crafts also commanded a good deal of space in more general women's magazines. *Le Follet* (1846–1900), the *Fan* (1881), *Fashionable London* (1892–4) and *Hearth and Home* (1891–1914) were all directed at women of the middle, upper-middle and upper classes and all regularly included Arts and Crafts items.

For readers of the *Fan* or *Hearth and Home*, Arts and Crafts

were an expansion of the sorts of pastimes which had occupied middle and upper-class women for generations. But the Arts and Crafts Movement brought about considerable changes for these women. It enormously expanded their repertoire of pursuits from the tapestry, embroidery and sewing of their forebears. Periodicals for women dealt with an increasingly wide range of crafts. Designs for metal inlay work, repoussé metal work, fretwork and basketry as well as for ornamental glove boxes, sewing boxes and card cases went side by side with embroidery designs. The common denominator of all these pursuits, and the 'feminine' crafts, was that they were all small scale, they did not use cumbersome and expensive equipment, they were 'clean' and they could be carried on in the home. They did not require a studio or workshop. Thus, while they do point to the division of crafts into 'masculine' and 'feminine', they were also suitable for middle-class hobbyists who were less concerned with making a living than with making dainty objects to adorn their homes.

It is clear that women were denied access to the higher levels of the Arts and Crafts pyramid. They were excluded from the movement's institutions, and there were few major designers. For the most part professional craftswomen simply made what men had designed. But for the amateurs who made up the the majority of those in the movement, Arts and Crafts did bring real benefits. The Arts and Crafts Movement invested amateur producer and product with a new and positive moral value. Because of the movement's aesthetic goals, amateurs aspired to the status of 'artworkers' (or artists if they misinterpreted the Arts and Crafts aesthetic). That meant that their products were no longer 'fancy work' but 'art objects'. An erstwhile pastime, that had been beyond the pale of exhibition, sale and record, became at least partially integrated into the vast institution of art. Homework and artwork became connected, and women's stake in the latter grew appreciably. In addition, the notions of moral worth, seriousness and self-improvement which characterised the professional side of the movement filtered down in diluted form to amateurs. An erstwhile pastime became a useful and educative occupation. Like the professionals, amateurs could thus derive a feeling of moral well-being by engaging in handicraft. They could even feel that they were participants in a virtuous way of life. For a socialist amateur, indeed,

every stitch was one small step towards the Great State, every tap of the chisel the announcement of the new dawn.

Because of this common ground amateurs and professionals could agree, in principle, on the kinds of activities to be undertaken. But, because not all amateurs put a moral gloss on their work and not all professionals were socialists, the meanings of these activities could be very different. That in turn meant that the significance attached to Arts and Crafts products could vary greatly according to the meanings with which producer or consumer invested them. For the middle-class amateur a pot could be primarily a signal of social and aesthetic status, with the merest hint of a moral overtone. For the socialist professional a pot could be filled with political and ethical import but barely touched with fashionableness. While such divergence was widest between the fashionable amateur and the utopian professional, there were considerable differences of opinion in the professional body itself. But until the formation of the Arts and Crafts Exhibition Society in 1886, potential conflict was subsumed in the general desire to unify the arts, change taste and elevate the craftsman.

The Arts and Crafts Exhibition Society was formed when it became obvious that the Art Workers' Guild remained committed to anonymous endeavour, and would not sponsor members' exhibitions. The new body held very large triennial exhibitions at which articles were individually displayed and signed. Because the articles were for sale, in one sense the Society's exhibitions were simply a forum for generating commissions and revenue. But in another they were the outcome of the debate about how best to revive handicraft. Within that debate there was considerable disagreement about the role of the object itself, and thus about the significance to be attached to it. The display of signed works of individual craftsmen brought those for whom the significance of the object was primarily moral up against those for whom the significance of the object was primarily aesthetic. The disagreement was thus in part about whether the movement were to produce the moral object with its overtones of social regeneration, or the art object which had overtones of a more purely aesthetic appreciation and more fashionable connotations.

Many socialist and utopian thinkers in the movement attacked the notion of the art object and condemned the formation of a society which could countenance the sale of signed work. They

believed that the aims of the Arts and Crafts Exhibition Society
were incompatible with their own commitment to anonymous
collective effort. They were also afraid that craftsmen would be
diverted from the movement of ideas and towards the world of
commerce. Now it is entirely possible that the same object could
have different meanings for different consumers. It could have a
primarily moral significance for socialists and a superficially
aesthetic significance for followers of fashion. But critics of the
Arts and Crafts Exhibition Society felt that the works displayed
there had a commercial element. They held this work in contempt
precisely because it revealed the very close relationships between
Arts and Crafts production and commerce. Socialists wanted to
change those very relationships and they wanted Arts and Crafts
to help to do it. The Arts and Crafts Exhibition Society showed
them exactly what their difficulty was. Instead of being a product
of the Arts and Crafts Movement, objects on display at the Arts and
Crafts Exhibition Society became the Arts and Crafts Movement's
response to the demands of fashion and the pressures of commer-
cial society.

The Arts and Crafts Exhibition Society's shows brought about
precisely that transformation in the significance of the object and
the nature of the movement that its detractors feared. From the
1890s onwards it was as art objects that most Arts and Crafts
products were exhibited and purchased, while the impetus to
produce objects of use and 'socialist objects' progressively declined.
'The main result of the Arts and Crafts Exhibition Society', said
Gill later, was to 'supply beautiful handmade things to the rich,
and imitation ditto to the not-so-rich'.[28] If the art object supplied
the connoisseur and the rich, objects that were reproducible
supplied the less wealthy art lovers who could not afford the objects
themselves, but who could transform their homes with repro-
ductions. Again, Gill said the shows were 'in effect a free presen-
tation of new and fashionable designs . . . there came into existence
all the Liberty and Waring and Gillow and Heal tradition of
supplying, by factory methods, goods which, to the ordinary refined
inhabitant of the suburbs and provinces looked just like the genuine
arts and crafts'.[29] Mackmurdo, at an optimistic point in his *History*,
made the most of this, declaring bravely that 'one had not long to
wait before the shop windows of Tottenham Court Road reflected
the incoming tide of a better taste and a frank sense of enjoyment

in the simple look of things'.[30] Cobden-Sanderson, one of the Society's original members, did acknowledge that there was a danger of the public being 'diverted from the movement of ideas and action thereupon, to the mere production and exhibition of exhibits'. But he still maintained that Arts and Crafts was 'a movement in the main of ideas and not of *objets d'art*'.[31] The Society's shows, however, made such confidence increasingly difficult to sustain.

At the height of the Arts and Crafts Movement, between the late 1880s and the early 1900s, then, the reproducible art object was the most widely disseminated Arts and Crafts product. The dictates of fashion had, by this time, triumphed over the movement of ideas for the majority of consumers and participants. The Arts and Crafts Movement here melted into the Aesthetic Movement and shared some of its vocabulary. The Arts and Crafts object did indeed become the 'art object' and 'art' status was attached to a wide variety of activities, objects and abstractions. *Hearth and Home* mentioned 'art furnishers and decorators', 'art drapers', 'artistic dress and mantel designers' (1891), 'artistic garden seats', 'Art wall and ceiling papers', 'art carpet' (1908), and an 'artistic selection of furniture' (1903).[32] Established companies like Waring and Gillow advertised their wares with the same prefix, while new ones like the Art Metal Work Co. Ltd also hoped to do business under its aegis.[33]

The second striking result of the Arts and Crafts Exhibition Society shows was that they brought the consumer face to face with the craftsman in far greater numbers than ever before. In so doing they brought together two groups whose interests were very often antipathetic to one another, but whose relation was necessarily symbiotic. The 'movement of ideas' was dedicated to sweeping away both bourgeois and connoisseur, but could only exist with their patronage. The connoisseur and bourgeois, while unlikely to be sympathetic to the social aspirations of the movement, were very eager for its products.

This tension between the producer who was dedicated to the movement of ideas and the consumer who was eager for the art object is exemplified in the career and works of the bookbinder, T. J. Cobden-Sanderson. In 1906, Cobden-Sanderson wrote that he had 'not sought' in his work 'to satisfy the instincts of exclusiveness of collectors, but rather to impart that sense of order and still

serenity of beauty which is excited by the contemplation of the universe itself'.[34] Nevertheless, as he admitted elsewhere, 'I aim at the ideal, and never get beyond the "collector" '.[35] He liked to think that his collector was 'the idealist too'.[36] If so, the collector was an extremely shrewd one. In 1900, the bindings which Cobden-Sanderson had originally sold for between £2 and £15 were sold at Sotheby's for between £85 and £177.[37] The rise in status which was signalled by and accompanied such a rise in value meant that these bound volumes became like pictures, not to be read or handled, but to be exhibited. James Bain, Cobden-Sanderson's London dealer, remembered that one of the most persistent buyers was Henry J. Bell, managing director of Garrards, the court jewellers. Bell 'decided to collect Cobden-Sanderson bindings, of which he gradually amassed a considerable number, placing them in a glass-fitted bookcase, with green silk curtains to protect the books from too much light'.[38]

Once the book had become art, the bookbinder became an artist. Large fine binderies like Zaehnsdorf, Morrell and Riviere, or Sangorski and Sutcliffe bound in standard patterns and to order. But, as one contemporary commentator said, 'Cobden-Sanderson will not bind to order. He binds only those books that please him, and he binds them as he pleases. He is independent of the caprices of his customers. . . . Every one of his bindings is as unique as a picture; there are no replicas.'[39]

Although buyers regarded Cobden-Sanderson's bindings as art objects, he himself maintained his belief in the Arts and Crafts Movement as a movement of ideas. If, as has been seen, most participants in the movement were swayed by the desire for fashionable products and pursuits, a significant number of craftsmen and their followers persisted in regarding the object as moral and as redolent of a particular way of life. Despite this tension, utopian craftsmen and their followers were a vital component of the movement. Many of their beliefs, indeed, were filtered in diluted form to the movement of fashion. So both sides within the Arts and Crafts Movement found common ground upon the social issues which were the major concern of visionary and socialist participants. Two issues, in particular, which claimed the attention of a great many involved in the movement had repercussions for the aesthetic and reception of early Modernism. These were the reorganisation of the means of production and attitudes towards town and country.

Many professional craftsmen, taking their lead from William Morris, believed that reform of the means of production was a necessary condition of reform of aesthetics. They held that the modern factory system, based upon the machine, produced a variety of evils. First, it substituted the notion of profit for the notion of excellence. Second, it was centred on commercial competition rather than corporate endeavour. Finally, they said, the division of labour which it entailed robbed man of his humanity, of the expression of joy in his work, and thus of art.

Many felt that the wrongs of the system could be redressed by the return to a system of guilds. Briefly, the guild system, as they understood it, involved small units of production composed of craftsmen working for the common good, without division of labour, and with direct contact between consumer and producer. It was thus seen as the very antithesis of the modern factory system. Those who advocated this guild system drew their inspiration from the craft guilds of the Middle Ages, although Ruskin's ill-fated Guild of St George, established in 1871, provided a more recent model. The writings of Sorel, Marx and the Russian anarchist, Prince Kropotkin, fed its theory.

The restoration of guilds was advocated within the Arts and Crafts Movement with varying degrees of rigour. At one extreme lay those like Ashbee, who tried to put all guild principles into operation with his Guild of Handicraft.[40] Others, like Lethaby and Cobden-Sanderson, shared some of the guild movement's wider social and moral aims, but did not actually attempt guild reconstruction. So Lethaby called for the creation of craft guilds, responsible not only for working conditions but also for the quality of their products, to replace existing trade unions.[41] Mackmurdo went so far as to say that the medieval guilds were themselves little more than trade unions, and that new guilds should not be based too closely on their practice. For, he said, 'they were defensive and economic organisations. . . . The modern catholicity of spirit induces association, not for the sake of a possible gain from the pursuit, but for the sake of a gain to that social purpose towards which the arts minister'.[42] Cobden-Sanderson, less practical still, demanded a nationwide network of guilds to spread Arts and Crafts ideas throughout society.

Furthest from Ashbee's position, however, lay most of the movement's members. They remained content with the associations of

the guild movement but did not attempt to put its principles into practice. Professional organisations like The Art Workers' Guild (1884), The Century Guild (1882–88), The Guild of Art Craftsmen (1899), and The Working Ladies Guild (1902), educational organisations like The Trades Guild of Learning (1877), and amateur organisations based around publications, like The Hearth and Home Art Guild (1891) and the Clarion Handicraft Guild (1901), all drew on the attractive connotations of excellence, pleasurable labour and collective altruism which characterised descriptions of medieval guilds.[43] For these guild members, then, the very idea of guilds lent dignity and status to their organisations. Whereas for Ashbee foundation of a guild was a matter of principle, for the majority of amateur craftsmen it was a matter of fashion.

Nevertheless, both Ashbee and amateur guildsmen regarded guilds as antipathetic to factory life.[44] The polarity which they established between the two set hand production against the machine. For committed guildsmen working by hand became symbolic of the new way of life which they wished to establish, while the machine came to symbolise the society which they wished to eradicate. Amateurs diluted this distinction into enthusiasm for hand production and distaste for the machine. But for both, a hand-turned chair or a hand-carved inscription was indicative of moral excellence, while the use of the machine for the same job denoted moral decadence.

The attitudes of members of the Arts and Crafts Movement towards the machine and the factory were completely consistent with their social and moral aims. It was primarily a movement of social and moral reconstruction and was never a movement about industrial design. Despite occasional attempts to romanticise the machine – Morris, late in life, called the factory the 'palace' of industry – most theorists either argued for its control or hoped that its use would be confined to 'rough work'.[45] This seems to have been Morris's desire. For while 'a state of social order would probably lead at first to a great development of machinery for useful purposes', later, if a certain industry could be 'carried on more pleasantly as regards the worker, and more effectively as regards the goods, by using hand-work rather than machinery, they will certainly get rid of their machines'.[46] Mackmurdo, in much the same vein, oscillated between acceptance of the machine and a tremendously forceful reaction against it. 'We must for the moment

accept the fact that mechanical processes will tend more and more to take the place of handicrafts in the production of those things which the homes of the millions must accept for their use', he wrote in his *History*.[47] But he was obviously not satisfied with the implications of such a statement, and added a handwritten addendum to his manuscript which showed that as late as the 1920s the idea of a society like the one Morris had longed for had not lost any of its appeal. 'In the future', he declared, 'automotive power will be severely restricted, first to giving man control over certain natural forces, secondly, to freeing human power for its fullest and great exercise by and through pure craftsmanship'.[48]

Members of the Arts and Crafts Movement added a further polarity to the antitheses which they had established between factory and workshop, machine and hand. They contrasted city and country, the urban environment with the rural way of life. The former they associated with the factory and the machine, the latter with the workshop and the land.

Some craftsmen, notably Morris and Ashbee, went so far as to establish their workshops in the countryside. Ashbee, indeed, tried to develop a self-sufficient rural community when he moved the Guild of Handicraft from London's East End to Chipping Campden in Gloucestershire.[49] But most Arts and Crafts practitioners never went beyond rural nostalgia, a sentimental yearning for a pre-industrial way of life. Lewis Day's description of Morris's Merton Abbey Works for the readers of the *Art Annual* in 1899 epitomises this vision. Even though Day was not himself hostile towards machine production, he none the less portrayed Merton Abbey as a rustic idyll. 'Imagine', he said, 'by the Wardle's side, an old walled garden, on the banks long, low-roofed worksheds, and a waterwheel revolving at its ease'.[50] The garden here suggests paradise or the rose gardens of medieval romance, while the waterwheel, actually a means of power, suggests not work, but leisure. The plates which accompanied the piece drew a picture of the calm and solitude of the rural workshop.

The rural way of life and handicraft were also associated with spontaneity and expressiveness. These qualities, which were of very great importance in Arts and Crafts schema, were not confined by rural revivalists to the creation of art but were extended to cover every aspect of life. Conversely their advocates condemned the rigidity and inhumanity which they associated with the city and

machine-based life. Materialism and empirical science, which they saw as the creators of the urban environment, were also unfavourably contrasted with expressiveness and with art.

This cluster of attitudes towards the machine, the factory and the city was anything but the purlieu of the Arts and Crafts Movement. The British Left rejoiced in a long anti-machine tradition, while destruction of capitalism and destruction of the factory were seen as synonymous by many late Victorian socialists. The elevation of the country over the city was given a socialist slant by Arts and Crafts theorists. But the polarities which they advanced had not only a long literary history but also considerable commerce amongst the middle classes of all political persuasions. The British countryside has been one of the most enduring of national obsessions.[51]

In a movement composed of such disparate elements, theoretical confusion and disagreement were bound to arise. But it is important to stress that there were common ideals which induced in all participants the feeling that they were part of a shared cause and a movement. All could agree that with the split between the greater and lesser arts, 'the artist came out from the handicraftsmen, and left them without hope of elevation',[52] and all could share the wish to 'restore building, decoration, glass painting, pottery, wood carving and metal work to their rightful place alongside painting and sculpture'.[53]

All agreed too that the basis of handicraft lay in the expression of the individual craftsman. To Christian socialists within the movement that meant the individual showing his love of God through art. For others it meant the expression of love for his fellow man. But art started, in the Arts and Crafts schema, with man and his need to reveal something of his joys and beliefs. When early Modernists first came to explain a new art to a general audience, they too stressed the importance of the individual. In 1910, the claim to the right to, and need for, self-expression became the stick with which to beat widely accepted artistic convention. In the same way, Mackmurdo celebrated 'the enfranchisement of art from barren method and meaningless rule; the frankly placing art [sic] upon the solid basis of emotional experience'.[54]

If the arts were to be reunited, a definition of art was needed that could embrace all branches of the fine and decorative arts. Unlike a painting, the Arts and Crafts object could not illustrate ideas. It could not, for instance, portray the elements of society,

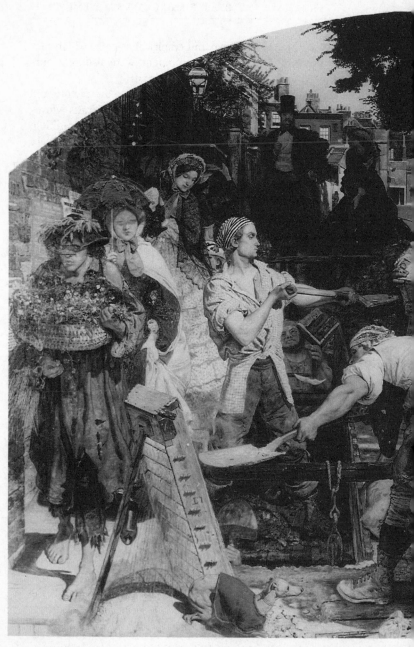

Ford Madox Brown, *Work*. (Reproduced by permission of Manchester City Art Gallery.)

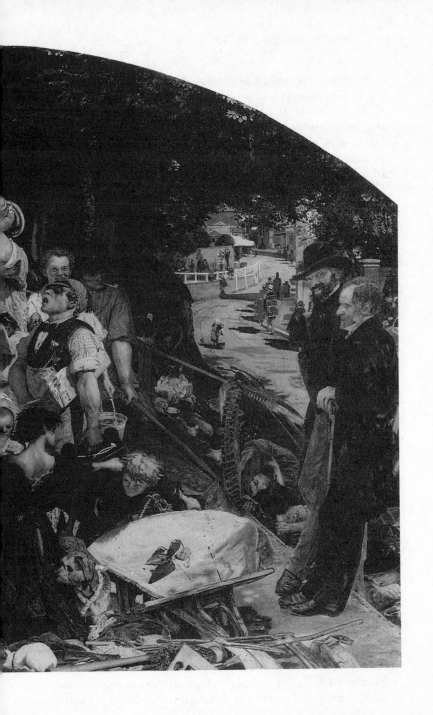

existing or to be wished for, in the way that Ford Madox Brown did in his celebrated canvas *Work* (1852–65). The idea shown in *Work*, one grand idea, is the different kinds of labour in society and their relationship to one another. It is as much a picture of how things might be as how they are. The foreground of the painting is occupied by a group of navvies representing manual labour; to the right, F. D. Maurice, founder of the Working Men's College, and Carlyle, who represent intellectual labour; and a woman and child who stand for the defenceless in society. Behind the building site which the workers occupy – a space like a boxers' ring – are the bourgeoisie, or the rich, a top-hatted man and a gloved woman on horseback. Their way towards the front of the picture is blocked by the building site. Beyond and to the right of them are a group of electioneers carrying placards, and in the far distance, posters about the Working Men's College are going up. There is no doubt that the figures in the foreground are engaged in constructive endeavour, from which the rich are excluded. *Work* represents and brings to the fore in its very composition the elements of society which Brown most revered and which, he hoped, could work together. Maurice and Carlyle literally share a space with the workers, women and children, while the rich are pushed to the background. *Work* 'shows' us both pictorially and in its composition what Brown sees in and wants from society. As a painter, moreover, he has put himself 'in the ring' with the 'workers', because the space they occupy extends beyond the picture plane. Both the painter and the viewer can stand within it.[55]

A Morris wallpaper, a series of marks which told no 'story' could not work in the same way as such a painting. Neither could a Cobden-Sanderson binding. But both did have a 'message' related to Brown's which could be grasped and understood. The form and the message were, in the case of Arts and Crafts objects, one and the same. That meant that the object was in itself a signpost to the new society. Madox Brown's own bedroom set (see plate) was a physical embodiment of the moral qualities which would inform the society towards which the movement was striving. It was simple, rugged, obviously handmade, and it was the very image of respect for materials because it so closely mirrored the form of the tree from whence it came. In its simplicity it stood as a condemnation of the luxury and comfort represented in the heavily upholstered

Ford Madox Brown, *Bedroom Set*. (Reproduced by permission of the Society of Antiquaries of London.)

mid-Victorian bed. Technique and form thus encapsulated, embodied content. Arts and Crafts did not attempt to portray the future so much as to capture it physically. It was to be symbolised in objects rather than displayed in images. The definition of art put forward by Arts and Crafts theorists reflected this shift away from representation to embodiment. Since form was idea, it was form that was stressed in Arts and Crafts writing. Technique, the way in which an object was made, was also elevated. The degree to which technique, form and idea could be made to work together became the means of judging a work of art. Technical and formal

excellence working together could produce an object which embodied the values which the movement stood for.

X

Once the normative standard had been shifted away from the successful depiction of ideas, the definition of the artist would change as well. Thus Morris defined the artist as 'but a workman who is determined that, whatever else happens, his work shall be excellent',[56] and Lethaby supplied the corollary that 'a work of art is a well made thing, that is all'.[57]

Although the demand for technical excellence might seem at first to separate professional and amateur, the means by which they could both espouse this new definition of their enterprise was contained within Lethaby's statement itself. If for the professional it was a demand for a rigorous professionalism, for the amateur it followed that anyone who made anything well was an artist. For most amateurs, however, this did not mean an artist in Morris's sense, but a fine artist. The *Poster and Art Collector* said in January 1901 that 'The man who can design a fine binding is an artist as certainly as he who paints or etches finely'.[58] In the same vein the author of the Arts and Crafts volume of the *Women's Library* asserted, in 1903, that 'the craft of woodcarving cannot be considered as an art standing alone; it is a member of a large art family, the highest of which is sculpture. . . . This is the Art of Pheidias, Praxiteles, Donatello, Michael-Angelo.'[59]

To extend the definition, the shift towards technique meant that not only those who made something well were artists, but that those who did something well were too. It was at this point that the desire to make a good thing shaded into the desire to make a good man, and to pursue 'the art of life'. There is thus a very close link between technical and moral excellence in Arts and Crafts theory. The desire to create conditions in which the good man could flourish stemmed in part from this connection.

To Arts and Crafts theorists, then, labour and life came together. It was a necessary condition of the production of art that labour should be both pleasurable and dignified. If this condition were not met – and it could not be met under factory conditions – man became simply a machine without the means of self-expression. Art could never result from production devoid of the human element, for, as Crane put it, art was simply 'the faculty of expression itself'.[60]

Professionals and amateurs alike agreed that the creation of a

work of art could both produce and contribute to the kind of life which they desired. Both also believed that the work of art should itself be useful to the mind or body. For many craftsmen and amateurs the idea of 'use' was associated with the utilitarian or everyday object. Lewis Day said that, 'the association of art with every common object of daily use seems to be in the natural order of things',[61] while Morris declared that 'nothing can be a work of art that is not useful'.[62] *Useful Arts and Handicrafts* was the title of a compendious three-volume guide to 'the adornment of the home' which appeared in 1901.[63]

These moral overtones informed every aspect of the Arts and Crafts aesthetic. All Arts and Crafts descriptive categories carried with them overtones which invoked the wider aims of the movement. Just as the object itself was the embodiment of these aims, so the deployment of the Arts and Crafts aesthetic called them forth. Arts and Crafts writers developed a genealogy for their products and a corpus of critical and descriptive terms which thus referred constantly both to the place of Arts and Crafts within the institution of art and within a larger, social context.

The purpose of a genealogy was to place craftsmen firmly within a tradition which would dignify their endeavour and help to raise its status. The pattern of argument employed for this purpose was essentially the same for both amateur and professional audiences. Writers first asserted the ancientness of their product and showed how it had flourished and declined. After this they announced its resurgence. Crane went 'back into prehistoric obscurity to find the first illustrator, pure and simple, in the hunter of the cave'.[64] The writer of the *Arts and Crafts and Technical Instructor* simply asserted that 'needlework may, I think, lay claim to be one of the earliest of the Arts, if not the most Antient'.[65] W. N. Brown, in his amateur guide *The Art of Enamelling on Metal*, claimed that the history of that craft might 'be said to be that of civilization',[66] while the designer G. W. Rhead – for many years an employee at Doulton's Lambeth works – said that metal work had 'formed one of the most important branches of the applied arts since the days of Tubal Cain'.[67] Day went considerably further to find the origins of ornament. 'For', he said, 'if we were to trace it to its beginnings, we should find ourselves in Eden'.[68]

If we unravel what Day is saying we can illuminate the connections between the Arts and Crafts aesthetic and and the movement's

ethical aspirations. Day's statement looks innocent enough. It summons up a pre-lapsarian world where the arts flourished in unity. It is an example of the 'golden-ageism' which riddled the Arts and Crafts Movement. But Day's golden age is also the Judaeo-Christian golden age, and this religiosity is in keeping with the general tenor of the movement as a whole. It reminds us that as early as the 1870s, long before he became a socialist, Morris saw his task as a 'holy war' whose purpose was to restore the Eden lost by the bifurcation of the arts. But such religiosity could not be divorced from socialism, for the paradise regained by the Arts and Crafts Movement was to be a socialist one. Day's vocabulary carried with it all these overtones.

Most writers, however, did not go as far back as paradise. They looked instead to what they regarded as another supremely religious (and perhaps socialist) age, the era of guilds and the Gothic. It was then that the arts flourished in unity. Then, according to Lethaby, 'the mere getting through of life appears to have been more romantic: people seem to have played at war romantically, and to have traded artistically, and to have built fairy architecture'.[69] Then, too, said Morris, 'the mystery and wonder of the handicrafts were well acknowledged by the world'.[70] But at some point – and the point varied with the predilections of the writer – the arts became dissociated, and handicraft began to lose its rightful status. For Rhead, that moment was 'the invention of oil painting in the early part of the fifteenth century'.[71] Morris and Crane thought it was the mid-sixteenth century, when 'classical art got the upper hand', and 'the youthful spirit of the early Renaissance became clouded and oppressed and finally crushed with a weight of pompous pedantry and affectation'.[72]

Theorists who disapproved of Renaissance arts did so on the grounds that they were based upon the importation of classical and foreign models. These implied both theory and, in the case of architecture particularly, the drawing up of detailed plans. To Arts and Crafts theorists – many of them refugees from architects' offices – this was deplorable pedantry and academicism, and a denial of the tradition of passing knowledge from hand to hand. Rejuvenation of handicraft, they argued, must therefore go along with a resurgence of that tradition. While Morris rather imprecisely suggested that such a revival would only be 'a carrying on of progress where we abandoned it a while ago',[73] others liked to

assert a more exact schedule for revival. For Crane, it was Blake who began to undo the damage of centuries, for, he said, 'we see in Blake something of the spirit of the medieval designers'.[74] Rhead concurred, and added that the good work was continued by Ford Madox Brown, Burne-Jones and William Morris.[75] Most accounts, however, particularly those addressed to amateurs, laid the greatest emphasis on Morris's role. 'For', said Day, 'he it was snatched from the hand of Ruskin the torch which Pugin earlier in the century had kindled, and fired the love of beauty in us.'[76] This way of writing history – the dependence on a selective tradition to underscore present practices was also used, and used to powerful effect by the majority of early Modernist critics in England.

The construction of such genealogies lent weight to the Arts and Crafts aesthetic. It was an attempt by critics to establish the importance of the movement's claims and endeavours. Having thus laid out the pedigree of their undertaking, Arts and Crafts writers could go on to describe its products in greater detail, to back up general assertion with particular, and formal, claims to excellence.

While very different meanings could be given to any particular word in this descriptive process, both professionals and amateurs used the same vocabulary. Description of the product took two forms. The first was the representation of the whole product. This was usually achieved through description by analogy, and was very often morally weighted. The other was the representation of the constituent parts of the product. This in turn had two elements, the description of the activity of design, which resulted in the creation of ornament, decoration and pattern, and the moral and technical imperatives which accompanied that activity. Sometimes these moral and technical imperatives were fused. But it was over this point – the degree to which they should be fused – and over the exact nature of the imperatives, that writers' opinions diverged to the greatest degree.

Most Arts and Crafts theorists believed that when the arts were unified they were all arts of building, and all contributed to architecture. Following Ruskin, they cited the Gothic cathedral as a symbol of the perfect conjunction of the minor arts with architecture. Thus Morris asserted that 'the popular arts might all be summed up in that one word Architecture; they are all parts of that great whole. . . . We might yet frame a worthy art that would lead to everything, if we had but timber, stone and life'.[77] G. W. Rhead,

who took his lead from the early theorist Owen Jones, also placed the arts in this context. He said that 'the Decorative Arts arise from, and should properly be attendant upon Architecture'.[78]

The building, therefore, became the symbol of the newly revivified and unified arts, and architecture became a synonym for excellence. Thus Morris asserted that ornament on the printed page must 'become architectural'. He called printing 'book building' and suggested that a book could become 'a work of art second to none, save a fine building duly decorated, or a fine piece of literature'.[79]

The prominence accorded to architecture placed emphasis on the space which the object was to occupy. The designer E. S. Prior said that 'the room should be for the furniture just as much as the furniture for the room'.[80] It followed from this that it was a complete environment rather than an isolated object that was the ultimate aim of designers. Object, setting and structure were most significant when they were all designed together. For this reason, Morris's Red House, his remodelling of Kelmscott or the decoration of a manor house like Wightwick, near Wolverhampton, could stand as concrete symbols of the fulfilled aesthetic aspirations of the movement.[81]

Such statements, however, were beyond the power, and very likely beyond the desire, of most amateurs, who were making single detached objects to be placed in their own homes. Perhaps for this reason, the architectural analogy was seldom used by those who designed or wrote for amateur producers and consumers. Instead, they either used a musical analogy, or omitted discussion of the whole product altogether, preferring to concentrate upon its constituent parts.

Writers regarded the constructive parts of an object as the outcome of design. But since designing was the activity from which design could result, theorists often ran the two together, and so described the activity and the product simultaneously. Frequently, moreover, they made little distinction between the other most common descriptive terms, 'ornament', 'pattern', and 'decoration'. This was especially so when amateurs were readers or writers. Most of these terms, then, had no very precise definition. They were defined instead by an accumulation of associations for which they served as focal points. Each one was the hub of a plethora of connotations which conjured up the aspirations and ideals of the movement, and, in consequence, they had very strong positive

overtones. When early Modernist writers came to use some of this terminology it would still have the same aura for erstwhile members of the Arts and Crafts Movement, and its use would conjure up the same host of attractive associations.

R. G. Hatton, in a practical manual for students written in 1902, defined the designer as 'one who arranges the form of an object'.[82] All Arts and Crafts writers agreed with him that design concerned the structure of a work. They all agreed also that it was of fundamental importance. Crane asserted that the decorative designer looked 'not for picturesque accidentals, but essentials, or *typical* line and form'.[83] Similarly, Selwyn Image, a founder member of the Century Guild, and later Slade Professor at Oxford, said that 'in every form of art the thing which is of primary importance is the question of design'. To Image, art and design became synonymous because design was 'the inventive arrangement of lines and masses, for their own sake, in such a relation to one another that they form a fine, harmonious whole ... so completely satisfying us that we have no sense of demanding in it more or less'.[84]

Hatton, however, providing an example of the sort of linguistic inexactitude that has just been mentioned, made the same claims for pattern as Image did for design. He asserted that 'patterns are a rhythmical form of Art, with a justification of their own', and went on to say, 'some have not hesitated to ascribe to them a deeper, more mystical and more symbolic, significance than pictorial Art can itself claim'.[85] Lewis Day described pattern more simply. He said it was 'ornament in repetition'.[86] Rhead also suggested that ornament resulted from pattern when he told his readers that 'Geometry is the most important factor in ornament, since it forms the basis of all surface patterns'.[87]

If there was a distinction to be made between 'pattern', 'decoration' and 'ornament', it perhaps lay in the nature of the surface or object to be covered. As the statements of Rhead and Day show, ornament could encompass pattern, while pattern and decoration were often synonymous. But ornament was usually associated with three dimensions, and thus with architecture, while pattern and decoration tended to be used in connection with the flat surface. Thus Morris would say that 'the complete work of applied art, the true unit of art, is the building with all its due ornament and furniture'.[88]

Since ornament was connected with architecture it was used as

a descriptive term primarily by professionals, because, as has been seen, it was professionals who tended to use architecture as an analogy for and symbol of their work. It followed that amateurs, having little use for the architectural analogy, had little use for ornament as a descriptive term either. Those who wrote for amateurs or for those who designed on flat surfaces nearly always used the word 'decoration' when they were describing the parts of their products. This may have been due in part to the attractive associations it had for them. Decoration was a term associated not only with Arts and Crafts but also with the fine art of painting, so it could be used to connect amateur endeavour to that of great painters of the past. Thus while A. L. Baldry, in his monograph *Modern Mural Decoration*, published in 1902, could assert that 'if the classic masterpieces of any school or period are analysed, it will be found that their greatness in each instance is in exact proportion to the extent of their decorative quality',[89] so *Arts and Crafts* magazine could describe itself in 1890 as a 'popular paper reflecting the advanced taste in matters decorative'.[90] The status attached to the kind of decoration which Baldry discussed could – by linguistic sleight of hand – be transferred to the kind of decoration *Arts and Crafts* magazine was talking about. The effect of this was to imbue the term 'decoration' with a notion of the quality to which amateurs aspired. Thus in 1908, *Hearth and Home* could speak of a 'decorative door curtain' and 'decorative panels' as if decoration and quality were synonymous.[91] Whereas to the professional 'pattern' and 'decoration' remained more or less synonymous descriptive terms, to the amateur their meanings diverged. 'Pattern' continued to hold its original sense, but 'decoration', with its new overtones of quality, also began to imply a positive value judgement.

The taxonomic confusion which writers displayed, however, did not obscure their common aims. Beneath it they were asserting something which they all regarded as of fundamental importance to the revival of handicraft. The need for a new vocabulary arose from the desire on the part of professionals to distinguish handicraft from the fine arts. This distinction was seen as that between fundamental, even skeletal coherence on the one hand, and inessential and surface details on the other. Because of the correlation between art and morality, this distinction could be ethical as well as aesthetic.

When writers laid out the particular qualities that they thought

were important in design, 'pattern', 'ornament' or 'decoration', technique and morality often came together. Arts and Crafts writers agreed on three conditions necessary to the production of the well-made thing. The craftsman should respect the nature of his material. He should also concentrate on the function of the object, and not attempt to use it to depict ideas or stories. Finally, in both these aims he should strive for simplicity and purity rather than gorgeousness of effect. But differences of opinion were voiced over the acceptable means of effecting simplicity. This was because writers disagreed on their attitudes towards nature, and the degree of abstraction from nature which could be allowed.

The idea of 'truth to materials' and the desire to make the functional object were obviously connected. Day said that 'the notion of a china flower vase in imitation of wicker work is scarcely less trivial than that of a dessert dish representing vine leaves modelled in majolica'. The reason for this was that it neglected 'the beautiful and altogether appropriate forms natural to the . . . potter's wheel'.[92] 'Truth to materials' then became an index of quality. For Morris, indeed, working on the terms set by the medium itself was both one of the justifications and the joy of decoration. 'It is', he said, 'the pleasure in understanding the capabilities of a special material, and using them for suggesting (not imitating) natural beauty and incident, that gives the *raison d'etre* of decorative art'.[93]

As Day's assertion shows, the call for 'truth to materials' was also a call for specificity of medium. It was a demand that porcelain should not be regarded as basketry. By extension, it was also a demand that craft should not be regarded as fine art. It was thus one means of establishing craft as a discrete category of aesthetic production. As will be seen, early Modernist sculptors and their champions also used the idea of 'truth to materials' as a way of asserting the worth of a new endeavour.

If craft were to be seen as separate from painting, it was necessary to establish a notion of quality that did not involve one of the most central criteria for the judgement of fine art, namely the successful transmission of ideas and concepts. Many writers went further than the assertion of a distinction between art and craft. They tried to elevate craft by attacking fine art. 'Symbolism and mysticism are the weak side of all our modern art', said *Art* magazine in 1903, 'they denote a feeble mind, and in the long run might develop into

a quality which shall replace the real aesthetic element'.[94] Day said more briskly, 'the object of ornament is to ornament something; it has primarily nothing to do with story, poetry, or any other purpose than that'.[95]

What remained when content or ideas had been banished was form. It followed that form had an aesthetic quality peculiar to itself that could produce a kind of pleasure which was quite different from that experienced in front of a painting. So the writer in *Art* set the weakness of painting against the 'pure art' of carpets which, he said 'consist of colour and design, and nothing else, and the very fact of these qualities being limited renders them expressive to the last degree'.[96] Rhead praised ornament 'in which the purpose is solely decorative, without any distinctive or definite meaning other than the appreciation of the beautiful'.[97] Day went further than *Art* magazine and asserted that 'form is best appreciated in its naked purity. It certainly needs no "development" by means of colour.'[98] Taking the idea of nakedness to a greater extreme, he urged designers to attend to the 'dry bones of design'.[99] Crane similarly praised those who thought 'of their picture in the skeleton'.[100]

These writers all suggested the positive and expressive qualities of limitation, purity, nakedness and (stripped further) of the skeleton or the constructive centre of a piece of work. The bare bones, the nakedness and the restraint of craft were contrasted with the superfluity and thus the superfluousness and superficiality of contemporary painting. It was a short way from a charge of superficiality to a charge of ill-health and thence to a charge of corruption. Thus the purity of craft could be contrasted with the debasement of a fine art which, as Morris said, 'sickens under selfishness and luxury'.[101] By the same token Crane dismissed *l'art nouveau* as a 'strange decorative disease'.[102] He also brought the dual virtues of health and skeletal form together, and criticised designers who filled their borders 'with overfed pediments, corpulent scrolls and volutes'.[103]

The opposite of the luxury that Morris deplored in painting was, of course, simplicity. Simplicity was regarded by Arts and Crafts writers as both cause and effect of purity and of concentration on the essential rather than the superfluous. An early theorist and instructor at the South Kensington schools, F. W. Moody, told his students that 'the great lesson we have to learn in all things, is

simplicity. . . . We may trace all our artistic troubles and failings
. . . to the want of it. The rendering of mere detail, though now
so much vaunted, holds but a low place in art.'[104] The *Arts and
Crafts and Technical Instructor* told its reader to 'avoid putting into his
work any lines which are superfluous or meaningless'.[105] Lethaby
suggested that 'design, indeed, really fresh and penetrating, co-
exists it seems only with the simplest conditions'.[106]

What Moody implied and Lethaby made explicit was the belief
that simplicity – as well as purity and the search for the fundamental
– was the outcome of a certain way of living. Simplicity in art was
seen as the concomitant of simplicity in life, 'in all things'. Lethaby
went on to say – and here he followed Morris – that 'when we
have leisure to be happy and strength to be simple we shall find
art again'.[107] It followed that a work of art which displayed tech-
nique rather than ideas, and slenderness and economy of form
rather than a corpulent superfluity of useless ornament, was a
concrete symbol of the kind of life which Morris and many of his
followers wished to see re-established.

Looking at Arts and Crafts products today – Crane's busy,
overfilled pages or the detailed fussiness in some of Morris's wall-
papers – it is easy to feel that Arts and Crafts designers were the
very last to follow their own prescriptions. Morris's designs certainly
grow and flow in a way eminently in keeping with his desire for an
organic society, but they are far from simple. Theory and practice
do not seem to correspond here any more than they do in early
Modernist calls for pure form. But just as early Modernists set
Cézanne's form, which they thought of as 'pure', against the
impurities of Impressionism, so Arts and Crafts theorists set the
'simplicity' of Morris's wallpapers against the more highly repre-
sentational and more diversely coloured patterns of his day. The
gap which we see between Arts and Crafts theory and practice is
a gap which Arts and Crafts theorists have themselves helped to
create. The search for simplicity and purity of form led eventually
to a much greater formal spareness, which makes earlier efforts
seem out of step with their own aesthetic. To contemporaries with
no knowledge of the changes to come, theory and practice seemed
to march in parallel.

For many members of the Arts and Crafts Movement then,
fundamental principles of life were embodied in pure and simple

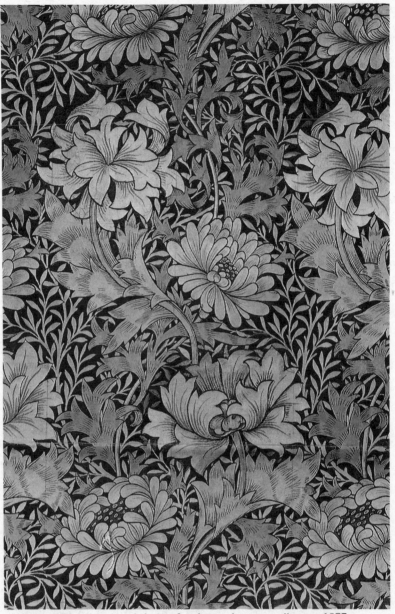

William Morris, original design for chrysanthemum wallpaper, 1877.
Water colour, pen and ink, 101 × 67 cm. (Reproduced by permission
of the William Morris Gallery.)

form. Others, less committed to social regeneration, were nevertheless in accord with the attack on contemporary fine art in the name of structural simplicity and clarity. As has been noted, truth to structure and the primacy of design were associated by many with the processes of purification and simplification. The latter were set against representation or truth to aspect. Inevitably, then, a debate arose about the degree of simplification or deviation from appearance allowable, and about the degree to which 'truth' and 'nature' were compatible.

Walter Crane succinctly summed up the dilemma many felt. 'The more of nature – at least of her superficial facts – the less, apparently, of art.'[108] Rhead's solution to this problem was to suggest that ornament be 'based on the observance of the general principles of nature, rather than a direct imitation of natural forms'.[109] For, claimed Rhead, 'it is not possible to invent any new motive which is not already suggested by nature'.[110] In effect, this was a means of allowing the most abstract forms to take refuge in the idea of 'truth to nature', and was thus a way of combining a belief in 'truth to nature' with a practice which might seem to belie it.

But some commentators went so far as to advocate a dissociation between nature and design. The earliest of them was Owen Jones. Although Jones was a generation older than Morris and was primarily associated with attempts to reform design after the Great Exhibition, his textbook, *The Grammar of Ornament*, was standard reading until well into the twentieth century. He claimed that 'in proportion as design approached natural form, it had less claim as ornament'.[111] Day, following Jones, asserted that ' "truth to nature" is a cry to which the ornamentalist may turn a deaf ear. He has chosen his course, which is not that of nature.'[112]

For these men, the designer's model was mathematics or music, or both, rather than nature. Moody said that if ever decorative art was to be exalted, 'it will be by the study of the abstract laws of harmony and composition, and not by mere imitation'.[113] Day brought geometry and music together 'Take any form you please', he said, 'and repeat it at regular intervals, and, as surely as recurrent sounds give rhythm or cadence ... you have pattern'. It was a condition of pattern that 'the lines of its construction may be traced; they pronounce themselves, indeed, with geometric precision'.[114] For Rhead the beauty of abstract form arose 'chiefly from the

correlation of the lines and shapes in contrast or harmony with one another'.[115]

The question of the associations of words like 'harmony' and 'rhythm' which were imported into the critical language of the visual arts is too wide-ranging to be brought within the scope of this study. Harmony was, of course, invoked for its emotional as well as its musical (and therefore 'pure') associations. It denoted a work that not only approached the condition of music in required Paterian fashion, but was also *unified*. That is, a collection of elements which were, like the notes of a chord, 'in harmony' and conducive to pleasure.

While the invocation of musical terms is now associated in England primarily with Whistler, musical terminology was very widely applied to the visual and verbal arts from the eighteen-seventies onwards. Gradually, 'rhythm' began to supercede 'harmony' as a term not only of generalised praise, but also as an indication of novelty, just as in musical composition itself rhythm became of increasing structural importance. As rhythm grew in importance in the critical lexicon it gradually accrued new associations. These were with Afro/American music and dancing and, by extension, with spontaneity and the unburdened sexuality with which African and other 'primitive' peoples were credited. It therefore became a particularly appropriate term to apply to art which was stylistically 'primitive', naive or childlike, and became even more apposite once primitive art was actually used for formal models. Thus the way in which Arts and Crafts writers used the term gradually became fused with its newly fashionable associations. By 1910, when reviewers praised Gauguin's rhythmical qualities they hinted at the supposedly uninhibited sexuality of the South Sea islanders he depicted as well as at the spontaneity, freedom and naturalness invoked by Arts and Crafts critics.

Morris's stand on truth and nature was the opposite of the position taken by Owen Jones. While Jones severed truth and nature, Morris made them largely synonymous. In his first lecture 'The Lesser Arts', he maintained that 'everything made by man's hand has a form, which must be either beautiful or ugly; beautiful if it is in accord with Nature, ugly if it thwarts her'.[116] Day suggested that in practice Morris did abstract from natural fact to produce ornament.[117] But Morris's *stance* at least was unequivocal. His attitude towards abstraction was consistent with his attitude towards

the kind of world which he thought resulted from a denial of nature. It was thus ethical as well as aesthetic. It was a position he maintained throughout his career. Nearly twenty years after his first lecture, in *Arts and Crafts Essays*, Morris contrasted Impressionism 'which is pushing rather than drifting into the domain of the empirical science of today', with Arts and Crafts, which 'can only work through its observation of an art which was once organic, but which died centuries ago'.[118] It was this organic art, the image of an organic society, which Morris wanted to revive.

There was thus great diversity of views on the question of truth to nature within the Arts and Crafts Movement. Indeed Jones and Day seem nearer to Oscar Wilde – that is to the representative of the Aesthetic Movement – than to Morris. Wilde adopted a languidly dismissive attitude towards nature and set art and nature completely at variance. He thus stood at the opposite end of the spectrum to Morris. Jones and Day – confining themselves to design and nature rather than art as a whole and nature – stood somewhere in between. The relationships between all four theorists serve to remind us that Arts and Crafts theory was not homogeneous and was not, for some, completely opposed to aestheticism. A designer such as Day provides a link between the Arts and Crafts Movement and aestheticism that encourages us to to see these movements not as the occupants of opposite aesthetic camps but rather as a spectrum of beliefs. To amateurs, the ethical implications of the debate over form were perhaps limited to a belief in simplicity rather than luxuriousness. But for those who practised craft for its social *cachet* rather than moral value even this was likely to have been a pietistic rather than a pious stance. Certainly, in publications for amateurs, formal questions were usually subservient to the desire for decorative quality. In a Teach Yourself Book, called *Home Arts and Crafts*, published in 1903, Montague Marks struck a middle course in the debate about form. The aim of all art, he said, was 'to accent and bring out the order that we find in Nature'. But his interests lay in the direction of means rather than ends, and his book was an attempt to tell the amateur how to proceed. So he went on to say that 'the first thing for a young designer to do, then, is to work out simple geometric designs. That will teach him their great decorative value.'[119]

The salient features of the Arts and Crafts aesthetic, then, for both professionals and amateurs, were the commitment to funda-

X' mentals in art and life, to truth to materials and to formal simplicity and purity. These qualities were infused into the language of description; into pattern, ornament, design and decoration. As we shall see, early Modernist theorists, and especially Roger Fry and his circle, shared much of this aesthetic with their Arts and Crafts counterparts. They were able to attract an audience in large part because of these shared concerns.

By 1907 it was apparent that the audience for Arts and Crafts was diminishing. Contemporaries believed that both the fashionable and the regenerative sides of the Arts and Crafts Movement collapsed between 1905 and 1907. The sudden death of several Arts and Crafts periodicals in the same years would seem to support their view. Not all Arts and Crafts activities, though, declined so precipitously, and the end of the movement as a whole was anything but clean cut. Many amateurs obviously sustained their hobbies and many educational institutions continued to teach them. That meant that the ideas which we have been discussing were still circulating right up to the First World War and beyond. The fashion for Arts and Crafts was moribund by 1905, but Arts and Crafts terminology remained part of the critical vocabulary of large numbers of people. So, although much of this language and theory had been promulgated a generation earlier, we should not assume that, when early Modernists used it, it was 'inherited' or 'passed on'. In a sense it was simply passed sideways. Most early Modernists and their audience had, after all, been born in the 1880s, while Fry was well into his thirties by the turn of the century. Older men like Fry (an exact contemporary of Ashbee) and Michael Sadler had been in their late 'teens and early 'twenties during the Arts and Crafts Movement's most actively socialist years. Younger members of the Post-Impressionist audience, M. T. H. Sadler or Vanessa Bell, for instance, had grown to maturity at the height of the movement's commercial success and at the zenith of amateur involvement when Arts and Crafts prescriptions were being disseminated to vast numbers of people.[120]

The longest survivors of professional Arts and Crafts endeavours were the private presses, which continued to cater for the connoisseur market on both sides of the Atlantic for many years. Ashbee's Essex House Press lasted until 1914, and Cobden-Sanderson finally flung his Doves Press type into the Thames in 1916. Other presses flourished intermittently in the following two

decades. As late as 1921, the novelist and chronicler of Impressionism, George Moore, glancing at the fashionable output of the Arts and Crafts Movement, wrote that 'all the crafts are past and gone, even as the birds of Paradise that were slain for the decoration of cruel women . . . but the craft of printing remains to us'.[121]

The decline in consumption, and hence in output, in other parts of the movement was, however, very obvious to contemporaries. They attributed it variously to the movement's theoretical failure,[122] to competition from amateurs, and to the higher cost of new Arts and Crafts artifacts compared with the cost of the old articles which the movement had made fashionable,[123] and to economic conditions. To this might be added the waning interest in schemes of social regeneration and the changing concerns of consumers between 1890 and 1908.

These last three factors should be briefly considered. First, the claim that the Arts and Crafts Movement was the victim of external economic forces. When Ashbee tried to account for the failure of the Guild of Handicraft in 1907, he dwelt not only upon unfair competition from the lady amateur who was 'prepared to sell her labour for 2d an hour, where the skilled workman has to sell his for a 1s',[124] but also upon 'the decrease in purchasing power of the Guild's clientele'. 'Where in the years 1900–1 some of the Guild's clients spent £50 with it', he said, 'they in the year 1906–7 spent only £5 or £10'.[125] Figures supplied by later economists support Ashbee's observations. In the third quarter of the nineteenth century, real incomes were probably growing at the rate of seventeen to twenty-five per cent per decade, but this growth fell away very sharply in the early years of the new century. Between 1905 and 1914 real incomes were some seven percent less than the average for the immediately preceding decade.[126] If we presume that some people in the middle class – who were the main beneficiaries of the increase in national income – spent surplus money on luxury goods like those which constituted most of the output of the Guild of Handicraft, it is not surprising that this enterprise should have suffered when their purchasing power declined. The Guild could not be revived in 1912 when real incomes began to rise again. By that time, middle-class attention was directed towards a different product, and it was not Ashbee who would take advantage of this return to prosperity, but his childhood friend Roger Fry.[127]

The demise of Arts and Crafts was also explained by the change in political and social attitudes. As has been seen, much professional Arts and Crafts endeavour was an attempt at social and moral regeneration. But this intimate connection between art and social concerns was gradually severed as socialists began to move away from schemes of social regeneration which involved a complete restructuring of society. The radical Left became increasingly committed to reform of and improvements to the existing social and political framework. The intention of the Independent Labour Party, founded in 1893, was to change society through parliamentary representation – that is, the political process – rather than through extra-parliamentary schemes of moral regeneration. By 1895, the ILP had several hundred branches and about 20,000 members. In the general election of that year it ran 28 candidates.[128] A. O. Orage, the editor of the *New Age*, was in no doubt that the socialist movement had 'absorbed the political enthusiasm of the Arts and Crafts Movement'.[129] He commented bitterly that 'from the moment of the rise of the Labour party, the Arts and Crafts movement became less and less interested in its own political future and more and more concerned with its economic present. Then began the lamentable series of little guilds ... and all the indications of a movement that has ceased to be a movement at all'.[130]

As increasing numbers of people came to share the gradualist, materialist premises of the ILP rather than the visionary, regenerative aims of earlier socialists, so fewer connected handicraft with an attempt to change society. This had three results. First, it meant that many radicals concentrated on direct party political involvement rather than on schemes like Ashbee's Guild of Handicraft which attempted to change the very bases of man's existence. Radicals became increasingly interested in working for a better world rather than creating a new one. While in 1896 an enterprise like the Haslemere Hand Weaving Industry would have commanded widespread sympathy, ten or twelve years later it may have seemed a worthwhile or viable project to comparatively few. The Haslemere weavers were attempting to achieve moral regeneration and trying to further the cause of economic independence for women. In 1908, practical attention was devoted to changing existing structures – those of suffrage and divorce, for instance – rather than changing the entire premises of women's existence.[131] Second, it meant that those involved in Arts and Crafts began to

see politics and handicraft as separate activities. Third, as a result of this, the objects that craftsmen produced were seen less and less as embodiments of moral values. This was true for both producers and consumers. In other words, the significance of the objects themselves changed, and for some, they became less compelling. Because of this, the demand for Arts and Crafts products may have fallen amongst the liberal educated middle classes, which was that section of the movement to which Arts and Crafts appealed partly as a result of its moral qualities. This gradual separation of art and 'life' facilitated (and went along with) the gradual acceptance of the art object rather than the moral object. As the art object became more acceptable so too did the notion of a more purely aesthetic appreciation of a work of art. This gesture towards aestheticism meant that theories of art, including Post-Impressionism, which rested, at least in theory, upon·that separation were more easily accommodated.

One significant result of the collapse of the Arts and Crafts Movement was that it left two important groups of consumers without an aesthetic cause consonant with their beliefs – or at the very least, with some of their beliefs. In other words, it left a market to be tapped. These two groups were the wealthy upper-middle and upper-class patrons and the radical and liberal educated classes. In the first group were those who had money to buy original objects rather than reproductions, and may have bought for social as well as aesthetic reasons. They had sustained the demand for expensive art objects with the status of exclusivity attached to them – Cobden-Sanderson's bindings, for instance, or De Morgan's ceramic tile pictures. Some of them had commissioned expensive schemes of interior decoration or costly embroideries of the kind Morris and Co. made to order. It was to this group that Fry appealed when he opened his Omega Workshops in 1913. It was this group also who were in a position to buy Post-Impressionist paintings, both English and Continental.[132]

But it was the second, much larger, and more solidly middle-class group which provided the backup for the new painting. They subscribed to the theory that accompanied it, went to exhibitions, and bought reproductions. As Arts and Crafts declined, liberals and radicals were left without any suitable visual correlative to their aesthetic. The demand for simplicity and purity cut them off from both idealist and neo-classical academic art, while their dislike of

scientific representation cut them off from Impressionist painting which was thought to be almost exclusively a translation of recent optical and colour theory onto canvas.

The educated middle classes had, moreover, imbibed from Arts and Crafts theorists a belief in the importance of seriousness and sincerity in both producer and product. This belief, perhaps, suggests one reason why Whistler, who might have represented an acceptable alternative to French Impressionism, had little widespread popularity. Although Whistler had proclaimed an art that was superior to nature, his roguish professionalism, his disdain for the dilettante and the amateur, and the provocatively frivolous tone in which he declared both cut him off from the earnest intelligentsia.

It was more likely that the liberal middle classes would turn to Whistler's pupil, W. R. Sickert, much of whose subject matter could be accorded the necessary degree of seriousness. His technique, moreover, could be seen as that of recording fact, putting nature 'to service', rather than that of representing single impressions. But Sickert never achieved widespread popularity. In the first place he paraded himself as a man of many personae, an actor, a dandy, a Don Juan, a *bon viveur* and even a charlatan. He was certainly capable of espousing the most unfashionable of views in order to draw attention to his disagreement with prevailing opinion, as he did in the years following 1910. His was an elusive, complex and highly coloured character, and his outrageousness may have hidden his rigorous professionalism from a potential audience. Clive Bell, for instance, acknowledged Sickert's stature, but deplored his lack of seriousness. In his memoirs, he declared that 'Sickert was a *poseur* besides being a great painter'.[133]

Sickert was, moreover, primarily an urban painter. His English subjects were mainly city scenes and interiors. Despite – or perhaps partly because of – its urban nature, much of middle-class England was imbued with rural nostalgia, a belief in the 'rural' values of simplicity, decency, honesty, and a wish to bring these values to the town, to make 'garden cities'. Sickert's painting did not cater to these notions. It was the promoters of Post-Impressionism who managed successfully to combine seriousness and largely non-urban subject matter, and to equate both with aesthetic and social radicalism.

# NOTES

1 Philip Henderson, *William Morris, his Life, Work and Friends* (London: Thames and Hudson 1967), p. 63.
2 A. H. Mackmurdo, *Pressing Questions* (London: John Lane 1913), p. x.
3 Gillian Naylor, *The Arts and Crafts Movement: A Study of its Sources, Ideals and Influence on Design Theory* (London: Studio Vista 1971), p. 122.
4 Naylor, *Arts and Crafts*, pp. 145–6, 179–80.
5 A. H. Mackmurdo, *History of the Arts and Crafts Movement*, ts (with addenda), William Morris Gallery, Walthamstow, p. 207.
6 E. P. Thompson, *William Morris: Romantic to Revolutionary* (1955; revised ed. New York: Pantheon 1976), p. 216.
7 *Arts and Crafts Essays by Members of the Arts and Crafts Exhibition Society* (London: Rivington Percival 1893).
8 L. F. Day, *Some Principles of Everyday Art* (1886; rpt. London: Batsford 1894).
9 Walter Crane, *The Claims of Decorative Art* (London: Laurence and Bullen 1892).
10 W. R. Lethaby, *Mediaeval Art* (London: Duckworth 1904).
11 H. Dolmetsch, *Historic Styles of Ornament* (London: Batsford 1898).
12 Julia de Wolf Addison, *Arts and Crafts in the Middle Ages* (London: G. Bell 1908).
13 C. R. Ashbee, *The Building of Thelema* (London: Dent 1910).
14 C. R. Ashbee, *From Whitechapel to Camelot* (London: Essex House Press 1892)
15 Richard Lunn, *Pottery* (London: Chapman Hall 1903).
16 Douglas Cockerell, *A Note on Bookbinding* (London: W. H. Smith & Son 1904).
17 Frank G. Sanford, *The Art Crafts for Beginners* (London: Hutchinson 1906).
18 Mabel T. Priestman, *Handicrafts in the Home* (London: Methuen 1910).
19 H. Snowden Ward, *Profitable Hobbies* (London: Danbarn Ward 1907).
20 Emily J. Skeaping, *The Art of Dainty Decoration* (London: Windsor and Newton n.d. [1914]).
21 Mackmurdo, *History*, p. 201.
22 For a harsher reading of women's role in the Arts and Crafts Movement, see Anthea Callen, *Angel in the Studio, Women in the Arts and Crafts Movement 1870–1914* (London: Astragal Books 1979).
23 'The Haslemere Hand Weaving Industry' *Women's Employment*, 4 April 1902, p. 2. This workshop seems to have been a separate enterprise from the Haslemere Peasant Industries, founded in 1896, and discussed in Callen, *Angel in the Studio* pp. 119ff. Haslemere was obviously an Arts and Crafts haven in the 1890s, for besides

these two businesses, it was also the home of Arnold Dolmetsch's instrument making workshops.

24  G. Elliot Anstruther, *The Bindings of Tomorrow* (London: Guild of Women Binders 1902), p. vii.

25  Anstruther, *The Bindings of Tomorrow*, p. xiv. Callen discusses the Guild on pp. 191–4 of her book, although she does not make use of this material.

26  'Fields of Employment open to Women: Furniture and Wallpaper Designing', *Spinning Wheel*, 26 April 1893, p. 403.

27  'Women's Handicrafts', *Arts and Crafts*, 14 February 1891, p. 75.

28  Eric Gill, *Autobiography* (London: Jonathan Cape 1940), p. 270.

29  Eric Gill, *Autobiography*, p. 268.

30  Mackmurdo, *History*, p. 241.

31  T. J. Cobden-Sanderson, *The Arts and Crafts Movement* (London: Hammersmith Publishing Society 1905), p. 30.

32  *Hearth and Home*, 25 May 1891, pp. ii, iii; 9 July 1891, front cover verso; 5 March 1908, pp. 734, 742, 787; 29 January 1903, p. 603.

33  *Furnisher*, No. I, October 1899, p. xxxi.

34  T. J. Cobden-Sanderson, *Journals 1879–1922*, 2 vols (London: Richard Cobden-Sanderson 1922), vol. 2, p. 70.

35  Cobden-Sanderson, *Journals*, vol. 2, p. 25.

36  Cobden-Sanderson, *Journals*, vol. 2, p. 25.

37  Cobden-Sanderson, *Journals*, vol. 1, p. 390.

38  James S. Bain, *A Bookseller Looks Back* (London: Macmillan 1940), p. 208.

39  Brander Matthews, *Bookbindings Old and New* (London: G. Bell 1896), p. 135.

40  For the Guild of Handicraft see Naylor, *Arts and Crafts*, pp. 166–77, and C. R. Ashbee, *A Few Chapters in Workshop Reconstruction and Citizenship* (London: Essex Ho. Press 1894); *An Endeavour Towards the Teaching of John Ruskin and William Morris* (London: Edward Arnold 1901); *A Description of the Work of the Guild of Handicraft* (Campden, Glos. and London 1902); *Craftsmanship in Competitive Industry* (London: Essex Ho. Press 1908).

41  W. R. Lethaby, 'Of Beautiful cities', in *Art and Life and the Building and Decoration of Cities: A Series of Lectures by Members of the Arts and Crafts Exhibition Society* (London: Rivington Percival 1897), p. 79.

42  Mackmurdo, *History*, p. 231.

43  For the Clarion Guild of Handicraft see Chris Waters, *Socialism and the Politics of Popular Culture in Britain, 1884–1914*, Ph.D thesis, Harvard University, 1985, pp. 478–481, and A. J. Penty, 'The Clarion Guild of Handicraft', *New Age*, September 1907, p. 349, and Callen, *Angel in the Studio*, p. 7. For the Century Guild see Mackmurdo's ms, and Lionel Lambourne, *Utopian Craftsmen: The Arts and Crafts Movement from the Cotswolds to Chicago* (London: Astragal Books 1980), pp. 36–52.

44  Ashbee accepted the machine as 'the basis of the new society' as

early as 1894, and he had rejected 'the intellectual Ludditism of
Morris and Ruskin' by 1908. But, although he accepted machinery
provided it was regulated in the interests of the craftsman, he
never accepted the factory system and never tried to tailor design
to machinery. See *A Few Chapters*, p. 23; *Craftsmanship in
Competitive Industry*, p. 194.

45 Naylor, *Arts and Crafts*, pp. 178, 191 ff.
46 William Morris, 'How we Live and How we Might Live' (1884) rpt.
in A. L. Morton, ed., *Political Writings of William Morris* (London:
Lawrence & Wishart 1973), p. 156.
47 Mackmurdo, *History*, p. 243.
48 Mackmurdo, *History*, p. 244.
49 While Ashbee's move was, happily, in line with the movement's
prescriptions, it has also been interpreted as a defeat. Ashbee
moved to Chipping Campden after the failure of his venture in the
East End. By uprooting his craftsmen he actually gained a greater
control over them, and was thus able to indulge his own autocratic
nature to a far greater degree. See Seth Koven, 'Culture and
Poverty the London Settlement House Movement, 1870–1914',
Phd thesis, Harvard University, 1987.
50 L. F. Day, *William Morris and his Art* (London: Virtue 1899), p. 6.
51 For a general introduction to the antithesis between country and
city in English literature, see Raymond Williams, *The Country and the
City* (London: Chatto 1973), pp. 215–80.
52 Walter Crane, *Decorative Illustration* (London: G. Bell 1897), p. x.
53 The tenets of the Century Guild, quoted in Naylor, *Arts and Crafts*,
p. 115.
54 Mackmurdo, *History*, p. 120.
55 This interpretation is strongly challenged by Chris Smith in *Signs
for the Times: Symbolic Realism in the Mid-Victorian World* (London:
George Allen and Unwin 1984), pp. 136–8.
56 *William Morris, with Introductions by his Daughter May Morris,
vol. XXII, Hopes and Fears for Art, Lectures on Art and Industry*
(London: Longmans Green 1914), p. 23.
57 W. R. Lethaby, *Art and Workmanship* (1913 rpt. Birmingham:
Birmingham School of Printing 1930), p. 3.
58 C. Hiatt, 'Oxford University Press Bindings', *Poster and Art Collector*,
January 1901, p. 9.
59 Ethel M. McKenna, *The Woman's Library: Some Arts and Crafts*
(London: Chapman Hall 1903), p. 141.
60 Walter Crane, *The Claims of Decorative Art*, p. 17.
61 L. F. Day, *Some Principles of Everyday Art*, p. 5.
62 Morris, 'The Lesser Arts', *Works*, vol. 22, p. 23.
63 H. Snowden Ward, ed., *Useful Arts and Handicrafts*, 3 vols (London:
Dunbarn Ward 1901).
64 Walter Crane, *Decorative Illustration*, p. 5.
65 *Arts and Crafts and Technical Instructor*, vol. I, no. 2, November 1896,
p. 37.

66 W. N. Brown, *The Art of Enamelling on Metal*, (London: Scott, Greenwood 1900), p. 8.
67 G. W. Rhead, *Modern Practical Design* (London: Batsford 1912), p. 158.
68 Day, *Everyday Art*, p. 5.
69 Lethaby, *Art and Life*, p. 76.
70 Morris, 'The Lesser Arts', *Works*, vol. 22, p. 9.
71 Rhead, *Practical Design*, p. vii.
72 Morris, 'The Lesser Arts', *Works*, vol. 22, p. 9.
73 William Morris, 'The Acts and Crafts of Today', in *Art and its Producers and the Arts and Crafts of Today* (London: Longman 1901), p. 43.
74 Crane, *Decorative Illustration*, p. 136.
75 G. W. Rhead, *The Principles of Design: A Textbook for Teachers, Students and Craftsmen* (London: Batsford 1905), p. 14.
76 Day, *William Morris*, p. 1.
77 Morris, 'The Beauty of Life', delivered before the Birmingham Society of Arts and School of Design, 19 February 1880, rpt. in *Works*, vol. XXII, p. 73.
78 Rhead, *Principles*, p. 15.
79 William Morris, *The Ideal Book* (1893 rpt. London: LCC Central School of Arts and Crafts 1908), p. 13.
80 Edward S. Prior, 'Furniture and the Room', *Arts and Crafts Essays*, p. 261.
81 Such buildings did not, of course, represent a fulfilment of the movement's social aspirations. Indeed, a house like Wightwick stood as an embodiment of the movement's commercial and fashionable success as well as its aesthetic prescriptions.
82 R. G. Hatton, *Design* (London: Chapman & Hall 1902), p. 1.
83 Walter Crane, *Line and Form* (London: G. Bell 1900), p. 210.
84 Selwyn Image, 'On Designing for the Art of Embroidery', *Arts and Crafts Essays*, p. 414.
85 Hatton, *Design*, preface (unpaginated).
86 L. F. Day, *The Planning of Ornament* (London: Batsford 1887), p. 2.
87 Rhead, *Principles*, p. 177.
88 William Morris, 'The Arts and Crafts of Today' in *Art and its Producers and the Arts and Crafts of Today*, (London: Longman 1901), p. 26.
89 A. L. Baldry, *Modern Mural Decoration* (London: George Newness 1902), p. 8.
90 'Of Ourselves', *Arts and Crafts*, 27 September 1890, p. 1.
91 *Hearth and Home*, 30 January 1908, p. 573; 13 February 1908, p. 645.
92 Day, *Everyday Art*, p. 60.
93 William Morris, speech to the Arts and Crafts Exhibition Society, *Pall Mall Gazette*, November 2, 1886, p. 6, quoted in Peter Stansky, *Redesigning the World: William Morris, the 1880s, and the Arts and Crafts* (Princeton: Princeton University Press 1985), p. 217.

94 'Daventer Tapestry and Collenbrander's Designs', *Art*, vol. 1, no. 1, June 1903, p. 60.
95 L. F. Day, *Nature in Ornament* (London: Batsford 1908), p. 111.
96 *Art*, vol. 1, no. 1, pp. 58 and 67.
97 Rhead, *Principles*, p. 169.
98 Day, *Everyday Art*, pp. 134–5.
99 Day, *Planning of Ornament*, p. 5.
100 Walter Crane, *The Claims of Decorative Art* (London: Lawrence & Bullen 1892), p. 164.
101 Morris, *Works*, vol. 22, p. 25.
102 Walter Crane, *William Morris to Whistler: Papers and Addresses on Arts and Crafts and the Commonwealth* (London: G. Bell 1911), p. 232.
103 Crane, *Decorative Illustration*, p. 129.
104 F. W. Moody, *Lectures on Decorative Art* (London: G. Bell 1908), p. 137.
105 *Arts and Crafts and Technical Instructor*, vol. 1, no. 3, December 1896, p. 45.
106 W. R. Lethaby, 'Carpenters' Furniture', *Arts and Crafts Essays*, pp. 302–3.
107 Lethaby, *Arts and Crafts Essays*, p. 309.
108 Crane, *Claims of Decorative Art*, p. 163.
109 Rhead, *Principles*, p. 155.
110 Rhead, *Principles*, p. 11.
111 Jones, quoted in L. F. Day, *Nature in Ornament*, p. 1–2.
112 Day, *Nature in Ornament*, p. 270.
113 Moody, *Lectures*, p. 61.
114 Day, *Planning of Ornament*, p. 2.
115 Rhead, *Principles*, p. 3.
116 Morris, *Works*, vol. 22, p. 4.
117 Day, *Nature in Ornament*, pp. 1–2.
118 Morris, preface, *Arts and Crafts Essays*, p. ix.
119 Montague Marks, ed., *Home Arts and Crafts*, (London: C. Arthur Pearson 1903), p. 119.
120 It is important to establish here the distinction between Michael E. Sadler (1861–1943), who bought a number of early Modernist paintings before the First World War, and his son Michael T. H. Sadler (1888–1957). M. T. H. Sadler, who later changed his name to Sadleir to avoid confusion, was one the major spokesmen for the British fauve painters before the war. He later became a novelist, bibliographer and biographer of his father.
121 George Moore, 'A Communication to Book Collectors', 1921, rpt. in the *Fleuron*, vol. 4, 1925, p. 49.
122 Gill, *Autobiography*, p. 297.
123 Evidence from printed materials, especially periodicals, suggests an enormous growth in connoisseurship from the 1890s onwards. Magazines included *Collector and Art Furnisher* (1886), *Collecting*

(1907), *Expert* (1907), *Printseller and Collector* (1913) and *Collector's Magazine* (1903).

124  Ashbee, *Craftsmanship*, p. 38. Anthea Callen regards what Ashbee calls competition as sexist exploitation of poor gentlewomen who were forced to work for lower wages than men undertaking the same work. Skilled craftsmen, many of them in trade unions, tried to keep their professions exclusively male: a combination, perhaps, of the desire to keep up wages and the desire to keep out women. See Callen, *Angel in the Studio*, pp. 4–8, 190–91.

125  Ashbee, *Craftsmanship*, p. 22.

126  Figures from W. Ashworth, *An Economic History of England 1870–1939* (London: Methuen 1960), pp. 240–1.

127  For Fry's friendship with Ashbee, see Frances Spalding, *Roger Fry; Art and Life* (London: Granada 1980), pp. 19–25.

128  See Stanley Pierson, *British Socialists. The Journey from Fantasy to Politics* (Cambridge: Harvard 1979), pp. 37–40.

129  A. O. Orage, 'Politics for Craftsmen', *Contemporary Review*, June 1907, p. 783.

130  Orage, *ibid*, p. 787.

131  For a detailed history of the women's suffrage movement, both at grassroots level and as a brilliantly successful publicity campaign by the Pankhursts and their followers, see Jill Liddington and Jill Norris, *One Hand Tied Behind Us: the Rise of the Women's Suffrage Movement* (London: Virago 1978).

132  Douglas Cooper in *The Courtauld Collection* (London: Athlone Press 1954) charts the buying of Continental Post-Impressionist paintings in the early years of the century. What he ignores is the possibility that British collectors bought directly from Parisian dealers. While British buying was obviously meagre compared with German or Russian patronage, purchase of Post-Impressionist work, along with that of Matisse and the younger French painters, was probably more extensive than Cooper maintains.

133  Clive Bell, *Old Friends*, (London: Chatto and Windus, 1956), p. 22.

# EARLY MODERNISM AND THE ARTS AND CRAFTS MOVEMENT

The Arts and Crafts Movement shared more with early English Modernism, however, than the adherence and support of the intelligentsia. English Modernism, as it was described and practised before the First World War, subscribed to many of the basic tenets of the Arts and Crafts Movement. In the first place, like Arts and Crafts theorists, Modernist writers saw themselves as asserting, against the prevailing trend of fine art, the importance of fundamentals against inessentials, and structural coherence rather than surface detail. Modernist writers concurred with the Arts and Crafts belief that these fundamentals required 'truth to materials', purity and simplicity, and concentration on form rather than content.

'Truth to materials' had very much the same implications for Modernist theorists as it did for craftsmen. Day's call that potters should respect the laws and limitations of their medium was central to avant-garde sculptors both before and after the war. As will be seen, Gaudier, Gill and (briefly) Epstein championed direct carving into stone or metal against the prevailing sculptural method, which was to model in clay and then cast in metal or copy in stone. Like Arts and Crafts writers, early English Modernists used specificity of medium, along with the attendant notions of purity and limitation, to distinguish their product from the various fine arts contaminated by rhetoric and anecdotalism. Thus, in 1911, Roger Fry said that to get at 'material beauty' it was 'necessary to respect the life and quality of the material itself'.[1] A year later he wrote of

some Byzantine enamels that, 'more and more the general ideas of these type-characters of the Virgin and Apostles had to be condensed, intensified and purified of all that was superfluous and redundant, in order that they might admit of perfect execution within the hard limits of the material'.[2]

X     These ideas of purity and limitation implied, in Modernist and Arts and Crafts thinking alike, a concentration on structure. The alliance of purity and structure led to the associated ideas of naked and skeletal form. But Modernists went further than this common theory, and proceeded to translate these ideas into practice. Nakedness and skeletal form were not only ends but also means. Before the First World War, however, purity and nakedness were largely descriptive terms. Clive Bell, in his *Art*, published in 1914, asserted that 'critics of the Impressionist age are vexed by the naked bones and muscles of the Post-Impressionist pictures'.[3] Wyndham Lewis used the same vocabulary. In the second and final number of the Vorticist polemic *Blast*, published in 1915, he applied the image of stripped flesh, and, consequently, nakedness, to contemporary European painting. In European painting today, he proclaimed, 'things stand up stark and denuded everywhere as the result of endless visionary examination'.[4]

X     Skeletal form as subject matter, as the visual manifestation of this aesthetic, was used by painters, sculptors and poets during the First World War and in the two decades that followed it. The sculptors Henry Moore and Barbara Hepworth used bones (and rocks and stones) as formal models for sculpture in the late twenties and thirties. The brothers John and Paul Nash painted skeletal form by way of denuded trees in their battlefield pictures of 1917–19. Here it wore an unattractive aspect, pointing to death, destruction and the crucifixion, yet after the war both continued to use it in more placid landscapes. Paul Nash's *Dymchurch Wall* (1923) and *The Shore* (1923) both concentrate upon the shape of the landscape rather than the natural forms it contains. Both reveal landscape purified of all superfluous vegetation and of all humanity.

The notion of purity, as opposed to inessential luxuriousness, was central to both Modernist and Arts and Crafts thinking. We have seen how Crane criticised ungainly 'overfed pediments' and 'corpulent scrolls'. Roger Fry praised their opposite in strikingly similar terms. As an example of 'plastic coherence and unity' he chose a house 'where the facades are absolutely bare – there is not

a single moulding of any kind round the windows, no cornice, no projection of any kind'.[5] Again, like Crane, Fry set the notion of purity against corruption. Where the former called *l'art nouveau* a 'strange decorative disease',[6] Fry condemned it as 'the eczema' which 'spread from the offices of *The Studio* all over the world'.[7]

Like Arts and Crafts writers, early English Modernists saw pure form and simplicity as antithetical to the representation of natural fact. Fry said in his 1909 'Essay in Aesthetics' that artists could 'dispose once and for all with the idea of likeness to nature, of correctness or incorrectness as a test, and consider only whether the emotional elements inherent in natural form are adequately discovered'.[8] Yet, at the same time, he asserted that 'the relation of art to Nature' was, 'perhaps, the greatest stumbling block to the understanding of the graphic arts'.[9] We shall see later how Fry redefined the idea of 'truth to nature' when he characterised Post-Impressionism and found a way round this block.[10]

What is interesting about his statement, however, is that it reveals how seriously he took the idea of 'truth to nature'. Right up to the 'twenties Fry clearly felt the need to justify his departure from the standards of his youth. He was unable simply to dismiss the problem, but constantly had to explain and justify his stance.

It was not Fry alone who was worried about the relationships between nature, beauty and truth. Other early Modernists also felt it necessary to justify their theory and practice. Truth to nature was one of the subjects which was most intensely debated amongst the avant-garde between 1910 and 1914. Abstraction from nature was consistently seen by these men in the context of truth to nature. The former was debated very much as if it were a reaction against the latter rather than an autonomous 'style' and aesthetic. In 1920, Fry praised Whistler precisely because he had tried 'to sweep away . . . the web of ethical questions, distorted by aesthetic prejudices, which Ruskin's exuberant and ill-regulated mind had spun for the British public'.[11] And it was in the dictum 'truth to nature' that Ruskin was held responsible for mixing up ethics and aesthetics. This preoccupation with the need to find an alternative to 'truth to nature' serves as another reminder of the reactive quality inherent in English Modernist thinking.

But Fry also criticised Whistler: Whistler the showman and the aesthete. He said Whistler was too 'cavalier' in his attitude towards Ruskin.[12] Aesthetics were, he implied, a serious matter. Bell

dismissed Morris with a similar charge. Morris, said Bell, 'was not serious enough about his art. He tended to regard art as a part of life instead of regarding life as a means to art.'[13] This concern with seriousness – and Bell's need to overturn Morris's kind of seriousness with his own shows it very well – with the commitment to simplicity, sincerity and professionalism, together with the religious language used to describe the endeavour, was held by Modernists and craftsmen alike.

These ideas, moreover, had considerable repercussions for subject matter. To Arts and Crafts writers, purity of form was inherent in the object. This meant that the object itself could become a work of art. In England early Modernist sculptors applied this idea to their own efforts. They used it as a means of extending their range of subject matter, and thus for creating new possibilities and new media for sculpture. Instead of an art object, the three-dimensional product became a sculpture. Thus Gaudier-Brzeska's door knocker and toys had an aesthetic and not a functional purpose. Epstein's *Rock Drill* presented a prefabricated utilitarian object as a component part of the sculpture without any intervention by the sculptor himself.

For painters, the object could be translated from three dimensions to two. Pure form was seen as apparent in the relations between forms on a two-dimensional surface. Moreover, because, in theory, objects were devoid of ethical implications, their presentation would make these significant formal relations more overt. It is not surprising, then, that utilitarian objects feature prominently in the work of the Bloomsbury painters. Grant, Bell and Fry all painted considerable numbers of still lives between 1910 and 1920, although their formal models were French rather than English.

Another preoccupation of Bloomsbury Post-Impressionism was landscape painting. Such a concentration on the local and the particular may seem surprising in view of early English Modernist theory, which championed an art that transcended the boundaries of time and space. Bell expressed this belief in his review of A. Clutton-Brock's monograph on William Morris. He criticised Morris because 'his mind could rarely escape from the place and age in which it was formed'.[14]

But, despite this theory, the First Post-Impressionist Show concentrated on the work of three painters, Cézanne, Van Gogh and Gauguin, in whose work the local and the particular held an

important place. Of these, it was Gauguin who received the greatest praise. In his South Seas pictures, Gauguin presented images of an organic, rural society, which was still full of the mystery and romance Morris felt industrial society had lost. Gauguin's painting held a special attraction because it catered to the streak of anti-urbanism which ran through the middle classes, conservative and liberal alike.

Along with the dislike of the city went dislike of the machine. Roger Fry concurred with the Arts and Crafts belief that the machine destroyed the possibility of individual self-expression and thus the possibility of art. Like them, he felt that 'the Victorian effort to produce works of art by machinery led to a terrible deception'. Speaking on 'Art and Commerce' in 1926, he claimed that 'wherever the machine enters, the nervous tremour of the creator disappears'.[15]

Fry had held this view for many years. Two decades earlier he had explicitly tied together the creator and the craftsman in an article on Wedgwood china for the *Athenaeum*. There, he asserted that Wedgwood's pottery 'contributed to the final destruction of the art, as an art, in England, because it set a standard of mechanical perfection which to this day prevents the trade from accepting any work in which the natural beauties of the material are not carefully obliterated by mechanical means. In fact Wedgwood destroyed the craftsman's tradition by substituting the artist turned craftsman for the craftsman grown artist by experience and natural aptitude'.[16]

In his prospectus for the Omega Workshops published in 1915, Fry reiterated his unfavourable comparison between handmade and machine-made goods and declared his intention of reinstating the art of pottery 'as an art'. The success of the workshops, and the success of Bloomsbury Post-Impressionism, which eschewed machine forms, shows that many were receptive to his views.

If Arts and Crafts and early Modernist writers shared many ideas, they also shared a terminology with which to discuss them. The word 'decoration', for instance, which was the most common of all Arts and Crafts descriptive terms, was extensively used by Roger Fry in his writings on both the fine and decorative arts before the First World War. 'Decoration' in Fry's early critical lexicon was indicative of just the same emotionalism and expressiveness as it was for Arts and Crafts thinkers. For Fry, in 1908, pattern simply expressed emotions, and thus 'much that is usually

classed as merely decorative in aim is really profoundly expressive of emotional content'.[17] With this, many Arts and Crafts writers and practitioners were in complete agreement. So when Fry used it in 1910, it could retain the association it had for Arts and Crafts readers. Moreover, just as 'decoration' and other descriptive terms went into the making of an aesthetic which could hold together disparate groups in the Arts and Crafts Movement, so they and their associations became for Fry the means of securing the allegiance of wealthy patrons, the radical and liberal educated classes and the socially aspiring.

Just as important as shared aesthetic ideas and common terminology was the similarity in tenor between the Arts and Crafts Movement and early Modernism, a similarity particularly marked between Arts and Crafts and Post-Impressionism. Both the followers of the Arts and Crafts Movement, and many adherents of early Modernism saw art as a spiritual matter and their movements as crusades with implications wider than the aesthetic domain. That meant that their ventures were viewed religiously and that to some degree both Arts and Crafts and early Modernism were about faith and redemption as well as about aesthetic opinion. This religiosity about art has a long history within the institutions of art and literature themselves. In the history of art and literature in nineteenth-century England it was apparent especially at moments and in movements where art and politics or reformist zeal or mysticism intersected. In the late nineteenth century the connection between religion and art must be seen as one manifestation of a pervasive religiosity which was channelled from a variety of sources into political as well as aesthetic language.

The Arts and Crafts Movement had a specifically Christian component lacking in early Modernism. Before he became a socialist, Morris intended to be ordained, and planned a campaign to transform taste which he called a 'holy war against the age'. The Arts and Crafts Movement as a whole also sheltered many Christians, from various kinds of Christian socialists to the kind of mystic best represented by Cobden-Sanderson, for whom the practise of craft was worship.[18] But besides these overtly Christian elements, the Arts and Crafts Movement shared with the early socialist movement of which it was a part a general religiosity. Socialists in the Arts and Crafts Movement saw in Arts and Crafts a means towards social salvation and redemption, a promise of a

completely new life founded on a transformation of the way of living rather than a redistribution of the means of living. It was a cause and a crusade, with sages, evangelists and converts. The socialist movement of the eighteen-eighties and early 'nineties in which Arts and Crafts participated was as much emotive as empiricist and as much moralist as materialist.

The early followers of Post-Impressionism, too, saw in the new X movement evidence of an upsurge of profound emotionalism. They believed that it heralded the rejection of the mistakes and misunderstandings of the science-besotted nineteenth century. One reason for this belief was Fry's use of language which had associations with the Arts and Crafts Movement and therefore with the religiosity both of Arts and Crafts and of the early socialist movement. Virginia Woolf's statement that in the year of 'Manet and the Post-Impressionists', 1910, 'all human relations changed' – and for the better – testified to the notion of Post-Impressionism as a cause and the harbinger of a new life.[19] Post-Impressionism, she hinted, brought about a transformation which decades of socialist idealism had been unable to achieve.

This close correlation between early Modernism and ethical transformation was brief. By 1912, and the second Post-Impressionist show, these redemptive associations had given way to the more generalised religiosity which characterised early Modernist endeavour throughout Europe, from Fry to Kandinsky and Eliot to Bergson. Pound, like Morris, saw himself as a crusader battling against the forces of oppression to redeem the world. Morris's 'earthly paradise' became Pound's *paradiso terrestre* and the poet said of himself, 'I lost my centre fighting the world'.[20] Bell, like early socialists who wanted to take mankind back to a morally pure world, called Post-Impressionism a 'return to first principles'.[21]

This religiosity was by no means confined to the aspiration and associations of early Modernism. It also spread into the ways in which the movement's products were described and assessed, and into the very core of its aesthetic. Roger Fry, whose own non-conformist background perhaps made him sensitive to the religious nuances of his vocabulary, persisted in seeing Post-Impressionism within a generalised Emersonian mystical framework. The feelings expressed by form, he wrote, 'are the directest indication of the general spiritual activity of a class of people. Also I think they are

always universal emotions not directed to any particular person or thing but express the whole reaction of the individual to the universe. They are of the nature of cosmic emotions.'[22] Clive Bell was far less afraid of direct connections between Post-Impressionism and religion. Indeed, he said in *Art*, 'Art and religion are, then, two roads by which men escape from circumstance to ecstasy'. But Bell did not simply draw a parallel between art and religion. He wanted to amalgamate the two. Thus he went on, 'Art . . . may satisfy the religious needs of an age grown too acute for dogmatic religion'.[23] Early Modernism was imbued with religiosity in more particular ways than Bell's very generalised assertion indicated. Post-Impressionism as an aesthetic had affiliations with the doctrine of transcendence. It was presented as a way of seeing some kind of reality more essential and universal than was perceptible in the everyday world. Michael Sadler thus suggested that Gauguin could recover or release something transcendent through his painting. Sadler was interpreting Gauguin through Kandinsky, and so he said that he 'sacrifices conventional form to inner expression, but his art tends ever towards that profounder emphasis which cannot be expressed in natural objects'.[24] Bell turned this idea of transcendence, of Post-Impressionism reaching towards the universal, into one of immanence, of Post-Impressionism incorporating the universal. Fusing this notion of immanence with a smattering of G. E. Moore he said that 'when we consider something "as an end in itself" we become aware of its essential reality, of the God in everything, of the universal in the particular, of the all pervading rhythm'.[25]

The religiosity of early Modernism was more than aesthetic. Like the Arts and Crafts Movement, early Modernism carried with it some of the paraphernalia of a religious movement. It had sages, disciples and sects. Clive Bell portrayed Cézanne as a saint who had 'a revelation that has set a gulf between the nineteenth century and the twentieth'.[26] Hind saw Van Gogh not as a saint but as a preacher, an 'eager evangelist'.[27] D. H. Lawrence felt that it was Fry and his followers who were evangelist. But instead of praising them for bringing news of the good life, he – who was all too familiar with sectarianism himself – castigated them for narrowness and a Calvinistic elitism. After Impressionism, said Lawrence, came Post-Impressionism, and 'this new chaos, of course, needed new apologists, who therefore rose up in hordes to apologise, almost,

for the new chaos. They felt a little defiant about it, so they took on new notes of effrontery, defiant as any Primitive Methodists, which indeed they are: the Primitive Methodists of art-criticism. . . . They discovered once for all that the aesthetic experience was an ecstasy granted only to a chosen few, the elect, among whom said critics were, of course, the arch-elect. This was outdoing Ruskin. It was almost Calvin come to art.'[28] Wyndham Lewis, glancing at Fry's Quakerism, also charged the Bloomsbury group with puritanism, with being 'dissenters'. They were, he said, a group of 'strayed and dissenting aesthetes'.[29]

Along with its sages and sects, early Modernism also had its converts. This was especially true of Post-Impressionism, partly because of the way Post-Impressionism was presented and perceived and partly because of the apparent suddenness of its appearance. C. L. Hind described his acceptance of Post-Impressionism in the same way as early socialists described their conversions to the cause. For both, their realisation of the new movement's importance was a religious experience. Hind, indeed, portrayed himself wrestling with Van Gogh in the darkness, just as Jacob wrestled all night with an angel, before he realised the truth. After his conversion he was to become one of Post-Impressionism's most tireless supporters and proselytisers.[30]

This aura of religiosity surrounding early Modernism inevitably    ✗
encompassed its descriptive language as well as its apparatus and aesthetic. The notion of purity, especially of purity of form, so central to early Modernism and Arts and Crafts alike was thus cast within this religious framework. 'Pure form' could mean not only 'form alone', or 'only form' but also form refined or purified from its earlier impure or corrupt state. This purification led to the simplification of form and thence to those much praised qualities of nakedness, bareness, sparsity and limitation. For Arts and Crafts and early Modernism, the more you stripped away the more you revealed; form was almost pentecostally purified and revealed grace as a condition of purification. Needless to say seriousness and sincerity were necessary to achieve this purity of form.

The commitment to seriousness and sincerity which was shared by Arts and Crafts and early Modernist writers and practitioners, as well as the general tenor of the movements, provides a way of making distinctions between Arts and Crafts and early Modernism on the one hand and aestheticism and the decadence on the other.

For although we have stressed that Arts and Crafts and aestheticism were enmeshed, particularly at an amateur level, we should not overlook the opposing impulses which underpinned them in their undiluted forms. These contradictory impulses gave rise to differences which became more marked as the Aesthetic Movement of the 1870s and 1880s was pushed into the decadence of the 1890s, and as aesthetic design was superceded by art nouveau. The distinctions between the Arts and Crafts Movement and aestheticism or decadence and then between early Modernism and aestheticism or decadence are important because they enable us to highlight the temperamental and ethical differences between early Modernists amd the aesthetes and decadents usually regarded as their forebears.

The chosen professional representatives of the aestheticism of the late 1870s and 1880s are usually Whistler and Wilde, while Pater is seen as the instigator of the movement in rather the same way that Ruskin was presented *vis-à-vis* the Arts and Crafts Movement. The hallmarks of aestheticism were provocative frivolity, dandyism, and rogueishness. These were underscored, particularly in Whistler's case, by a commitment to the search for aesthetic experience in art and to the separation of that art from everyday life and morality. The Arts and Crafts belief in the expression of personality found its opposition in the aesthetic creation and display of personality, and the Arts and Crafts belief in spontaneity and naturalness in the aesthetic championing of artifice. In the early 1890s these traits of aestheticism were pushed into more extreme stances and the movement became less of a fashion acceptable to many and more of a cult followed by the few. Simultaneously, the movement became less centred on the visual arts and more exclusively literary. It was then amongst those dubbed decadents that the element of playfulness and precocity in the Aesthetic Movement developed into a much more complex investigation of duplicity, and that the creation of personality became the masking of personality. Gradually, too, the distinctions between person and pose were worn away. Whistler remained acceptable to English critics and patrons in part because they were able to make some distinction between the levity of his public posture and the seriousness of his professional work. By the early 'nineties Wilde had eradicated such distinctions. For him, and the very few who could accept the implications of his aesthetic, duplicity was

sincerity, artifice was art, the pose was the person and the mask was the man.

At the level of fashion the decadence was available to a far wider audience than those who could accommodate Wilde's beliefs. For many people aestheticism, Arts and Crafts and the decadence were all jumbled up together in a fashionable pot-pourri by the 1890s. J. L. May, the chronicler of those years, nicely observed the convergence of aestheticism, Arts and Crafts and decadent pursuits. 'The naked marble of our mantelpieces was now veiled in art serge hangings bedecked with conventionalised lilies or sunflowers. Ladies took up poker work or macrame, or beaten bronze. Some of the more advanced burned joss-sticks.'[31] Here the Arts and Crafts pastime of working in bronze merged with 'aesthetic' interior design and was topped off with the burning of joss-sticks, a quintessentially decadent pursuit. Together they contributed to and advertised a fashionable way of living which was underscored by a fashionable set of ideas. It was here that the contradictions between Arts and Crafts, the Aesthetic Movement and the decadence were held in suspension by fashion.

Beneath this surface, however, there were fundamental aesthetic differences between Arts and Crafts and aestheticism and then Arts and Crafts and decadence. In their most extreme forms their interests were complementary opposites and suggest that their positions were to some extent defined by one another. Thus Morris's very commitment to the idea of truth to nature was highlighted by Wilde's advertisement of his detachment from it. When contemporaries read Wilde declaring 'Enjoy Nature! I am glad to say that I have entirely lost that faculty', they must immediately have been aware of the opposite viewpoint, for without it Wilde's statement lacked any force.[32] This does not mean that Wilde wilfully took up contrary notions or that he defined himself by virtue of his opposition to the accepted view. He was never susceptible to so simple a reading. But it does mean that Arts and Crafts and aesthetic and decadent attitudes do need to be interpreted in the light of their opposites.

Nowhere is this more true than in the contrast in religiosity between Arts and Crafts and early Modernism on the one hand and aestheticism and the decadence on the other. Arts and Crafts and early Modernism writers consistently used the positive benefits of religion to make parallels with their endeavours. They were

interested in 'salvation', 'purification' and the return of various
kinds of innocence. The connections which they made between
religion and art suggested that art could unlock some kind of special
spiritual realm for those gifted and serious enough to follow its
path. Aesthetic writers laid the stress on the the refinement of
sensation which both art and religion could provide and the simi-
larities between religious devotions and the devotions of aesthetes
at the altar of art. To a non-conformist like Fry, this connection
between the beauties of art and the beauties of holiness might have
smacked dangerously of Anglo-Catholicism, of superficiality and
of Keble College, Oxford, that bastion of High Church attitudes.
Aesthetic language mirrored aesthetic religiosity. Aesthetic jargon
lampooned by Du Maurier in *Punch* was quite different from early
Modernist jargon. Instead of being praised as 'simple', 'natural', or
'pure', artefacts and experiences were described as 'consummate'.
'precious' or 'blessed'.[33]

In the 'nineties this partly playful juggling with religious language
and association was pushed – primarily by Wilde – into an explor-
ation of the negative benefits of religion. Wilde became interested in
breaking and overturning religious laws, in heresy, sin and sinners.
These were categories of persons and things which were enshrined
in catholicism, fashionable amongst Anglo-Catholics in the late
nineteenth century and frowned upon or denied by nonconformists.
Furthermore, this exciting whiff of popery went along with an
interest in other kinds of lawbreakers, from murderers to fraudsters
and opium addicts to homosexuals. More picturesque groups from
the underbelly of society, particularly tramps and gypsies, attracted
painters and writers who were happy to make parallels between
themselves and bohemians and wanderers but were not prepared
to go as far as Wilde and set themselves beside out and out villains.

For Wilde himself, then, it was by the 1890s sin and beauty
rather than purity and beauty that combined to produce art. Robert
Hitchens satirised this conjunction in his 1894 best seller *The Green
Carnation*, a book whose very title called attention to the decadents
'unnatural' preoccupations. There his Wildean hero declared, 'To
sin beautifully, Reggie, as I have sinned for years, is one of the
most complicated of the arts. . . . To commit a perfect sin is to be
great.'[34] Wilde himself never rejected this reversal of the positions
of art and religion. In his last work, *De Profundis*, he sought to
show not that art was a spiritual endeavour, but that the spiritual

life was artistic. Christ, therefore, became the paradigmatic artist, and, Wilde asserted, there was nothing that Christ said that could not 'be transferred immediately into the sphere of art and there find its complete fulfilment.'[35]

At the extreme position occupied by Oscar Wilde, then, decadent religiosity was different both in character and in kind from that of the Arts and Crafts Movement and early Modernism. Wilde was ultimately interested not in art becoming religious, but in religion become artistic. In England in the 1890s his position was highly publicised but very marginal. The decadence he stood for was not a movement and scarcely a fashion. Very little of the audience for early Modernism could have come from Wilde's erstwhile followers. Neither did it come from out and out aesthetes, for they too were few. Post-Impressionism's supporters, moreover, did not respond to the paintings, sculpture and objects which they saw as things of beauty alone. They did not respond as true aesthetes should. But many of early Modernism's supporters did come, especially after Post-Impressionism became socially acceptable, from that middle ground between Arts and Crafts and the Aesthetic Movement.

The contrast in tenor between early Modernism and aestheticism and the decadence encourages us to regard the relationship between their aesthetics as less close than first glance might suggest. Early Modernists might concur with some Whistlerian or even Wildean statements about art, but none of them shared the aesthetes' attitude towards it. Thus Fry might go a fair way towards accommodating the aesthetic and decadent detachment of art from morality and everyday life, but he could never behave in a non-moral way towards it. His stance was imbued with that reverential seriousness characteristic of the Arts and Crafts Movement. At bottom Fry and many other early Modernists were interested in the regenerative powers of art and regarded the decadence as marginal, corrupt and even degenerate. That is why Fry agreed with Crane's assessment of art nouveau. Crane called art nouveau a 'decorative disease', while Fry called it an 'eczema', that is, a disease of the surface, a superficiality that had nothing to do with the essential and universal that early Modernism and Arts and Crafts critics and practitioners held in such high regard.

The similarity in tenor between early Modernism and Arts and Crafts Movement, and their congruent religiosity, had important

implications for the reception and acceptance of new painting in the early years of the century. The descriptive and normative terminology which Fry used had manifold associations with the Arts and Crafts Movement and thus also with the early socialist movement of which Arts and Crafts was a part. Post-Impressionism's early supporters saw a regenerative blueprint in the paintings they looked at partly because of the way in which they were described. Critics who were hostile to Post-Impressionism also reacted to the ethical associations inherent in Post-Impressionist language. But to the new movement's detractors Post-Impressionism summoned up not visions of the new life, but echoes of the potentially revolutionary threat of early socialism.

The similarities of tone that we have been charting should not blind us to the fact that early Modernists had more than just theoretical links with the Arts and Crafts Movement. There were also extensive if unacknowledged practical connections. The four years after the First Post-Impressionism Show in 1910 saw three attempts by Modernist practitioners to take advantage of the market which the demise of the Arts and Crafts Movement had exposed. Earliest and most successful were the Omega Workshops, set up by Roger Fry in May 1913. Wyndham Lewis's Rebel Art Centre followed about a year later. The last, Ezra Pound's College of Arts, was announced in November 1914. The Omega Workshops were eventually liquidated in February 1920. The Rebel Art Centre lasted only a few months, while the College of Arts remained merely a paper project. Pound's college was distinguished from the other two ventures because it was overtly educative and was intended to sell knowledge rather than goods. It therefore would have catered to a somewhat different clientele. But it was linked to them because it used the same means – the precepts early English Modernists shared with Arts and Crafts allied to the fashionable status of the contemporary avant-garde – to attract custom.

The Omega Workshops consisted of a shop and a small workroom in 33 Fitzroy Square. The workshops sold fabrics, pottery, rugs, hand-painted furniture, screens, trays and lampshades with which to adorn the home. They also sold handbags and necklaces to adorn the person. A limited amount of work was carried out on the site by paid women assistants working from patterns. But most goods were designed by the Omega's artists, and made under

contract by commercial manufacturers. Omega artists also carried out specially commissioned schemes of interior decoration for the workshop's richest clients. Fry paid his artists 30/– a week in return for their services. Bell, Grant, Frederick Etchells, Lewis, Wadsworth, Doucet, Roberts, Raold Kristian, John Turnbull and Cuthbert Hamilton all had spells there. Nina Hamnett, Gladys Hynes, Jessie Etchells and Winifred Gill worked as paid assistants. The Omega also sold paintings and drawings by Grant, Bomberg and Kristian, and drawings and sculpture by Gaudier-Brzeska.

Fry had, in fact, been interested in craft for some time before he started the Omega. He admitted that in his youth he was 'bitten by Ruskin's style-mongering', and many of his youthful essays were attempts to come to terms with and rebut Ruskin's strictures about truth to nature and art and morality.[36] His essay 'Aestheticism and Symbolism', indeed, was a sustained (and sometimes incoherent) tilt at Ruskin's chapter on 'The Nature of the Gothic' in *Seven Lamps of Architecture*. It was the first of Fry's many attempts to abandon Ruskin and to come to terms with aestheticism. By the turn of the century, Fry's close association with C. R. Ashbee was waning, and Ruskin himself was fading out of his prose. Apart from occasional asides (one of which was the extraordinary pronouncement about *Art* which I discuss in Chapter six) the Victorian sage did not reappear in Fry's published work. What did not fade away, however, was the concern for and need to find alternatives to Ruskinian attitudes towards art. Fry was an aesthete of sorts by conviction, but he was never an aesthete by temperament. While he reacted against Ruskin, gave up early ideas about becoming an architect and did away with his early Ruskinian drawing style, he nevertheless went on to build a house for himself which fulfilled his desire for simplicity and functional form.

Fry also wrote extensively about applied art. In the early years of the century he contributed several articles on the minor arts to the *Athenaeum*, in which scorn for the fashionable side of the movement was tempered by admiration for the work of many professional craftsmen and for the medieval work which those craftsmen sought to emulate.[37] In 1902 he praised the work of Walter Crane, May Morris, Philip Webb, Selwyn Image and Edward Johnson in a review of a decorative arts exhibition in Turin, and in 1906 he paid fulsome tribute to Johnson's pupil Eric Gill

when he discussed the Arts and Crafts Exhibition Society show at the Grafton Galleries.[38]

Mrs L. Walter, authoress of *Instructive and Ornamental Paperwork* was not accorded the same consideration. 'We had hoped', Fry wrote dismissively in 1901, 'that "the numerous dainty ornaments of the home" of which the author speaks so affectionately in her preface were gradually disappearing.'[39] Despite his scorn, however, Fry did not himself hasten their disappearance. For although he derided the crepe paper flowers which Mrs Walter told her readers how to make, some years later paper flowers became one of the most successful minor products of the Omega Workshops.

While he may have expressed scepticism about some of the products of the Arts and Crafts Movement, Fry continued to be interested in its precepts. In July 1909 he wrote to Winifred Gill's father that 'in the crafts the general level of taste and understanding is already much higher than it is in painting'.[40] He revealed more general connections with Arts and Crafts thinking in his 1912 essay 'The Artist in the Great State', one of a series in a volume called *Socialism and the Great State*, edited by H. G. Wells, G. R. S. Taylor and the socialist aristocrat Lady Warwick. There he expressed a hope that some kind of guild system might be restored, and a belief that fine art and craft would benefit from greater connection with one another. He suggested that 'in a world where the objects of daily use and ornament were made with practical common sense the aesthetic sense would need far less to seek consolation and repose in works of pure art'.[41] He looked forward to a time when art would be 'purified of its present unreality by a prolonged contact with the crafts'.[42] Despite the inference that craft might reclaim art for the common good, Fry elsewhere asserted that something of the 'sanity' of the artist ought to be infused into the craftsman, something, too, of his 'creative energy and delight in his work'.[43] This suggested that artists, of the right kind, were in a position to help craftsmen. It was this belief that informed practice at the Omega.

The other side of Fry's interest in craft was not in artists helping craft, but in artists using craft for their own purposes. This attitude was already apparent by 1910, when Fry displayed pottery alongside paintings and drawings at the First Post-Impressionist Show. This helped an audience, already familiar with the claims Arts and Crafts writers made for utilitarian objects, to transfer the shared parts of

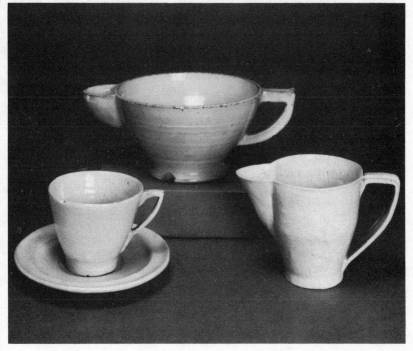

Roger Fry, Omega Workshops pottery. (Reproduced by permission of the Victoria & Albert Museum.)

the aesthetic to the paintings around them. It was explicit in Post-Impressionist theory that an object could stand side by side with a painting as a work of art because of its formal properties. 'No one ever doubted', said Bell confidently in 1914, 'that a Sung pot was as much an expression of emotion as any picture that was ever painted'.[44]

By 1912, Fry had elaborated upon the possibilities of using craft for formal experiment. Discussing Byzantine enamels in the *Burlington Magazine*, he said that 'it is only now when we have begun to learn something of the meaning of pure design, the effectiveness for the imagination of certain abstract relations of form and colour, that we are prepared to see how complete and definite these figures are'.[45] The Omega Workshops allowed artists to experiment with 'pure design' in media where it was already

accepted, and to use this acceptance to further the cause of Post-Impressionist painting and sculpture. Thus, in the Omega prospectus, Fry said that 'pottery is essentially a form of sculpture', and its surface should 'express directly the artist's sensibility'.[46] Besides announcing belief and intention, such a statement was also a good way of selling the product. It was exactly in accordance with the prevalent amateur and consumer desire in Arts and Crafts to give the objects they made or bought 'art status'.

Indeed, the Omega prospectus reveals in its language and approach that it was to those familiar with Arts and Crafts precepts that Fry was appealing. In it he distinguished between factory and handmade products. The former, he said, hinting at the commercialism so despised by craftsmen, were made 'almost entirely for gain, no other joy than that of making money entered into their creation'. But handmade articles were imbued with and revealed something of 'greater value and significance'. This was, he said, pointing to the Arts and Crafts definitions of art and belief in the dignity of labour, the expression of 'joy in creation'. Finally, glancing at the movement's social prescriptions, he suggested that 'in the long run mankind will not be content without sharing that joy through the possession of real works of art, however humble or unpretentious they may be'.[47]

What is interesting about Fry's prospectus is that it was a description of the aspirations and predilections of the Omega's audience rather than a description of its product. In its methods of production the Omega was often in direct contravention of the prescription Fry outlined for the 'real work of art'. Many Omega goods were the 'modern factory products' Fry condemned. The pottery was manufactured at Poole, and the textiles were printed in France, and neither the cloth nor the crockery were made by hand. It was important to Fry that the right kind of manufacturer be employed. He wrote to G. L. Dickinson that the French company were 'altering all their processes to get rid of the mechanical and return to older, simpler methods'.[48] Nevertheless, his praise of handmade goods in the prospectus was an appeal to customers. It seems to have been very successful. Winifred Gill recalled that 'the word 'workshop' led people to the idea that we were followers of William Morris, and made the furniture ourselves. The fact that Morris had lived a few doors down from us on the

same side of the square may have contributed to this in some subtle way.'[49]

The importance of the Omega Workshops was that they brought Post-Impressionism and Arts and Crafts together. Fry used the latter to serve the former. The freedom of working in the applied arts gave Fry's artists the confidence to experiment with various new techniques and media. The Omega also helped to secure support for Post-Impressionism through support for craft work. The paintings and drawings exhibited and sold at the Omega were – in theory at least – concrete manifestations of the connections between Post-Impressionism and Arts and Crafts. Fry also provided a verbal – and very partial – account of this alliance. In a 1917 article for *Colour* magazine, he asserted that, 'it is true that it is only of late years, and among more modern artists, that all this interest in the decorative possibilities of paint . . . has grown up. It is all part of the reaction against the photographic vision of the academic schools, and of the interest in pure design.'[50]

Fry himself did not overtly encourage connections between the Omega and its possible English antecedents.[51] Indeed, he presented it, as he presented Post-Impressionism, as a new departure that was continental in origin and grounded on a break with past practices and beliefs. The Omega artists were presented as radicals, and this tended to mask the emotional and theoretical continuities between Fry and Arts and Crafts thinkers, and between the workshops and efforts like the Century Guild and the Guild of Handicraft. C. R. Ashbee could not resist the opportunity to make such comparisons. He wrote in his diary that it was 'curious and interesting to see him apparently treading the same ground with his venture that we had been over twenty years before with the "Guild" shops and the "Arts and Crafts" exhibitions'.[52] Fry was not going over old ground, but many of his attitudes were rooted in the same soil that gave rise to Ashbee's ventures. How otherwise do we account for Fry's statement of 1911 that Gill's carving showed 'the immense advantages of the craftsman's training of the Middle Ages over the studio training of our own days'.[53] Or, more crucially, his delight over the Omega's textile company abandoning modern practices for 'older, simpler methods'? Fry's statement about Gill shows exactly the same enthusiasm for the training craftsmen received in the Middle Ages as has been seen in the Arts and Crafts theorists, while his equation of older with simpler and there-

fore better is one with which we are by now very familiar. Both show, moreover, that Fry viewed the past and the present in relation to one another. He judged the present as wanting in comparison with the past and the past as purer, simpler and better than the present. Now it is true that Fry's yardstick was, by 1913, not so much the medieval as the primitive in the sense that Matisse and the French Fauves used it. That is, what Goldwater calls 'romantic primitivism'.[54] But just as the Arts and Crafts revivalist styles called attention to what they valued in medievalism – its simplicity, purity and expressiveness – so Fry's art based on French (and African and 'childlike' mediated through French) styles called attention to those very same and equally desirable qualities. The models may have been different but the essential prompt was the same. Nothing could underline this fact more strongly than Fry's sale of African fabrics alongside fabrics designed by his Omega artists, and the exhibition of children's art held at the workshops in 1919.

As we have seen, Fry presented the Omega not only as a new endeavour but one which was prompted by continental practice and theory. In his 1912 publicity notice Fry pointed, not to any English models, but to the École Martine in Paris. The École Martine was a workshop in which girls turned out handmade fabrics. Fry's gesture towards it was designed to cement Post-Impressionism's links with French practices. This would tend to emphasise both its modernity and its value, for French art had become, partly through Fry's own exertions, the fashionable yard-stick by which to measure British efforts. His gesture, however, may lead back to an English source, and thus point to the ways in which English Post-Impressionism came upon Arts and Crafts theories by roundabout methods. We need to consider to whom the founders of the École Martine were indebted, and what stimu-lated the demand for the fabrics made there. It would seem likely that the École was itself set up to take advantage of the fashion for handmade goods created in part at least by the continental circu-lation of magazines like the *Studio*, which (for all its early espousal of Beardsley) gave a good deal of space to English Arts and Crafts exhibitions and designs. If Arts and Crafts theory did filter into France through such channels then Fry was simply reimporting it.

There is another indirect relationship between Fry and the Arts and Crafts Movement. Along with the aesthetic ideas and language

which they shared, and the way in which Fry described the Omega products, was the very idea of the pursuit of excellence through the commercial possibilities of craft. Unless we admit of this kind of indirect relationship, the ideas underpinning the Omega seem to contradict Fry's statements about the nature of art itself. This does not make Fry any the less 'modern' in the English context of 1910–14, it simply prompts us to re-examine what the nature of his modernity was.

Despite Fry's pronouncements about the detachment of art from life, he showed a persistent unwillingness to abandon an attitude towards life in which art was an active moral agent. Post-Impressionism as he conceived it in 1910 was founded on the individual and his right to self-expression. It made no explicit statement about art's power to affect life. But the way in which Fry projected and envisaged the Omega Workshops was shot through with the belief that the production of craft by artists could elevate people's taste and thus improve their lives.

Nowhere did Fry's youthful belief in his social responsibility and duty surface more obviously than in the way he thought about the role of craft. It was here that the Ruskinian residue within him was allowed some rein. In some notes for an unpublished (and perhaps dangerously recidivist) lecture on the Omega, he enlarged upon the social context of taste. He blamed the machine for the destruction of 'the sensibilities of the lower classes'. Then, mixing Arnold and Disraeli, he went on to suggest that craft could reunite the taste of the two nations, 'one cultivated, the other barbarous', that industrialised society had created.[55] There is no socialism here, but there certainly is a belief that craft could play an egalitarian role within the aesthetic domain. There is also a strong sense that Fry regarded himself as a man who had a duty to bring such beneficial changes to the public. In an early letter to Ashbee Fry wrote, 'I do think that on the whole it is a beastly nuisance that the time should be out of joint and I shd. like to repress that uneasy suggestion that I among many others have been born to do what little we can [in] the very nasty work of setting it right.'[56] The feeling that he was born to 'put things right' never left Fry, and goes some way towards explaining the intensity of his feelings about Post-Impressionism. When he championed the new movement, his early feelings of social duty were transferred to the aesthetic domain.

He felt that in Post-Impressionism he had indeed found the right way to proceed and he never materially altered his position on it.

Indeed, after the two Post-Impressionist shows, Fry increasingly saw himself as occupying a position of aesthetic and moral centrality. He went about improving the public's artistic taste with confidence and zeal. Unlike other early Modernist thinkers, he never adopted an antagonistic position towards his public, even if his constituency was one limited by his own elitism. The characteristic Modernist stance of 'outsider', so suited to Lewis's situation and character, was never to be found in the Bloomsbury painters. And in his optimism – in the belief in the possibility of his own moral authority – Fry was, like Pound (and much more successfully), closer to Morris or Ruskin than to Whistler, Wilde or even Pater. Thus it was that Fry could occupy a central position in the London art world for so many years, instead of being confined to the highly publicised but marginal position of a man like Wilde.

The Omega Workshops flourished as a commercial venture. They were supported by the liberal middle classes and by wealthy patrons like Ottoline Morrell and Lady Tree. They were not so successful as an expression of philanthropy towards artists. Less than six months after the workshops opened, a dispute arose between Wyndham Lewis and Fry over a commission for the *Daily Mail* Ideal Home Exhibition. This quarrel, which came to be known as the 'Ideal Home Rumpus', precipitated the walk-out of five artists from the Omega, and an acrimonious and public schism between Bloomsbury and those who followed Lewis.

The causes and progress of this affray are still obscure, despite the mass of literature on the subject. The *Daily Mail* asked some artists connected with the Omega to furnish and decorate a room at the Ideal Home Exhibition. Every subsequent event – even, indeed, the question of to whom the commission was directed – has been interpreted differently by the partisans of each side. It was a messy quarrel that proceeded in stages. First there was the commission itself. This was perhaps intended originally for Spencer Gore and Wyndham Lewis but eventually devolved upon the Omega as a whole. The Lewis camp accused Fry of annexing the commission to benefit the Omega and therefore Bloomsbury. On top of this came the apportioning of tasks. Lewis worked on a mantel piece while Bell, Grant and Fry worked on mural panels. Lewis, who was no sculptor, claimed that Fry had denied that there

would be any murals in the room and felt tricked out of being included in their execution. Fry, on the other hand, suggested that he regarded Lewis's mantel piece as the centre piece of the whole room and that Lewis was therefore complaining unnecessarily. As views on each side hardened the dispute escalated. Four other Omega employees stood behind Lewis and, after an acrimonious exchange of views he and his supporters walked out. The schism was made public by a 'Round Robin' which the Lewis group sent to the *Observer*. It has rumbled on in print ever since, and has become an issue around which to define a stance towards Bloomsbury and Lewis.

The practical consequence of the 'Ideal Home Rumpus' was the formation of the Rebel Art Centre in the spring of 1914 at 38 Great Ormond Street. The Centre was managed by Lewis and backed by Kate Lechmere with whom he was associated. The artists connected with it were Wadsworth, Etchells, Nevinson, Hamilton, Helen Saunders and Jessica Dismoor. Its only product was the Rebel Stand at the 1914 show of the Allied Artists Association.[57]

The 'Ideal Home Rumpus' was, however, of importance for three other reasons. First, it is noteworthy that Lewis chose the issue of a commission over which to voice his dissent. It shows a recognition that the audience for Arts and Crafts and the audience for Post-Impressionism – or, as it was to become for Lewis, Vorticism – overlapped considerably. Lewis was thus bringing his defection to the attention of his potential market. The painter William Roberts, who was briefly associated with the Omega and later signed the first issue of *Blast*, went so far as to say that 'this was not a dispute of two erudites over a subtle point of aesthetics, but a clash between rivals for profits of the English interior-decorating market'.[58] Second, it is significant that Lewis's defection was public. After the First Post-Impressionist Show it was evident that media coverage and public attention and also scandal and public attention, were closely connected. During the 'Ideal Home Rumpus' Lewis used the press to drum up as much attention as he could. As Roberts said, the manifestos of the Italian Futurist poet, Marinetti, had 'made Lewis realise how valuable a manifesto of his own would be to himself. Fry was the first to feel the force of this new weapon; it was inevitable that sooner or later he would be served with a

manifesto, as an ally he was too powerful for someone aiming at a leading role in the English revolutionary art movement.'[59]

The last result of the dispute was that it crystallised aesthetic differences between Lewis and Fry. As we shall see, Lewis championed an art that proclaimed its use of machine forms and urban life, was nationalistic, energetic and violent. He was also at pains to establish a position towards nature that would set him apart from Bloomsbury. In his 'Review of Contemporary Art' in *Blast* 2 (1915), Lewis claimed that the Vorticist was the equal of nature because he invented nature for his own purposes. So 'the only people who have nothing to do with Nature and who as artists are most definitely inept and in the same box as the Romantic – who is half way between the Vegetable and God – are these between-men, with that most odious product of man, modern DECORATION'. As examples of these producers of odium, he cited, amongst others, 'Mr Roger Fry's belated little Morris movement'.[60]

Ezra Pound, who shared Lewis's dislike of Bloomsbury, also propounded a scheme in which the crafts held a central place. Four months after the Rebel Art Centre collapsed, Pound proposed a college of his own in which several artists associated with Vorticism were to teach. The prospectus, published in the *Egoist* in November 1914, offered the services of (among others) Wyndham Lewis, Edward Wadsworth and Helen Sanders (i.e. Saunders), all of whom had been connected with Great Ormond Street. Pound may have partly intended to fill the gap left by the collapse of Lewis's venture. But the College was a scheme which in outline and detail showed the impress of beliefs which were of primary importance in Pound's career.

Looking back on his project fifty years later, Pound described it as 'wishful thinking', suggesting that it was an idealist scheme as much as a practical one.[61] Throughout his career Pound was animated by the belief that there was much wrong with the western world, and that art could play an important part in its resurgence. That meant that far from producing his work in isolation the artist would be a man whose work could have a direct moral and practical purpose. The College of Arts, indeed, was the least grandiose of a series of enthusiasms. Pound went on to put his faith in Social Credit, in Syndicalism and in Mussolini's regime as ways of bringing his ideals to realisation.

The ideal which informed all Pound's work was the attempt 'to

make a *paradiso terrestre*.[62] Central to the idea of the *paradiso* (that most Morrisian of places) was the idea of learning, of 'sail[ing] after knowledge',[63] and Pound looked back to the early Renaissance for his models of institutions of learning. To bring forth a new Renaissance and to promote his *paradiso*, new institutions of learning were needed. Initially Pound sought an American Renaissance – and it was to Americans that his college was directed – but eventually he demanded nothing less than the re-education of Europe. Pound had aired the idea of an American 'super-college' in a series of articles in Orage's *New Age* in May and June 1913. His London college differed from his New York one only in that – for economic reasons, perhaps – it was to be a centre for teaching rather than just consultation and dispute. But in both cases, Pound stressed the need for the involvement of professional craftsmen and artists rather than pedagogues. His teachers, like the heroes of his *Cantos*, were to be men of action.

Pound's London college was divided into seven faculties. These were sculpture, painting, music, letters, photography, crafts and the dance. Sculpture was to be taught by Henri Gaudier-Brzeska. In the painting faculty, besides Lewis, Wadsworth and Saunders, were Matilde Huhn, R. H. Wilenski and W. P. Robins. Wilenski was an artist and an art critic who later became well known for his work on twentieth-century French painting and modern sculpture. William Palmer Robins was an etcher primarily associated with the Royal Society of Painter-Etchers and Engravers.

The faculty of music was headed by Arnold Dolmetsch. Instruction on violin, cello and piano was offered, the latter by the American pianist K. R. Hayman, whom Pound first met in 1904. Vocal training and the services of a diseuse were proposed. The inclusion of a diseuse may have owed something to Pound's early fascination with the French diseuse Yvette Gilbert. Finally, Edwin Evans was to lecture on 'modern Russian composers'. Evans later became music critic of the *Daily Mail* and was painted by Wyndham Lewis when he was president of the International Society for Contemporary Music. He was known in 1914 not only for his work on Tchaikovsky but also for his intimacy with Stravinsky, whom he accompanied on London tours of the Ballets Russes.

Arnold Dolmetsch was an authority on seventeenth- and eighteenth-century music, and was well known for his performances on copies of early instruments which he made himself. He spent most

of the 1890s in London, where his friends included William Morris, Selwyn Image, Herbert Horne, Arthur Symons, W. B. Yeats, Swinburne, Sturge Moore and Laurence Binyon. He gave his first concert of English music in 1891, and in 1894 was introduced to Morris by Burne-Jones. Morris, he said, 'Understood this music at once. . . . He had found the lost art, and on his deathbed summoned me to Kelmscott House, to let him hear once more the strains beloved.'[64] Dolmetsch made his first harpsichord at Morris's suggestion, displayed it with the Arts and Crafts Exhibition Society in 1896, and subsequently became a member of the Art Workers' Guild.

Pound and Dolmetsch were introduced by Alvin Langdon Coburn, who photographed Dolmetsch and was later co-opted by Pound for Vorticism. Pound wrote three articles about Dolmetsch and his music. In the *Pisan Cantos*, written thirty years later, he remembered him in his elegiac celebration of London life before the First World War.

In 1914, Dolmetsch's music appeared to Pound to be the historical equivalent of *vers libre*, and thus it became not only valuable in itself, but a precedent which would justify metrical experiment in verse. In 'Vers Libre and Arnold Dolmetsch', Pound praised this music because, like the verse which he championed, it incorporated rhythmic irregularity in its time schemes. In an article written in the *Egoist* in 1917, Pound linked Dolmetsch's music even more closely to modern experiment in the arts. Before the eighteenth century, he stated, the 'neophyte' would have been given 'the main structural forms, he would have played the bare form of the piece'. But later, 'greater rigidity in matters of minutiae had forced a break up of the large forms . . . compare academic detail in one school of painting, and minute particularisation about light and colour in another'.[65] What Pound discovered in Dolmetsch's music, then, was the concentration upon structure and 'bare form' that characterised the contemporary poetry and painting which he supported. Borrowing Arts and Crafts terminology, he called it 'pattern music' in order to stress its constructive and abstract qualities.[66]

Pound's faculty of letters consisted of the Russian/American novelist and translator, John Cournos, a drama critic, Cecil Inslee-Dorian, an authority on 'Russian contemporary thought', Zinaida Vangerowa, and Pound himself. This Russian component was

included perhaps for reasons of fashion. A cult of all things Russian, stimulated by the popularity of the Ballets Russes and the translations of Russian literature, was in full sway in London.

Photography in the college was to be taught by Alvin Langdon Coburn. 'Laboratory Sandheim' was to instruct on silver and ornament, Charles T. Jacobi was to teach printing, and George Sutcliffe bookbinding. J. W. Sandheim was a teacher at the Sir John Cass Technical Institute. Charles Jacobi was managing partner of the Chiswick Press, and George Sutcliffe was a well-known fine binder.

Charles Jacobi, associated with the Chiswick Press from 1866 to 1922, had printed several volumes of Pound's verse for Elkin Mathews. These were *Personae* and *Exultations* (1909), *Canzoni* (1911), the combined *Personae* and *Exultations* (1913) and *Ripostes* and *Cathay* (1915). He was a member of the Art Workers' Guild and provided many services for members of the Arts and Crafts Movement and other figures in Pound's college. Jacobi and the Chiswick Press were also intimately connected with the production of fine books. Holbrook Jackson, in his 1913 monograph on the 1890s, suggested that 'the revival of the art of printing began when Messrs Charles Whittingham revived Caslon's famous founts at the Chiswick Press in 1844'.[67] The press became famous for its use of old typefaces, and Jacobi became an authority on them. He advised Morris before the setting up of the Kelmscott Press, and printed several volumes for him.[68]

Like Jacobi, Sutcliffe (1878–1943) was a noted figure in the book world. He made his name with his partner Francis Sangorski (1878–1912) when he made the first modern jewelled binding in 1903. A long succession of bindings followed, culminating in a copy of the *Rubaiyat* of Omar Khayyam, sunk with the Titanic, whose covers were inlaid with silver, satinwood and ebony, and no less than 1050 jewels.[69] The *Connoisseur* of May 1914 reported that Sutcliffe's binding of *Some Poems* by Keats was 'illustrated throughout with original miniatures, and bound with covers, doublures, and fly-leaves patterned with inlays of richly coloured leathers, gold tool work, and precious stones. Over a thousand precious stones had been used in this enrichment, and the effect, without being too ornate was sumptuously beautiful, like that of an elaborate and well-designed piece of jewellery.'[70]

These bindings, with their emphasis on preciousness, gorgeousness and the surface glitter of their jewels, seem to belong more

to the 1890s than to the second decade of the twentieth century. Their maker seems especially out of place in the college of a man who at that very moment was denouncing rhetoric, bombast and superficiality in the name of honesty, simplicity and structural coherence. What it shows is the existence of contrasting imperatives in Pound himself. If his public face in 1914 was turned three quarters toward the new, his private face was still turned toward the decades in which he grew up. Critics who persist in presenting Pound as exclusively forward looking give us a simplified and even distorted picture of his artistic predilections. For Pound, like early Modernism in general, was Janus faced.

Sutcliffe's presence in Pound's college may owe as much to his high reputation as a teacher as to Pound's interest in binding. Jacobi's presence is more easily explained, for Pound had been interested in printing since the early years of the century. His first volume, *A Lume Spento* (1908), was inscribed 'in the city of Aldus'. In *The Spirit of Romance* (1910) he credited printers with a part in the revival of learning which fuelled the achievements of the Renaissance, and called them also 'conservators of tradition'.[71]

It was not simply knowledge that these men conserved, but also the tradition of fine printing itself. That meant the tradition of printing by hand. Like Arts and Crafts theorists, and despite his involvement in Vorticism, Pound had a profound dislike of mechanical processes. He reserved a special place for steam presses in the Hell of *Cantos* XIV-XVI, from where there emanated 'howling, as of a henyard in a printing house, the clatter of the presses'.[72]

The last faculty in the College of Arts was that of the dance, to be taught by Dolmetsch's wife, Mabel. Mrs Dolmetsch specialised in sixteenth-century court dances, and provided a visual accompaniment to her husband's performances. Pound thought that these dances, like Dolmetsch's music, were anti-rhetorical and anti-impressionist. 'It is,' he said, 'a dance, danced for the dance's sake, and not for the sake of display. It is music that exists for the sake of being music, not for the sake of, as they say, producing an impression.'[73]

Pound's college, then, was a seemingly eclectic mixture of Modernist artists and skilled craftsmen intimately connected with the Arts and Crafts Movement. As such, it was the embodiment of his beliefs. For, of all the Modernist practitioners we have been discussing, Pound shared most with Arts and Crafts theorists. In

his youth he had read Morris and Ruskin along with the Yellow Book poets in Mosher's *Bibelot*.[74] He shared with Ruskin the belief that the quality of all art reflected the quality of the culture that gave rise to it, and thus that a work of art was an ethical symbol. And, like Ruskin, the vehicle he used for this symbolism was architecture. In the *Cantos*, the tempio at Rimini, built by Sigismundo Malatesta, becomes, along with other buildings that 'rhyme' with it, a symbol of the good government and good patronage that Sigismundo represents. And like Arts and Crafts theorists, Pound looked for his models in a pre-lapsarian world where Art and Craft were united. 'Time was,' he said, 'when the artist grew out of the master craftsman. Before art was arty, before the artist was recruited from the ranks of the vegetarian and simple lifer . . . the artist had to have the common sense requisite for a decent carpenter's job or something of the sort.'[75] Like Arts and Crafts theorists, too, he directed his efforts towards a time and place, the *paradiso terrestre*, where 'the house becomes individual, and ceases to be a thing made by the dozen and limited to a mould'.[76]

Pound's interest in architecture centred on the techniques of building, so that the way in which a building was constructed became in itself symbolic of moral worth. Hand carving in stone represented for Pound both moral and technical excellence. Thus, when he came to review the iniquities of usury, which he believed was responsible for the decline and corruption of government and morality, craft and the craft of carving in particular stood as symbols of all that usury had destroyed:

> Usura rusteth the chisel
> It rusteth craft and the craftsman
> It gnaweth the thread in the loom
> None learneth to weave gold in her pattern.[77]

This association between the decline of craft and morality, and the practice of usury was one Pound held in common with many members of the Arts and Crafts Movement. Like Ruskin and Mackmurdo, Pound demanded a moral economy. Like Mackmurdo, he came to champion a system of Social Credit, where the medium of exchange was credit exchangeable for goods, rather than money. Pound had initially discovered Social Credit theories in the pages of Orage's *New Age*. There also he may have become

acquainted with the Guild Socialism which Orage had learned from Penty. Pound took up Guild Socialism in its European form known as Syndicalism in the late twenties, and came to believe that it could be put into operation in Mussolini's Italy.[78]

A common feature of Syndicalism and guild socialism was their stress upon local markets and upon the importance of the land as a source of wealth. Despite Pound's early belief that art was a matter of capitals, his *paradiso*, like the various utopias of the Arts and Crafts Movement, was essentially rural. It was, of course, peopled by pagan gods and Poundian heroes rather than socialists. But it was full of the mystery and romance that Morris thought were lacking in the modern world, and which he hoped would return under socialism.

When Wyndham Lewis dubbed those involved in the Omega Workshops, 'Mr Roger Fry's belated little Morris movement', he was attempting to lay the charge of conservatism upon them. But the Omega, Pound's college, and the Rebel Art Centre were not, in fact, regarded as conservative. In 1914, Ezra Pound could be accepted equally as the instigator of Imagism, the polemicist of Vorticism, and the conservator of the tradition of fine printing.

Such a combination of Arts and Crafts and Modernist preoccupations was not seen as inconsistent either by practitioners or by observers. This chapter has suggested why this was so and has delineated the common ground between Arts and Crafts writers and early Modernist theorists. But the success of early English Modernism, and the success of Post-Impressionism in particular, did not lie simply in the forging of these connections. It lay in employing them as a means of securing an audience.

It was in 1910 that theorists and audience came together, when 'Manet and the Post-Impressionists' was staged at the Grafton Galleries. It was then that Fry's presentation of Post-Impressionism attracted the allegiance of the Arts and Crafts audience, and it was then that the story of his dominance within the avant-garde began.

## NOTES

1  Roger Fry, 'Chinese Porcelain and Hard Stones', MS, Fry Papers, King's College Library, Cambridge, p. 2.

2 Roger Fry in O. M. Dalton, *Byzantine Enamels in Mr. Pierpont-Morgan's Collection* (London: Chatto 1912), p. 16.
3 Clive Bell, *Art* (London: Chatto 1914), pp. 215–6.
4 Wyndham Lewis, 'Review of Contemporary Art', *Blast* 2; rpt. in Walter Michel and C. J. Fox, eds, *Wyndham Lewis on Art* (London: Thames & Hudson 1969), p. 69.
5 Roger Fry, *Architectural Heresies of a Painter: A Lecture* (London: Chatto 1921), p. 33.
6 Walter Crane, *William Morris to Whistler*, p. 232.
7 Fry, *Architectural Heresies*, p. 18.
8 Roger Fry, 'An Essay in Aesthetics', 1909, rpt. in *Vision and Design* (1920; rpt. London: Allen Lane 1937), p. 40.
9 Fry, *Vision and Design*, p. 39.
10 It is important to remember when we discuss the Post-Impressionism of 1910, that the degree of abstraction Fry was defending both in 'Manet and the Post-Impressionists' and in his 1909 *Essay* was very limited. It was not until 1912 that he had to muster any kind of argument on behalf of Cubism. Just as with Arts and Crafts, practice and theory in 1910 were still a good way apart.
11 Fry, 'A Retrospect', *Vision*, p. 232.
12 Fry, 'A Retrospect', *Vision*, p. 232.
13 Clive Bell, *Pot Boilers* (London: Chatto 1918), p. 152.
14 Bell, *Pot Boilers*, p. 152.
15 Roger Fry, *Art and Commerce* (London: Hogarth Press 1926), pp. 17–18.
16 Roger Fry, 'Wedgwood China', *Athenaeum*, 15 July 1905, p. 89.
17 Roger Fry, 'Expression and Representation in the Graphic Arts', 1908, Fry Papers, King's College Library, Cambridge, Box 3/12.
18 For Christian Socialists in general, see Peter d'A. Jones, *The Christian Socialist Revival*, 1877–1914 (Princeton: Princeton University Press 1968).
19 Virginia Woolf, *Mr. Bennet and Mrs. Brown* (London: L. & V. Woolf 1924).
20 Ezra Pound, *The Cantos*, revised edition (London: Faber & Faber 1975), p. 802.
21 Clive Bell, *Art*, p. 44.
22 Roger Fry, 'Applied Art and the New Movement', n.d., Fry Papers, King's College Library, Cambridge. Box 12/24.
23 Bell, *Art*, pp. 92, 282.
24 Wassily Kandinsky, *The Art of Spiritual Harmony*, trans. M. T. H. Sadler (London: Constable 1914), p. xvii–xviii.
25 Bell, *Art*, p. 69.
26 Bell, *ibid*, p. 208.
27 C. L. Hind, 'Consolations of a Critic' (London: A & C Black 1911), p. 53.
28 [D. H. Lawrence] *Phoenix, the Posthumous Papers of D. H. Lawrence* edited with an introduction by Edward D. Macdonald (London: Heinemann 1936; rpt. 1961), p. 565.

29  Wyndham Lewis, *Wyndham Lewis on Art.*
30  C. L. Hind, 'Consolations', pp. 52–4. For conversions to socialism, see Stephen Yeo, 'A New Life: The Religion of Socialism in Britain 1883–1896', *History Workshop Journal* 4, 1977.
31  J. L. May, *John Lane and the Nineties* (London: John Lane 1936), p. 34.
32  Oscar Wilde, 'The Decay of Lying. An Observation', in *Intentions* (London: Methuen 1891), p. 1.
33  See Ian Small, *The Aesthetes, a Sourcebook* (London: RKP 1979), p. xv.
34  [Robert Hitchens], *The Green Carnation* (London: Heinemann 1894), p. 28.
35  Oscar Wilde, *De Profundis* in *The Works of Oscar Wilde 1856–1900* (London: Collins 1948), p. 867.
36  Fry, *Architectural Heresies*, p. 11. Fry's reference to Ruskin as a dealer or a trader in 'style' has obvious similarities with his castigation of Alma-Tadema for providing the lower-middle classes with a commodity. (See Chapter Four). This kind of snobbery directed by professionals at those engaged in trade – Fry's father was a judge, Ruskin's was a wine merchant – is an indication not only of Fry's social confidence but of the increasing domination of cultural life by the growing professional class.
37  Roger Fry, 'English Embroidery at the Burlington', *Athenaeum*, 20 May 1905, pp. 632–3.
38  Roger Fry, 'The Exhibition of Decorative Art at Turin', *Athenaeum*, 11 October 1902, p. 492; and 'The Grafton Gallery', *Athenaeum*, 3 February 1906, pp. 144–5.
39  Roger Fry, review of Mrs L. Walter, *Instructive and Ornamental Paperwork*, *Athenaeum*, 19 October 1901, p. 529.
40  Pamela Diamond, *Some Recollections, and Reflections about the Omega* (unpublished typescript, London 1968, photocopy Victoria and Albert Museum), p. 11.
41  Roger Fry, 'The Artist in the Great State', in *Socialism in the Great State*, H. G. Wells, Lady Warwick and G. R. S. Taylor, eds (London: Harper & Brs. 1912), p. 271.
42  Fry, in *Socialism in the Great State*, p. 271.
43  Fry, in *Socialism in the Great State*, p. 263.
44  Bell, *Art*, p. 58.
45  Fry in Dalton, *Byzantine Enamels*, p. 16.
46  [Roger Fry], Omega Workshops, *Prospectus*, 1915, p. 10.
47  [Fry], Omega *Prospectus*, p. 3.
48  Roger Fry to G. L. Dickinson, rpt. in *Letters of Roger Fry*, ed. and introd. D. Sutton, 2 vols (London: Chatto 1972), p. 369.
49  Winifred Gill, letter to Duncan Grant, in Diamond, *Reflections*, p. 41.
50  Roger Fry, 'The Artist as Decorator', *Colour*, April 1917, p. 93.
51  For a reading of the Omega Workshops which argues their radicalism, see Judith Collins, *The Omega Workshops* (London: Secker & Warburg 1983).

52  C. R. Ashbee, Journal, 1913, Ashbee Papers, King's College,
    Cambridge, 1913/174.
53  Roger Fry, *Nation*, 28 January 1911, in Robert Speaight, *The Life of
    Eric Gill* (London: Methuen 1966), p. 54.
54  Robert J. Goldwater, *Primitivism in Modern Painting* (New York:
    Harper 1938), pp. 54–82.
55  Roger Fry, 'Applied Art and the Modern Movement', n.d., Fry
    Papers, KCC, p. 4.
56  Fry to Asbee, 21 November 1887, in Asbee's *Journal*, 1887, Ashbee
    Papers, KCC, 1887/166.
57  'The Ideal Home Rumpus' has been extensively discussed in, among
    others, Richard Cork, *Vorticism and Abstract Art in the First Machine
    Age*, 2 vols (London: Gordon Fraser 1976), vol. 1, pp. 92–8; Jeffrey
    Meyers, *The Enemy: A Biography of Wyndham Lewis* (London:
    Routledge & Kegan Paul 1980), pp. 39–54.; Collins, *Omega*,
    pp. 54–6, and earlier in Quentin Bell and Stephen Chaplin, 'The
    Ideal Home Rumpus', *Apollo*, October 1964, pp. 284–91, and 'Reply
    with Rejoinder', *Apollo*, January 1966, p. 75. My own view of the
    affair is that Lewis was certainly wronged and very likely by Fry.
    Fry's sense of his own moral superiority would probably have
    forbidden him from remembering what his treatment of Lewis was.
    But Lewis's career was not blighted simply by Fry's neglect or
    hostility. With enough patronage Lewis could probably have battled
    on. The result of the quarrel was to push into the shade a man who
    was already at the edge of a very small world – a world so small,
    indeed, that the discussion of this quarrel can still polarise opinion
    today.
58  William Roberts, *Some Early Abstract and Cubist Work 1913–20*
    (London: A Canale Publication 1957), p. 7.
59  Roberts, *Some Early Abstract and Cubist Work*, p. 7.
60  Lewis, 'Review', in *Lewis on Art*, p. 76.
61  Ezra Pound on typescript of Patricia Hutchins, *Ezra Pound's
    Kensington* (London: Faber & Faber 1965), Patricia Hutchins Paper,
    British Library, Add. Mss 57725, fo. 369.
62  Ezra Pound, *Drafts and Fragments* p. 32.
63  Ezra Pound, Canto XLVII, *The Cantos*. (London: Faber & Faber
    1964), p. 246.
64  Mabel Dolmetsch, *Personal Recollections of Arnold Dolmetsch* (London:
    Routledge & Kegan Paul 1958), p. 163.
65  Ezra Pound, 'Arnold Dolmetsch', 1914, rpt. in *Pavannes and Divisions*
    (New York: Knopf 1918), p. 257.
66  Pound, *Pavannes and Divisions*, p. 147.
67  Holbrook Jackson, *The Eighteen Nineties* (London: Grant Richards
    1913), p. 309.
68  Charles T. Jacobi, numerous published books. Ms in Victoria and
    Albert Museum; Chiswick Press Papers, British Library; letters, New
    York Public Library.
69  'The Book Beautiful: Sangorski and Sutcliffe', *Bookbinding Trades*

*Journal*, July 1914, p. 248; and John Harrison Stonehouse, *The Story of the Great Omar* (London: Piccadilly Fountain Press 1933).

70  'Jewelled Bindings', *Connoisseur*, May 1914, p. 44.

71  Ezra Pound, *The Spirit of Romance* (London: Dent 1910), p. 251.

72  Ezra Pound, Canto XIV, *The Cantos*, p. 66.

73  Pound, *Pavannes*, p. 149.

74  Ezra Pound, Preface to *The Poetical Works of Lionel Johnson* (London: Elkin Mathews 1915), p. viii.

75  Ezra Pound, 'America: Chances and Remedies . . . vi', *New Age* 5 June 1913, p. 143.

76  Pound, 'America: Chances and Remedies . . . vi', *New Age*, 5 June 1913, p. 143.

77  Pound, Canto XLV, *Cantos*, p. 240.

78  A. J. Penty, *The Restoration of the Guild System* (London: Swan Sonnenschein 1906).

# 3

## THE FIRST
## POST-IMPRESSIONIST SHOW

The official title of the the First Post-Impressionist Show was 'Manet and the Post-Impressionists'. It opened to the public on Tuesday, 8 November 1910 at the Grafton Galleries off Bond Street, and ran until 15 January of the following year. The press day was Saturday, 5 November. Eight of the eleven daily newspaper reviews which will be considered in this section appeared either on the 7th or the 8th, so that a substantial amount of press reaction was available to viewers before they saw the exhibits themselves. During the following two months over 25,000 people visited the exhibition. With their shilling entrance fee they received the catalogue with its introduction by Desmond MacCarthy. So even without the furore that 'Manet and the Post-Impressionists' caused in the press, the principles of Post-Impressionism were digested by many thousands of people.[1]

The visitor began with a roomful of Manet and Cézanne, a prelude to a show consisting of 155 paintings, 51 drawings and 22 bronze and pottery pieces. Most of the paintings the visitor looked at were by dead men, for the show concentrated on the work of Cézanne, who died in 1906, Gauguin, who died three years before him, and Van Gogh, who died in 1890. Several younger painters were represented, notably Matisse (b. 1869), Picasso (b. 1881), Vlaminck (b. 1876), Denis (b. 1870) and Derain (b. 1880). But most reviewers followed MacCarthy's lead in the catalogue and pointed readers and viewers firmly in the direction of the dead. So what was being discussed, vilified and defended in 1910 was mostly

continental painting from the 1880s and 1890s. Thus, in the context of England in 1910, it is not the form of these paintings that demands explanation, it is their success; not their style, but their attraction – as form and subject – for painters, public and dealers. It is worth bearing in mind also that Fry, in championing Cézanne, Van Gogh and Gauguin, was mounting a case only for a limited degree of abstraction. Despite the extreme terms in which arguments for both sides were couched it was not until the second Post-Impressionist show two years later that 'up to date' continental experiment was on display. In 'Manet and the Post-Impressionists', only Picasso's *Portrait of Clovis Sagot* gave a hint of the avenues he was exploring at the time. This piece was so isolated that it could be passed over in favour of the artist's drawings and earlier work, and thus Fry had no need to put forward any developed justification for Cubism.

Cézanne, Van Gogh and Gauguin formed the core of 'Manet and the Post-Impressionists', because their work overwhelmed other paintings purely by number, and because they bulked equally large in the show's catalogue. Reviewers selected six works by Cézanne for close attention. These were *Portrait de l'artiste* (catalogue no. 10), *Portrait de Madame Cézanne* (11), *Dame au chapelet* (13), *Baigneurs* (19), *Portrait d'homme à cravate bleu* (sic) (47) and *Maison à Auvers-sur-Oise* (61). Eight Van Gogh pieces commanded a great deal of space in the notices. These were *Le Postier* (66: Boston, Museum of Fine Arts), *Jeune fille au bleuet* (the mad girl in Zola's *Germinal*) (67), *Cornfield with Rooks* (71), *Les Soleils* (72), *Dr Gachet* (73: Paris, Louvre), *Pietà* (74) *Resurrection of Lazarus* (75) and *La Berceuse* (76: Otterloo, Rijksmusuem Kroller-Muller). Five works by Gauguin provoked considerable comment. These were *L'Esprit veille* (42), *L'Esprit du mal* (43), *Maternité* (44), *Le Christ au Jardin des Oliviers* (85: West Palm Beach, Norton Gallery) and *Grand Baigneuses* (86). Manet's *Un bar au Folies Bergères* (7: London, National Gallery) and Matisse's *La femme aux yeux verts* (11: San Francisco, Museum of Art), *Tête de femme* (195) and *Femme accroupie* (sculpture no. 13) were the subject of controversy.

'Manet and the Post-Impressionists' was assembled largely from dealers' collections in Paris and Holland by Roger Fry and Desmond MacCarthy. MacCarthy wrote the catalogue introduction from notes which Fry provided. Fry also assembled an Honorary Committee and an Executive Committee. These bodies were

Cézanne, *Portrait de Madame Cézanne* (*Madame Cézanne in a Red Armchair*). Oil on canvas, 72.5 × 56 cm. (Reproduced by permission of the Museum of Fine Arts, Boston. Bequest of Robert Treat Paine, 2nd.)

Matisse, *La Fille aux yeux verts* (*The Girl with Green Eyes*), 1908. Oil on canvas, 60 × 50.8 cm. (Reproduced by permission of the San Francisco Museum of Modern Art. Bequest of Harriet Lane Levy.)

presumably intended to add critical and social weight to the enterprise.

Fry's exhibition was not the first occasion on which late Impressionist painting had been exhibited in England. Cézanne had been shown at the International Society Exhibitions in London in 1898, 1906 and 1908, and many of the younger artists included in Fry's Post-Impressionist Show had been displayed in Robert Dell's Brighton show in June 1910.

None of these exhibitions, however, provoked the same kind of debate as 'Manet and the Post-Impressionists'. Although the accent of Fry's show was rather different from those held earlier, concentrating on Cézanne, Gauguin and Van Gogh, with Matisse and Picasso as their progeny, it seems likely that the paintings acquired interest and significance because the manner of their presentation in 1910 entrenched them firmly in the London art world, critically, socially and economically. Fry's own standing as a critic, his appointment of respected artists like Sargent to the Honorary Committee, the site of the show in a major West End gallery and the promotion of Post-Impressionism in an established magazine like the *Burlington*: these circumstances combined to advertise Fry's claim for the central importance of Post-Impressionism to the understanding of contemporary art.

Fry also used the work itself to substantiate his claim for the seriousness and achievement of the Post-Impressionist painters. Along with the paintings, sculpture and ceramics, he included fifty-one drawings. Since these were, in the main, recognisably 'skilled' and recognisably 'representational' or 'true' enough to nature to even the conservative contemporary eye, they helped to rebut the charges of incompetence and 'bad drawing' levelled particularly against Matisse and Picasso. By deferring to existing standards in this way, Fry furthered the Post-Impressionist cause. Because of the existence of the drawings, some critics felt that the paintings by the same hands must be deliberately bad. This helps to explain the belief that Matisse and Picasso, in particular, were simply charlatans seeking to gain attention and notoriety.

The subjects and terms of the debate over 'Manet and the Post-Impressionists' were set by the catalogue introduction. The catalogue was written by Desmond MacCarthy, who recalled that he put it together very hurridly, fortified by champagne, from notes which Roger Fry provided.[2] MacCarthy's style was jaunty and

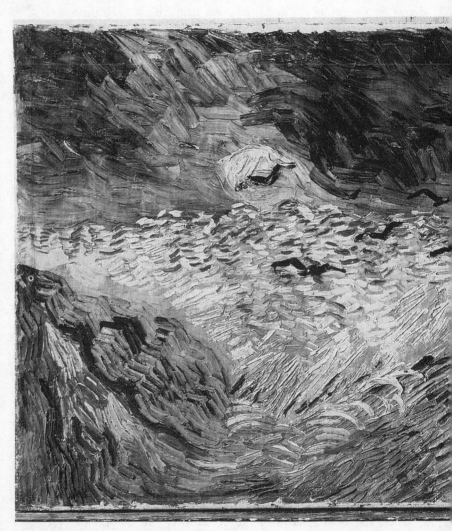

Van Gogh, *Korenveld met kraaien* (*Cornfield with Rooks*), 18 × 24 cm.
(Reproduced by permission of the Stedelijk Museum, Amsterdam.)

occasionally almost offhand, and some of his more inelegant phrases provided nervous critics with ready-made material for sarcasm. But if the committed seriousness so characteristic of Fry's prose was not there, the underlying premises clearly bore his stamp.

In the catalogue, MacCarthy described the principles of Post-Impressionism and then laid out a Post-Impressionist genealogy from Manet to Cézanne, Van Gogh and Gauguin, and thence to the younger artists spearheaded by Matisse and Picasso. MacCarthy insisted first and foremost that the basis of art lay in self-expression. Self-expression was not to be achieved by the nineteenth-century ideal of 'the close representation of nature', but by 'synthesis in design'. This synthesis resulted from the conscious subordination of representational elements in order to foster the co-ordination of the whole. It would, if successful, transmit 'that emotional significance which lies in things, and is the most important subject matter of art'.[3]

Crucial to MacCarthy's definition of Post-Impressionism was the relative importance of self-expression and representation of the external world in the production of a work of art. As has been seen in the study of Arts and Crafts writers, this question had been debated vigorously in the last quarter of the nineteenth century, when Fry and many of the Post-Impressionist audience were young. Fry had, indeed, conducted his own, internal, version of the debate. So, when MacCarthy – or Fry 'ghosted' by MacCarthy – raised the question of representation, he was bringing to the surface a question which had continually worried Fry since his undergraduate days. In Fry's youth the discussion had been conducted and represented by Ruskin on one side and by the Whistlerian aesthetes on the other. But, even in 1910, the debate could not be conducted without the spectre of Ruskin rising to play its part, for Ruskin had made the notions of self-expression and 'truth to nature' the foundations of his mature criticism. Ruskin's formulations, as they were interpreted in 1910, provided the detractors of Post-Impressionism with the standards by which they judged Post-Impressionist painting and found it wanting.

In *Modern Painters*, Ruskin defined truth in art as a 'faithful statement, either to the mind or sense, of any fact of nature'.[4] He distinguished, however, between that truth and a mere imitation of nature. Truth resulted from an act of expression on the part of the artist, which would intensify and universalise the representation of

single facts of nature. The necessary result of successful expression was beauty.

Ruskin did not deny that selection and arrangement of nature could be conditions of self-expression. He increasingly regarded form as a vehicle of self-expression, an embodiment of the artist's mind and character. In *The Stones of Venice*, Ruskin gave the material itself an active role, so that it was an influence upon those who worked it. Nevertheless, he maintained a precarious distinction between nature and the artist.

Ruskin provided a 'standard' for judging success or failure in a work of art, despite the difficulties there were in its application. The more true a work was to nature, the better it would convey facts, thought and ideas to the mind. The more that could be communicated, the greater the success of the work, since, 'the greatest picture is that which conveys to the mind of the spectator the greatest number of the greatest ideas'.[5]

If Ruskin maintained some balance between the artist and nature, MacCarthy tipped the scales in favour of the artist. Natural fact became subordinate to the artist's self-expression. Truth then became the property of the artist and ceased to pertain to the natural world. The more true to the artist's nature a work was, the more complete his self-expression, the more successful the painting. Success was thus not measured, as with Ruskin's followers, by the quality of ideas communicated but by the quality of the emotion.

The shift of interest away from the external world resulted in a greater emphasis on the constructive parts of the work of art, on what MacCarthy called 'synthesis in design'. When he came to discuss individual artists, MacCarthy amplified this notion, and introduced the descriptive language that rapidly came to characterise Post-Impressionism. Thus Cézanne 'aimed first at a design which should produce the coherent architectural effect of the masterpieces of primitive art', and he showed 'how it was possible to pass from the complexity of the appearance of things to the geometrical simplicity which design demands'.

Gauguin felt that modern art had 'neglected the fundamental laws of abstract form, and above all had failed to realise the power which abstract form and colour can exercise over the imagination of the spectator. He deliberately chose, therefore, to become a decorative painter.' And with Matisse, said MacCarthy, the 'search

for an abstract harmony of line, for rhythm has been carried to lengths which will often deprive the figure of all appearance of nature'.[6]

What happened in MacCarthy's introduction was that the need for self-expression, or the expression of personality, became allied to the concern for form. The belief that man could express himself through pattern, decoration and the manipulation of materials had, indeed, been implicit in Arts and Crafts theory. But MacCarthy linked them more overtly. He stressed, for instance, Gauguin's act of will in choosing to concentrate upon the decorative rather than the narrative elements within his painting. At the same time, however, this link between self-expression and formal purity contained within itself the seeds of an aesthetic that seemed to allow the individual very little room for manoeuvre. In the hands of a man such as Bell, the onus was increasingly shifted from self-expression to the creation of significant form. So the formal parameters of the new painting began to contract, in theory at least, to those which would produce that form.

Fry backed up MacCarthy's catalogue with two articles in the Liberal periodical the *Nation*, the first printed two weeks after the show opened and the second a fortnight later. In them he re-emphasised the Post-Impressionist committment to form, and said of the painters at the Grafton Galleries that, 'more and more regardlessly they are cutting away at the merely representative element in art to establish more and more firmly the fundamental laws of expressive form at its barest, most abstract elements'.[7]

Fry's glee at the limitations inherent in increasing formalism suggests that it was not in formalism alone that he saw the virtues of Post-Impressionism. For Fry, formalism implied limitation, bareness and purity. Purity of form carried with it overtones of essentialism and could imply a spiritual or 'religious' interpretation of art. This was what Fry showed in his *Nation* articles. Running alongside the formalist urge was an overtly spiritual interpretation of Post-Impressionism that encouraged, or fitted in with the way in which Post-Impressionism's early supporters saw the new painting. In the second of his two pieces Fry called Post-Impressionism a 'great movement' and Van Gogh a 'great visionary'.[8] Cézanne's work, he said, 'has that supreme spontaneity as though he had almost made himself the passive, half-conscious instrument of some directing power'.[9] By 1912, when Fry was

constructing his 'classic tradition' in which Cézanne figured so
largely, he preferred to stress the Frenchman's detachment in the
face of objects. In 1910, however, he thought that Cézanne was
possessed of a kind of efflorescent naturalness. He thought of him
as spontaneous to the point of being an unconscious medium,
his hand directed from above. This was exactly what the Post-
Impressionists' detractors said, although they construed it rather
differently. Robert Ross condemned Van Gogh's painting because
it was suggestive of the 'chicaneries of spiritualism'.[10] Fry, on the
other hand, went nearly to the point of putting Cézanne forward
as a proof of spiritualism. With Van Gogh he went a step further.
Casting Quaker equivocation to the winds he actually invoked God
himself. To laugh at Van Gogh, he said, 'is to forget how rare it
is to see God and yet live. To Van Gogh's tortured and morbid
sensibility there came revelations fierce, terrible, and yet at times
consoling, of realities behind the veil of things seen.'[11]

Fry did not repeat these extravagant claims for Manet and the
Post-Impressionists. Indeed, by the end of the second *Nation* article
he had retreated from hailing the Post-Impressionists as instru-
ments of the Godhead, and concluded with the more modest
assertion that, 'if the group of artists here exhibited had done
nothing else, their contribution to modern art would be sufficiently
striking, in that they have shown the way to the creation of entirely
fresh and vital pattern designs'.[12]

By early December 1910, when Fry wrote the second of his two
*Nation* articles, he may have been caught up in and contributed to
the extremism that characterised the responses to Post-
Impressionism, from Robert Ross's disgust to the 'wild enthusiasm'
of the paintings' supporters.[13] But Fry had, nonetheless, set the
stakes high for Post-Impressionism from the very begining when
he urged that the artists shown at the Grafton Galleries were part
of a movement. He suggested that individual painters should not
be seen as unconnected, but as contributors to a coherent and
definable change in artistic practice and purpose. The hostility he
called forth was in some degree proportional to the claims he made.
The anger of hostile critics was partly a response to Fry's own
statements, a reply, rather than an unprovoked explosion.

Writers on 'Manet and the Post-Impressionists' have seen fit to
concentrate on the bitterness it aroused rather than seeking to
understand or explain the reasons and grounds for disagreement.

They have treated it as a scandal and not a debate. In so doing, they have concentrated on the most condemnatory reviews and overlooked those which greeted the show with approval. Virginia Woolf bears some responsibility for this emphasis. In her biography of Roger Fry she asserted that 'only one of the London critics, Sir Charles Holmes, came out on the side of the Post-Impressionists'.[14] It is not clear where Woolf got her information, for, although exact numbers are difficult to determine because some critics were anonymous and at least one wrote more than one review, there must have been almost a dozen notices, as well as many letters whose writers supported the new art. Woolf then goes on to quote the art critic of *The Times*, Charles Ricketts and W. S. Blunt, three commentators who reacted very strongly against the show. Subsequent scholarship has tended to mirror Woolf's argument.[15]

At least 40 publications contained material directly concerned with the Post-Impressionists between November 1910 and February 1911. As well as daily and Sunday newspapers, these included weekly, fortnightly and monthly journals, ranging from society magazines like *Mayfair* to serious commentaries like the *Nineteenth Century*. Almost all of them had a potentially national circulation, although some, like the *Tramp* had, in practice, a mainly metropolitan and fairly restricted readership. By no means all of these forty publications contained reviews of 'Manet and the Post-Impressionists'. There were also letters – in two important instances, the *Morning Post* and the *Nation*, a series of letters – articles and satirical verses, skits and sketches. Some of the articles – Denis on Cézanne and Meyer Riefstahl on Van Gogh in the *Burlington*, for instance – were not responses to the show. Indeed they should be seen as carefully planned 'anticipations' of it. Nevertheless, like T. B. Hyslop's article in the *Nineteenth Century*, they provided readers with detailed explications of particular critical standpoints, and became part of the critical debate.

Thirteen of the forty publications which discussed the First Post-Impressionist Show came out on balance against the exhibition, and fourteen came out in its favour. Eleven adopted a stance of neutrality, either because they openly declared suspended judgement, or because they refused in practice to commit themselves, or because the show was not a matter for judgment but material for satire or humour. The remaining two publications printed material which was not a direct response to 'Manet and the Post-

Impressionists', but which was read in the light of the show. The proviso 'on balance' is important. Most critics found something to praise or something over which to hesitate. In fact, those who were enthusiastic about the show produced words of praise far more unqualified than the words of disapprobation written by those who disliked it. Those who came out against the show often exempted Manet from their strictures, while those who came out in its favour frequently expressed some doubts as to the success of particular works, despite their acceptance of Fry's premises.

The publications which declared against the show consisted of six daily papers, one weekly paper, three serious periodicals, two art journals and one fashionable monthly. The six dailies were the *Daily Express*, the *Globe*, the *Morning Post*, the *Star*, *The Times* and the *World*. All of these papers were politically conservative, supporting the opposition Conservative/Unionists, except the *Star*, a Liberal daily owned by the Quaker industrialist George Cadbury. Cadbury's other paper, the *Daily News* supported 'Manet and the Post-Impressionists'. The key to this divergence probably lies more in differences in the papers' politics or readership than in Cadbury's indifference to art, which allowed critics a high degree of autonomy. Although he was a firm believer in education, Cadbury had no interest in art. For him, aesthetic matters paled into insignificance beside global problems. 'Why should I hang a fortune on my walls', he said, 'when there is so much misery in the world?'[16]

Only two reviewers in these papers signed their pieces, Robert Ross, the literary critic and friend of Oscar Wilde, in the *Morning Post*, and A. J. Finberg, the curator of the Turner Bequest, in the *Star*. C. J. Weld-Blundell, the Catholic aristocrat and collector, wrote *The Times* piece. Besides Ross's review, the *Morning Post* printed an additional article and conducted a heated correspondence about the show. The *Saturday Review*, the weekly which attacked the show, was also a Unionist journal. It contained a notice by Lawrence Binyon. Like Ross, Binyon had made his reputation in the eighteen-nineties. He was assistant keeper of prints and drawings at the British Museum, a poet and an authority on Far Eastern art.

The *Academy*, the *Nineteenth Century and After*, and the *Spectator* made up a trio of dissenting serious magazines. The *Nineteenth Century* put out the text of a lecture on Post-Impressionism by T. B. Hyslop, senior physician at Bethlem Royal Hospital, while the

other two carried anonymous reviews. The *Connoisseur*, one of two art magazines which came out against the show, also had an unsigned notice, while the *Art Chronicle* piece was by J. J. Woods. Finally, *Mayfair and Town Topics*, a society magazine, printed a review signed, appropriately, 'the Dilettante'.

Four daily newspapers, three weekly newspapers, five serious periodicals and two art magazines were in favour of 'Manet and the Post-Impressionists'. The four dailies were the *Daily Chronicle*, with a review by C. L. Hind, the *Daily News* and the *Pall Mall Gazette*, both of which had anonymous notices, and the *Westminster Gazette*, whose critic signed himself 'E. S.'. All of them supported Asquith's Liberal party, except the *Pall Mall Gazette* which was a fervently Conservative/Unionist paper. The *Westminster Gazette* also printed a humorous dialogue about the show. The three weeklies were the *Illustrated London News*, the *Sunday Times* and the *Nation*. *The Illustrated London News* printed photographs as well as a commentary on the show. The *Sunday Times* carried a review by Frank Rutter, the art critic who had started the Allied Artists' Association, an exhibition society which opposed the jury policy of the New English Art Club. The weighty Liberal *Nation* put out two articles by Roger Fry and a long correspondence about Post-Impressionism. C. L. Hind also provided enthusiastic notices in two serious reviews, the autodidactic *T.P.'s Magazine* and the primarily literary *English Review*.

The three other serious journals which approved of the show were the liberal *Athenaeum*, the self-consciously bohemian *Tramp* and the high Tory *Fortnightly*. The first two had unsigned notices, but the *Fortnightly* carried both a review by W. R. Sickert and the text of a lecture by Fry. Although it was a Tory periodical, the *Fortnightly* had a consistently liberal arts policy. Four years later it published an article by Ezra Pound on Vorticism very similar in intention to Fry's piece.[17] Finally, two art journals, the *Burlington Magazine* and the *Art News*, supported the show. Frederick Spencer Gore, the Camden Town painter, writing in the *Art News* declared himself, with some qualifications, in favour of 'Manet and the Post-Impressionists'. The *Burlington* had 'prepared' its readers for the Grafton Galleries by printing a series of articles on painters whose work they would see there. It also published an article about the Post-Impressionists by A. Clutton-Brock.

Three daily papers and one Sunday paper, all of which were

Unionist supporting, failed to reach a verdict about 'Manet and the Post-Impressionists'. They were the *Daily Graphic*, the *Daily Telegraph*, where Claude Phillips reviewed the show, and the *Daily Mail* and the *Observer*, for both of which Paul Konody acted as art critic. In addition to these papers, seven magazines whose attitude towards the show was satirical remained neutral. The *Imp* and *Punch* had cartoons about the Post-Impressionists, and *Punch*, *Granta*, the *Isis*, *London Opinion* and the *Tatler* all had humorous commentaries. The remaining publication to stay neutral on Post-Impressionism was *Public Opinion*, which summarised some well-known views on the show and discussed it using arguments from both sides of the dispute.

Two other magazines contained material which related directly to 'Manet and the Post-Impressionists'. These were *London Magazine* and the *Art Journal*. *London Magazine* published a short piece by Sir William Richmond, one of the most vociferous of the correspondents to the *Morning Post*. Between July and December 1910 the *Art Journal* ran a series of articles by C. L. Hind on modern European painters, many of whom were included in the Grafton Gallery show.[18]

When we assess critical views about 'Manet and the Post-Impressionists' and the ways in which they were expressed, we need to consider the forces to which their ideas and styles were subject. Proprietors, editors and the readers being addressed could and did affect what was said about Post-Impressionism and how it was said.

In the first place it is important to take into account the timing of notices. The critics writing in the dailies were those who initiated the controversy about 'Manet and the Post-Impressionists'. Once it was clear that Post-Impressionism was a matter of wide interest the weeklies, the monthlies and the satirists got to work. The writers in these journals had an advantage over their colleagues on the dailies. The effect of the confusion displayed in the daily press may have been to induce either greater caution or greater belligerence in critics who wrote for periodicals. Time both to peruse the first reviews, to visit the show again, and to take stock of the controversy may have produced an unwillingness to appear foolish or a desire to declare strongly one way or the other. Moreover, the Manets in the show served as a reminder that taste was anything but immutable. The spectres of Manet's early detractors

began to haunt cautious critics. They saw a possible parallel between the growth of Manet's reputation after scurrilous attacks by the press and the fate of Cézanne. These worries got the better of two writers, in the *Athenaeum* and the *Graphic*, who qualified their first opinions with later articles. They may, of course, simply have changed their minds. But they may have altered their positions to save their critical credibility.[19]

If time could prompt critics to see Post-Impressionism in particular ways, so could newspaper proprietors and editors. Editors could and did exercise considerable control over the content of reviews. J. A. Spender, the editor of the *Westminster Gazette* left his writers alone, mindful of the story that Keats was killed by a reviewer. 'As an editor', he said, 'I thought it better to give the critic a licence in eulogy on the chance of discovering one Keats than to run the risk of killing a Keats in an indiscriminate slaughter of imposters'.[20]

Other editors and their proprietors may have been more interventionist. The way in which Paul Konody wrote about Post-Impressionism in the *Observer* and the *Daily Mail*, for instance, may have owed a good deal to the attitudes of his proprietor. The *Daily Mail* and the *Observer* were both part of the rapidly expanding Northcliffe-Rothermere empire. Northcliffe was a firm Unionist who was preoccupied with threats to the British Empire and constitution. Konody said in the *Daily Mail* review that 'even the worst' of Post-Impressionism was 'stimulating', and that much of it 'deserves the most serious consideration'.[21] In the *Observer*, he said that it was based on 'fundamentally sound principles', was 'not to be dismissed with derision' and praised Gauguin, despite disliking Van Gogh and Cézanne.[22] Notwithstanding his evident interest, he said in the *Daily Mail* that Post-Impressionist paintings were not for 'permanent possession'. In the *Observer* he concentrated praise and blame in a single sentence. 'It is not likely', he said, 'that English collectors will follow the lead of Germany and rush blindly into filling their houses with pictures that are highly interesting on the walls in an exhibition, and that may even contain a hint of the direction the normal evolution of art may take in the future.' He concluded by saying that the paintings 'are not things to live with. Germany is welcome to them'.[23]

This kind of xenophobia is to be found in several reviews of the show. In every other case, however, British or English values were

defended against French or Parisian infiltration. Konody was born in Budapest and educated in Vienna. It is possible that he had particular reasons for choosing Germany (the reference is to the whole nation) as an example to avoid, or conversely, for stressing the distinctive qualities of British collectors. He may also have been aware of the strong interest German collectors were taking in the work of Cézanne, Van Gogh and Gauguin. But it is equally possible that Northcliffe's stance towards Germany helped to determine Konody's choice of negative exemplar. Northcliffe was vehemently anti-German, and, according to one of his biographers, he would not 'let his readers take their eyes off Germany'.[24] Through his papers he issued continual warnings about the German military threat. It is therefore tempting to see in Konody's description of German collectors an echo of Northcliffe's attitude to German arms build-up.

If Konody was under constraint from his proprietor, or shared his proprietor's fears, Claude Phillip's notice in the *Daily Telegraph* was probably affected by personal considerations which stopped him from giving full rein to the adverse judgement of Post-Impressionism which two years later he admitted that he had formed. Phillips was a member of Fry's Executive Committee. MacCarthy insisted in the show's catalogue that the committees were not responsible for the choice of pictures, and did not necessarily give it their approbation. Nevertheless, the disclaimer was disregarded by many reviewers. In view of the prominent place given to the lists of the committees in the catalogue this was hardly surprising. Phillips' notice applauded the intentions of the Post-Impressionists, but by no means all of their products. Nevertheless, his presence on the committee amounted to support for both. It is possible, then, that the difficulties of his position inclined him to 'watch and wait', as he put it.[25]

Fry himself seems to have felt no conflict between his role as organiser of 'Manet and the Post-Impressionists' and his role as a journalist. As founder and co-editor of the *Burlington Magazine*, he used his editorial authority quite deliberately to promote the Post-Impressionist cause. Fry shared the editorial post of the *Burlington Magazine* with Lionel Cust. This allowed him to introduce the Post-Impressionist painters and the terms in which they were discussed to this very influential audience. By placing his articles – Meyer-Reifsthal on Van Gogh, Maurice Denis on Cézanne,

A. Clutton-Brock on Post-Impressionism itself – strategically, by embedding them within discussion of art which was respected and secure, and in which the readers' interests were involved, Fry smoothed the way for Post-Impressionism's acceptance. The February 1910 issue, containing the second of Denis's articles on Cézanne, also had pieces by Lionel Cust, Claude Phillips and Charles Holroyd, who were all to become members of Fry's Executive Committee. Their association with Post-Impressionism, and thus their usefulness in lending it critical support, would seem heightened to those who turned to Denis' article for information at the time of the show.

It was in the *Burlington Magazine*, moreover, that Fry's most dextrous juxtaposition of Arts and Crafts and Post-Impressionism occured. In the November 1910 number of the *Burlington* there were three articles written in sequence. The first, by Laurence Binyon, was on Chinese painting, the second, by Meyer-Riefstahl was on Van Gogh, while the third discussed 'Hispano-Moresque Carpets'.[26] Fry helped to drum up interest in and support for Post-Impressionism by sandwiching the article on Van Gogh between a piece written by a well-respected critical figure and an article written in the Arts and Crafts language familiar to many of the *Burlington's* readers. Binyon helped Post-Impressionism not merely because of his standing but because he shared a good deal of critical terminology with Post-Impressionist writers. So, even though he did not write a favourable review of 'Manet and the Post-Impressionists', Binyon could be recruited as an unwitting advocate of the new painting.

By putting the article on carpets immediately after the Van Gogh piece, Fry moved readers from Chinese painting, to Post-Impressionism, to craft. Design, pattern and abstraction from nature were for Binyon the mainsprings of Eastern art. Meyer-Riefstahl talked of the decorative principle which, as he said a month later, led Van Gogh to adopt 'a purely carpet-like style of work'.[27] In the November issue, carpets themselves were described as having a 'geometrical basis', to which were added, amongst other things, 'trees so extremely conventional in treatment that all semblance to Nature has been lost'.[28] Fry thus planted Post-Impressionism in the fertile ground of the *Burlington* between discussions whose descriptive language was similar to that which

Post-Impressionist writers used. In so doing, he attracted an audience towards it which was predisposed to acceptance through familiarity with its claims and its methods of description.

It was not necessarily an editor who 'stage-managed' the presentation of copy. It could be the critic himself. Robert Ross, as art critic of the *Morning Post*, was probably called in to advise upon the way in which the paper should handle the response to his review of 'Manet and the Post-Impressionists'. That meant that he helped to determine what correspondence about Post-Impressionism should be printed. The *Morning Post* correspondence was biased heavily towards disapproval of Post-Impressionism, in keeping with the position which Ross had taken in his review. Nine letters were printed expressing dislike of the show against only four in its favour. Moreover, five of those opposed to Post-Impressionism were personally connected to one another and to Ross himself, W. B. Richmond, Charles Ricketts and Jacques Emile Blanche were all Ross's personal friends, while Richmond was an associate of Phillip Burne-Jones, and Burne-Jones a close companion of E. F. Benson. The character of this correspondence shows that public discussion of Post-Impressionism in the *Morning Post* was controlled in such a way that it took place amongst relatively small connected circles.

Ross narrowed down the *Morning Post* correspondence to his own views and his own acquaintance. The critic C. L. Hind regarded his own work as equally malleable. Hind recognised that the stance and readership of a journal was very important to the format, tone and content of any article about Post-Impressionism. He wrote laudatory pieces on Post-Impressionism for the *Art Journal, T. P.'s Magazine*, the *Daily Chronicle* and the *English Review*. Although all were enthusiastic, each took a different form.

Neither the *Art Journal* nor *T.P.'s Magazine* were 'highbrow' publications. Instead of the continuous narrative appropriate to a scholarly review Hind therefore composed brisk dialogue for their readers. In the *Art Journal*, Hind adopted the expedient of two art lovers talking to one another. The less convinced of the two is given colourless prose. He says that he is 'interested in Van Gogh because he was really the parent of the neo-impressionist movement'. The proseletiser is given rhetoric. He says, 'Van Gogh pursued me all night – Van Gogh, eager evangelist and frenzied

artist, in whom the spirit of life boiled'.[29] The reader who was susceptible to such flourishes was bound to incline to his side. In *T.P.'s Magazine*, the presuppositions of the doubter were exposed within a dramatic framework that distanced them from the reader.[30] So in both magazines the case for the new French art was made less by assertion than by dramatic sleight of hand. 

In his *Daily Chronicle* review Hind was far more sober. His allusion to the moral qualities of Matisse, the man, and to the need for hard work on the part of the viewer does, as will be seen, reflect a particular attitude towards art. But it was also in keeping with the tone of judicious enquiry in which the paper was couched, as well as the self-educative propensities of some of its readers. Matisse, said Hind, 'is a serious man and means things seriously. Submit yourself to his intention, and his works will repay effort. They have life. They communicate life.'[31]

Again, for the *English Review*, Hind switched tone. The *English Review's* readers were supposed to possess a considerable amount of art historical knowledge, for they were credited with being intellectuals. Hind adopted this – perhaps – flattering assumption and constructed an imposing genealogy for Post-Impressionism, starting with Turner and running through Constable, Delacroix, Manet, Seurat and Signac.[32]

Hind was, indeed, the most credulously enthusiastic as well as the most prolific supporter of Fry's show. His contribution lay not in elucidating Post-Impressionist theory but in advertising the attractions of Post-Impressionism as an art redolent of a committed and serious approach to life. By his journalistic pieces Hind made converts to Post-Impressionism as a cause. He saw the Post-Impressionist painters as visionaries in the same mould as artists he had previously celebrated – Rembrandt, Velasquez, Blake, Turner – great men who 'trained themselves to be ready for the supreme moment when some power lifted them above themselves, and swept them into the region where art endures'.[33] The new painting was 'an attempt to unbare essentials in the search for expression'.[34] Hind found a place for Post-Impressionism 'in that land of dreams, east of the sun and west of the moon where all enduring and beautiful things happen'.[35] He found a place for all his pieces on Fry's show in a book entitled *The Post-Impressionists*,[36] which allowed a wider public than his magazine audience to share his discovery. As Bell admitted in his somewhat ungrateful review

of the book in the *Athenaeum*, 'persuasive journalism may carry further than passionate eloquence or subtle dialectic'.[37]

Clearly, then, the stance, tone and putative readership of publications were very important in deciding the style and content of reviews. So was the degree to which publications, and their writers and readers, were involved in Post-Impressionism. Magazines whose primary concern was art had, in theory, more at stake in the success or failure of Post-Impressionism than daily papers, because their standing and sales could be affected. This was certainly true of the *Art News*, which represented both a group of painters and a series of attitudes which were vulnerable to Fry's incursions. The *Art News* was the official magazine of the Allied Artists' Association and was edited by the Association's founder Frank Rutter. The Allied Artist's Association was an open exhibition society which had strong enough continental links to be well acquainted with the newest French, German, and Russian art. Although the Allied Artist's Association was, because of its open policy, a very hetero-geneous body, aesthetically and stylistically, the *Art News* represented its more radical element, and it was the Camden Town painter F. S. Gore who wrote its review of 'Manet and the Post-Impressionists'. The journal was thus the only publication covering the show which promulgated an aesthetic any where near to that which Fry was putting forward.

The *Art News* treated the exhibition with easy familiarity, complaining only that it was not 'entirely modern'.[38] This complaint contained the germ of the disagreement which was to break out between Bloomsbury and Camden Town once Post-Impressionism was established. Gore opened the rift by asserting that it was the Allied Artists' Association which represented truly 'modern' opinion and styles, and not the Post-Impressionists. He also criti-cised Fry for trying to 'separate the decorative side of painting from the naturalistic', for stressing the abstract qualities of form divorced from natural fact or truth.[39] Here again Gore was taking up position against Fry, a position to which he and Ginner were still committed as late as 1914, when Camden Town was just one of a number of groups struggling to establish a credible alternative to Post-Impressionism. The *Art News*' welcome to Post-Impressionism in 1910, then, was a guarded welcome to a potential rival.

Those who wrote satirical material about 'Manet and the Post-Impressionists' also held a position towards Post-Impressionism

quite different from that of most art critics. The journals they wrote for were only tangentially concerned with the place of Post-Impressionism in the institution or history of art. They were primarily concerned about cashing in on the interest 'Manet and the Post-Impressionists' aroused. Only two weeks after the show opened it was a means of satirising fashion and the fashionable. *London Opinion* – a magazine which boasted a circulation of 200,000 in 1910 – used it as a yardstick of ugliness in matters close to the hearts of its readers. 'A frock coat', it said, was 'far, far uglier than anything in the Grafton Gallery', and it wondered whether Matisse, Van Gogh and the other Post-Impressionists had perceived its 'splendid ugliness'.[40]

The *Westminster Gazette* used a husband and wife dialogue as its format. The husband showed no interest in visiting the show, but the wife was determined to fit it in with her 'non-militant' women's meeting and plays by Bernard Shaw and Shakespeare.[41] The woman it portrayed was, moreover, of a particular cast, as her attitudes revealed. She was interested in suffrage and in Shaw, who was associated with the portrayal of radical women and with socialist politics. But, the *Westminster* hinted, it was a limited and perhaps fashionable radicalism. The woman attended a group which did not advocate militant feminist action, and the safety of Shakespeare tempered the socialism of Shaw.

*Punch* opened its dialogue with 'visitors discovered, some making irreverant remarks, but the majority trying to understand, if not admire the works which they have been assured by the only people who know represent French art'.[42] *Punch* thus implied that the desire to understand Post-Impressionism sprang as much from social as from personal reasons. It also suggested that the dissenting voices were comparatively few.

In the *Punch* sketch, it was a woman who was trying to understand, and a male art critic who was trying to inform. The *Westminster Gazette* suggested that it was women who took an interest in the show. Both papers, despite their digs at the follies of the *beau monde*, made it quite clear that there was a large female contingent among the followers of Post-Impressionism. *Isis* was more explicit. 'London', it said, 'for once, has allowed herself to be startled. I found her (she was mainly female) gaping and at a loss for words before the Grafton Post-Impressionists'.[43]

Underneath their humour these sketches revealed men's shock,

anxiety and, perhaps, fear that women were entering an institution that had hitherto been almost exclusively masculine. There were, as yet, no female critics, so the *Punch* writer could comfort himself by portraying the man as the guide and explicator, and the woman as unknowing and ductile. The columnist in *Isis* diffused his anxiety by hinting that women were speechless and open-mouthed, almost peasant-like in their ignorance.

We need not take *Isis* and the *Westminster* at face value when they suggested that the majority of visitors to the Grafton Galleries were women. But it is plausible to infer that many more women were there than critics were accustomed to see at exhibitions of modern art. A modicum of social and financial emancipation may have contributed to their presence. But the key to their numbers lay in the way in which Post-Impressionism was presented and in the language and associations of its aesthetic. As we have seen, during the Arts and Crafts Movement large numbers of women took some part in making, showing and selling art work, and were thus brought into the ambit of art as a profession rather than a hobby. Women had also become familiar with the language and the aesthetic of the movement, and thus with handling words and ideas which had previously been controlled and constructed by men. But when MacCarthy and Fry used words like decoration, pattern and design to describe Post-Impressionism and embraced some of the movement's aesthetic tenets, women were put in a position to participate in the reception of the new art in a way that they had never been before. Quite simply, they were in a position to use the language and aesthetic provided to understand Post-Impressionism for themselves. Few, of course, actually became professionals, and none – unless we include Virginia Woolf – promoted Post-Impressionism or any other form of early Modernism in print. But they did buy and commission: Marjorie Strachey bought post-impressionist paintings after Fry's show, and most patrons of all the pre-war applied arts ventures were women.

These new, though limited, roles in the art world were quickly accepted. In 1910, the arrival of large numbers of women in the exhibition halls was viewed with suspicion. Those who wanted to strike a triple blow – misogynist, chauvinist and philistine – suggested that women were socially grasping and prey to passing crazes, so that as soon as Post-Impressionism became socially

acceptable, 'the latest thing from Paris'[44], they would flock to the gallery as if it were a fashion house. But by 1912 and the time of the Second Post-Impressionist Show, such satirical attacks upon women had vanished. In the two years between the shows, the general critical acceptance of Post-Impressionism meant that women were no longer singled out as a special group. Nevertheless, just as women had been so important in sustaining the Arts and Crafts Movement, so they continued to play a significant role in Fry's success.

Pushed around as he was by his editor, his proprietor or his paper's demand for satirical copy, the writer was nonetheless at least an equal partner in the creation of his story. Quite as important as potential pressures from outside were those from within, the opinions and experiences which the author himself brought to bear on what he saw. Those who approved of Post-Impressionism did so in part because it was compatible with views which they already held. Equally, those writers who disliked Post-Impressionism were unable to reconcile it with their existing attitudes and preferences. Post-Impressionism's detractors were not just reacting to Fry's show. They were also actively defending their beliefs.

The ways in which individual beliefs and interests and a more generally held aesthetic combined to make critics hostile to Post-Impressionism are clearly seen in the reactions of a trio of writers who denounced 'Manet and the Post-Impressionists' as 'degenerate' and 'uncivilised'. All of them had a personal stake in combating what they saw as degenerate elements in art and society. But all subscribed to a very widely held view of society as a degenerate organism that might produce a degenerate art. These were C. J. Weld-Blundell, T. B. Hyslop and E. Wake Cook.

Weld-Blundell, the critic of *The Times*, was the least strident of the three. Weld-Blundell called Post-Impressionism an 'abandonment of what Goethe called the "culture-conquests" of the past'.[45] He had particular reason to be disturbed by this construction of Post-Impressionism, for those 'culture-conquests' were of intimate importance to him. The *Art Chronicle* reported that 'there are few galleries in Europe with which Mr Weld-Blundell is not intimate, and besides being an artist, he possesses one of the finest collections of Old Masters and Greek Sculpture in this country'.[46] Weld-Blundell's taste and his purse inclined towards the art which his contemporaries regarded as highpoints in the development of natu-

ralism, and above all in the representation of the human figure. It
is hardly surprising that he should reject an artist like Matisse in
whose work 'appearance to nature'[47] was given short shrift.

The way in which Weld-Blundell couched his opinions of Post-
Impressionism was not simply the result of his aesthetic stance.
When he said that Post-Impressionism was like 'anarchism in poli-
tics . . . the rejection of all that civilisation has done', a personal
crusade lay behind his choice of language.[48] Weld-Blundell
believed that social reform was necessary to halt the increasing
degeneracy of the English race, and that political reform was
necessary to revitalise a degenerate party political system. After a
brief excursus into party politics he retired to his country estates
where he mixed connoisseurship with the promulgation of a social
reform programme which fused temperance and religious reviv-
alism with rural resettlement, rearmament, and the demise of party
politics.[49]

Many shared Weld-Blundell's view that degeneracy in art was
symptomatic of a wider disorder which might divest the public of
their taste and preference for 'healthy' art. The connection between
degeneracy in art and degeneracy in society had been popularised
by the translations of the work of Max Nordau, whose *Degeneration*
had appeared in 1895. 'Degenerates are not always criminals, pros-
titutes, anarchists and pronounced lunatics', said Nordau, 'They
are often authors and artists'.[50]

Degeneracy was diagnosed by proponents of healthy art as a
sickness which produced physically and mentally abnormal
members of society. Health and physical and mental normality were
the obverse of degeneracy. If the degenerate person produced
ugliness, then the healthy person produced beauty as a condition
of his health. Beauty was defined as 'truth to nature' and thus
healthy art was defined as art that was true to nature. Conversely,
degenerate art was that which departed from 'truth to nature' and
was therefore ugly.

Degeneracy, it was argued, could be shown to be the result of
psychological and physiological conditions, and it could, therefore
be tested using scientific method. Similarly, health and 'truth to
nature' could be subjected to empirical observation and vindicated
by the imprimatur of science. Nordau and his sympathisers talked
of 'a really scientific criticism, which would judge a work upon the
psycho-physiological elements from which it sprang'.[51] These men

were part of a much wider attempt to understand the intangible by means of the tangible. Like the Arnoldians who wanted to underpin belief or faith with empirically verifiable 'experience', they wanted to give art the security of scientific truth.

To those critics who accepted some or all of the premises of this theory, 'Manet and the Post-Impressionists' seemed an alarming symptom of degeneracy. The Post-Impressionists' persistent distortion of nature was deemed to be evidence of their abnormality. The critics' correlation between abstraction and insanity was apparently verified by Van Gogh's acknowledged madness, Gauguin's rejection of the civilised world, and Cézanne's reclusive habits. These perceptions were fuelled both by MacCarthy's claims in the catalogue and by Post-Impressionism's supporters in the press. MacCarthy's catalogue had reacted so strongly against the reliance on empiricism, that far from equating truth with natural fact, he equated truth with the perception of the individual, and art with an expression of his individuality. Post-Impressionism as it was described in 1910 was 'anti-scientific' (and Fry's claim that it showed the 'science of expressive design' does not confound the more general equation) and anti-materialist.[52] Its advocates in the press, moreover, confirmed the worst fears of those like Wake Cook and Hyslop. For they singled out just those 'degenerate' elements of the art for the highest praise. As will be seen, Gauguin's espousal of a 'primitive' or 'organic' culture, Van Gogh's rejection of metropolitan civilisation, and the sincerity and seriousness which their advocates read into their technique were all imbued with positive values for those who, like Morris, condemned Impressionism on precisely the ground that it was scientific. Far from being degenerate, the Post-Impressionists seemed to them to announce a resurgence of art which they could embrace with religious fervour.

The two most vehement proponents of 'healthy' art who criticised 'Manet and the Post-Impressionists' were T. B. Hyslop and E. Wake Cook. Both had their own good reasons for attacking Post-Impressionism in its name. As senior physician in Bethlem Royal Hospital, T. B. Hyslop could argue the case from first-hand observation of lunatics. But, as Wake Cook said of him, he was also an 'accomplished artist' himself, an exhibitor at the Royal Academy, a member of the Art Club and the promoter of the 'Art Lovers' League'.[53] His researches into insane art, pursued for over

thirty years, thus had a dual purpose. They defined what was bad
(by what was mad) and encouraged what was good, which would
'endure by reason of its appeal to the greatest number' and 'by
reason of its being true to nature'.[54] His attack upon Post-
Impressionism, published in the *Nineteenth Century*, 'Post-
Illusionism and Art in the Insane', was part of a lifelong attempt
to halt degeneracy and produce both healthy men and healthy art.[55]

If Hyslop looked to medicine for detailed confirmation of art's
degeneracy, E. Wake Cook looked to politics. He had, indeed,
been publicising the connections between art and politics since
1890 and continued to do so for the next thirty-five years. His
*Anarchism in Art*, published in 1904, made persistent parallels
between the degenerate art world which produced aberrant styles
and institutions, and the degenerate body politic which produced
anarchism.[56] In 1924 he claimed that attacks on the Royal Academy
made in 1895 'were mainly in the interests of the New English Art
Club, and the foreign Bolshevicks of the International Society.
This was a mild analogue of the dread International of Karl Marx
which threw its shadow over Europe in the 'sixties'.[57] It was not
simply the effect of the show upon him, then, that led Wake
Cook to describe Cézanne and his fellow exhibitors as 'Insensate
revolutionaries'.[58]

If in his criticism Wake Cook diagnosed the problems of contem-
porary art, in his practice he attempted to provide a cure. Wake
Cook's insistence on 'truth to nature' did not preclude him from
describing himself as a idealist painter. That is, he attempted to
create an ideal beauty, not from the record of isolated facts of
nature, but from their sum. The paintings that resulted consisted,
in the main, of brightly coloured, highly finished oils of Italian
lakes viewed from villa terraces and gardens overhung with brilliant
vegetation. They were constructed so as to draw the eye further
and further into the enchanted region. The Post-Impressionist
practice of keeping the eye near to the surface of the canvas would
have been unlikely to have found favour with him, the more so
because it stressed the painting as material construction rather than
mystic causeway.[59]

Weld-Blundell, Hyslop and Wake Cook, along with several other
critics who subscribed to the theory of degeneracy, were actively
defending their beliefs in the face of what they regarded as an
attack mounted by Fry. It was, in other words, partly the way Post-

Impressionism was presented that caught their attention and stung them into action. By the same token, Post-Impressionism also attracted supporters from the other side of the political divide, people who saw in it not degeneracy, but the possibility of regeneration, or signs that from the decay of society a new world and art might rise.

The socialists Walter Crane, R. B. Cunninghame-Graham, and the Radical Liberal Arthur Clutton-Brock also sought in Post-Impressionism some confirmation of their beliefs. Clutton-Brock, who published a laudatory article on the Post-Impressionists in the *Burlington*, was, besides being a friend of Roger Fry, an authority on William Morris and a writer on the English Romantic poets.[60] His use of Morrisian language to describe Post-Impressionism, and his implicit linking of it to Romanticism was a way of making the movement personally as well as publicly intelligible. The religiosity of Post-Impressionism's early supporters and Fry's presentation of the Post-Impressionists as visionary and spiritual was admirably in keeping with the way in which Clutton-Brock presented and perceived both the English Romantics and the Arts and Crafts Movement.

Cunninghame-Graham, celebrated by Ezra Pound in Canto LXXIV and sculpted by Jacob Epstein, was a very colourful figure, a 'traveller, poet, horseman, scholar, Scottish-nationalist, laird and socialist'.[61] Cunninghame-Graham was closely associated with John Burns and Hyndman's Social Democratic Federation. The SDF was the only thoroughgoing Marxist organisation in Britain and the only socialist grouping that consistently advocated the revolutionary overthrow of capital by labour. Cunninghame-Graham did not offer an overtly political interpretation of Post-Impressionism. His defence of the Post-Impressionists was based on the same grounds as his sympathy for the oppressed, the right to self-expression.

Cunninghame-Graham's friend Walter Crane did not remain with the SDF after the mid-1880s. He followed William Morris into the Socialist League which the latter founded in January 1884 after his split with Hyndman. We have already noted how close Arts and Crafts theory and language – of which Crane was a major proponent – was to the Post-Impressionist aesthetic. The premises and aims of the Post-Impressionist painters, as Fry described them, undoubtedly predisposed Crane towards their work. Despite his theoretical reservations about fine art and despite his dislike of the

'sensation and audacity in paint' at the Grafton Galleries, Crane, applauded the 'decorative effect' achieved by Gauguin, Denis and Flandrin.[62] At the same time he was describing Morris's textile designs as 'decorative poems in terms of form and colour'.[63] Crane's use of the word 'decorative' to commend both Arts and Crafts and Post-Impressionist endeavour provides a good example of way in which Arts and Crafts vocabulary, and its associations, was applied to the new painting. If a major Arts and Crafts figure like Crane saw no difficulty or contradiction in the transference of such language, neither, presumably, would the majority of the Grafton Galleries audience.

Crane, like conservatives who subscribed to the theory of degeneracy, saw art as a reflection of society. He believed that an unjust society was responsible for poor quality art, but he did not believe that good art could remedy society's ills. So, Post-Impressionist paintings seemed to him, far from being revolutionary acts, to reveal 'the art of the portable picture painting' in 'its last stage', which must 'decompose before springing into really healthy life with the growth of new social ideals and a new social order'.[64] Both Crane and Wake Cook responded to Post-Impressionism as a symptom of degeneracy. The difference between them lay in how they interpreted that degeneracy; it could portend the end of civilisation or the beginning of a new moral and social order. Despite his belief that fine art was crumbling with the capitalism that gave rise to it, Crane saw some hope in 'Manet and the Post-Impressionists'. Because he admired the Post-Impressionists' decorative qualities and because he responded to the religiosity which surrounded the movement, Crane perhaps hoped to recruit the Post-Impressionists for the Arts and Crafts' cause. He saw the Post-Impressionists, indeed, as strayed craft workers. The effect they achieved suggested to him 'mistaken material or medium, and that the painters ought to have been weavers, mosaic workers, or pottery painters'.[65] Far from finding echoes of the Arts and Crafts and early socialist movements in the aesthetic and presentation of Post-Impressionism, Crane was so committed a Morrisian that he saw Post-Impressionism as a possible adjunct of the Arts and Crafts Movement.

It is obvious from glancing at these critics' reviews that their response to 'Manet and the Post-Impressionists' was highly politicised. A significant number of those who wrote about the first

Post-Impressionist show had strong social and political convictions which informed their impressions of the exhibition. Others, with less overt political interests than Wake Cook or Walter Crane, still used the language of politics, the way politics was described by journalists, to discuss Post-Impressionism. The metaphors they used ranged from praise for the 'new revolutionists' in the *Athenaeum*,[66] to toleration of the 'amiable anarchists' by the *Westminster Gazette*,[67] to the fear of 'invasion' expressed by Burne-Jones in the *Morning Post*,[68] and the fifth of November 'plot' discovered by Ross in the review in the same paper. These metaphors helped journalists to heat up the atmosphere surrounding 'Manet and the Post-Impressionists' by comparing the show to extreme forms of activity in another sphere familiar to readers. They were also used in keeping with the papers' own politics. When the *Westminster Gazette* dubbed the Post-Impressionists 'amiable anarchists', this reflected the comfortable, almost friendly, superiority which it showed to Post-Impressionism in all its reporting of the show, and which it elsewhere extended to the harmless fringes of left-wing politics.[69] When Ross called 'Manet and the Post-Impressionists' a 'plot', there was, on the other hand, a mirroring of the aggressive volatility of a high Tory paper like the *Post* towards even the most harmless of radicals.[70]

Such epithets did have more than a journalistic function, however. The passion that accompanied them suggests that 'Manet and the Post-Impressionists' did have a political context and was subject to some kind of political interpretation. Certainly the divide between Liberal and Conservative/Unionist papers over the show compels consideration of Post-Impressionism as far more than the appearance of a new formalist preoccupation amongst painters. As we have seen, with the exception of the Liberal *Star*, all the papers which came out against 'Manet and the Post-Impressionists', and which had discernible political attitudes, were Conservative/Unionist supporters. Obviously they had differences of political priority. But they were all behind the Conservative/Unionist Party in the election campaign that was running at the same time as the first Post-Impressionist Show. All the papers which applauded Post-Impressionism, with the Conservative *Pall Mall Gazette* as the solitary exception, were Liberal and progressive in sympathy, and put their weight firmly behind Asquith's ruling Liberal Party.

It makes some sense to see a parallel between the contents and

attitudes of newspapers and the beliefs of their readers. We can tentatively assume that the majority of conservative papers' readers would share their papers' hostility to Post-Impressionism. E. Wake Cook certainly thought that aesthetic and political preference should go together, and that both should concur with readers' beliefs. After the Conservative/Unionist *Pall Mall Gazette* came out in support of 'Manet and the Post-Impressionists', he wrote the paper a furious letter, asking 'why is it that the most conservative papers generally have the most reckless Anarchists for art critics?'[71] Wake Cook's charge of critical anarchism was extreme in view of the moderate welcome given to Post-Impressionism by the *Gazette's* hapless reviewer. But it is likely that other readers shared Wake Cook's disapproval both of the critic and of the paper's editorial policy in allowing his views to be printed.

The relationship between Liberal papers' aesthetic stance and that of their working-class readers is more complicated than the reciprocity between readers, writers and editors of papers catering to the higher social classes. Two Liberal papers with working-class readers did review 'Manet and the Post-Impressionists' and came out in support of the new art, although others, notably the *Morning Leader*, the *Daily Mirror* and the Sundays, *Reynold's Newspaper*, the *People* and the *Sunday News of the World* were silent. The populist *Daily Graphic* and Cadbury's *Daily News* both voiced support for Post-Impressionism. The readers of these papers, unlike those of papers such as the august *Morning Post*, had little stake in changes in aesthetic preference or painterly practice. Once Post-Impressionism became notorious and fashionable, autodidacts or the socially aspiring might turn to journals like *Public Opinion* which summarised arguments from both sides about the new painting. But at the time the show opened the presence of reviews in populist papers probably owed more to editorial convictions than to readers' demands. For the belief still flourished among Liberals and social-ists that the working class should be allowed to take full advantage of the beauties of culture. The belief in culture was a cornerstone in the foundations of such institutions as Toynbee Hall and organis-ations like the Workers' Education Authority and University Exten-sion. The working classes were to be given the full benefits of a liberal education, not merely practical or technical instruction that would help their social amelioration. They were given education for a new world as well as a new job.[72] Liberal or radical editors

might see it as part of their job to help in this endeavour, while readers who were being educated might have been pursuaded to take Post-Impressionism seriously.

At first glance the correlation between support for Post-Impressionism and the Liberal press seems obvious enough: no more than progressive papers endorsing what was regarded as progressive, modern art. At second glance it seems much less obvious. Many radicals would argue, as Crane did, and like critics of the right, that such painting revealed nothing so much as a decadent society. The key to the support of radicals and Liberals for Post-Impressionism lay in the connections between Post-Impressionism, the Arts and Crafts Movement and early socialism. Because of the way the movement was presented, described and interpreted, many of Post-Impressionism's early adherents saw in it evidence of an upsurge of profound emotionalism that would sweep away corrupt practices. It was the harbinger of a new life, and a new spiritual, moral and social order. Post-Impressionism was, in other words, a regenerative force. Conservative and hostile critics also responded to the connections between Post-Impressionism and the Arts and Crafts Movement, though they interpreted them in the opposite way.

Because of these evident correlations between Post-Impressionism and politics, it is easy to assume that the new painting must be seen 'in the light of' contemporary political events, that it referred, pointed to or mirrored political and social changes in Britain before the First World War. George Dangerfield, in *The Strange Death of Liberal England*, made explicit connections between Post-Impressionism and political and constitutional change, and art historians have tended to follow where he led.[73]

Historians agree at least that the political atmosphere in 1910 was highly charged. In November 1910, the month in which 'Manet and the Post-Impressionists' opened, the Liberal leader, Asquith, called the second general election that year. The press and the nation concentrated on three connected issues. First, reform of the House of Lords to ensure that they could no longer veto government legislation. Second, Home Rule for Ireland. Third, tariff reform. Lords Reform and Home Rule were connected because Asquith's majority in the Commons was dependent upon Irish MPs. Asquith had promised Home Rule in return for their support. The Liberals promised Lords reform, the presentation of a

Home Rule Bill, and free trade. The Conservative/Unionist oppo-
sition were against Lords reform, against Home Rule and in favour
of trade barriers. They particularly reproached John Redmond,
leader of the Irish MPs. Redmond had just returned from a trip
to the United States to raise money in support of Home Rule. This
led the opposition to declare that American money was supporting
the attack on the Lords. Preservation of the Lords seemed to
them to be the preservation of national interests from foreign
intervention. The political columns in the press were filled with
this controversy. Less press attention was paid to the strike of
Welsh miners. This long-running dispute was passed over in favour
of political stories until it erupted in violence at Tonypandy in
November.

Art historians have assumed or claimed that these events created
a climate that so disturbed the ruling elites that they saw in Post-
Impressionism one more threat to their supremacy. Alternatively
they have seen Post-Impressionism as some sort of ingredient in
and sign of social unrest and constitutional upheaval.

Historians no longer agree with art historians' views of events in
Britain before the First World War. Neither do they agree among
themselves as to how those events should be interpreted. There
remains controversy over the degree to which the radical left was
swallowed by the Liberal Party after the entry of Labour MPs into
Parliament in 1906,[74] and over the question of whether or not there
was a social and intellectual crisis in Britain in the years before the
war.[75] But there is a prevailing opinion both that socialists did
become more gradualist and materialist after the formation of the
ILP (1893) and the Parliamentary Labour Party (1906), and that
Dangerfield overestimated the dangers of social upheaval and the
degree of crisis in Edwardian Britain. Bloodshed in the cause of
political change was very limited and parliament held on firmly to
its executive authority.

If this new historical interpretation has any plausibility it obviously
ruins the notion of Post-Impressionism as a sign of, or element in,
social turbulence. But it could nevetheless be argued that contem-
poraries thought that they were in the middle of social and political
trauma and that Post-Impressionism was a reflection or component
of what they perceived, a mirror of their own preoccupations. This
position forces us to ask two separate questions. First, did those
who wrote about Post-Impressionism think that the times were

turbulent, and did their contemporaries endorse that view? Second, did critics make any connections between the upheaval they believed was around them and the paintings on the walls of the Grafton Galleries?

Most writers on Post-Impressionism had little to say about the politics of 1910, and the relationships between political 'events' and people's perceptions of them has not been enough studied for us to fill their silence with recent recovery of attitudes.[76] Of course contemporaries realised that Liberal reforms like the 1909 Budget would have far reaching consequences, and while Liberals rejoiced Conservative/Unionists obviously disliked them.[77] But in 1910, Conservative Unionist papers did not appear to regard social reform or social unrest as the precurser of either revolution or the destruction of parliamentary democracy. They were far more interested in the constitutional issues raised by Asquith's proposed reform of the Lords than in the riots in Tonypandy.

There were, moreover, no explicit statements from either side that linked the Post-Impressionist with any perceived social turbulence. Conservatives did not, for instance, make any parallels between the riotous behaviour of Welsh miners and the revolutionary propensities of the Post-Impressionists. Neither did radicals suggest that the Post-Impressionists were actively campaigning for the overthrow of the old order.

It is in vain that we look for specific connections between 'Manet and the Post-Impressionists' and events of 1910. The show's political context was much more vague and nebulous. It lay in the perception that the tenor of Post-Impressionism was similar to the tenor of the early socialist movement. Post-Impressionism's early disciples 'saw' some of the aspirations of early socialism in Post-Impressionism and were prompted and encouraged to do so by the use of Arts and Crafts language to describe the new painting, for the Arts and Crafts Movement was one component of early socialism. For those who approved of 'Manet and the Post-Impressionists', the language Fry and MacCarthy used and the religiosity which surrounded Post-Impressionism conjured up memories of the crusading Left in the 1880s and 1890s. While this echo may have sounded louder in the political climate of 1910, the fervour which greeted Post-Impressionism was more appropriate to the heady days of socialist idealism than to the

gradualist, materialist aims of the Left before the war. 'Manet and the Post-Impressionists' appealed to those who were accustomed to see art in a social context, because the Arts and Crafts Movement had firmly placed it there. But that did not mean that they saw the paintings in the Grafton Galleries as revolutionary acts, or as objects capable of sparking off a revolution. Post-Impressionism did not bring radicals renewed hope of political triumph. That they did, however, see Post-Impressionist paintings as embodiments of certain moral values and attitudes was manifest. The enthusiasm of Post-Impressionism's supporters shows that for many art still operated in an emotional and moral sphere. For these people Post-Impressionism was not simply a matter of excellent technique, Cézanne was not just the man who had solved a painterly conundrum, and the appreciation of art was not just a matter of rarified satisfaction or aesthetic enjoyment. Post-Impressionism was associated by its supporters with aesthetic and social changes, with a new kind of life about which its adherents felt the fervour of zealots. Fry himself, with his talk of Van Gogh as a visionary who had seen God helped to fuel these interpretations. He allowed this religiosity about the new art to run side by side with his formalism.

Those who lined up against 'Manet and the Post-Impressionists' matched its disciples in the extremity of their views. Where those in favour of Post-Impressionism saw regeneration, the dawn of a new aesthetic era, the triumph of an anti-materialist, emotional response to life, hostile critics saw degeneracy, lunacy and gross subjectivism in the face of natural truth and scientific fact. Once again it was the connections between Post-Impressionism, the Arts and Crafts Movement and early socialism that drew the likes of Wake Cook into the fray. Wake Cook and others who diagnosed Post-Impressionism as degenerate, would very likely also have seen it as revolutionary or anarchic, because the theory of degeneracy had explicitly linked physical and mental breakdown to political chaos. Once again, too, the reactions from Post-Impressionism's detractors were more appropriate to the political climate of the late nineteenth century than to that of their own day. 'Manet and the Post-Impressionists', indeed, reminded Wake Cook of the First International, the beginnings of the socialist movement, rather than the Tonypandy riots.[78] Like Wake Cook many of Post-Impressionism's most implacable enemies were men who had lived through

the last years of the old century and who were clearly fearful of anything that carried associations of them.

Conservative critics' reaction to the ethical and moral overtones carried by the Grafton Galleries paintings was, however, inextricably mixed in with their aesthetic response, and their response as professionals in the art world. They attacked the show not simply because it seemed to be evidence of degeneracy, but because they saw that Post-Impressionism as a painterly practice threatened their livelihoods as painters, critics and men with considerable purchase on society's leading institutions. 'Manet and the Post-Impressionists' brought to light the crumbling position of conservative painters and critics within the art world, a position already shaken by the artistic developments of the last quarter of a century, including, as Wake Cook pointed out, the establishment of the New English Art Club.

In this confrontation between those who saw Post-Impressionism as evidence of a new emotionalism and those who demanded that art be linked to scientific and natural fact, Impressionist critics and painters were squeezed out. Post-Impressionism, billed by MacCarthy as a reaction against Impressionism, drew very little public comment from either champions of Impressionism like D. S. MacColl or George Moore, or from Impressionist painters themselves: Clausen, Tonks, Stevens or Brown. Only W. R. Sickert of the established non-academic painters made a public statement about Post-Impressionism. Post-Impressionism was construed by Fry and MacCarthy as an alternative to and not as a development of Impressionism. But the way the debate was conducted – that is, as a struggle between Post-Impressionist standards and academic standards – indicates the marginal position of the Impressionist artists within the British art establishment. It was, in fact, Academic painters and critics who saw themselves as the potential losers if Fry triumphed. If Post-Impressionism were to become established, they would concede not only their aesthetic standards but also an important part of their audience.

Only Jacques Emile Blanche mounted any sort of attack on 'Manet and the Post-Impressionists' in the name of Impressionism. Blanche, painter, critic and associate of Impressionist painters was not so much concerned about English institutional standards as with painterly practice in France itself. Because he was French, because he was Manet's biographer and because, as he said,

'several of the exhibited works have at one time or another been my own property', Blanche claimed a special position in repect to the First Post-Impressionist Show. He disliked the exhibition because it coupled Manet with the younger generation of painters. As Manet's biographer, Blanche wished to keep him unsullied by contact with the 'decadent' Gauguin, the 'amateur' Cézanne, and the 'unfortunate lunatic' Van Gogh.[79]

Blanche also suggested that Fry, in putting forward a lineage of painters from Manet through Cézanne, Van Gogh and Gauguin to Matisse and Picasso, was constructing a version of the history of French painting which had no legitimacy in France. Blanche thereby attempted to destroy critical confidence in the younger painters like Matisse and Picasso by removing them from the back-drop against which Fry had placed them.

For the most part, however, Impressionists mounted no assault on Post-Impressionism. The success of Post-Impressionism meant that Impressionism was swamped before it became firmly estab-lished. The reasons why Post-Impressionism was so much more successful than its forerunner lay in its claim to be a movement and its presentation as a coherent and sweeping break with past practices.[80] It was also surrounded with a religiosity quite absent from even the most widely circulated Impressionist tracts like R. A. M. Stevenson's *Velasquez*.[81] Post-Impressionism was presented and perceived at its first appearance as expressive, anti-materialist and anti-scientific. Form and technique were emphasised but had ethical overtones. Impressionism, on the other hand, was seen by its detractors as a purely scientific exercise, as an interest in tech-nique *per se*, and as a concentration on the superficial appearance of things. The *Daily News* took it as given both that Impressionism was essentialy materialist, and that this materialism was redundant by 1910 when it asked 'in their reaction against the impressionistic doctrine that visual impressions, unemotionalised and divorced from associated thought, provide the only legitimate foundation for a painter, do [the Post-Impressionists] creatively throw back to deeper and more enduring sources?'[82]

Those who reacted against 'Manet and the Post-Impressionists' thought not. They rejected not just the intention and style of the painters, but the whole notion of Post-Impressionism. Post-Impressionism's detractors doubted its claim to be a movement and its claim to greatness, and resented Fry's apparent betrayal

of their interests. The central charge of those opposed to Post-Impressionism was that it either displayed or would result in a loss of critical standards. 'In art', said the *Daily News*,' we have to a large extent lost our standards'.[83] The *Morning Post*, more implicated in their survival, said 'existing standards of beauty are not to be ignored'.[84] Those standards, the *Post* added, were upheld by 'Ruskin and his school'.[85] Phillip Burne-Jones explained why standards were needed. 'Certain standards must be generally acknowledged', he asserted in the *Post*, 'certain rules must be adhered to if the temple is to be safeguarded from the invasion of the savage and the frankly incompetent'.[86]

The cardinal rule of those who opposed Post-Impressionism was the Ruskinian maxim of 'truth to nature'. Their belief in 'truth to nature' led them to attack the Post-Impressionists for insincerity, incompetence and childishness. To call the Post-Impressionists amateurish or incompetent was simply another way of saying they were unable to be true to nature. To call them insincere was to say they were unwilling. The last charge was levelled at Picasso and Matisse in particular, because their drawings showed that they had no need to display amateurishness or incompetence. The accusation of childishness also upheld Ruskin's standard of perfection. For Ruskin, greatness depended on appeal to the most highly developed and sophisticated mental faculties. Childish simplicity could not make such an appeal. Sometimes childishness was seen as a pose and merely another kind of insincerity. It could however, be regarded in a more threatening way. Loss of standards was seen as opening the door not only to childish simplicity, to pre-civilised endeavour, but also to uncivilised endeavour, to primitivism, savagery or barbarism. The Post-Impressionists, charged the *Connoisseur*, with an attempt at irony, 'have discarded the accepted tenets of art as resulting in work too subtle and complicated to arouse the emotions, and have gone back to the simple and primitive forms of expression, those of children and savage races. . . . The walls of the Grafton Galleries are hung with works which are like the crude efforts of children, garishly discordant in colour, formless and destitute of tone.'[87]

A. J. Finberg in the *Star* added madmen to children and savages, although he had more sympathy for all three than most hostile reviewers. 'The aim of the Post-Impressionists like Cézanne, Gauguin, Van Gogh and Henri Matisse', said Finberg in some

bewilderment, 'seems to be to get to something . . . elemental. . . .
They want to represent the sensations of savages, children or
madmen . . . to go back to an ultra primitive directness of vision.'[88]

Finberg did not go so far as to say that the Post-Impressionists
were lunatics. Many others did. The belief that the Post-
Impressionist painters were mad resulted from the critical attempt
to put 'truth to nature' on a scientific footing, and to show it was
the necessary result of health. It led to the other main argument
against 'Manet and the Post-Impressionists' which was that it was
evidence of a widespread degeneracy and that the artists were
either lunatics or other kinds of degenerate. 'Many insane artists',
said Hyslop, 'do not see nature as do the sane'.[89] It followed that
Van Gogh's painting, with its distortion of nature, must be, as Ross
said, 'the visualised ravings of an adult maniac', and Van Gogh
himself 'the typical matoid and degenerate of the modern sociol-
ogist'. Because of this it followed that 'the emotions of these pain-
ters (one of whom was a lunatic)' were 'of no interest except to
the student of pathology and the specialist in abnormality'.[90] The
*Athenaeum*, before its change of heart, used degeneracy as a meta-
phor for Van Gogh's style. 'With Van Gogh', it said, 'the churned
up paint moves . . . spasmodically: beside the well-controlled stroke
of the great masters, this is the twitch of the paralytic'.[91] Wake
Cook managed to bring insincerity and insanity together with his
assertion that the whole show was 'intentionally made to look like
the output of a lunatic asylum'.[92] Occasionally the show was
regarded as not only degenerate but indecent or pornographic.
That is, it displayed a special form of degeneracy.

W. R. Sickert did not subscribe to the theory of degeneracy
which equated abstraction with lunacy. But, despite his position as
the leading non-academic painter, he adhered to academic stan-
dards. Sickert believed that the ability to be true to nature was a
necessary skill for a great artist, even though the artist need not
always employ it. So, while he praised Gauguin and Van Gogh, he
called Cézanne a failure because he was 'utterly incapable of getting
two eyes to tally, or a figure to sit without lurching . . . the great
painters get their objects *d'aplomb*'.[93] This did not mean that Sickert
did not accept distortion. It meant that he did not regard the Post-
Impressionist criterion of self-expression as a sufficient condition
of success. Great painters must be capable of representation in
case they needed to use it.

Most of the objections to Post-Impressionism were an attempt to maintain the critical status quo. Sometimes this was accompanied by an assertion of the social status quo. 'Cézanne', Sir William Richmond declared, 'should have been a butcher, not a brave but a harmless profession'.[94] 'If that is art', added Ross, 'it must be ostracised'.[95] But this ringing declaration revealed its writer's fears. As Ross's language shows, some critics felt that the Post-Impressionists should be given treatment more appropriate to the criminal than the lunatic. The *Connoisseur* said that 'they might be better employed even in stone-breaking for the roads'.[96] Stone breaking was an occupation of convicted criminals. The *Connoisseur* regarded the Post-Impressionists as having broken aesthetic laws, but it wished to exact social retribution. Both the *Connoisseur's* critic and Richmond displayed, moreover, a displaced violence in their choice of alternative profession. The butcher cutting meat or the criminal breaking stone are both inflicting the kind of damage on the objects before them that these critics wished to inflict on the Post-Impressionist paintings. Once again it was Ross who pushed to its conclusion the belief that the Post-Impressionists were criminals. According to those who subscribed to Nordau's tenets, criminality was causally connected to physical and mental degeneracy just as surely as lunacy was. It followed that criminality often went hand in hand with lunacy, and that if the Post-Impressionists were degenerate it was entirely possible that they were criminals as well as lunatics. Thus, said Ross, 'At Broadmoor there are a number of Post-Impressionists detained at His Majesty's pleasure'.[97]

Sometimes this fear of Post-Impressionism was indicative of a more general xenophobia. Post-Impressionists, the *Art Chronicle* said, 'may obtain a short-lived reputation in Paris, but let us hope that the cooler-headed natives of these islands will judge them by the [sic] intrinsic worth'.[98] The populist *Daily Graphic* was also on the side of the natives, maintaining that 'they will think that on the whole they greatly prefer home-made British art'.[99] Occasionally nationalism and the urge to halt degeneracy came together (as they did in another sphere with Robert Baden-Powell). Richmond said that 'the youth of England, being healthy in mind and body, is far too virile to be moved save in resentment at the providers of this unmanly show'.[100] The most extreme fear that writers felt is implicit here. Degeneracy produced instability, which, it was thought, was more likely to be found in women than men. Hence the show was

dubbed 'unmanly'. The *Art Chronicle* felt that the Grafton Galleries contained 'repeated examples of this girlish, hysterical impatience in paint'.[101] Finally, this fear could embody a specifically sexual threat. The painter and stained glass designer Henry Haliday, writing to the *Nation*, said that 'no young painter who has fallen in love with Nature will let himself be seduced from his pure love by such stuff as this'.[102]

Hostile critics were so busy defending their own standards and practices, so intent on making a general case against Post-Impressionism, that they did not pay much attention to individual works or painters. Van Gogh and Matisse, however, whom these critics saw as the most extreme exemplars of tendencies which they deplored, received more comment than most. Van Gogh fascinated Post-Impressionism's detractors as much as its disciples. The facts of his life appeared to corroborate the theory of degeneracy, for, as Konody succinctly observed, he 'died in a lunatic asylum after having mutilated his own body'.[103] His paintings, too, particularly *Cornfield with Rooks* and *Jeune fille au bleuet*, seemed clear evidence of mental and physical collapse. The very subtitle of the latter, 'The Mad Girl in Zola's *Germinal*', was confirmation enough. Here was a degenerate artist depicting a degenerate character from a quintessentially degenerate author. Writers who knew their Nordau might have remembered that Nordau saw Zola as one of the most dangerous examples of the degenerate modern writer.

Although no details of Matisse's life were mentioned by writers on Post-Impressionism, his work fared scarcely better than that of Van Gogh. The *Daily Express* declared, 'words are powerless to describe an epileptic landscape by Henri Matisse'.[104] Phillips called Matisse's *Femme aux yeux verts* an 'insult to the public', while Konody said it was an 'intentionally childish daub'.[105] C. L. Hind played with hostile critics' correlations between Matisse's work and degeneracy by courting charges of degeneracy himself. 'If asked to choose one work from 'Manet and the Post-Impressionists' to keep, I would choose *The Woman with Green Eyes* even at the risk of being confined in a lunatic asylum', he said.[106]

Where hostile critics everywhere saw degeneration, savagery and the desire to shock, Post-Impressionism's supporters saw regeneration, simplicity, spontaneity and the sincere desire to communicate profound emotion. While they paid homage to the form of Post-

Impressionism, it was the movement's religious and emotional associations which stirred their hearts.

First of all, supportive critics vociferously reiterated the artists' sincerity and seriousness. Matisse, said Hind, was 'audacious in his sincerity'.[107] The *Athenaeum*'s reviewer said that the painters were 'themselves obviously moved', while Rutter added that 'no one fully acquainted with the lives of Cézanne, Gauguin and Van Gogh . . . could honestly charge them with insincerity'.[108] Cunninghame-Graham carried the premise to its logical conclusion and to what would become a common Modernist standpoint. He defined true artists as 'those who were trying to express themselves sincerely'.[109]

This reiteration of the artists' sincerity was more than simply an expression of support for the endeavour and a reply to those critics who claimed that the Post-Impressionists were imposters and charlatans. The sincerity of the artist was used by favourable critics to defend the sincerity of his art, and thus a bridge was effected between producer and product. The work, as well as the artist, it was claimed, was sincere, and thus sincerity represented one of the few 'standards' by which the new art could be identified and judged. Given sincerity, a work could be more or less successful according to the quality of emotion which it expressed. Thus Gore said of Cézanne that 'it is the intense sincerity with which he pursues his object that gives his work that wonderful gravity'.[110] Sincerity and the quality of emotion (or the quality of the affection, as Pound put it) were to become touchstones of English Modernist criticism.

Along with sincerity went the spontaneity that Fry discovered in Cézanne and the simplicity, both of line and life, that writers found in all the Post-Impressionists. Gauguin, said Konody, 'went to Tahiti to live the life of a native and to evolve a pictorial style of archaic, primitive simplicity'.[111] The *Daily Graphic* called its readers' attention to the way in which Cézanne and Gauguin 'extract from life and nature a kind of vast simplicity'.[112]

Konody and his colleague at the *Graphic* imbued the notions of simplicity with an overarching morality, and suggested that the Post-Impressionists' response to the world about them was a crucial element in the formation of their style. Their painting was thus regarded as a way of seeing the world. Simplicity of form was seen as a need or demand for simplicity of life. To Arthur Clutton-

Brock, that meant that the Post-Impressionists 'expressed the emotional experience of their time'.[113]

Post-Impressionism's adherents were quite clear what kind of world the painters were rejecting and what kind of world they were encouraging, painting and presenting. Clutton-Brock explained that 'the sincere artist finds himself hating almost as many things as he loves for their emotional associations, and he finds that many things in the mechanical bustle of modern life have no emotional association for him whatsoever'.[114] It was mechanical, modern life that these writers believed the Post-Impressionists wanted to cast away, the civilised, industrialised, conventional, bourgeois world. Just as Post-Impressionism's detractors derided its retreat from civilisation, so its supporters used that retreat as an indication of worth. The Post-Impressionists, said Hind, 'revolted from convention, from culture, from the accepted canons of academicism, and the orthodox way of painting things seen'.[115] Gauguin 'fled from Europe and civilisation',[116] a particular source of satisfaction to the fashionably bohemian, eminently urban *Tramp*. The *Tramp's* critic elaborated upon Gauguin's simple existence for its readers. 'Tired of European pettiness, [Gauguin] would seem to have voyaged to Tahiti, lowered his bucket into the pure wells of Tahitan art, and adopted all the native conventions'.[117]

This rejection of the superficiality and artifice of European life implied an urge towards a new world, and an embrace of life at its most fundamental. The Post-Impressionists, said the *Tramp*, were 'vital'.[118] Matisse's works, said Hind, 'have life. They communicate life',[119] while Gauguin, said Clutton-Brock, painted 'life itself'.[120] This vitalism and this urge to uncover and tap an elemental force was a way of life to which both Arts and Crafts theorists and early supporters of Post-Impressionism aspired. Moreover, for the adherents of Post-Impressionism, these painters were not just the communicators of the vital force, but its explorers, 'pioneers opening new avenues of expression and emotion'.[121] It followed that Post-Impressionism's supporters saw the paintings themselves as both symbols and embodiments of moral values and social aspirations. The very things to which Fry called attention, the paintings' techniques and design, served not only as the sources of aesthetic emotion but also as the confirmation of these values. The decorative qualities of Gauguin, the rough, untutored – or supposedly untutored – assertiveness of Van Gogh's brush stroke, the gauch-

eries of Cézanne's drawing, together with the 'unfinished', unpolished surface of the paintwork of all three artists seemed to those used to a moral reading of technique to be redolent of spontaneity and simplicity of life. They also provided a visible alternative to the kind of highly finished, glossy paintings which were held up as the epitomy of shallowness, luxuriousness and insignificance.

The biographical details which were circulating about Cézanne, Van Gogh and Gauguin provided extra fuel to such interpretations, particularly for those disposed to connect the quality of a life with the quality of its works. Van Gogh's intensity, or madness, proved his sincerity. Cézanne's seclusion in Provence was conclusive evidence of his rejection of the city and his dedication to his art. Gauguin, best of all, had cast away all the hampering burdens of the civilised industrialised world and gone to the South Seas to find a purity of vision. His death, moreover, could be cast in Byronic mould, as that of a fighter for a cause. The lives of all three, then, could be seen as the spurning of the so-called civilised world and as voyages to discover more enduring and fundamental values. These values could be transposed to society at large. A social dimension could be added to the search for moral purification. Along with the individual quest went the rediscovery of a simple, pure, benign and spontaneous society that was infused with the mystery and wonder that modern society had lost.

Post-Impressionism's supporters were drawn towards the paintings and encouraged to interpret them in these sorts of ways because the very language which Fry and MacCarthy used to describe Post-Impressionism had a plethora of moral and social overtones, associations with sincerity, with purity, with simplicity. These in turn were paradigmatic of a vision of society and of the hope for a certain way of life. It was these overtones which prompted the talk of the life-giving qualities of Post-Impressionism which ran so counter to Fry's incipient formalism.

Post-Impressionist painting, like the products of the Arts and Crafts Movement, was described in terms of pattern, decoration and design. These three words could be combined either with one another or with widely current metaphors of description. These were usually musical or mathematical analogies, which already carried suitable overtones of abstraction, purity and simplicity. Fry himself gave credence to the association of these metaphors by suggesting that the Post-Impressionists were trying to discover the

'visual language of the imagination', and that their problems were similar to those of musicians.[122] Occasionally an architectural analogy was used (usually following Cézanne who had used it himself), but it was, perhaps, insufficiently abstract to have a wide application.

The language which supporters of Post-Impressionism used was saturated with Arts and Crafts terminology. Pattern, design and decoration were employed in a multiplicity of combinations. There was, said Fry in the *Nation*, 'a discretion and a harmony of colour, a force and completeness of pattern, about these paintings'.[123] 'Intense aesthetic pleasure', he reiterated in the *Fortnightly*, could be got from a pattern, if it was 'really noble in design'.[124] 'The science of expressive design' was the discovery of Post-Impressionism, he added.[125] MacCarthy said that Cézanne showed how to move from representation to the 'geometrical simplicity which design demands'.[126] Design was used particularly in Cézanne's case. He used it, said Fry, to build up a 'compact unity by his calculated emphasis on a rhythmic balance of directions'.[127] Decoration was used particularly for Van Gogh and Gauguin. Of all the terms, it was the one most readily accepted and was even used by hostile critics to describe Van Gogh and Gauguin. Finberg said, 'the only reason for admiring their work is its claim to be a novel form of decoration'. But 'decoration of what? The mud huts of savages?'[128] The *Athenaeum* thought the opposite. 'Gauguin painted south-sea islanders, and made decorations not unsuitable for our own houses'.[129] The *Observer* praised Gauguin's 'great decorative effectiveness'.[130] Rutter praised Van Gogh's *La Berceuse* 'with its wonderful arabesque background, its carelessness of actuality and forcible co-ordination of essential conventions for decorative effect'.[131] The *Daily News* was also impressed by Van Gogh's work and said that two of his flower paintings 'declare themselves as powerfully consummate decorations with an expressional value'.[132] Post-Impressionism, said Fry, was a 'new conception of art, in which the decorative elements' predominated.[133] Other typical phrases were 'rhythms of line', 'abstract harmonies of line', 'harmonies of colour' and 'synthetic simplification'.

The associations which this vocabulary called up had important repercussions for the significance of Post-Impressionism to many of its early supporters. Through the medium of this highly charged language adherents of Post-Impressionism may have seen the paint-

ings at the Grafton Galleries as the embodiments of particular
moral and social aspirations. There is ample evidence, from detrac-
ters as well as supporters, that Post-Impressionism was seen in this
light, as a cause. It was surrounded with an aura of religiosity, and
like the Arts and Crafts Movement and early socialism, was
described in religious language. Here Fry himself, as we have seen,
led the way. Other critics were quick to follow, ornamenting their
reviews with a variety of religious epithets and metaphors. The *Pall
Mall Gazette* justified Post-Impressionism on the grounds that 'the
bond that links man to his surroundings can only be expressed by
a full confession of personal experience',[134] while the *Athenaeum's*
critic, presumably considering himself an initiate, addressed the
'lay reader'.[135] The *Westminster Gazette* explained that 'Manet and
the Post-Impressionists' 'must be regarded as a very deliberately
missionary effort'.[136] Ricketts, from the other side, noted that the
Post-Impressionist ' "cult" has its headquarters in Paris'.[137]

To those familiar with the Arts and Crafts and early socialist
movements – even to those who subscribed to the rhetoric of the
Arts and Crafts Movement rather than its social prescriptions and
aims – such an ethical and religious interpretation of the work
of Gauguin, Van Gogh and Cézanne had manifold attractions.
Gauguin's work in particular provided an image, even if it was in
the South Seas, of the kind of society which Morris and many
other early socialists dreamed of establishing. Unadulterated by the
machine or the city, simple and organic, it was still potent with
lore, legend and mystery. For Hind, writing this time in *T.P.'s
Magazine*, it was this essential mystery, a pre-rational, pre-cognitive
force, that Post-Impressionism revealed: 'suppose that this elusive,
spiritual, insistent something that we call by the vague term of
religion, rejoins art; suppose that through . . . [the Post-Impression-
ists'] fierce desires for true realities, the veils of sense and stupidity,
for some of us, are torn away, the walls parted, and the essence of
things, the quest for the unseen part which is elemental, be seen
in everyday art in simplicity and beauty, would not that be very
strange and wonderful'.[138] Hind thought that Post-Impressionism
could tap an elemental force within mankind for good. This belief
that at the core of humanity was a force for beauty and for good
was exactly consonant with the optimism of early socialists that
beneath the layers of poverty that capitalism created lay an
inexhaustible well of goodness.

Post-Impressionism's supporters saw the movement as a whole, and Cézanne, Van Gogh and Gauguin in particular, as bearing this kind of grace. But these painters also appealed to the more earthly aspirations of their adherents. Cézanne, Van Gogh and Gauguin catered to the anti-mechanical, anti-urban strand in the ideology of the Arts and Crafts Movement and other forms of early socialism. Unlike their continental successors, most Arts and Crafts theorists looked forward to a reformed society which was essentially rural and in which the machine had a very limited place. In this, of course, they were quintessentially British and middle class. Cézanne's rugged landscapes and compact villages, Van Gogh's waving cornfields, gnarled olive trees and vibrant sunflowers, no less than Gauguin's Breton or Tahitian peasant girls could – and eventually *did* – appeal to the age-old, but endemic, equation of nature with naturalness, to that obsession with the countryside that was rife amongst not just Morrisian socialists but amongst large sections of the British urban middle class.

So, ironically, the language which Fry used to describe the constructive qualities of painting encouraged some of the visitors to 'Manet and the Post-Impressionists' to make such ethical connections. While Fry was emphasising form, many of his readers were seeing form and content. Fry's own equivocation about the way in which Post-Impressionism should be interpreted did nothing to dampen these perceptions. It is arguable that although the more sophisticated of Post-Impressionism's supporters and the majority of the critics had fully absorbed the formalist gloss on the new painting by the time of the Second Post-Impressionist Show, much of the more popular support for the movement was founded on a partly narrative, or 'literary' interpretation.

Some critics of 'Manet and the Post-Impressionists' drew a more direct analogy between craft and the Post-Impressionist painters. Cézanne, said Denis, 'assembles colours and forms without any literary preoccupation. His aim is nearer to that of a Persian carpet weaver than of a Delacroix.' His work, like Chardin's, 'somewhat resembles a mosaic or patchwork like the needlework tapestry called cross-stitch'.[139]

Fry made this comparison concrete. Along with the paintings and drawings in the show, he included pottery by Matisse, Vlaminck, Derain, Girieud and Friesz. He made a degree of abstraction in painting more comprehensible by putting it alongside

work in a medium where abstraction was already accepted. Pottery was particularly useful for the audience, because the efforts of Arts and Crafts writers as well as the productions of painters and sculptors had given it a status bordering on that of a fine art. Thus Fry could justifiably say 'I would instance as a proof of the direction in which the Post-Impressionists are working, the excellencies of their pure design as shown in the pottery at the present exhibition'.[140] Rutter was quick to pick up Fry's lead and wrote that 'Derain and Vlaminck's pottery is better represented than their painting, and should help to convince people of the merit of their purely decorative principles'.[141]

Those who were unwilling to be convinced were only too happy to call attention to the exhibition's theoretical rather than material links with the Arts and Crafts Movement in the hope that Fry's efforts would thereby be nullified. Charles Ricketts tried to undermine 'Manet and the Post-Impressionists' by calling attention to Arts and Crafts' lowly status. 'I take it', he said, 'that Mr Fry considers that what is too silly to be called painting may be good enough for decoration'.[142] Jaques Emile Blanche was more specific. He complained in the *Morning Post*, 'pattern, pattern . . . such is the word Mr Fry goes on uttering. This word brings us back to the time of William Morris, with associations of wall-papers, artistic materials, chintz. I wish Mr Fry would explain clearly what he means by "pattern". The voice gets subdued, one chokes, when the glorious word gets pronounced.' Furthermore, 'Mr Fry . . . makes one sorry that he should thus mix separate branches of art. Mr Fry wishes that we would only look at the Post-Impressionist's picture the way we look at a bed.'[143]

When Fry used the word pattern, he did not want to take people back to the time of William Morris. What he did was to take people to Post-Impressionism via the Arts and Crafts Movement. It was not important that he define or explain his terms. It was perhaps advantageous that he did not. What was important was that the audience at the show felt at home within the very generalised descriptive framework that was offered to them, and that, because they felt they understood it, they were prepared to accept its transposition from one sphere to another. In one sense, then, the language used to describe Post-Impressionism was the culmination of Arts and Crafts writers' laborious attempts to elevate their products by redefining the nature and purpose of art. The products

themselves mostly remained lowly, but the language acceded to a higher sphere.

When the Arts and Crafts language was transferred, so too were large parts of the Arts and Crafts audience. Wealthy patrons or buyers, some of them women, the liberal and radical middle classes, the self-improving and, at a later stage, the followers of fashion were all directed towards Post-Impressionism. One of the consequences of 'Manet and the Post-Impressionists' was that it brought out this new public and market. Fry wrote that 'it is really the return to Byzantine and early Christian art, and I suppose corresponds with the newer tendencies of thought in the rising generation'.[144] In the previous pages we have been able to identify that 'rising generation' – and some who shared their views – with some precision. The emergence of these groups made it evident that Fry was to become an important arbiter of taste, that Post-Impressionism was to become an established force in London's art world, and that there was a significant audience for modern art.

The liberal educationalist M. E. Sadler bought four Gauguins, *L'Esprit veille, La Lutte de Jacob avec L'ange*, a self-portrait and a pastel of a Tahitian girl, along with Cézanne's *La Maison abandonée*, soon after the end of the first Post-Impressionist Show.[145] He went on to build up an impressive collection of early Modernist painting, concentrating particularly on French Post-Impressionist and German Expressionist work. Sadler was typical of Post-Impressionism's early supporters, a zealous reformist with radical connections.

The success of Post-Impressionism, however, was not secured by men like Sadler, but by the upper-middle classes, who saw profit not paradise in Post-Impressionist painting. It was this group that John Galsworthy anatomised so accurately. When Galsworthy came to satirise the habits of the acquisitive, philistine upper-middle classes before the First World War he included the purchase of Post-Impressionist painting amongst their foibles. Soames Forsyte, the hero of *The Forsyte Saga*, bought Post-Impressionists because they were in fashion, even though he did not like them: 'he stood before his Gauguin – sorest point of his collection. He had bought the ugly great thing before the War, because there was such a fuss about those Post-Impressionist chaps.'[146] Soames unwisely sold his Gauguin for the £500 he paid for it, and Galsworthy, writing in the 1920s, has a joke with his readers at Soames' expense.

Even conservative critics recognised the importance of 'Manet and the Post-Impressionists'. 'No doubt, there must be progress, there must be something which can be called "Post-Impressionism" ' said the *Academy*.[147] The *Athenaeum* was more forthright. It said that there was 'a combination of attractions which British art patrons will not long resist. Inevitably the Post-Impressionist pictures will be purchased in considerable numbers.'[148] Post-Impressionism's very first detractors showed the way. Despite their attempt to maintain their own critical standards, critics sometimes capitulated to those outlined in the catalogue by using language they found there to describe the show. The *Connoisseur*, for example, saw the show as a 'negation of art'. But when it expressed doubt about the degree of that negation, it did so in the language which MacCarthy used. 'Several of the landscapes of Seurat and Signac', it said, 'though painted in pure colour which gives them a texture a cross between Berlin wool-work and mosaic, are wonderfully luminous'.[149] Although this comparison was intended to belittle the two painters, it may have had the opposite effect, because the same sort of analogy was used elsewhere as a means of praise.

Fostered by critics like the one from the *Connoisseur*, capitulation to Post-Impressionist descriptive language was remarkably swift. Even Sir William Richmond adopted its metaphors only three months after the show opened. Asked by the *London Magazine* to consider the 'prospects' for 1911, Richmond responded using Post-Impressionist language, and predicted that painting would be informed by Post-Impressionist values. 'Many of our painters', he wrote, 'will devote themselves to a less literal and more idealistic interpretation of Nature. They will strive to express the deeper significance of things rather than produce a make-believe of plastic reality. They will search for a new rhythm of line and colour, for a summary treatment of the really essential features.'[150] Richmond clearly recognised that Post-Impressionism was already a sufficiently powerful force to affect aesthetic standards and artistic practice.

Patrons and the public could solidify a change of taste by buying pictures, reproductions or books, and going to shows. But they were not the only interested groups. The success of the Grafton Galleries show was bound to stimulate production and discussion amongst painters, and in particular amongst painters younger than

Fry. The show made it clear to young painters that they were in a position to capitalise upon the presence of the new public. And it showed finally that controversy was more conducive to success than silence.

But not all of these painters were able to make use of this potential. For the show had effectively placed power in the hands of one coterie. That in turn sparked off the formation of various groupings and tremendous dissension amongst them. The First Post-Impressionist Show was the last time before the First World War when conservative painters and critics engaged in acrimonious self-defence. For the next four years, uproar was to be the prerogative of the avant-garde.

# NOTES

1  These figures are quoted in Collins, *Omega Workshops*, p. 9, and are corroborated by extrapolating from MacCarthy's account of the show. See Desmond MacCarthy, 'The Art Quake of 1910', *Listener*, 1 February 1945, p. 129.
2  Desmond MacCarthy, 'The Art Quake of 1910' p. 129.
3  [Desmond MacCarthy], *Manet and the Post-Impressionists* (London: Ballantyne 1910), pp. 7–12.
4  John Ruskin, *Modern Painters*, with an introduction by Lionel Cust, MA, 5 vols (1843–60: rpt. London: Dent 1906), I, 20.
5  Ruskin, *Modern Painters*, I, 11.
6  [MacCarthy], *Manet and the Post-Impressionists*, pp. 10–11.
7  Roger Fry, 'The Grafton Gallery – 1', *Nation*, 19 November 1910, p. 332.
8  Roger Fry, 'The Post-Impressionists', *Nation*, 3 December 1910, pp. 402, 403.
9  Fry, *ibid*, p. 402.
10  Robert Ross, 'Twilight of the Idols: Post-Impressionism at the Grafton Galleries', *Morning Post*, 7 November 1910, p. 3.
11  Fry, *ibid*, p. 403.
12  Fry, *ibid*, p. 403.
13  See Clive Bell, *Old Friends* (London: Chatto 1956), p. 82.
14  Virginia Woolf, *Roger Fry, a Biography* (London: Hogarth Press 1940), p. 154.
15  Two writers, Ian Dunlop and Charles Harrison have given the show more detailed treatment and have put it into a political context. See Ian Dunlop, *The Shock of the New: Seven Historic Exhibitions of Modern*

*Art* (London: Weidenfeld 1972), and Charles Harrison, *English Art and Modernism 1900–1939* (London: Allen Lane 1981).

16 Walter Stranz, *George Cadbury* (Aylesbury: Shire Publications 1973), p. 43.

17 Ezra Pound, 'Vorticism', *Fortnightly*, 1 September 1914, pp. 461–71.

18 For a discussion of political stance, editorial policies and readership of these journals, and details of their critics' backgrounds and beliefs see S. K. Tillyard, 'Arts and Crafts and the Avant-Garde in London 1910–14: A Study in the Reception of Early English Modernism in the Visual Arts', unpublished Ph.D. thesis, Oxford, 1986.

19 Anon., 'Manet and the Post-Impressionists', *Athenaeum*, 12 November 1910, pp. 498–9; 'Post-Impressionists and Others Reconsidered', *Athenaeum*, 24 December 1910, p. 801; 'E.S.G.', 'Impressionism at its Latest: French Pictures at the Grafton Galleries', *Daily Graphic*, 7 November 1910, p. 14; 'The Newest Art: With the Visitors at the Grafton Gallery', *Daily Graphic*, 9 November 1910, p. 12.

20 J. A. Spender, *Life, Journalism and Politics* (London: Cassell 1927), p. 59.

21 P. G. Konody, 'Shocks in Art: "Post-Impressionists" in London', *Daily Mail*, 7 November 1910, p. 10.

22 P. G. Konody, 'Post-Impressionists at the Grafton Galleries', *Observer*, 13 November 1910, p. 9.

23 Konody, *Observer, ibid.*

24 Tom Clarke, *Northcliffe in History* (London: Hutchinson 1950), p. 93.

25 Sir Claude Phillips, 'Grafton Galleries: The "Post-Impressionists"', *Daily Telegraph*, 11 November 1910, p. 5.

26 Laurence Binyon, 'Chinese Paintings in the British Museum – II', *Burlington*, November 1910, pp. 82–91; R. Meyer-Riefstahl, 'Vincent Van Gogh – I', *Burlington*, November 1910, pp. 91–9; W. G. Thompson, 'Hispano-Moresque Carpets', *Burlington*, November 1910, pp. 100–111.

27 R. Meyer-Riefstahl, 'Van Gogh – II', *Burlington*, December 1910, p. 156.

28 W. G. Thompson, 'Hispano-Moresque Carpets', *Burlington*, November 1910, p. 101.

29 C. Lewis Hind, 'Consolations of an Injured Critic', *Art Journal*, July 1910, p. 193.

30 C. Lewis Hind, 'A New Movement in Art, Reflections and a Discussion', *T.P.'s Magazine*, March 1911, pp. 684–9.

31 C. Lewis Hind, 'Maniacs or Pioneers? Post-Impressionists at the Grafton Galleries', *Daily Chronicle*, 7 November 1910, p. 8.

32 C. Lewis Hind, 'The New Impressionism', *English Review*, December 1910, pp. 180–192.

33 C. Lewis Hind, *Adventures Among Pictures* (London: A & C Black 1904), p. xvi.

34  C. Lewis Hind, *From My Books* (London: Collins 1927), p. 189.
35  Hind, *From My Books*, p. 114.
36  C. Lewis Hind, *The Post-Impressionists* (London: Methuen 1911).
37  Clive Bell, review of C. Lewis Hind, *The Post-Impressionists*, *Athenaeum*, 8 July 1911, p. 51.
38  'F. S. G.', 'Cézanne, Gauguin, Van Gogh, etc. at the Grafton Galleries', *Art News*, 15 December 1910, p. 20.
39  Gore, *ibid*, p. 19.
40  James Douglas, 'The Frock Coat', *London Opinion*, 26 November 1910, p. 324.
41  'E. S.', 'Post-Impressionism', *Westminster Gazette*, 21 November 1910, p. 3.
42  'Post-Impressionist Problems', *Punch*, 23 November 1910, p. 368.
43  Desmond Coke, 'Our London Letter', *Isis*, 19 November 1910, p. 78.
44  Headline in the *Star*, 9 November 1910, p. 2.
45  C. J. Weld-Blundell, review of 'Manet and the Post-Impressionists', *The Times*, 7 November 1910, p. 12.
46  *Art Chronicle*, 19 November 1910, p. 38.
47  [MacCarthy], *Manet and the Post-Impressionists*, p. 11.
48  Weld-Blundell, *The Times*, 7 November 1910, p. 11.
49  C. J. Weld-Blundell, *The Party Spirit and How to Wean It* (privately printed pamphlet, 1912).
50  Max Nordau, *Degeneration*, trans. from the 2nd edition of the German work (London: Heinemann 1895), p. vii.
51  Nordau, *Degeneration*, p. vii.
52  Roger Fry, 'The Grafton Gallery – 1', *Nation*, 19 November 1910, p. 332. This collapse of polarities, like Pound's demands for expression and objectivity, are good indications of the way in which early Modernism was formulated around a series of opposites or dualisms. When the two are brought together in cases such as these, the more 'invisible' side of theory is revealed, and theorists have found a way of reconciling what appear to be mutually exclusive demands. Science here has come to mean exactitude and care and should be seen as a forerunner of Fry's later call for classicism rather than as a concession to the empiricist urges of men like Hyslop and Wake Cook.
53  Wake Cook, *Retrogression in Art*, p. xv.
54  Theo. B. Hyslop, *Mental Handicaps in Art* (London: Balliere, Tindall & Cox 1927), p. 3; and *The Great Abnormals* (London: Phillip Allan 1925).
55  Theo. B. Hyslop, 'Post-Impressionism and Art in the Insane', *Nineteenth Century*, February 1911, pp. 270–281.
56  E. Wake Cook, *Anarchism in Art and Chaos in Criticism*, (London: Cassell 1904), *passim*.
57  E. Wake Cook, *Retrogression in Art* (London: Hutchinson 1924), p. 26.

58  Wake Cook, letter to the *Pall Mall Gazette*, 10 November 1910, p. 7.

59  See the plates to *Retrogression in Art*.

60  See A. Clutton-Brock, *William Morris, his Work and his Influence* (London: Williams & Norgate 1914). For Clutton-Brock, see also Peter Clark, *Liberals and Social Democrats* (London: CUP 1978).

61  *Dictionary of National Biography 1931–40*, p. 354; *The Cantos of Ezra Pound* (London: Faber & Faber 1964), p. 461.

62  Walter Crane, letter to the *Morning Post*, 18 November 1910, p. 10.

63  Walter Crane, *William Morris to Whistler* (London: G. Bell 1911), p. 4.

64  Walter Crane, letter to the *Morning Post*, 18 November 1910, p. 10.

65  Walter Crane, letter to the *Morning Post*, 18 November 1910, p. 10.

66  'The Post-Impressionists and Others Reconsidered', *Athenaeum*, 24 December 1910, p. 801.

67  'E. S.', 'The Post-Impressionists', *Westminster Gazette*, 10 November 1910, p. 3.

68  Phillip Burne-Jones, letter to the *Morning Post*, 18 November 1910, p. 10.

69  'E. S.', 'Post-Impressionism', *Westminster Gazette*, 10 November 1910, p. 3.

70  Robert Ross, 'The Post-Impressionists at the Grafton Galleries: Twilight of the Idols', *Morning Post*, 7 November 1910, p. 3.

71  E. Wake Cook, letter to the *Pall Mall Gazette*, 10 November 1910, p. 7.

72  'Educating the people into socialism' as Morris put it can obviously be seen in a far grimmer light, as a means of social control.

73  George Dangerfield, *The Strange Death of Liberal England* (London: Constable 1936), pp. 63–4.

74  Kenneth Morgan puts the case for the survival of ethical, regenerative socialism in both the ILP and the PLP in 'Edwardian Society', in Donald Read, ed., *Edwardian England* (London: Croom Helm 1982), pp. 93–111. Peter Clarke's essay 'The Edwardians and the Constitution' in the same volume, pp. 40–55, takes the opposite view.

75  See Walter C. Arnstein, 'Edwardian Politics: Turbulent Spring or Indian Summer?', in Alan O'Day, ed., *The Edwardian Age: Conflict and Stability 1900–1914* (London: Macmillan 1979), pp. 60–78.

76  For an oral history of the era, see Paul Thompson, *The Edwardians: The Remaking of British Society* (London: Weidenfeld 1975).

77  See Peter Clarke, *Liberals and Social Democrats* (Cambridge: CUP 1978), p. 116.

78  E. Wake-Cook, *Retrogression in Art* (London: Hutchinson 1924), p. 26.

79  Jacques Emile Blanche, letter to the *Morning Post*, 30 November 1910, p. 5.

80  For the reception of Impressionism see Kate Flint, ed., *The*

*Impressionists in England: The Critical Reception* (London: RKP 1984).

81  R. A. M. Stevenson, *Velasquez* (London: George Bell 1895).

82  'Problems for Visitors at the Grafton Galleries (by our Art Critic)', *Daily News*, 7 November 1910, p. 3.

83  *Ibid*, p. 3.

84  'C', *Morning Post*, 16 November 1910, p. 5.

85  Ross, *Morning Post*, 7 November 1910, p. 3.

86  Phillip Burne-Jones, letter to the *Morning Post*, 18 November 1910, p. 10; and the pages on Burne-Jones and Claude Phillips in the autobiography of Burne-Jones' friend and fellow correspondent to the *Morning Post*, E. F. Benson, *Final Edition*, (London: Longmans 1940), pp. 61–2.

87  'French Post-Impressionism at the Grafton Galleries and Works by Jules Flandrin at the the Stafford Gallery', *Connoisseur*, November 1910, p. 316.

88  A. J. Finberg, 'Art and Artists: The Latest Thing From Paris'. *Star*, 9 November 1910, p. 2.

89  Hyslop, 'Post-Illusionism', *Nineteenth Century*, February 1911, p. 274.

90  Ross, 'Post-Impressionism', *Morning Post*, 7 November 1910, p. 3.

91  'Manet and the Post-Impressionists', *Athenaeum*, 12 November 1910, p. 599.

92  E. Wake Cook, letter to the *Morning Post*, 19 November 1910, p. 4.

93  W. R. Sickert, 'Mesopotamia-Cézanne', *New Age*, 5 March 1914, p. 560.

94  W. B. Richmond, letter to the *Morning Post*, 16 November 1910, p. 5.

95  Robert Ross, 'Post-Impressionism', *Morning Post*, 7 November 1910, p. 3.

96  'French Post-Impressionists at the Grafton Gallery', *Connoisseur*, December 1910, p. 316.

97  Ross, *Morning Post*, 7 November p. 3.

98  J. J. Woods, 'The Post-Impressionists', *Art Chronicle*, 19 November 1910, p. 37.

99  *Daily Graphic*, 7 November 1910, p. 14.

100  Richmond, letter to the *Morning Post*, 16 November 1910, p. 5.

101  *Daily Graphic*, 7 November 1910, p. 14.

102  Henry Haliday, letter to the *Nation*, 24 December 1910, p. 316.

103  Paul Konody, 'Art Notes: Post-Impressionists at the Grafton Galleries', *Observer*, 13 November 1910, p. 9.

104  'Paint Run Mad: Post-Impressionism at the Grafton Galleries', *Daily Express*, 9 November 1910, p. 8.

105  Phillips, *Daily Telegraph* 11 November 1910, p 5, Konody, *Observer*, 13 November 1910, p. 9.

106  Hind, *Daily Chronicle*, 7 November 1910, p. 8.

107  Hind, *ibid*.

108 *Athenaeum*, 12 November 1910, p. 599; Frank Rutter, *Sunday Times*, 13 November 1910, p. 14.
109 R. B. Cunninghame-Graham, letter to the *Morning Post*, 18 November 1910, p. 10.
110 Gore, *Art News*, 15 December 1910, p. 19.
111 Konody, *Observer*, 13 November 1910, p. 9.
112 *Daily Graphic*, 9 November 1910, p. 12.
113 A. Clutton-Brock, *Burlington*, October–March, 1910, p. 217.
114 Clutton-Brock, *ibid*, p. 217.
115 Hind, *Daily Chronicle*, 7 November 1910, p. 8.
116 'A Member of the Public', 'Manet and the Post-Impressionists', *Tramp*, January 1911, p. 361.
117 *Ibid*, p. 36.
118 'Manet and the Post-Impressionists', *Tramp*, January 1911, p. 362.
119 Hind, *Daily Chronicle*, 7 November 1910, p. 8.
120 Clutton-Brock, *Burlington*, October–March, 1910–11, p. 219.
121 Hind, *Daily Chronicle*, 7 November 1910, p. 8.
122 Roger Fry, 'Post-Impressionism', *Fortnightly Review*, January–June 1911, p. 857.
123 Roger Fry, 'The Grafton Gallery – 1', *Nation*, 19 November 1910, p. 332.
124 Fry, 'Post-Impressionism', *Fortnightly*, January–June 1911, p. 862.
125 Fry, *Nation*, 19 November 1910, p. 332.
126 MacCarthy, *Manet and the Post-Impressionists*, p. 10.
127 Roger Fry, introduction to Maurice Denis on Cézanne in the *Burlington*, January 1910, p. 207.
128 Finberg, *Star*, 8 November 1910, p. 2.
129 *Athenaeum*, 12 November 1910, p. 598.
130 Konody, *Observer*, 13 November 1910, p. 9.
131 Rutter, *Sunday Times*, 13 November 1910, p. 14.
132 *Daily News*, 7 November 1910, p. 9.
133 Fry, *Fortnightly*, January–June 1911, p. 862.
134 *Pall Mall Gazette*, 7 November 1910, p. 1.
135 *Athenaeum*, 24 December 1910, p. 801.
136 'E. S.', *Westminster Gazette*, 10 November 1910, p. 3.
137 Charles Ricketts, letter to the *Morning Post*, 9 November 1910, p. 6.
138 Hind, *T. P.'s Magazine*, March 1911, p. 692.
139 Maurice Denis, 'Cézanne', *Burlington Magazine*, January 1910, p. 214; and February 1910, p. 279.
140 Fry, *Fortnightly*, January–June 1911, p. 862.
141 Rutter, *Sunday Times*, 13 November 1910, p. 14.
142 Ricketts, letter to the *Morning Post*, 9 November 1910, p. 6.
143 J. E. Blanche, letter to the *Morning Post*, 30 November 1910, p. 5.
144 Roger Fry, letter to his father, *Letters of Roger Fry*, ed. with introduction by D. Sutton, 2 vols (London: Chatto 1972), p. 339.
145 See Michael Sadleir, *Michael Ernest Sadler (Sir Michael Ernest Sadler, KCSI) 1861–1943. A Memoir by His Son* (London: Constable 1949).

146 John Galsworthy, *To Let*, *The Forsyte Saga*, vol. 3, Chapter Nine.
147 'The "Post-Impressionists" at the Grafton Galleries', *Academy*, 3 December 1910, p. 547.
148 'The Post-Impressionists and Others Reconsidered', *Athenaeum*, 24 December 1910, p. 801.
149 'French Post-Impressionists', *Connoisseur*, December 1910, p. 316.
150 Sir William Richmond, 'What are the Prospects for 1911?', *London Magazine* January 1911, p. 551.

# 4

## SCULPTURE AND THE AVANT-GARDE BEFORE THE FIRST WORLD WAR

A few weeks after the opening of 'Manet and the Post-Impressionists', a young carver, Eric Gill, wrote to the artist William Rothenstein. In his letter he described the show as a 'reaction and transition'. The people who disliked it, he said, were those connected with the things reacted against, while the people in its favour were those who were part of the transition. 'If, on the other hand,' he went on, 'you are like me and John and McEvoy and Epstein, then, feeling yourself beyond the reaction and beyond the transition, you have a right to feel superior to Mr Henri Matisse'.[1]

Gill's comment shows that in 1910 he assessed his work against the background of the changes he discerned in painting, and regarded himself as connected with the figures who were helping to bring those changes about. It serves as an indication of the way in which the status and assessment of sculpture changed in the few years before the First World War. Not only did it become linked with avant-garde painting, but, partly as a result, produced an avant-garde of its own. That meant that sculptors began to make the same sorts of claims for themselves and their products as did avant-garde painters. It also meant that they became part of the controversies which split the avant-garde after the First Post-Impressionist Show.

The three sculptors who were principally associated with these changes were Henri Gaudier-Brzeska (1891–1915), Jacob Epstein (1880–1959) and Eric Gill (1882–1940). Gaudier was a Frenchman who settled in London late in 1910. Epstein was a New Yorker

of Polish Russian extraction who came to London in 1905 after studying in Paris. Eric Gill was English. After attending the Central School in the early years of the century he became a professional stone mason and typographer.

While Gaudier and Epstein described themselves as sculptors, Gill described himself primarily as a carver. But he was described and regarded both by contemporary and later critics as a fine artist. It was through their efforts that Gill came to be seen for a few years as a Modernist sculptor. Indeed, the emergence of an avant-garde in sculpture was due in part to the interest displayed in the medium by practitioners and critics primarily associated with painting, literature and philosophy.

Sculpture became useful to critics and artists in other disciplines because they saw in it the embodiment of the aesthetics they were propounding. This critical attention was important for three reasons. First, it drew sculpture towards the avant-garde in other disciplines. Second, in so doing it helped formulate a language with which sculpture could be identified and discussed. Third, it brought sculpture to the attention of that section of the public to whom avant-garde production in other media appealed.

Now it may be said that, when critics in other media approached the sculptors' work, they were interested in it for piratical purposes and that their discussions or defences of it were thus inevitably distorted. Pound's monograph on Gaudier can be held up as an example of this kind of annexation. It is undoubtedly the case that Pound 'used' Gaudier to assert the solidity and weight of Vorticism as it crumbled from a loose grouping to a completely disaggregated set of individuals during the war. But the writings of Pound, Hulme and Fry remain almost the *only* writings about pre-war Modernist sculpture. So we have nothing, except for a few reviews, (where, as will be seen, sculpture was usually treated as an adjunct of painting) against which to measure this distortion. To add to this, post-war sculptors and some critics read Pound and Hulme as if they were writing about sculpture. In this way Pound's and Hulme's criticism entered the Modernist canon.

One example of the way in which sculpture was used by critics in other disciplines can be seen in Fry's interest in Eric Gill. The association Fry made between painting and sculpture can be seen in his notice of Gill's first exhibition, which opened in the Chenil Gallery in January 1911. The fact that Fry reviewed the show was

in itself a connection between Gill's work and Post-Impressionism, because Fry's show and the controversy it had aroused were still receiving a considerable amount of attention. The readers of the *Nation*, where the notice appeared, were especially likely to make such a connection, for it was in the *Nation* that Fry's immediate defence of Post-Impressionism had been printed. Moreover, the *Nation* had come out strongly in favour of Post-Impressionism, so for Fry to praise Gill in its pages was to bring him to the attention of a potentially sympathetic audience.

It is no surprise, then, to find that Fry appealed to that audience in language which was by this time doubly familiar to them: the language of Arts and Crafts and the language of Post-Impressionism. He laid stress on the formal quality of Gill's work rather than its subject matter, and praised the 'exquisite quality and finish of his surfaces'. Gill's carving, said Fry, showed, 'the immense advantage of the craftsman's training of the Middle Ages over the studio training of our own days'.[2] But although Fry seemed to suggest here the value and importance of craft, he called Gill not a craftsman, but a sculptor. In so doing, he claimed that Gill was a fine artist, whose work was comparable to that of the painters he championed.

Fry was one of several critics who took up the cause of sculpture before the First World War. But, significantly, he did not find a sculptor who both exemplified and acquiesced in Post-Impressionist aesthetics until the early 1920s. The poet Ezra Pound and the philosopher and poet T. E. Hulme were more successful. Pound wrote about both Epstein and Gaudier before the outbreak of war, helped maintain and enhance Gaudier's posthumous reputation and went on to promote Brancusi after Gaudier's death. Hulme was especially interested in Epstein's work, which he regarded both as an exemplification of and a justification for his own vision of the world.

While Hulme championed Epstein according to his own philosophical tenets, Fry described Gill's work in the language of Post-Impressionism. Pound discussed Epstein and Gaudier using the language of Vorticism as he conceived it. Critics recruited sculptors for their factions within the avant-garde. Of the sculptors themselves only Gaudier allied himself publicly with the faction which supported him. When he did so, he picked up and used Hulme's beliefs in his Vorticist writing.

Those who saw or read about early Modernist sculpture did not, however, approach it merely within the terms of reference of, say, Post-Impressionist or Vorticist paintings. They also approached it within the terms of the medium itself. That is, they saw it against the background of the changes sculpture had undergone in the years before Modernism emerged.

These changes had taken place largely as a result of the contact between academic sculptors and sculptors who saw themselves as part of the Arts and Crafts Movement. These last introduced Arts and Crafts practices and terminology into the demesne of sculpture. As a result, the definitions and boundaries of the art became broader. We have already discussed the stances and terminology that early Modernism shared with the Arts and Crafts Movement. When sculptors joined Modernists in other disciplines and adopted, or were described in Modernist language, they necessarily came to share in these ties with the Arts and Crafts Movement. Those critics and members of the public who had accepted the Arts and Crafts terminology and practices adopted by earlier sculptors, would have no difficulty in accepting some of the ways Modernist sculptors described themselves and their endeavours. Many Modernist claims were already familiar to them via the Arts and Crafts Movement. Whereas many opponents of Fry's first show refused to see Post-Impressionist painting as within the acceptable definitions of the art, those who disliked the work of Epstein, or Gaudier never denied it the title of 'sculpture', abhorrent, indecent or incomprehensible though it might have been.

In order to understand the acceptance of Modernist sculpture, then, we need to look at the ways in which the medium was changing in the last quarter of the nineteenth century. It is important to remember, while we do so, that, compared with painting or Arts and Crafts, sculpture was a concern that involved very few people. Those calling themselves professional sculptors could have numbered only a few hundreds. That was a small fraction of the many thousands of professional painters. Unlike painters, moreover, sculptors had no organised institutional frame-work exclusive to their art within which to operate until the formation of the Society of British Sculptors in 1904. Before the Society's foundation sculptors showed their work either under the aegis of the Royal Academy or, after 1884, with the Arts and Crafts Exhibition Society. They frequently exhibited with both. The Grosvenor

Gallery also mounted group exhibitions, but there was no large scale show devoted solely to sculpture.

This lack of gallery exposure was due partly to the kinds of work sculptors produced and partly to the size of the audience. We have seen how, in the case of Arts and Crafts, tremendous amateur interest helped the professional market. The amateur element in sculpture, except where it shaded into Arts and Crafts, was extremely small. The evidence of surviving publications suggests that individuals, as opposed to corporate or public bodies, had a very muted interest in the art.

This comparative indifference is revealed by the scarcity of both periodicals and books about sculpture. Although articles on the subject appeared in fine art and architecture journals, there was only one magazine devoted exclusively to sculpture in the period with which we are dealing. This was the *Sculptor*. In its first number in March 1898, its editors boldly declared, 'our aim is to give effective journalistic representation to the sculptor's art'.[3] Their confidence does not seem to have been matched by a large enough readership to bring their intention about, however, and the *Sculptor* folded after three issues.

Manuals for students, general histories and biographies of major figures were less scarce. Amongst the manuals were *Modelling* (1902–4) by Edward Lanteri (d. 1917), a Frenchman who taught at South Kensington from 1880 until his death,[4] *The Art of Modelling in Clay and Wax* (1892), by T. C. Simmons, head of the Municipal School of Art in Derby,[5] and *Modelling and Sculpture* (1911) by Albert Toft (1862–1949),[6] Lanteri's pupil and fellow Academician. These manuals are useful not only because they show what their authors saw as the most important sculptural techniques, but also because they include authorial asides about the nature of the medium. General survey books included E. H. Short's *A History of Sculpture* (1907),[7] Hans Stegman's *The Sculpture of the West* (1907),[8] Sir William Armstrong's *Art in Great Britain and Ireland* (1909),[9] which allotted sculpture several chapters of its own, E. B. Chancellor's *The Lives of the British Sculptors* 'from the earliest days to Chantrey' (1911),[10] and a picture book *Masterpieces of Sculpture* (1909), by Georg Gronau.[11]

Full scale biographical treatment was reserved for a very few. Among them Michelangelo and Rodin were preeminent.[12] Alfred Stevens was the subject of two monographs. The poet and critic

John Addington Symonds produced a very popular version of Cellini's *Life* in the 1880s[13] and C. R. Ashbee translated his treatise on goldsmithing and sculpture in 1898.[14] All four sculptors helped to underpin the claims made by contemporaries that sculpture should be taken just as seriously as painting. As Ashbee's interest suggests, Cellini and Michelangelo were also important to sculptors who sought historical justification for their own theory and methods. Cellini was used to underpin the demand of those like Alfred Gilbert and his supporters that works in metal should be given the same status as works in marble. Michelangelo was used to justify the practice of carving into stone.

The paucity of literature on sculpture was most marked in the domain of contemporary British endeavour. The only critical monograph published before Modernism aroused widespread interest was Marion Spielmann's *British Sculpture and Sculptors of Today* which appeared in 1901.[15] Spielmann (1858–1948) was a prolific journalist who wrote extensively on literature, painting and sculpture. He was art critic of the *Pall Mall Gazette* between 1883 and 1890, and also contributed to the *Westminster Gazette* and his own *Magazine of Art*. Spielmann's monograph set out to describe and praise the emergence of what was dubbed 'The New Sculpture' in the years after 1875. In it he stated that 'the present general belief, apparently, is that in picturesqueness, restrained and in good taste, lies the future of sculpture'.[16] Spielmann made it clear that he shared this belief when he reiterated it, along with a summary of his monograph, in a talk to the Royal Institute of British Architects seven years later.[17] He was, not surprisingly, opposed to Modernism, and approvingly quoted Hamo Thornycroft, one of the major figures in his 1901 monograph, on the subject. Thornycroft, said Spielmann, had spoken of Modernism as ' "rubbish". He quickly learned to appreciate its real significance and . . . he said simply – "it distresses me a bit to see the pseudo-Egyptian cum-Peruvian Sculpture which now prevails in some quarters". He thought it worth not more protest than that.'[18]

The scarcity of critical literature at the time when Spielmann wrote his *British Sculpture* suggests that sculpture was a subject neither for extensive debate nor for frequent controversy. It was only with the emergence of Modernism and the debate it engendered that a corpus of critical material was formed. Books dealing exclusively with sculpture began to appear as early as 1911. Much

of this literature, like that of the 1920s, was designed to rebut or support Modernist theory and practice.

One reason for the lack of public debate may, paradoxically, have been the very public nature of a large part of the sculptor's output. Large-scale monuments and commemorative statues were seen as serving an important moral end independent of any specifically sculptural or aesthetic merit. Albert Toft, for example, demanded monuments which would 'elevate the intelligence of the people, by keeping green the memory of our noblest heroes who have built up for us the history of this mighty empire'.[19] Writing at the height of the war in 1916, the architect T. P. Bennett gave detailed instructions for the layout of a memorial to a departed monarch. It should include, he said, 'not only a portrait status of the King, but also the outstanding features and developments of his reign – the absorption of colonies, the development of great industries, the value of the arts, or the glory of a successful campaign'.[20] With a few exceptions – the Albert Memorial in particular came under attack by critics of all shades of opinion for its lack of intrinsic merit – the means tended to be passed over in favour of discussion of the end.

Because differences between critics were not marked, there was little need for them to try to discredit one another by asserting the validity of a particular version of the past. So writers tended to be in broad agreement on their construction of the history of sculpture. The version of history produced was in many ways – and as one might expect – the obverse of the history put out by Modernists. The Hellenic period and the first half of the sixteenth century, which early Modernist theorists saw as the twin nadirs of sculptural output, were described by earlier critics as the two zeniths to which sculptors aspired. Scant attention was paid to archaic Greek, Egyptian or Assyrian sculpture. At best they were seen in evolutionary terms as paving the way for later achievements. Stegman said that 'the technical skill of the earliest sculptors still arouses our admiration, and we cannot wonder that eastern art, notwithstanding its limitation and lack of inspiration, exercised a powerful influence over the civilised nations of the West'.[21]

Other critics began their histories by describing the glories of Pheidias and his contemporaries. For it was with them, said Stegman, that 'Greek art reached its highest point of perfection'.[22] The critic and watercolourist D. S. MacColl (1859–1948), who

became Keeper of the Tate Gallery in 1906, suggested that while the nineteenth century had seen the last stages of growth in the art of painting, 'sculpture, in this sense, was complete with the Greeks', who had developed to the full 'its resources for representing form in the round or the conventions of relief'.[23]

Pre-Modernist critics singled out for reverence not only the Greeks but also the high Renaissance. Margaret Thomas, whose manual, *How to Understand Sculpture* (1911) was written largely as a rebuttal to Post-Impressionist theory in painting, saw Donatello and Michelangelo at the apex of sculptural development. 'Since the days of these two artists of supreme achievement', she declared, 'sculpture has made no advance, perhaps because it had attained the highest; rather it has retrograded'.[24] Those writers who wanted to promote contemporary British sculpture had to assert that such an opinion was unfounded. In order to justify their admiration for the New Sculpture they needed to reconcile it with a past that was seen as very different in aspiration.

It was generally held that both the Greeks and the Italians achieved greatness through their depiction of the 'ideal' and through their presentation of abstract ideas by means of idealised forms of the human body. The New Sculpture, on the other hand, was regarded as 'realistic' and 'picturesque' because it tended towards portrayal of individuals in particular situations. But the New Sculpture needed the weight of tradition behind it. So Spielmann brought the new and the old together by maintaining that a salient feature of the New Sculpture was 'the effort towards such realism and picturesqueness of treatment as do not detract from the dignity of the conception'.[25] Toft, who practised a revised classicism himself, claimed that realism was simply the pathway to the ideal, for, he said, 'to become an idealist you must necessarily first be a realist. So taught the Greeks, the Italians. . . . Realism broadens, deepens and expands our vision'.[26]

As Spielmann described it, the New Sculpture encompassed the output of two generations of British sculptors who benefitted from the teachings of Dalou and Lanteri at South Kensington, and Dalou and W. S. Frith at the South London Technical Art School in Lambeth. This sculptural renaissance amounted to no less than the creation of a British School in the eyes of enthusiasts. It was seen as starting with the exhibition of Lord Leighton's *Athlete Struggling with a Python* at the Royal Academy in 1877. William

Goscombe John, one of those trained by Frith at Lambeth, said in 1909 that Leighton 'was perhaps more responsible' for the revival of the previous thirty years 'than anyone else, and his figure of "The Athlete" . . . was really an epoch-making work'.[27]

Many of the men involved in the New Sculpture were not only full or associate Academicians, they were also members of the Art Workers' Guild. Some, at least, saw themselves as primarily bound to the Arts and Crafts Movement, and thus as art workers or craftsmen rather than as fine artists. The *Art Journal* of November 1897 included a piece called 'George Frampton, A. R. A., Art Worker', the title of which encapsulated the very convergence of fine and applied arts that its subject wished for. So the article began, 'George Frampton is an all-round craftsman, and prefers to be known as an art-worker, and not by the more restricted title of sculptor, though it was his originality and skill in that direction which gained him the associateship of the Royal Academy'.[28] It was this very distinction, however, as the *Art Journal* admitted, that Frampton was challenging. The article went on to say that 'he would repudiate classifications such as "fine" art, "decorative" and the like.'[29]

Sculptors who held Arts and Crafts beliefs were dedicated to reuniting the arts, not in order that craft should be elevated to the same status as fine art, but in order that both craft and art would benefit from co-operation. One of the ways in which they could foster that unity was by exhibiting figurative work and art objects simultaneously at the Academy and with the Arts and Crafts Exhibition Society.

The success these sculptors achieved in the transference of methods, materials and objects displayed at the Arts and Crafts Exhibition Society to the sculpture halls of the Royal Academy points to the ways in which the definitions of sculpture and sculptural practice changed in the last two decades of the nineteenth century. Materials such as metals and precious stones became acceptable sculptural media, while objects made from them became acceptable sculpture. Frampton's bust *Lamia*, for instance, exhibited at the Academy in 1900, and widely praised by critics, was made of bronze, ivory and opals. These changes were accompanied by demands, notably from critics, that the personality of the sculptor should be allowed expression, and that he and his product should be accorded status nearer to that held by fine artists.

The status of sculptors was lower than that of painters for two reasons. First, much public sculpture was dependent upon commission. The design and execution of commemorative and decorative sculpture was thus circumscribed by financial constraints and subject to decisions taken by committees. Both subject matter and form could be imposed upon a sculptor. This meant that the element of self-expression, which had come to be seen as such an important part of a work of art, was potentially denied to commemorative sculptors. Bennett went so far as to say that 'in designing decorative schemes or ornament, the sculptor should endeavour to suppress his individuality for the time being – or, rather, express it in terms used by the architect'.[30] This kind of subjugation was also very often the lot of the portrait sculptor. He was likely to be imposed on, not by an architect or a committee, but by a sitter. Bennett's caution to sculptors indicates a second reason for their lowly status. This was that sculpture was thought of as a dependent art – usually dependent on architecture – rather than an art in its own right. As a result, much of its critical language was shared with architecture.

Apologists sought to elevate sculpture in two ways. The first was to create a pedigree for it which linked it to producers whose artistic status was beyond doubt. That meant placing it within an artistic tradition. The method that writers used was the same as that employed by Arts and Crafts theorists. It began with the assertion of the art's antiquity, proceeded to describe its rise and decline, and concluded by linking a present renaissance to the moments and figures of greatest achievement.

Thus the editors of the *Sculptor* said, 'the greater part of the specimens of the art of the past are in the form of sculpture'. 'It is possible', they added, 'that sculpture was the earliest of the arts'.[31] A decade later Thomas simply asserted, 'Sculpture is the oldest of the arts'.[32] Writers also looked back to fifth century Athens and fifteenth- and sixteenth-century Italy to find sculptural perfection and models. They invoked great sculptors from these two eras as justification for present practice. Alfred Gilbert, for instance, saw Donatello as above all an artist concerned, as he was, with self-expression. He said he was impressed with Donatello's works because of 'the absolute independence and freedom of thought and truthful representation of the ideas they possessed . . . they revealed to me what I then understood as "style", but which

I have since learned to regard as the expression of the artist's individuality'.[33]

After the 1880s, when Rodin began to show at the Grosvenor Gallery and the Academy, writers could bring their pedigrees up to date with the example of a pre-eminent contemporary sculptor who never scrupled to impose his own personality on his work. For it was Rodin, explained Holbrook Jackson, in 1911, who 'liberated sculpture from outworn convention. . . . He is the master sculptor of our age, just as Michelangelo was the master sculptor of the Renaissance.'[34]

If the personality and character of the sculptor himself became increasingly important, so too did the distinctive qualities of the medium in which he worked. The second way in which writers asserted the importance of sculpture was to proclaim that it need no longer have a dependent status and critical language. To Arts and Crafts theorists, this implied that the sculptor, architect and craftsman should all co-operate for their mutual benefit, and that the status of all should be raised while the rifts between them closed. This belief presumably informed many of the decorative schemes in which those involved in the New Sculpture took part.

To a critic like Spielmann, however, who concentrated upon studio work which had no immediate architectural setting, the elevation of the sculptor implied something very different. Spielmann asserted that sculpture was an art with its own qualities which were distinct from those of architecture. Writing in the *Graphic*, he said that there was one quality necessary to sculpture besides those it shared with the other arts. It possessed, he said, a 'structural, essential quality that can only be described as "sculptural", not obtainable by the ordinary artist who is not a sculptor'.[35] It was by elaborating upon the methods and materials that were peculiarly 'sculptural', that a rudimentary critical language was forged for sculpture.

Along with the gradual enhancement of the position of the sculptor went changes in the definition of the field within which he worked. Before the last quarter of the nineteenth century, sculpture was defined as work in marble or metal alloy. The great majority of work was in marble, but some monuments were cast, usually with the help of continental founders. The sculptor's art consisted in making a model in clay, or, occasionally, wax, which was placed in the hands of pointers who reproduced it in enlarged

form in marble or in the hands of founders who cast it in metal. This meant that the sculptor had no need to work on the final version of any piece, although many did undertake their own finishing. It also meant that a sculpture was the embodiment of the division of labour – a division, moreover, in which the masons or founders were given no credit for the finished work.

The training at the South London Technical School ran counter to these received definitions and methods. Because it was informed by Arts and Crafts ideals, it stood out not only for the abolition of the division of labour, but also for the abolition of the distinctions between sculptor and mason, artist and craftsman. Moreover, Frith taught there those who were being trained or had been trained as craftsmen. His pupils came from firms like Farmer and Brindley, who produced architectural and monumental carving and provided pointers for sculptors, and from potteries like Doulton and Wedgwood. Other students included engineers and architects' assistants. Many of those who emerged from Lambeth had, in consequence, first hand experience of all the stages of stone carving and casting, and many had considerable skill with other media such as terracotta, ceramics, wood and precious stones. Because of their experience and training, these men held rather different attitudes from sculptors who had been taught exclusively at South Kensington or the Royal Academy. But because of the flow of sculptors from Lambeth to South Kensington, and from both to exhibitions with the Royal Academy and the Arts and Crafts Exhibition Society, the limited definitions of sculpture began to break down, new media were gradually accepted as sculptural and new kinds of objects as sculpture.

One of the consequences of Arts and Crafts theory and practice was to lift certain things – Cobden-Sanderson's bindings, for instance – out of the category of utilitarian objects and into the category of art objects, moving them one step towards the fine arts. A Cobden-Sanderson binding was not bought to be used but to be looked at. Because the Arts and Crafts Movement fought for the demise of the fine arts, such an object would not have been described in fine art terms when it was shown with the Arts and Crafts Exhibition Society. If, however, it had been shown at the Academy, it would have been dubbed 'fine art'. Similarly, when Frampton or Reynolds-Stephens exhibited with the Arts and Crafts Exhibition Society, their works were called art objects. But in

the sculpture hall of the Academy, the same works were called sculpture.

It was not those associated with the Arts and Crafts Movement, then, who suggested that these objects were sculpture or claimed that the men who made them were sculptors. The critics who made these assertions were those who sought to incorporate art objects and art workers within the demesne of fine art. Armstrong, Spielmann and Short all wrote from this standpoint. They each unhesitatingly dubbed Frampton a sculptor. Spielmann went further and recruited Walter Crane for the New Sculpture as one of a group of 'sculptor decorators'.[36] While Crane had impeccable Arts and Crafts credentials, he was never associated with the New Sculpture. It was by means of such co-option that the borders of sculpture as a fine art were expanded.

Gradually, the association between sculpture and Arts and Crafts became accepted. The consquences were threefold. Given the right setting, any art object could become a sculpture. To those outside the Arts and Crafts Movement an art object need have little or no reference to any ideas. So, when an art object became a sculpture, that sculpture need have no external reference. In other words, a sculpture needed to refer only to itself. It was defined as a sculpture rather than any other category of object for two reasons: because the sculptor announced it as such and because the audience accepted it as such. Given this complicity between artist and audience, any kind of object could become a sculpture. This possibility was implicit in the Academy's display of, say, a silver and bone dish by Reynolds-Stephens alongside marble figures in 1897, and in Spielmann's choice of a mace to illustrate Crane's sculptural output.

It is possible that the Academy accepted a piece like Reynolds-Stephens' because it was under pressure from the success of the Arts and Crafts Exhibition Society, and was mindful that the eventual absorption of new developments would ensure its own survival. But whatever the reasons, it is certain that public acceptance was swift. Not one of the major newspapers quibbled with the Academy's decision. While such a small object was easy to overlook in a show of over 2,000 pieces, mostly given over to oil paintings, critics nonetheless retained a nice eye for the anomalous or the unacceptable. None said that the dish should have been housed elsewhere or denied that it was sculptural.[37]

The acceptance of the non-referential object as sculpture had

important repercussions for the reception of Modernism. It meant that a piece like Epstein's *Rock Drill* could be more easily accepted as sculpture and that his transformation of utilitarian objects into an essential part of the sculpture did not force critics or public to make an impossible adjustment to their definitions of the art. *Rock Drill* was in fact accepted as sculptural without a murmur from critics.

The second result of the association between sculpture and Arts and Crafts was that elements of the language which Arts and Crafts writers used to describe art objects could be adopted for sculpture as a whole. The third was that, as new objects were accepted so, necessarily, were new media.

Most of those associated with the New Sculpture were trained craftsmen. Although some of the processes they used were recently revived, the materials they used were simply those already associated with the decorative arts. When Frampton made a screen in the 1890s which incorporated stained leather, lacquered gesso, enamel, silver, mother of pearl, aluminium, ivory and gold, he was using materials and techniques familiar to thousands of amateurs in the Arts and Crafts Movement. The same was true for his terracotta friezes, Reynolds-Stephens' beaten copper and brass work or Gilbert's metal statuettes.

Spielmann said of Gilbert's metal work that 'it is, of course, not sculpture at all, strictly speaking, being neither plastic nor glyptic'. But once he had claimed that 'it belongs at least to the domain of fine art', and once the Academy had concurred by exhibiting the work alongside its bronzes and marbles, then the definition of sculpture would very soon have been stretched to include it.[38] In 1897, for instance, Gilbert exhibited a piece described by the *Sunday Times* as a ewer standing in 'a magnificently designed dish of hammered silver, and . . . surmounted by an equestrian statuette of St. George slaying the dragon, richly encrusted with all sorts of beautiful materials'.[39] The *Art Journal* went a considerable way towards pushing such an object out of the domain of craftsmanship and into the domain of sculpture. It was, it said, 'a worthy example of the art of the sculptor-smith, which Mr. Gilbert above all others is doing so much to advance'.[40]

The Arts and Crafts practices of those whom Spielmann termed 'polyglot' sculptors also had implications for subject matter and technique. Unlike those who dealt exclusively with marble sculp-

ture, Arts and Crafts theorists paid comparatively little attention to Hellenic art, and certainly by no means all regarded the Renaissance as a high point. While those associated with the New Sculpture do not seem to have denounced the Renaissance, their acceptance of at least part of the Arts and Crafts version of history may have led to far less reliance upon Greek models than was common amongst Academic sculptors.

Not only did Arts and Crafts theory devote scant attention to Greece, but for a large number of those trained at Lambeth, Greek culture had limited symbolic appeal. Unlike many sculptors who emanated from South Kensington or the Academy, few came from those social groups which were well versed in classical languages and literature and which were taught to regard Athenian democracy and the ancient empires as prototypes of British government and colonialism. Instead, Lambeth sculptors turned for their subject matter and inspiration to an Arts and Crafts version of the past. Frampton's busts – *Mysteriarch* and *Lamia*, for instance – wore the appurtenances of the Pre-Raphaelite medievalism espoused by many craftsmen and writers within the Arts and Crafts Movement. The subject of *Lamia* is evidence of a fascination for Keatsian Romanticism shared with Burne-Jones, Rossetti and William Morris. Frampton also produced several statuettes of St George, England's patron saint, and, like Reynolds-Stephens, statues based on Tudor models.

Moreover, sculptors trained in the crafts could use the objects which they produced to challenge the Academic supremacy of the human figure. They were trained to regard the work of art not so much as the depiction of the human form but as the production of the well-made thing. That meant that a man like Frampton could say 'I can be just as much an artist in the way I use a leaf as in the way I use the human form'.[41] That in turn meant that they gave the objects they produced just as high a status as the figures.

If sculptors associated with Arts and Crafts did not share the Academy's reverence for Greek statuary, it is possible that they did not share the Academic reverence for marble. Marble was one of many materials used to produce the New Sculpture. These materials were not seen, however, in hierarchical relation to one another, but were approached with an equal respect in the light of the belief in 'truth to materials'. One reason, then, why the New

Sculpture produced so many carvers was that those trained at Lambeth were not only likely to be trained stone cutters, they were also acting according to Arts and Crafts precepts. 'Truth to materials' demanded specificity of medium. Academic methods, by contrast, produced only 'a translation out of another language'.[42]

Carving also represented a gesture against the division of labour entailed in Academic methods. By the 1890s, direct carving had begun to be associated with the idea of superiority. In 1891, when Pomeroy characterised the New Sculpture, he distinguished with undisguised partisanship between those who were merely modellers and thus limited by a lack of knowledge, and the 'body of carver modellers, men who have received a thorough *craftsman's* training'.[43]

When objects were transferred from the domain of Arts and Crafts to the domain of sculpture, ideas about carving and about 'truth to materials' were incorporated within the changing definitions of the art. The language writers used to set out these ideas became accepted in the same way. The virtues of simplicity and purity, the notions of the importance of form and abstraction and the attendant descriptive metaphors, both geometric and musical, all became associated with sculpture.

When Modernist sculptors and their champions came to describe Modernist output, they used a considerable part of this language, and they adopted many of the same stances towards their materials. It is likely, however, that some Modernist beliefs were derived from the vocabulary and tenets of Post-Impressionism and Vorticism, that is indirectly, rather than from the original source. Of the three sculptors involved in the creation of the Modernist avant-garde only Eric Gill had any first-hand connection with the Arts and Crafts Movement. Indeed, his commitment to Arts and Crafts ideology was so strong that in the end it militated against his commitment to Modernism. The Modernist aesthetic was incompatible with Gill's very specific social, political and later, religious, beliefs. Gaudier and Epstein, on the other hand, were both expatriates who saw themselves against the backdrop of Rodin and European sculptors. Their alignment with Arts and Crafts percepts came through their involvement with Modernism in painting. Post-Impressionist writers had adopted Arts and Crafts language and attitudes towards their products, but had divested them of their attendant social prescriptions. Epstein and Gaudier, therefore,

came across only those Arts and Crafts beliefs that were consistent
with the Post-Impressionist aesthetic.

If Gaudier and Epstein were innocent of their ideological
connections, many of their potential audience were not. So when
they or their champions used terminology associated (by 1911) with
both Arts and Crafts and the New Sculpture and Post-
Impressionism the ideas and claims put forward were familiar to
their potential audience through a number of possible channels.

Like Arts and Crafts writers, Modernists demanded a higher
status for the sculptor and his product. Like some of those
connected with the New Sculpture, they asserted sculpture's inde-
pendence. Gaudier went further and suggested that sculptors were
not only superior to architects, but were capable of reversing their
usual relationship. The way he did this was to dismiss the issue by
parodying it. 'Sculpture and architecture', he said, 'are one and
the same art. On many occasions artists like Epstein, Brancusi and
myself could easily build palaces in harmony with their statuary'.[44]

Modernist sculptors also shared the Arts and Crafts pre-
occupation with materials other than marble, the accompanying
dictum of 'truth to materials' and the consequent belief in direct
carving. Gaudier worked in plaster, terracotta, earthenware, wood,
brass and bronze as well as various kinds of stone. Epstein also
used a wide variety of stone, and in his *Rock Drill* mixed materials
by putting plaster and cast iron side by side.

Moreover, the objects which Gaudier produced in some of these
media underwent the same progression as the objects produced by
those connected with the New Sculpture. Like the objects the New
Sculptors exhibited at the Royal Academy, his toys, *Knuckleduster*
and *Doorknocker*, all of 1914, were utilitarian objects divested of
their functions in the transformation from 'articles of use' to art
objects, and thence to sculpture.

The idea of 'truth to materials' was applied impartially to all
media by Arts and Crafts theorists. In Modernist hands it came to
be associated especially with direct carving into stone, metal and,
to a lesser extent, wood. In England before the First World War
this had the effect of defining early Modernist sculpture as the
practice of carving in these media. This represented a contraction
of the boundaries established by apologists for the New Sculpture.
As early as 1912 (and perhaps with a knowledge of Brancusi's
carvings), 'G.R.H', the critic of the *Pall Mall Gazette* who had so

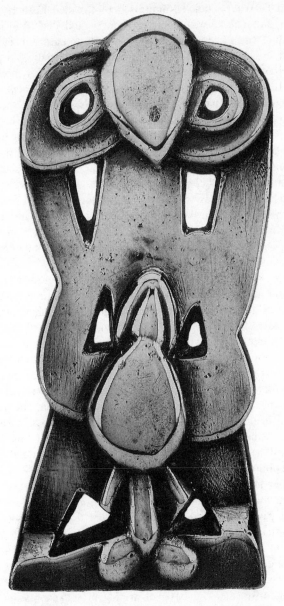

Gaudier-Brzeska, *Doorknocker*, 1914. (Reproduced by permission of Kettle's Yard, University of Cambridge.)

annoyed E. Wake Cook 18 months before, called Epstein 'a real sculptor' because he was 'a carver – not a modeller'. And just as favourable critics had stood out against truth to nature in 1910, so he used the same stand – allied to truth to materials – to justify Epstein's work. 'Imitation of nature', he said, 'whether in bronze or in marble, becomes mere futility and ape-work unless it be illuminated by a plastic idea, not only closely associated with and deriving its beauty from the medium in which it is worked, but suggested by it'. The resulting work would be 'a child of the marble . . . not an enlarged copy by some other hand of a highly finished plaster model'.[45] In 1914 Gaudier set the boundaries of sculpture within similar limits. 'The sculpture I admire', he said, 'is the work of master craftsmen. Every inch of the surface is won at the point of the chisel – every stroke of the hammer is a physical and mental effort. No more arbitrary translation of a design in any material.'[46] At this point we are taken straight back to Spielmann's denigration of 'translations' a decade or so earlier.

One reason why carving was championed was no doubt because casting on any scale was beyond the personal resources of either Gaudier or Epstein before the war. Another was that they saw carving as a means of dissociating themselves from Rodin, and from the impurities of the Impressionism with which Rodin was associated by contemporaries. But as Gaudier's assertion shows, carving was also attractive because it was difficult, and therefore beyond the scope of the dilettante. It could only be successful through the exercise of single-minded determination, energy and will, and it emphasised the importance of technique. 'In carving there is absolute finality about every movement', said Epstein' 'it is impossible to rub out and and begin again. This fight with materials imposes a constant strain.'[47]

Gaudier added to the list of virtues of carving by stressing its particular masculinity, and the rigidity and solidity of the forms to which it gave rise. All these qualities were, by 1914, associated with Vorticism, and were emphasised in part to distinguish Vorticism from the Post-Impressionism of Fry and his circle, which championed neither masculinity nor violence.

Modernist sculptors and their promoters agreed with Arts and Crafts theorists that the basis of art lay in self-expression. For sculptors this inevitably meant that working to commission became a compromised activity. In 1914, a few months before Lewis had

recruited him for Vorticism, Gaudier wrote of the 'modern sculptor' that 'what he feels he does so intensely that his work is nothing more nor less than the abstraction of this intense feeling'.[48] This notion of art as the distillation of emotion has obvious links with the definitions of Post-Impressionism that MacCarthy and Fry had outlined in 1910. By 1914, as will be seen in the next chapter, Post-Impressionism had long broken from the exclusive reliance on self-expression. Gaudier's statement seems therefore somewhat at odds with contemporaneous developments in theory. But a few months later he modified it by substituting the notion of thought for the notion of feeling so as to bring it more into line with the Vorticist position. 'We have made', he announced, 'a combination of all possible shaped masses – concentrating them to express our abstract thoughts of conscious superiority'.[49] Pound restated this position, in terms somewhat closer to those of Bloomsbury, in his 1915 *New Age* series. Speaking there about Epstein he said that, 'it is the artist's job to express what is "true for himself". In such measure as he does this he is a good artist, and, in such measure as he himself exists, he is a great one.'[50]

Modernists also shared with Arts and Crafts thinkers and their painting colleagues the belief that the use of the machine was antithetical to this self-expression. Sculpture, Pound declared, 'is not something suitable for plaster or bronze, transferred to stones by underlings. It regards the nature of the medium, of both the tools and the matter.'[51] This anti-mechanical streak had repercussions for the Modernist version of sculpture's history. It tended to mean that unmechanised societies and cultures were held in high esteem. T. E. Hulme, for instance, despite his advocacy of machine forms for modern art, believed that a slow philosophical decadence had set in as man, with the help of commerce and machinery, began to conquer his environment. Consequently, he found that 'the more serious kind of art that one likes sprang out of organic societies like Indian, Egyptian and Byzantine'.[52] Hulme's justification for this predeliction was what he called the 'religious attitude', which had superseded Fry's classicising urge and went far beyond Arts and Crafts medievalising in that it was anti-humanist. But the urge to justify new experiment by setting up a polarity between the close at hand and the far away, the corrupt and the righteous was still very much in the fore. The prompt to primitivism was still there.

It was, of course, desirable to build up a genealogy for modern sculpture by reference to organic or 'simple' societies and cultures. To Ezra Pound, for example, the Gothic era held a similar status. He reported the story told by Horace Brodsky, one of Gaudier's early London aquaintances, that 'Gaudier's ancestors ... had worked on the Cathedral of Chartres', and that 'Brodsky himself had discovered an almost exact portait of Gaudier, carved on some French cathedral'.[53]

Because of this attitude towards the past, both Modernist and Arts and Crafts writers persistently defined the span of time between the end of the Gothic Age and the late nineteenth century as decadent. Writers on sculpture exempted various figures, but the whole period was usually dismissed as artistically impoverished. In his defence of Epstein's 1912 *Tomb of Oscar Wilde*, Hulme declared it to be 'the business of every honest man at present to clean the world' of the 'sloppy dregs of the Renaissance'.[54] Gaudier revealed a similar desire for cleanliness and purity. He said that the sculptural Vortex 'gave forth SOLID EXCREMENTS in the quattro and cinque cento, LIQUID until the nineteenth century, GASSES whistle until now. THIS is the history of form value in the West until the FALL OF IMPRESSIONISM.'[55]

The bonds between Modernist sculpture, the New Sculpture and the Arts and Crafts Movement, then, helped critics and public to understand the products and claims of avant-garde sculptors before the First World War. But avant-garde sculpture could also be understood with reference to avant-garde painting.

The link between sculpture and the various avant-garde sects had several consequences. Sculpture became linked with the kind of controversy and debate which sustained avant-garde factions. Sculptors adopted some early Modernist stances towards their art and audience. This, in turn, meant that they adopted some of the language in which those stances were publicised. Like painters, moreover, sculptors looked towards Europe – and from Europe to Africa and the far East – for their sculptural models. And finally, some of the changes that underpinned stylistic changes also came from Europe. In the case of sculpture that meant that Hulme could justify Epstein's work using an aesthetic derived largely from a reading of Worringer.

The public association between sculpture and controversy came, in fact, two years before the First Post-Impressionist Show, with

the row about the figures which Epstein produced for the British Medical Association Building in the Strand. The debate was inaugurated and largely conducted by the *Evening Standard*. What is interesting about it is that although Epstein's figures were attacked as immoral, and therefore unsuitable for public display, they were accepted as sculpture. They were not seen, as were the Post-Impressionist paintings two years later, to be an attempt to redefine the premises on which the medium rested.

It was perhaps for lack of a precedent in sculpture that during this row Epstein's work was linked with painting. Epstein's support also came from those associated with painting rather than sculpture. One such was C. J. Holmes, the future author of *Notes on the Post-Impressionist Painters*, then Slade Professor at Oxford.[56] He justified the Strand statues by referring to a dispute about a Royal Academy picture over 60 years previously. 'We are', he said, 'once more face to face with a situation exactly like that of 1850, when Millais exhibited *Christ in the House of His Parents*'. Having established that such disputes could arise in even the most respectable of places, Holmes went on to assure his readers that Epstein was adhering firmly to Academic principles. For, he said, the work's 'main impulse is derived entirely from nature, as its technical treatment is derived from pre-Phaidian Greece'.[57]

Epstein furthered his avant-garde contacts when he stayed in Paris in 1912, and met, amongst others, Picasso, Modigliani and Brancusi. His short-lived alignment with the English avant-garde began when he joined the Fitzroy Street Group in 1913. Between 1912, when he met Pound and Hulme, and 1914 when he showed *Rock Drill*, Epstein showed his work several times with avant-garde groups, and both Pound and Hulme eagerly seized upon it to illustrate their own theories. Unlike Gaudier, however, Epstein did not publicly ally himself with any particular faction.

Gaudier proclaimed himself a Vorticist, was one of the signatories of *Blast*, and wrote a sculpture manifesto for its first number. In this sense, his acceptance of the avant-garde in other disciplines was more emphatic than that of Epstein. The manifesto that resulted from his Vorticist allegiance was significant because it formalised and publicised some of the bonds between painting and sculpture. In so doing, it provided a rudimentary language of form in which avant-garde sculpture could be described and discussed. When Gaudier was dead and his work dispersed, and when Epstein

had dismantled *Rock Drill* and turned away from abstraction, the Frenchman's document appeared to be the only statement of intent and practice to survive the war.

Gaudier's manifesto and his *Vortex Gaudier-Brzeska* (1915) reveal the debt which avant-garde sculptors owed to Post-Impressionism. Like other avant-garde writers, Gaudier stressed form at the expense of content. Like them also, he regarded abstract form as the expression of concentrated emotion. It was, he said, 'the Intensity of existence' that had revealed to man 'a truth of form'.[58] He insisted, too, that the emotion derived from a work of art was derived solely from that form. 'Sculptural feeling is the appreciation of masses in relation',[59] he declared. He proclaimed as well the importance of simplicity. A carving he made in the trenches 'got its effect', he said, 'from a very simple composition of lines and planes'.[60]

Despite delineating this common ground between three-dimensional and two-dimensional endeavour, Gaudier was intent upon publicising the special qualities of sculpture. He began his manifesto by announcing, 'Sculptural energy is the mountain. Sculptural feeling is the appreciation of masses in relation', and 'Sculptural ability is the defining of these masses by planes'.[61] By highlighting the importance of mass and plane Gaudier was maintaining that sculpture was independent. He was thus calling for specificity of medium. That specificity was signalled by the use of language to discuss the formal properties of sculpture which pertained to that medium alone.

This language, employed by all Modernist critics, described sculpture as masses and planes in relation to one another. It announced success as, in Epstein's words, 'simplification of forms, unity of design and co-ordination of masses'.[62] Thus Gaudier claimed that his 1914 *Boy with a Rabbit* was better than animal bronzes of the Chow dynasty because it had 'more monumental concentration – a result of the use of flat and round surfaces. To be appreciated is the relation between the mass of the rabbit and the right arm with that of the rest'.[63]

The Modernist critical language was not, however, a wholly novel way of describing sculpture. Rodin had stated that 'the science of planes is common to all great epochs',[64] while Adolf von Hildebrande had based his attack on Rodin on the premise that the

Frenchman had violated sculptural law by ignoring the importance of planar relationships.[65]

Modernist use of a terminology shared with Rodin reveals that sculptors, unlike painters, did not advocate a wholesale rejection of their immediate past. It is true that Modernist sculptors took up carving in part to distinguish their method from that of the Frenchman. Gaudier also repudiated the importance which Rodin placed on movement when he embraced the Vorticist notions of immobility, concentration and solidity. But he and others continued to use the descriptive categories which Rodin employed. Modernist sculptors did not worry about the precise nature of Rodin's role in changing their art. Indeed, they did not engage in any dispute amongst themselves about the value of past practitioners and theories. This suggests both that, compared with painters, the audience and influence they could win was fairly small, and that, in consequence, they had little need to claim tradition for themselves at the expense of their rivals.

There may have been another reason why the past was so light a burden. Sculptors and their champions perhaps concurred in Hulme's belief that modern sculpture was different from what preceded it, not in degree, but in kind.[66] While sculptors were sustained by Hulme's encouragement and polemics, they could afford to dismiss all sculpture from the Greeks onwards as irrelevant.

Hulme, like Pound, seems to have been attracted by Epstein's work because it appeared to provide an exemplification of his theory of modern art. 'I started', he said, 'with the conviction that the Renaissance attitude is breaking up, and then illustrated it by the change in art'.[67] Both Pound and Hulme saw this change as involving a denial of representation and of content. When content had been banished, form and technique were brought to the fore. One attraction of sculpture, then, was that it was so obviously concerned with form.

The interest that Hulme the philosopher and Pound the literary critic took in sculpture worked to the advantage of all parties. The sculptures gave Hulme a justification for his philosophy and provided Pound with a justification for *vers libre* and Imagism.[68] The sculptors could likewise use the philosophy to justify their sculptures. Thus Gaudier used Hulme as a back-up for his attack on the Greeks in the *Egoist* debate. 'Sculptors of today', he said,

borrowing Hulme's phraseology, 'differ from these later Greeks (i.e. Pheidias etc.) not in tendency but in kind'.[69]

By the time Hulme came to Epstein's defence in late 1913, he had abandoned both the Bergsonian slant of his early work and the promotion of classicism which came as a reaction to it. After his discovery of Worringer, Hulme rejected the Romantic/Classic dichotomy. In its place he proposed a new one, between East and West and between anti-materialist and materialist. This new slant did not change what it was that Hulme valued. He could still admire both Chinese and primitive art. But the reasons for his admiration changed. He now began to see such art, along with the work of his London protegées, not so much as examples of classicism but as embodiments of a particular attitude towards the world.[70]

Hulme's version of Worringer was fundamentally anti-humanist in that it came down on the side of a religious rather than an anthropocentric world. This sort of theism, or pantheism, resulted, he said, in abstraction rather than the sort of conventionalised representation that he had advocated in his 'classicism' period. Here Hulme followed Worringer in the notion that the use of abstract form was dictated by a desire to remove space from three dimensional forms because it was space that separated man from his fellows and his environment. Worringer contrasted this attitude with a humanistic attitude in which man existed in empathy with his fellows and his environment. So, Hulme suggested, 'the re-emergence of geometrical art may be the precursor of a corresponding attitude towards the world, and so, the break up of the Renaissance tradition'.[71] Thus Hulme's theory could be used to justify the use of both primitive models and abstract form. He could also use it to attack the idea of an aesthetic emotion detached from experience of the world, because, for him, art and life were causally connected. The theory, then, was not only a means of explaining Modernist sculpture, it was also a weapon to be used in avant-garde dispute.

The importance of Hulme's philosophy to the emergence and production of Modernist sculpture should not, however, be over-estimated. Although he gave several public lectures and published a series of articles in the *New Age* in 1914, none of his work was collected into book form until 1924. Moreover, although Hulme held a conference on Worringer's ideas in 1914, the German's

own treatise, *Abstraktion und Einfuhlung*, was not translated into English until 1940.[72] Apologists for Modernism may look back at Hulme's philosophising as a lone outcrop of new European thought in the desert of British isolationism. Such it may have been. But partisanship should not blind us to the limits of Hulme's influence. For the few thousand who could or did imbibe and follow the progress of his shifting theories there were many thousands more for whom he must have remained first just another name and then just another casualty.

There is also no evidence that Hulme's theory had practical repercussions on pre-war sculptors, whatever its post-war impact. He certainly did not introduce Epstein to primitive sculpture, and it is unlikely that he played any direct part in the creation of Epstein's abstract work. Epstein reported in his autobiography (although that autobiography provides a very partial account of his development and friendships) that 'in his own subjects of religion and philosophy', Hulme 'was a profound student. But of this side of him I understood little, though I often listened to his argumentative exegesis'.[73]

The part which Hulme played, however, does indicate the importance of critics and of written critical theory in the emergence and acceptance of the avant-garde in sculpture. Hulme, Pound and Gaudier provided a body of literature which justified abstraction and could be drawn upon by later practitioners and theorists.

This critical work was especially significant in view of the fact that it did not correspond very closely to the work which early Modernist sculptors produced. Most of this sculpture was by no means as non-referential as Modernist critics claimed it to be. A work like *Rock Drill*, for instance, was, despite its use of abstract form, a commentary on society, a depiction of mechanised, brutalised humanity.

Epstein, like Gaudier, never fully relinquished representation. Indeed, he eventually came to regard abstraction as an aberration. When he described himself as returning 'to the normal way of working', he called abstraction 'exhausted and impotent'.[74] What is interesting about this statement, made in his 1940 autobiography, is that Epstein persisted in reserving for himself those qualities of energy and vitality which the Vorticists, the avant-garde group most concerned with abstraction before the war, had made their hallmarks. Plainly too, Modernist language proved inadequate to

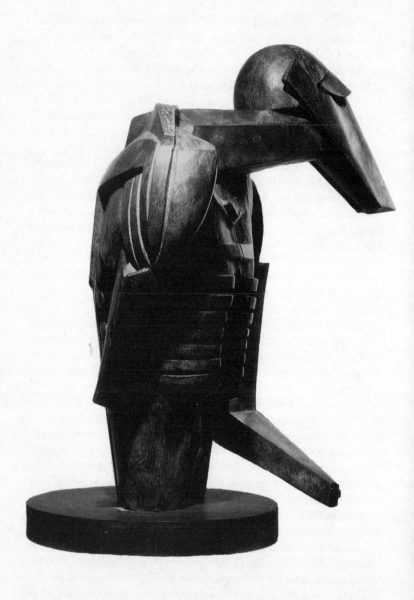

Epstein, torso in metal from *The Rock Drill*, 1913–14. Bronze, 44.5 cm deep, 70.5 cm high, 58.4 cm wide. (Reproduced by permission of the Tate Gallery, London.)

expound upon *Rock Drill*. So, when Epstein came to describe the statue, he abandoned the language of mass and plane, and explained the significance of what was represented. He recalled that he mounted on the actual drill, 'a machine-like robot, visored, menacing, and carrying within itself its progeny, protectively ensconced. Here is the armed, sinister figure of today and tomorrow.'[75] The subject matter of *Rock Drill* was a violent version of the subjects of his earlier marble doves and female figures. The idea of birth formed the subject of the latter. In *Rock Drill* the life-sized figure nursed its own offspring within his torso. The idea of mating and sexuality was the subject of the doves pieces. This was transmuted in the *Rock Drill* into an image of sexual menace.

Indeed, critics hostile to *Rock Drill* seemed to object more to its depiction of sexuality than to its formal adventurousness. The *Evening News* said that although Epstein's sculptures were 'clean', they were 'not necessarily respectable',[76] while the *Globe* charged that the whole of the exhibition in which they were shown was 'tainted perceptibly with indecency'.[77]

The critical reception of *Rock Drill*, shown for the first time in the second London Group show in March 1915, serves, in fact, to underline the ease with which technical experiment in Modernist sculpture was incorporated within the definition of the art. Not one reviewer revolted at the inclusion of a 'found object' in the piece. Those who criticised *Rock Drill* did so on rather different grounds. In the first place, critics took the opportunity to belittle avant-garde experiment in the light of world events. *The Times*, although it was remarkably lenient towards *Rock Drill*, condemned the whole show as 'Prussian in spirit'.[78] Claude Phillips in the *Daily Telegraph* delightedly took the opportunity to adopt a superior stance towards new art. 'Spectators from day to day of the most awe-inspiring events in history, of a world tragedy which overshadows and dwarfs all that had preceded it, these humourists [!] of the brush can yet persist in their elaborate and by this time hardly even comic mystification of a sore-tried public', he said.[79] Other critics condemned the show, and Epstein's part in it, on grounds by now familiar and welcome to its participants. The *Connoisseur* claimed that 'the work of Mr. Jacob Epstein and others of the London Group revealed that the aesthetic tendencies of the most advanced school of modern art are leading us back to the primitive instincts of the savage and of the young child'.[80] Only one censorious writer,

from the *Athenaeum*, commented on the rock drill itself. He said that 'the introduction of a piece of machinery as such ... is, of course, the key-note of the design', conceded that the piece was 'sculpturesque in its way', but concluded with the hope that it represented a temporary phase in Epstein's work.[81]

Favourable critics were more likely to point to Epstein's technical experiment, although even they exhibited confusion as to which 'school' he belonged to. Frank Denver in the *Egoist* called Epstein's art 'Cubist', the *Manchester Guardian* dubbed *Rock Drill* 'Post-Impressionist', the *New Age* described Epstein as a Futurist but saw *Rock Drill* itself as a refutation of Futurism.[82]

Epstein's contribution to the formation of an avant-garde was not confined to experiments with materials and form such as *Rock Drill*. It also included the controversy and hence, in part, the publicity his work produced. After the row over the supposed impropriety of Oscar Wilde's tomb, debate centred around a series of works beginning with the 1920 *Risen Christ*, the 1925 memorial to W. H. Hudson and the figures for the Underground Head-quarters building (1929). Controversy and the avant-garde in painting had been linked for audience and critics alike since 1910. So, it may have been as a result of his ability to excite persistent dissension that Epstein was regarded as an avant-garde sculptor long after he had abandoned abstract form and had recommenced modelling, portraiture and the production of highly referential works on commission.

Epstein quarrelled not only with the public but also with his fellow sculptors. In 1911 Eric Gill wrote excitedly to William Roth-enstein that he and Epstein had 'a great scheme of doing some colossal figures together (as a contribution to the world)'.[83] A few months later they had parted company and by 1940 Epstein spoke of Gill only as a 'scribbler'.[84]

If Gill did not describe himself thus, he did not describe himself as a sculptor in the fine arts sense either. 'I do not believe', he declared in his autobiography, 'in Art or the art world'.[85] He did, however, believe in the arts and in the importance of the arts as an integral part of the life of the community.

Unlike Gaudier or Epstein, Gill did not see himself in any European context. He placed his endeavour against the backdrop of what he regarded as the failure of the Arts and Crafts Movement. His aesthetic and his social stance were derived, if not from Arts

and Crafts practice, then certainly from Arts and Crafts theory. After 1913 Gill added a commitment to Roman Catholicism to the more generalised religiosity of the Arts and Crafts Movement and early socialism. But his attitudes remained close to those of Morris and Lethaby. So, although he claimed that in 1910, 'all without knowing it I was making a little revolution' the roots of his theory and practice went back over thirty years.[86]

Like many of those connected with the Arts and Crafts Movement, Gill began his professional career as an architect's assistant. Soon after he came to London in 1900 he studied masonry at the Westminster Technical Institute and lettering in Edward Johnson's class at the Central School. At the same time he read Ruskin, Morris, Fabian tracts and booklets of the Rationalist Press Association. By 1904 he had become a professed socialist and a professional letter-cutter. In 1910 he carved his first nude figure in stone. Between that time and the war he enjoyed the patronage and support of Bloomsbury and the Rothenstein family. He also exhibited at the Chenil Gallery (1911), in the Second Post-Impressionist Show (1912) and at the Goupil Gallery (1914).

The aesthetic that Gill propounded, however, showed no traces of Post-Impressionist theory. He defined the art of the craftsman (quoting W. R. Lethaby) as 'simply "the well-doing of what needs doing" '. 'Self-expression – and the art of the artist – is quite a secondary affair', he added.[87] Like Lethaby and other Arts and Crafts theorists, he believed that before 1500 'there was no such class of workmen as those we call artists'.[88] Gill equated the downfall of craft with the decline of religious belief. Loss of faith had led to the development of mercantile capitalism, the division of labour, the domination of contractors and the demise of the workshop. To remedy this he proposed, first, a socialism founded upon the dignity of labour and, subsequently, a spiritual revival.

Gill's attitude towards his product reflected this shift in opinion. His belief in the importance of the arts for moral and social amelioration was incorporated, after 1913, within the framework of Catholicism. Gill came to believe that, within a spiritually revitalised community, the Arts and Crafts belief in art as the expression of joy in labour would be combined with his own belief that art was also 'that which unites man with God'.[89] Then, he said, 'a lamp, a book, a carriage – all will be seized on to be the means whereby

man may express his joy in life, all will be mirrors reflecting the godhead in man'.[90]

Moreover, because Gill held a moral attitude towards technique, the process of carving itself became imbued with a degree of religious feeling which went far beyond the more generalised religiosity of his Arts and Crafts predecessors and Modernist contemporaries. He described the discovery of the form within the stone as a revelatory experience. Alongside this ran an unswerving commitment to 'truth to materials'. In 1917, Gill addressed the 'ordinary workman who, like myself, has in hand the job of carving stone', in the *Highway*, the journal of the Workers' Educational Association.[91] There he defined sculpture as 'that craft and art by which things are cut out of a solid material, whether in relief or in the round'.[92] He intimated that the best sculpture was achieved through co-operation between artist and material. The most successful works, he said, 'owed their quality . . . to the material of which they are made', and to the fact that 'the material inspires the artist and is freely accepted by him'.[93] Gill decried not just modelling, but all other intermediate processes. For, he said, 'stonecarving is *conceiving* things in stone, and conceiving them as made by *carving*. They are not only born but conceived in stone; they are made of stone in their inmost being as well as their outermost existence.'[94]

This attitude towards material and his insistence on the importance of technique provided a bond between Fry and the young carver. Gill's emphasis upon the surface of the stone, as well as his highly conventionalised representation of the figure were also in accordance with the Bloomsbury concern for form rather than content. In 1906 Fry had spoken of his 'pure, unqualified pleasure' in Gill's 'perfectly designed and exquisitely executed inscriptions',[95] while in 1911 he praised Gill's 'impassioned expression', and called the sculptor's works, 'the external realisations of ideas grasped with intense emotional fervour'.[96]

Gill himself, however, became increasingly concerned with content rather than form or execution. As his belief that art should be a vehicle for religious expression grew, so did his dislike of Modernism. For him, a genuinely religious attitude implied the moral and often the didactic stance that he believed Modernism to lack. The twentieth century, wrote Gill in 1943, had produced 'purely useless, non-didactic, non-anecdotal, non-representational painting'.[97] He contrasted his own century with the time when 'to

carve a statue of a king was to carve a statue of that king, and not make a sample of sculpture, an essay in "the relations of masses" '.[98] Finally, Gill attacked one of Modernism's fundamental tenets. 'The business of holding a mirror up to nature now means holding a mirror up to the nature of the artist', he said disapprovingly. 'It means nature subjectively felt and not nature definitely seen or imagined.'[99]

As Gill strengthened his belief in the need for Christian art, and as he began to accept commissions to produce it, his bonds with Bloomsbury inevitably became weaker, and the association less attractive to both parties. 'I was just as much in love with beauty as my high-art friends, but I was more in love than they were in what seemed to be that beauty's Author', he wrote in his autobiography.[100] This love was embodied in the many religious works he produced from 1914 onwards, beginning with the *Stations of the Cross* for the new Roman Catholic Cathedral in Westminster. Gill refused to join those he called 'prostitutes, flunkies, hirelings' and 'flatterers'.[101] Despite his dissociation from the world of what he called 'high-art', Gill was persistently regarded by critics and audience as a fine artist. Just as Crane was co-opted by Spielmann from the Arts and Crafts Movement for the New Sculpture, so Gill was co-opted by later critics for Modernism.

The story of Gill's absorption by, and then rejection of, early Modernism, highlights the years before the First World War as a period in which choices about the direction of Modernism were still being made and options were still open. In 1912 the boundaries of Modernism were still open enough to include Gill. He shared, that is, enough beliefs and practices with the formulators of theory. By 1915, developments in both the theory and the practice of painting and sculpture had pulled the parameters of Modernism in directions with which Gill's beliefs were incompatible. His own religious beliefs served to compound and complete the parting.

The gradual separation between Gill and the Modernist avant-garde left Bloomsbury without any English sculptor to promote.[102] This may be one reason why sculpture remained for so long a small and relatively unfashionable field. We have already seen not only how few practitioners there were, but also how little had been written on the subject of sculpture.

After the First Post-Impressionist Show, this situation altered, but it was not until several years later that writers elaborated and

restated the Modernist case, and thus built up a corpus of justifi-
catory literature. Ezra Pound's 1916 memoir of Gaudier-Brzeska
was the first monograph devoted – at least ostensibly – to Modernist
sculpture. The memoir was important for two reasons. First, Pound
took the opportunity offered by such a monograph to emphasise
Gaudier's Vorticist allegiances and attitudes at the expense of both
his wider connections amongst artists in the capital and of a large
part of his output. The partial account of Gaudier's achievements
which resulted stressed the formal elements of his work rather
that its often highly representational subject matter. The sculptor,
moreover, emerged from Pound's book a legendary figure.
Gaudier's importance lay partly in the example this myth provided.
He became the avant-garde artist *par excellence*, an isolated, misun-
derstood and passionately honest genius. Subsequent literature in
the same vein has assured him an important place in the history
of Modernism in England.

The second reason for the memoir's importance was that Pound
reprinted there Gaudier's 1914 manifesto, which served as an
ideological guidebook for young sculptors of the 1920s. So Henry
Moore, who bought Pound's book, spoke about his own work in
language which had been formulated many years previously. The
'awareness of world sculpture', he said, had helped the modern
sculptor 'to realise again the intrinsic emotional significance of
seeing mainly a representation value, and freed him to recognise
again the importance of the material in which he works, to think
and create in his material by carving direct, understanding and
being in sympathy with material'.[103]

The same echoes of early Modernist stances and the same
concern with the issues that confronted pre-war sculptors can be
seen in the writings of the post-war critics Stanley Casson and R.
H. Wilenski. Both these critics popularised Modernist sculpture
and provided critical ratification for the language in which it was
discussed.[104]

Such strengthening of the Modernist position, however, did not
go entirely unchallenged. In 1921, Kineton Parkes reasserted the
preeminence of Greek sculpture against the prevailing Modernist
use of primitive and archaic formal models, and praised Epstein
for dissociating himself from those who 'endeavoured to thrust
upon him a burden of stupidity that no artist could be expected to
carry'.[105]

Before the war Sir Charles Waldstein and Margaret Thomas also attempted to reinstate the Greeks. Like avant-garde sculptors themselves, Thomas regarded Modernist painting and sculpture as intimately connected, part of one avant-garde and open to a single interpretation. So, in her handbook *How to Understand Sculpture*, she attacked Modernist sculptors by using the same points of reference as those critics who attacked the first Post-Impressionist Show. 'Nature is the Alpha and the Omega of the student of art', she said, 'like a kind mother, she gives of her best to those who humbly, simply, and constantly love and study her'.[106] It was with these students 'quietly at work in their studios', she maintained, that the future of art rested. For they were doing art far better service 'than those iconoclasts . . . who cut a head and a few limbs roughly out of a block of marble and hurl defiance at the Greeks'.[107]

But in 1911, when Thomas's book appeared, the 'iconoclasts' with Fry at their head, were in such a powerful position that this sort of criticism was of little account. Fry, indeed, was occupied elsewhere. Far from temporising in the face of hostility, he was planning a second Post-Impressionist exhibition which would consolidate his position as leader of the avant-garde.

# NOTES

1 Eric Gill to William Rothenstein, 5 December 1910, in Walter Shewring, ed., *The Letters of Eric Gill* (London: Jonathan Cape 1947), p. 35.
2 Roger Fry, 'An English Sculptor', *Nation*, 28 January 1911, p. 719.
3 *Sculptor*, vol. 1, March 1898, p. 1.
4 Edward Lanteri, *Modelling* (London: Chapman Hall 1902–4).
5 T. C. Simmons, *The Art of Modelling in Clay and Wax* (London: George Allen [1893]).
6 Albert Toft, *Modelling and Sculpture* (London: Seeley & Co. 1911).
7 E. H. Short, *A History of Sculpture* (London: Heinemann 1907).
8 Hans Stegman, *The Sculpture of the West* (London: Dent 1907).
9 Sir William Armstrong, *Art in Great Britain and Ireland* (London: Heinemann 1909).
10 E. B. Chancellor, *The Lives of the British Sculptors* (London: Chapman Hall 1911).
11 George Gronau, *Masterpieces of Sculpture* (London: Gowans and Gray 1909).

12  Numerous monographs on Rodin appeared in both French and
    English between 1900 and 1914. For Rodin's own writing see A.
    Rodin, *Art*, trans. Mrs Romilly Feddon from the French of Paul
    Gsell (London: Hodder 1912).
13  *The Life of Benvenuto Cellini, newly translated into English by John
    Addington Symonds*, 2 vols (London: J. C. Nimmo 1888).
14  C. R. Ashbee, *The Treatises of Benvenuto Cellini on Goldsmithing and
    Sculpture (made into English from the Italian of the Marcian Codex by
    C. R. Ashbee)* (London: Essex House Press 1898).
15  M. H. Spielmann, *British Sculpture and Sculptors of Today* (London:
    Cassell 1901).
16  Spielmann, *British Sculpture*, p. 3.
17  M. H. Spielmann, 'British Sculpture of Today', in *Journal of the
    RIBA*, 3rd series, vol. xvi, 3 April 1909, pp. 374–394.
18  M. H. Spielmann, 'British Sculpture of Today', in *Journal of the
    RIBA*, 3rd series, vol. xvi, 3 April 1909, pp. 374–394.
18  M. H. Spielmann, *Works by the late Sir Hamo Thornycroft RA*
    (London: Fine Art Society 1926), p. 4.
19  Toft, *Modelling*, p. 22.
20  T. P. Bennett, ARIBA, *The Relation of Sculpture to Architecture*
    (Cambridge: CUP 1916), p. 177.
21  Stegman, *Sculpture of the West*, p. 1.
22  Stegman, *Sculpture of the West*, p. 10.
23  D. S. MacColl, *Nineteenth Century Art* (Glasgow: J Maclehose 1902),
    p. 1.
24  Margaret Thomas, *How to Understand Sculpture* (London: G. Bell
    1911), p. 11.
25  Spielmann, *British Sculpture*, p. 2.
26  Toft, *Modelling*, p. 23.
27  Reply to Spielmann's lecture, *Journal of the RIBA*, 3 April 1909,
    p. 395. In *British Sculpture and Sculptors of Today*, Spielmann
    concentrated upon studio work in various media and sizes, and on
    commemorative statuary. The New Sculpture has recently been
    described as a coherent movement of far greater variety. Susan
    Beattie has charted the achievements of the New Sculpture
    between the early 1880s and the end of the century in the fields of
    architectural decoration and small-scale reproductions as well as in
    the fields on which Spielmann concentrated. She suggests that the
    transformation of architectural carving and modelling 'from
    anonymous, scarcely noticed craft, to dynamic seductive art was the
    greatest collective achievement of the New Sculpture'. She regards
    the production of bronzes cast from small-sized reproductions of
    large works as a successful challenge to elitist Academic practices.
    They reflected, she believes, the Arts and Crafts desire to bring art
    into the home and the sphere of everyday life. In the domain of ideal
    sculpture, she discerns the formulation of a new sculptural language.
    Gilbert and his contemporaries, she says, attempted to redefine ideal
    sculpture by establishing links with the European Symbolist

Movement. According to Beattie the Symbolist work which the British sculptors created sprang from the desire to concentrate not on outward form alone, but upon outward form as the 'expression of an inner reality: the world of thought, emotion and imagination'.

28 Fred Miller, 'George Frampton, A.R.A., Art Worker', *Art Journal*, November, 1897, p. 321.
29 *Ibid*, p. 323.
30 Bennett, *Sculpture and Architecture*, p. 33.
31 *Sculptor*, no. 1, pp. 2–3.
32 Thomas, *How to Understand Sculpture*, p. 7.
33 Alfred Gilbert, quoted in Beattie, *The New Sculpture*, p. 73.
34 Holbrook, Jackson, 'An Impressionist of Sculpture', *T.P.'s Magazine*, March 1911, p. 755.
35 Spielmann in the *Graphic*, quoted in the *Sculptor*, vol. 1, no. 3, April 1898, p. 24.
36 Spielmann, *British Sculpture*, pp. 156–7.
37 Newspapers looked at were, the *Westminster Gazette*, the *Daily Graphic*, the *Morning Post*, the *Saturday Review*, the *Pall Mall Gazette*, the *Daily News*, the *Daily Telegraph*, *The Times*, the *Art Journal*, the *Sunday Times*, the *Illustrated London News*, the *Star*.
38 Spielmann, *British Sculpture*, p. 2.
39 H. A. K., 'The Royal Academy', *Sunday Times*, 2 May 1897, p. 2.
40 A. C. R. Carter, 'The Royal Academy, 1897', *Art Journal*, May 1897, p. 84.
41 Miller, 'George Frampton', *Art Journal*, November 1897, p. 323.
42 Spielmann, *British Sculpture*, p. 6.
43 Pomeroy, quoted in Beattie, *The New Sculpture*, p. 61.
44 Gaudier, in his review of the 1914 Allied Artists' Association show, printed in the *Egoist*, reprinted in Ezra Pound, *Gaudier-Brzeska: A Memoir* (London: John Lane 1916), p. 25.
45 G. R. H., 'Gallery and Studio: Oscar Wilde's Tomb' *Pall Mall Gazette*, 6 June 1912, p. 7.
46 Gaudier, 'Allied Artists' Association Ltd.', *Egoist*, 15 June 1914, p. 227.
47 Jacob Epstein, in *The Sculptor Speaks: Jacob Epstein to A. L. Haskell: A Series of Conversations on Art* (London: Heinemann 1931), p. 11.
48 Gaudier, letter to the *Egoist*, 18 March 1914, in Pound, *Memoir*, p. 35.
49 Gaudier, 'The Vortex', *Blast 1*, 1914, p. 158.
50 Pound, *Memoir*, p. 119.
51 Pound, *Memoir*, p. 130.
52 T. E. Hulme, 'Mr. Epstein and the Critics', *New Age*, 25 December 1913, p. 252.
53 Pound, *Memoir*, p. 86.
54 Hulme, in the *New Age*, 25 December 1913, pp. 251–3
55 Gaudier, 'The Vortex', in Pound, *Memoir*, p. 11.
56 C. J. Holmes, *Notes on the Post-Impressionist Painters* (London: Philip Lee Warner 1910).

57  C. J. Holmes, 'The British Medical Association: New Building', letter to *The Times*, 23 June 1908, p. 16.
58  Gaudier, 'The Vortex', in Pound, *Memoir*, p. 9.
59  Gaudier, in Pound, *Memoir*, p. 9.
60  Gaudier, 'Vortex Gaudier-Brzeska', in *Blast 2*, 1915 in Pound, *Memoir*, p. 21.
61  Gaudier-Brzeska, 'The Vortex', *Blast*, 1, 1914, p. 155.
62  Epstein, *Autobiography*, p. 71.
63  Gaudier, 'Allied Artists' Association', *Egoist*, 15 June 1914, p. 227.
64  Rodin, *Art*, p. 211.
65  Adolf von Hildebrand, *The Problem of Form in Painting and Sculpture*, 1893, trans. Meyer and Ogden (London: Stechert 1907).
66  Hulme, 'Modern Art and its Philosophy', in *Speculations*, p. 76.
67  Hulme, 'Modern Art II', *New Age*, 12 February 1914, p. 467.
68  Pound, *Memoir*, pp. 94–109.
69  Gaudier in Pound, *Memoir*, p. 34.
70  For an excellent discussion of the progress of Hulme's philosophy see Michael H. Levenson, *A Genealogy of Modernism. A Study of English Literary Doctrine 1908–22* (Cambridge: Cambridge University Press 1984), pp. 40–50; 85–102.
71  Hulme, 'Modern Art', *Speculations*, p. 78.
72  Wilhelm Worringer, *Abstraktion und Einfuhlung* (Munich: Piper 1908), trans. Michael Bullock, *Abstraction and Empathy* (1940, rpt. London: Routledge, 1953).
73  Epstein, *Autobiography*, p. 74.
74  Epstein, *Autobiography*, p. 71.
75  Epstein, *Autobiography*, p. 56.
76. 'Quex', 'Round about London', *Evening News*, 10 March 1915, p. 4.
77  Anon, 'Art and Artists: Exhibition at the London Galleries: Various kinds of art', *Globe*, 12 March 1915, p. 7.
78  Anon, 'Junkerism in Art; the London Group at the Goupil Gallery', *The Times*, 10 March 1915, p. 8.
79  Sir Claude Phillips, 'Goupil Gallery: The London Group', *Daily Telegraph*, 13 March 1915, p. 5.
80  Anon, 'The London Group', *Connoisseur*, May-August 1915, p. 56.
81  Anon, 'The London Group at the Goupil Gallery', *Athenaeum*, 13 March 1915, p. 242.
82  Frank Denver, 'The London Group', *Egoist*, 1 April 1915, p. 60; J. B., 'The London Groups: The Rock Drill comes to Art', *Manchester Guardian*, 15 March 1915, p. 6; Francis Macnamara, 'The London Group at the Goupil Gallery', *New Age*, 1 April 1915, pp. 591, 592.
83  Gill to Rothenstein in Speaight, *Life*, p. 48.
84  Epstein, *Autobiography*, p. 230.
85  Eric Gill, *Autobiography* (London: Jonathan Cape 1940), p. 173.
86  Gill, *Autobiography*, p. 162.

87 Eric Gill, 'The Failure of the Arts and Crafts Movement', *Socialist Review*, December 1909, p. 298.
88 Eric Gill, *Art and a Changing Civilisation* (London: John Lane 1934), p. 26.
89 Eric Gill, 'Masters and Servants', *Highway*, November, 1910, p. 23.
90 Gill, *Highway*, November 1910, p. 24.
91 Eric Gill, 'Arts and Crafts: Sculpture', *Highway*, June 1917, p. 143.
92 Gill, *Highway*, June 1917, p. 143.
93 Gill, *Highway*, June 1917, p. 144.
94 Gill, *Autobiography*, p. 161.
95 Roger Fry, 'The Grafton Gallery', *Athenaeum*, 3 February 1906, p. 145.
96 Roger Fry, 'An English Sculptor', *Nation*, 28 January 1911, p. 719.
97 Gill, *Art and a Changing Civilisation*, p. 107.
98 Gill, *Art and a Changing Civilisation*, p. 28.
99 Gill, *Art and a Changing Civilisation*, p. 108.
100 Gill, *Autobiography*, p. 177.
101 Gill, 'Masters and Servants', *Highway*, November 1910, p. 24.
102 Fry instead turned his attention to Maillol, whose sculptures, he said in 1910, 'take up those ideas so lucidly set forth by M. Maurice Denis in his articles on Cézanne'. See Roger Fry, 'Sculptures of Maillol', *Burlington*, April 1910, p. 31.
103 Henry Moore, quoted in John Glaves-Smith, 'Some Issues in British Sculpture in the 1920s', in Sandy Nairne and Nicholas Serota, eds, *British Sculpture in the Twentieth Century* (London: Whitechapel Art Galley 1981), pp. 77–9.
104 Stanley Casson, *Some Modern Sculptors* (London: Oxford University Press 1928) and *Twentieth Century Sculptors* (London: Humphrey Milford 1930); R. H. Wilenski, *The Meaning of Modern Sculpture* (London: Faber & Faber 1932).
105 Kineton Parkes, *Sculpture of Today*, (London: Chapman Hall 1921), vol. 1, p. 120.
106 Thomas, *How to Understand Sculpture*, p. 24.
107 Thomas, *How to Understand Sculpture*, p. 95.

# 5

## THE SECOND POST-IMPRESSIONIST SHOW

The success of 'Manet and the Post-Impressionists' prompted Fry to plan another Post-Impressionist show for the following year. The 1911 show was intended to be representative of contemporary British 'non-Academic' art. It would have been made up of contributions from the New English Art Club and the Allied Artists' Association. The Fitzroy Street Group – an exhibition and discussion society based in Sickert's 19 Fitzroy St studio – and the Friday Club – a similar kind of group which was founded by Vanessa Bell and centred on Bloomsbury – would also have sent contributions. Such a show would have had two consequences. First, it would have confirmed Fry in the eyes of the public as the leader of these groups since they would all have exhibited under his aegis. Second, because of this, all would have become associated with Post-Impressionism as Fry construed it. Sickert, as has been seen, displayed little enthusiasm for the 1910 show. Both Tonks and Rothenstein, whom Fry approached as prominent members of the New English, came out against it, and Tonks was also suspicious of Fry's motives. It can have been no surprise, then, that after Tonks, Rothenstein and P. W. Steer refused Fry their support, all plans for an English show in 1911 collapsed.

After the failure of this scheme, Fry turned again to the continent and to collaborators from amongst his immediate acquaintances. The second Post-Impressionist Show consisted of three sections, French, English and Russian. The French work was assembled by Fry himself, with the help of Parisian dealers. The English section

was chosen by Clive Bell, and the Russian section by Boris Anrep, a Russian artist living in London who was associated with the Bloomsbury circle. They were assisted by M. W. Wade and Robert Dell, the Paris editor of the *Burlington*.

The second Post-Impressionist exhibition, showing 257 works in all, opened in the Grafton Galleries on 5 October 1912 and ran until the end of the year. Because plans for the succeeding show fell through, Fry's show was extended, with a slightly altered format, until the end of January 1913. The exhibition was thus open to the public for twice as long as 'Manet and the Post-Impressionists', and was visited by twice as many people.[1]

In the First Post-Impressionist Show, Cézanne, Van Gogh and Gauguin were given nearly equal emphasis. In the second, Cézanne was pre-eminent, and he occupied within the show the position of an accredited innovator, similar to that of Manet two years before. No work by Gauguin was shown and Van Gogh was represented by only one canvas, but five oil paintings and six watercolours by Cézanne were on display.

Cézanne's prominence was the result of Fry's preference and of the version of the past to which that preference led. Fry's predilections also meant that considerable space was allotted to Matisse. The emphasis which Fry gave to both artists had important implications for the style of the painters from the Bloomsbury circle. Cézanne, rather than Van Gogh or Gauguin, and Matisse rather than Picasso became their formal models.

Although Matisse and Picasso were described in the English press as twin leaders of the modern movement in France, Fry himself made a visual declaration of his own preference by showing far more of Matisse's work. Twenty-two paintings and six sculptures by Matisse were on display against eleven paintings by Picasso. Fry was uneasy about Picasso's Cubist work and this unease was reflected in his choice of paintings for the remainder of the French section. Although his choice may have been partly determined by French dealers' stock, he selected artists who used geometric form as a means of simplification but who tended to espouse only a limited degree of abstraction. Set against Picasso's

(*Over*) Matisse, *Le Panneau rouge* (*The Red Studio*), 1911. Oil on canvas, 181 × 219.1 cm. (Reproduced by permission of The Museum of Modern Art, New York. Mrs Simon Guggenheim Fund.)

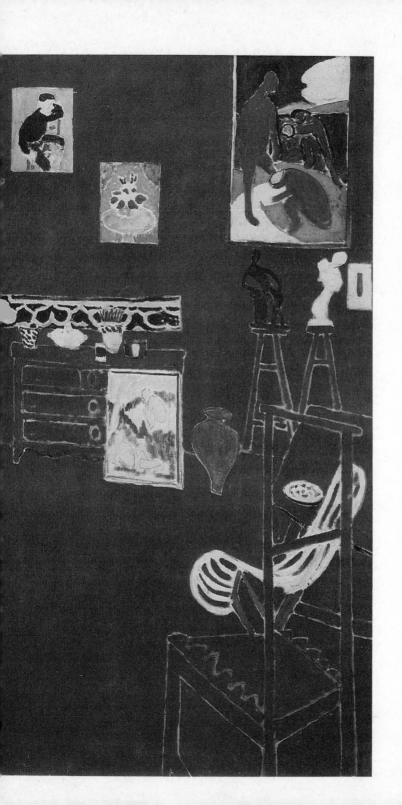

canvases were ten paintings by Herbin, eight by L'Hote, six by
Marchand and four by Derain, all of whom were described as
followers of Cézanne, but none of whom had developed Cézanne's
formulae as far as Cubism. Although Fry hung Braque's *Kubelik*
along with Picasso's Cubist work, his selection as a whole demon-
strated the limits of his tolerance towards Cubism, and his prefer-
ence for both Matisse and the 'Cézannist' work of artists like
Herbin and Lhote. As a result, Fry never developed an adequate
language in which to discuss Cubism. Without Fry's endorsement
and without such a language, it was unlikely that either Bloomsbury
painters or critics who took their lead from Fry and Bell would
ever fully assimilate Cubism.

Fry's choice of paintings defined the acceptable limits of practice
for English painters associated with Bloomsbury. Bell's selection
effectively defined who those painters were to be. The artists
chosen were Adeney (with five works), Bell (four), Frederick and
Jessie Etchells (four and one respectively), Fry (five), Gore (three),
Grant (seven), Hamilton (two), Lamb (one), Lewis (nine), Spencer
(two), and Wadsworth (two in the extended show).

Although Gore, Grant, Lamb and Lewis were members of the
Camden Town Group, an exhibition society formed from the
nucleus of the Fitzroy St Group in 1911 by Sickert and 15 painters
who had a commitment to some kind of naturalism, every one of
these painters was either already involved in Bloomsbury-based
enterprises or was shortly afterwards included in them. Adeney,
Etchells, Grant, Hamilton, Lewis, Spencer and Wadsworth had all
been drawn towards Bloomsbury from the Slade, where, despite
Tonks' opposition to Post-Impressionism, Fry was lecturing. Grant,
Etchells and Adeney had helped Fry on the Borough Polytechnic
murals which were commissioned in 1911. Grant and Wadsworth
showed with the Friday Club in 1910 and 1912 respectively. When,
in 1913, Fry and Bell left the Friday Club to form the Grafton
Group, an exhibition society formed out of the more diverse Friday
Club, Etchells and Grant became founder members. At the group's
first exhibition in the Grafton Galleries, only a month after the end
of the Second Post-Impressionist Show, Lewis, Gore and Hamilton
showed alongside this original quartet. Six weeks after this show
closed, the Omega Workshops were opened. Bell, Grant, Frederick
and Jessie Etchells, Hamilton, Lewis and Wadsworth all had spells
there.

Either by accident or design, many painters who had some claim to inclusion in the Second Post-Impressionist Show were left out of Bell's selection for the English section. After the failure of the 1911 scheme, it was inevitable that most members of the New English Art Club would not consider showing. But Bell also found no room for Augustus John, all the Camden Town Group except for Lamb, Lewis, Grant and Gore, and the group of artists associated with John Middleton Murray's *Rhythm* magazine, who styled themselves 'Fauves'. These were Dismoor, Fergusson, Peploe and Rice.

The reasons for the absence of these artists were probably partly aesthetic and partly administrative. Sickert's disapproval of Fry's version of Post-Impressionism and his uneasy relationship with the Bloomsbury circle may explain the absence of members of the Camden Town Group – Bevan, Gilman, Ginner and Manson for instance – who all shared Sickert's suspicion of Fry. Equally, however, some of the group's members may simply not have been able to furnish Bell with any material, for the third Camden Town show ran concurrently with the Second Post-Impressionist Show in December 1912. This did not, however, prevent Gore from hanging work in both exhibitions.

When the Camden Town show closed, there was a possibility of transferring some of the work to the extended Grafton Galleries exhibition for the month of January 1913. But Manson, the group's secretary, expressed his disapproval of this plan on the grounds that 'one does not like to accept anything from Roger Fry',[2] and the amalgamation was called off. This refusal to co-operate with Bloomsbury was in fact an acknowledgment of Fry's power, for it was clearly prompted by a fear that collaboration would involve some kind of subordination, a situation which the Camden Town Group was not willing to accept.

It is possible, then, that Manson and other members of the Camden Town Group may have refused Fry's offer of collaboration. Augustus John may also have turned down the chance of exhibiting in the 1912 show. During the first exhibition John had been used by critics to 'explain' and provide an English context for Post-Impressionism. Thus, said the *Athenaeum*, 'the function of the Post-Impressionists, and of Mr. John as a colourist, is to liberate colour design'.[3] The *Athenaeum* implied both that John was like the Post-Impressionists and that he was 'advanced'. Laurence

Binyon went one stage further and asserted that he was better than his French counterparts.[4] Whatever the reason for John's absence from the second show, its result was that no connection was made in the press between his work and the work of the painters represented there. So, in 1910 John was called a Post-Impressionist, but in 1912 he was not.

P. G. Konody, writing in the *Observer*, drew attention to the absence of the *Rhythm* group.[5] Again, the fact that Fergusson, Peploe, Dismoor and Rice were then showing at the Stafford Galleries may have made it impossible to include them. But, like the Camden Town Group, the *Rhythm* artists had aesthetic differences with Bloomsbury and they wanted to remain separate from it. M. T. H. Sadler, the first English translator of Kandinsky, had already attacked the idea of Post-Impressionism – and thus, by implication, Roger Fry – in the summer 1911 issue of *Rhythm*. He argued that Post-Impressionism was a misleading title for a new movement, and suggested that the name 'Fauve' should be adopted instead. But Sadler defined the hallmark of Fauvism as neither self-expression nor the creation of form, but 'the desire for rhythm'.[6] Because such a desire was inevitably connected with those who had named themselves in its honour, he was not simply renaming the modern movement, he was demanding a re-evaluation of painting away from the terms set up by Fry and towards the terms championed by the *Rhythm* group.

From the summer of 1911 onwards, then, the *Rhythm* group were trying to distinguish themselves from Fry and his circle. It may be that the *Rhythm* group voluntarily absented themselves from the Second Post-Impressionist Exhibition because of this. Equally, Bell may have left them out because they represented a potential threat to the Post-Impressionist construction of the immediate past.

The consequences of artists' absence from the 1912 show were swift and severe. One of the show's most important results was the advertisement, application and development of the critical language which Fry and Bell presented in their catalogue essays. That language was increasingly developed to describe only those works – past and present – which came within the Post-Impressionist domain. If an artist was absent from the show, then, he was not a Post-Impressionist according to the definition which Bell put forward in his selection of English artists. That meant that the Post-Impressionist language was not used to describe his work.

When, for instance, Augustus John was left out of the show, his work was no longer described as being connected with Post-Impressionism. But such painting was obviously not Academic. It was thus not suitable for discussion in the language which Fry and MacCarthy had challenged, and which, after the First Post-Impressionist Show became increasingly associated with Academic painting. The absence from the 1912 show of John and some members of the Camden Town group increasingly left critics and public without any acceptably 'modern' language of description to apply to their work and in particular to their subject matter. Hence John, and, as time went on, Sickert too, became increasingly difficult to evaluate and categorise. As the Post-Impressionist version of the past became gradually accepted, the two artists also became hard to place within any 'development' of English painting, and impossible to 'rehabilitate' without a reevaluation of that version of the past.

It was largely by means of the catalogue introduction for the second show that the Post-Impressionist language, as it had been developed by Fry and Bell since 1910, was publicised. Thousands of visitors to the Grafton Galleries looked at the work there with the help of the catalogue. Critics relied on it to find a vocabulary with which to describe and evaluate the paintings and an aesthetic with which to justify them. Since four times as many people visited the second show as had been to the first, there is likely to have been a commensurate increase in the number of catalogues circulated. It is possible that as many as twenty thousand were sold – that is, one for every four visitors. If this figure is set against the few hundred copies which were printed of magazines like *Blast* or *Rhythm*, the catalogue's significance becomes immediately obvious. Even Bell's *Art*, perhaps the most widely disseminated publication to emerge from the avant-garde before the First World War, is unlikely to have sold more than a few thousand copies.

The catalogue of the Second Post-Impressionist Show was divided into three parts, one for each section of the exhibition.[7] These three parts were prefaced by a short piece by Fry, in which he summarily dismissed the Futurists, who had been showing at the Sackville Gallery six months previously. Fry did not exclude them because of the quality of their productions. Instead he found them guilty of a misunderstanding of Cubism. A misunderstanding of Cubism implied a misunderstanding of Cézanne, because

Cézanne was regarded as the 'father' of Cubism. Fry excluded the Futurists, then, on the grounds that they were wrong about Cézanne. That implied that there was a 'right' understanding of Cézanne, which he himself was showing at the Grafton Galleries. He may have felt in 1912 that the Futurists were a threat to Post-Impressionism. A year or two later, with the Post-Impressionist understanding of Cézanne – and thus of the immediate past – firmly established, they obviously were not.

A confident essay by Bell followed Fry's piece. Bell announced victory for the new aesthetic and then went on to outline its salient features. The demise of representation meant that artists need 'recognise no authority but the truth that is in them', he said.[8] Their art was independent of everyday life and of any 'place or time, or a particular civilisation or point of view'.[9] Freed from dependence upon life, form in painting referred not to the outside world but to itself. So an object from which an artist created form was 'an end in itself.... A significant form related on terms of equality with other significant forms.'[10] 'Simplification' and 'plastic design' were hallmarks of the Post-Impressionist painting which displayed this 'significance of form'.[11] Bell added, glancing at what he was to call 'the great tradition'[12] that all great artists had regarded objects in this way.[13]

Although Bell reiterated that the purpose of Post-Impressionism was to 'express great emotions and to promote them',[14] his introduction shifted concentration from the expression of emotion to the exact nature of that emotion and the means by which it was realised and transmitted. The vocabulary that Bell popularised referred, in consequence, not to the artist but to the canvas. This represented a major change in the emphasis of Post-Impressionist theory.

In his introductory essay Fry did not go so far as to say that an object could be an end in itself, but he supported Bell's notion that art should stand on its own feet. 'All art', he said, 'depends upon cutting off the practical responses of everyday life'.[15] What followed, Fry suggested was the apprehension of 'a new and definite reality'[16] constructed out of forms which were not imitative but created by the artist himself.

Besides this analysis of the aims of Post-Impressionism Fry also introduced two important notions to the discussion of the movement. One referred to Post-Impressionism itself and the other

referred to the whole history of western art. The first notion was that of 'plasticity' or 'plastic art' and the second was the distinction between classic art and romantic art.[17] Although neither was by any means Fry's invention, it was he who coupled them with Post-Impressionism for the readers of his magazine articles and for visitors to the Grafton Galleries.

Plastic art, said Fry, was the art which, instead of delineating or illustrating form, constructed it by means of suggesting volume. In his catalogue introduction Fry added plasticity to the qualities which had been so praised during the first show – 'decoration', 'unity', 'design', 'rhythm', 'line' and 'pattern'. He then used it to distinguish between Picasso and Cézanne whom he saw as primarily plastic artists, and Matisse, who in his painting 'aims at convincing us of the reality of his forms by the continuity and flow of his rhythmic line, by the logic of space relations, and, above all, by an entirely new use of colour'.[18]

In his distinction between classic art and romantic art, Fry was, like Bell, evoking a tradition within which the new movement could be incorporated. Fry suggested that the classic spirit was common to all the best French work since the twelfth century. It resulted from the artist's unwillingness to 'rely for his effects upon associated ideas'. He relied instead upon the 'disembodied functioning of the spirit' which made his work 'free' and 'pure'. Such purity was evident in the work of Poussin, and Poussin's spirit, said Fry, 'seems to revive in the work of artists like Derain'. Romantic and realistic art, on the other hand, Fry stated, was dependent upon association and upon 'at least an imagined practical activity'. It was thus not 'completely pure and free'.[19]

Like Bell, Fry shifted his interest away from the artist and towards his product. This shift brought about new prominence for 'plasticity' and 'form'. This prominence was confirmed in a piece which Fry wrote for the *Nation* of 9 November 1912, in which he amplified upon his catalogue introduction and answered hostile critics. He stressed in his article that Post-Impressionism was in line, not with representation, but with 'the much older and longer and more universal tradition' that 'has used form for its expressive . . . qualities'. He praised Matisse's bronze heads on the grounds that 'in each successive state he has amplified the forms, working always towards a more complete and plastic unity', so that

in the final state, 'pure form . . . has an intensity, a compactness, an inevitability which gives it the same kind of reality as life itself'.[20]

Although the Second Post-Impressionist Show publicised the changed emphasis which Fry and Bell were placing upon Post-Impressionism, they had in fact been adding to the Post-Impressionist language and shifting the areas of discussion for over a year. This was due in part to Bell's contribution, for Bell was less equivocal than Fry about the need for art to be separated from life, and was thus more consistently interested in means rather than ends. But Bell and Fry also required a language for Post-Impressionism which referred not to the outside world but to itself, and was thus not 'descriptive' but self-contained. This did not mean that Fry and Bell abandoned the language of the First Post-Impressionist Show. Decoration, design, pattern, unity, form and self-expression remained. The new terms – very often new adjectives – were simply grafted onto them. Thus Bell spoke of 'significant form' or 'aesthetic emotion', while Fry stressed 'plastic expression' or 'plastic design'. This new vocabulary gradually took precedence over that used at the time of the first show. In this way the emphasis was shifted from the communication of emotion itself to the means by which that emotion was communicated, without entirely dropping the associations which had been so successful in winning support for Post-Impressionism.

When Bell began to write about Post-Impressionism in January 1911, he concentrated on self-expression. Criticising Holmes's *Notes on the Post-Impressionist Painters* in the *Athenaeum*, he asserted that the Post-Impressionists chose their 'peculiar technique' not to 'make beautiful patterns', but for the purposes of expression.[21] By the following month he had adopted Fry's application of plasticity to Post-Impressionism.[27] But it was not until he wrote his contribution to the 1912 catalogue that he developed Fry's concept of 'significant form', and not until a month after the show closed that he equated the creation of 'significant form' with the generation of aesthetic emotion.[33]

Fry connected the idea of plasticity with Post-Impressionism in January 1911 in his review of Eric Gill's show at the Chenil Gallery. There, he praised Gill for his gift of 'plastic expression', by means of which a form could 'impress one with a sense of its own independent reality' and become 'self-consistent and expressive of its own

imagined inner life'.[24] Fry explained plasticity in greater detail in another piece published in the *Nation* a few months later. He made it clear that plastic expression was necessary not only to good sculpture but also to good painting. For it was the presence of 'plastic design' which made the difference between a successful and an unsuccessful painting. 'This power of evoking voluminous and plastic ideas of form seems', he said, 'to distinguish more than anything else the artist from the delineator or illustrator'.[29] In effect, Fry was arguing here for supremacy of form, because he implied that quality depended upon means and not upon ends.

Bell and Fry were now developing a normative terminology. Approval could be bestowed upon a painting by the discovery that it was characterised by 'plastic design', 'pure form' or 'significant form'. So a Post-Impressionist work could be evaluated in terminology which applied only to itself. Because of this it was devoid of any outside, moral application. By the same token, disapproval of any work could be signalled by the witholding of the Post-Impressionist vocabulary. So, in July 1912, Fry disparaged the work of Sickert's pupils first by describing it in language which was not generally used when Post-Impressionist work was discussed, and then denying it the application of Post-Impressionist vocabulary. In their paintings, he said, 'the disposition of forms is always agreeable and harmonious, but it is not often significant'.[26]

As well as explaining the term 'plastic design' to interested readers before he used it in the catalogue of the second Post-Impressionist show, Fry also introduced them to his notion of classicism. In an article in the *Burlington* magazine of February 1911, he distinguished between two kinds of classicism, one exemplified by Maurice Denis and the other by Cézanne. Denis, Fry said, stood within 'that great classic tradition of France, the tradition of Poussin, Ingres and Puvis de Chavannes'. He defined Denis, and thus those other artists as well, as 'sympathetic and scholarly'. Cézanne, on the other hand, he regarded as without any connection to this tradition. He was 'classic' because he had the power of 'finding in things themselves the actual material of poetry and the fullest gratification for the demands of the imagination'.[27] By the time of the 1912 show these two definitions seem to have been partially fused. The 'classic spirit' which ran through Poussin to Derain had become equated with that dissociation of objects

from everyday life which Fry had associated with Cézanne in his *Burlington* article.

Whatever their understanding of Fry's introduction, it is likely that visitors to the show would have associated the idea of classicism with two things. The first was greatness, and this perhaps helped viewers to understand and accept the great tradition within which Fry and Bell were placing Post-Impressionism. The second was a negative or reactive definition of classicism as the opposite of romanticism. Fry made it clear in the catalogue that romanticism was equated with realism, and it was realism that Post-Impressionism was rejecting. Classicism thus implied the opposite of realism.

In linking Post-Impressionism with classicism, Fry was placing it within the context of a debate about the relative merits of romanticism and classicism which had already received considerable attention from theorists. Perhaps the best known was Irving Babbitt's, *The New Laokoon*, which had been published in England in 1910. Like early Modernist writers, Babbitt stood out against any evolutionary theory of the arts, and advocated 'vital concentration', specificity of medium and a greater emphasis on form, line and solidity.[28] All these virtues he equated with the idea of classicism. Defined in more or less the same terms, classicism was championed in England by early Modernists concerned with poetry as well as painting. As we shall see, because it involved versions of the history of art which could be disputed, it became a central element in the debate amongst avant-garde painters before the First World War.

The importance of the catalogue of the Second Post-Impressionist Show was, then, that it familiarised supporters of the new art with the language and ideas which Bell and Fry had been developing in the pages of the *Nation*, the *Burlington* and the *Athenaeum*. It meant for many people that the vocabulary which Fry and Bell used became associated with Post-Impressionism as it had been constructed in the two shows. The same associations were disseminated to an even wider audience than those attending the show because critics – even hostile critics – couched their reviews in the language of the catalogue.

The Second Post-Impressionist Show received twenty-eight notices in the press, a dozen or so fewer than the first show. Six of these notices were in publications which did not review the 1910 exhibition. These were the *New Age*, *Rhythm*, the *Outlook*, the

*Evening Standard* and the *Evening News*. Seventeen publications which had considered Fry's first show either directly or indirectly did not comment on the second. Among the daily and Sunday papers, the *Express* was now silent. Serious periodicals which did not mention the exhibition were the *Academy*, the *Art Journal*, the *Art News*, the *Athenaeum*, the *Burlington*, the *English Review*, the *Fortnightly*, *Public Opinion*, the *Spectator*, *T.P.'s Magazine* and the *Tramp*. The show was also passed over in several magazines where the earlier exhibition had been the object of satire. These were *Granta*, the *Imp*, *London Magazine* and *Punch*.

Some of the changes in the pattern of reviewing were due not to a shift of taste but to developments in the publishing industry. *Rhythm* magazine was not founded until 1911. The *Art Journal*, *T.P.'s Magazine* and the *Tramp* had all ceased publication between 1911 and 1912, the *English Review* had changed hands and become more exclusively literary, while the *Art News* had been amalgamated with the *Art Chronicle*.

The increase in the number of reviews in daily papers may simply reflect the fact, not evident to so many at the beginning of the 1910 exhibition, that Post-Impressionism was of interest to a large number of readers, one way or another, and hence 'good copy'. But the shift away from periodicals and satirical magazines also provides evidence of the changing character of the interest which the Post-Impressionists now excited. Although the Second Post-Impressionist Show generated considerably more excitement than other shows of non-academic groups in London – Camden Town or the Allied Artists' Association, for instance – it had now taken its place alongside them as another component in the cultural life of the capital. That meant that it was no longer a subject for such intense and prolonged discussion. Whereas the controversy over 'Manet and the Post-Impressionists' was prominent in newspapers and periodicals up until January 1911, most publications made only one mention of the 1912 show when it first opened. Except in the case of the *Saturday Reivew*, the exhibition provoked no extended discussion in later pages. As a result it received little attention from monthly journals. The October issues appeared before the show's opening, and such theoretical debate as it engendered had died down by November.

The *Burlington* may have been silent for a different reason. For a magazine which had become so closely connected with

Bloomsbury to have *reviewed* either of the shows might have savoured of nepotism. So whereas Fry had used the *Burlington* in 1910 to present Post-Impressionism to an influential section of the public, in 1912 it carried no material relating directly to the show. It did, however, advertise prominently in the catalogue for the Second Post-Impressionist Show and back numbers were sold in the gallery. So, despite the absence of coverage, the *Burlington* continued to play an important role in Post-Impressionism's acceptance.

The most striking difference between the reviews of the two shows was that, by 1912, there was no longer marked hostility to the premises of Post-Impressionism which MacCarthy had outlined in the catalogue to the first show. With a few notable exceptions, critics argued within the terms of reference set up in 1910. Even though critics judged the show harshly, they did not condemn it on the grounds that Post-Impressionism failed to adhere to the standard of 'truth to nature'. Instead, many found it wanting according to the criteria which had been established two years before and which were developed in the new catalogue. This means of evaluation revealed an underlying, if unacknowledged, accept-ance of the Post-Impressionist aesthetic. Consequently, the reviewers of the second show devoted far greater attention to indi-vidual paintings and painters than had the men reviewing the first. Using the language provided by Bell and Fry, they passed judge-ment upon the works they saw and made distinctions between them. Some reviewers passed adverse judgement on Matisse. But most, when they did so, used Post-Impressionist language, thereby signalling approval of the enterprise if not of the individual.

Nevertheless there were a number of critics who refused to accept the premises of Post-Impressionism and who advanced similar objections to those raised in 1910. The publications which took this stance towards the Second Post-Impressionist Show were the *Daily News and Morning Leader, London Opinion, Mayfair*, the *Morning Post*, the *New Age*, the *Outlook*, the *Saturday Review* and the *Star*. Except in the case of the *Daily News*, none had shifted from their position of 1910, and the grounds for their disapproval remained substantially the same. The *Daily News*, which had come out in favour of Post-Impressionism in 1910, now carried a harsh attack by M. H. Spielmann, whose dislike of Modernism we have already charted. Like the *Star*, the *Daily News* was owned by

George Cadbury at the time of the first show. The paper's changed stance may have been due in part to the amalgamation of the *Daily News* with another Liberal paper, the *Morning Leader* in May 1912. The trust which took over the papers when Cadbury retired perhaps changed editorial policy towards art. But, equally, the change may simply have resulted from Cadbury's indifference towards painting.

There were three other new reviewers who wrote against the Second Post-Impressionist Show. They were C. H. Collins-Baker in the *Saturday Review*, Anthony Ludovici in the *New Age* and J. B. Manson in the *Outlook*. C. H. Collins-Baker, a regular contributor to first the *Outlook* and then the *Saturday Review*, was an administrator and critic who was educated at the Royal Academy and subsequently became assistant and secretary to Charles Holroyd at the National Gallery. He also acted as honorary secretary to the New English Art Club between 1921 and 1925. All his allegiances, then, were owed to institutions which frowned upon Post-Impressionism. Throughout his career Collins-Baker's critical style refected these attachments. He consistently discussed painting in the language which had been used in 1910 by opponents of Post-Impressionism.

Anthony Ludovici's post as one of the regular art critics of the *New Age* was in line with the eclectic art policies of A. O. Orage, the paper's editor. A year after the Second Post-Impressionist Show, Ludovici, Hulme and Sickert, whose viewpoints were all mutually antagonistic, were writing concurrently in the magazine. Moreover, despite their different social attitudes, Orage and Ludovici shared a common interest in Nietzsche. It was not inconsistent, then, to find such a socially conservative writer in a journal which was noted for its radical politics.

Ludovici's position on Post-Impressionism tallied with the views on art which he had publicised not only in the *New Age*, but also in various books, especially in his *Nietzsche and Art*, which was published in 1910. Ludovici regarded art as symptomatic of the state of society. Like Wake Cook, with whom he acknowledged kinship, he saw in the decline of subject painting a general decline in morals and a loss of every kind of standard.[29] Without any standards of judgment, he said, the critic was forced to fall back upon discussion of technique. But Ludovici asserted that such a narrow focus was unjustified because 'technique is important only

as a means of betraying how a man approaches and deals with reality'.[30] 'I cannot expatiate, as some critics can', he stated defensively in 1912, 'upon a picture as a thing in itself, divorced from all its various relations'.[31] Since it was exactly that which Bell declared to be Post-Impressionism's salient characteristic, Ludovici's hostility was inevitable.

The last new reviewer was J. B. Manson, secretary to the Camden Town Group. His review was merely a confirmation of the hostility towards Bloomsbury's increasing domination of the avant-garde that we noted earlier. It is important, however, because it represents one of the first direct attacks on Fry and his circle from a member of another avant-garde grouping. Like other avant-garde writers a year or two later, Manson challenged Fry's version of the past and held it responsible for 'the chaotic state of modern art in England'.[32] He urged that instead of Post-Impressionism, the 'study of Impressionism' should be 'resumed and developed along logical lines'.[33] Three weeks after his review of the Grafton Galleries show he made it clear with whom that development lay. In praising the Camden Town show at the Carfax Gallery, he said that the group 'represents the logical development of Impressionism in this country, which is the traditional movement of art as it has progressed through Claude, Corot, Manet, Pissarro to the present day'.[34]

Manson's assessment of the Second Post-Impressionist Show then, should be seen in a different light from those of other hostile reviewers. He was arguing as Bloomsbury's potential competitor for support and patronage. In 1910, of course, it was painters like Burne-Jones and W. B. Richmond who believed that they occupied this position. Just two years later they had ceased to regard Post-Impressionism as a direct threat, and had ceded their place to members of the avant-garde. Henceforth the public attack on Post-Impressionism was to come not from painters who saw themselves as following the example of the pre-Raphaelites or the Academy. Instead it was to come from those who, like Fry, saw themselves as following the example of Cézanne and other French painters who were dubbed Post-Impressionist.

Like S. F. Gore, his Camden Town colleague who wrote the *Art News* review of the First Post-Impressionist Show, Manson argued for a modified naturalism. Manson's review, however, was a more direct challenge to Fry. He represented a smaller and more

coherent alternative grouping than had Gore two years before, an indication of the degree to which, as early as late 1911, radical opinion was beginning to crystallise into factions.

Despite the distinctive nature of Manson's review, he and the other critics who wrote against the Second Post-Impressionist Show offered the same general reasons for their dislike (although the implications of those reasons were, of course, very different for a painter like Manson who provided an alternative model of development). These reasons were identical to those given two years previously. Writers said that Post-Impressionist painting was either consciously bad or ugly or that it was symptomatic of moral degeneracy, and they continued to rebuke Fry for displaying it.

Spielmann, as a sculpture critic, concentrated his fury upon Matisse's bronzes. Nothing, he said, 'could be more loathsomely ugly than the bust, shown by casts in three "states" before it emerges, purposely divorced from life, in the excruciating bronze *Bust of a Woman*'.[35] Spielmann declared that the Post-Impressionists must be insincere, and the critics of *Mayfair*,[36] and the *Morning Post*, along with Douglas in *London Opinion*[37] agreed with him. The *Morning Post* writer (whose review was anonymous) called the show 'deplorable and degrading'.[38] Ludovici, whose review came closest, in language and tone, to some of those of 1910, asserted that it was degenerate. Marchand, Vlaminck and Derain, he said, were 'heralds of the decay and dissolution of art, and their colour is the colour of decomposed corpses'.

Ludovici, like Manson, was as ready as the reviewers of 1910 to state his standards. But other reviewers who attacked the Second Post-Impressionist Show were not. Though these standards were implicit in their criticism, they were not prepared to defend them in public. Collins-Baker attempted a middle course between these two positions. 'As everybody knows', he said, 'the function of pictorial art is to transmit to our consciousness the visualised consciousness of others, who are more or less fitted by a patient mastery of obvious external appearances to reveal more spiritual qualities'.[68] By a series of periphrastics Collins-Baker alluded to the importance of representation of 'truth to nature' but he avoided mentioning them explicitly. Like other hostile critics, he showed his understanding of the strength of Fry's position in his desire to keep the issues of 1910 out of print.

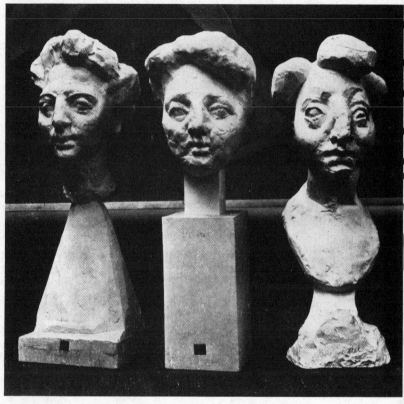

Matisse, *Bouste de femme*, first, second and third states.

If the number of reviews which were prevailingly hostile was much smaller than two years previously, so was the number which advocated unreserved approval. Along with the *Nation*, which signalled its approbation by printing Fry's 'Apologia', four newspapers came out in favour of the Second Post-Impressionist Show. These four were the *Daily Chronicle*, the *Daily Graphic*, the *Evening Standard* and the *Sunday Times*. The *Chronicle's* support was carried over from 1910, while the *Graphic* shifted from its earlier position of neutrality to one of praise.

The newspapers which advocated unconditional approval of the show tended, like the hostile papers, to reproduce arguments which

had been used two years before. So Hind, in the *Chronicle*, together
with the critics of the *Sunday Times* and the *Graphic*, relied on the
premises of MacCarthy's 1910 catalogue rather than the changed
premises put forward by Fry and Bell. That meant that they concen-
trated on self-expression rather than form.[69] All three emphasised
the seriousness and sincerity of the artists – this time it was Picasso
in particular who needed defending – while the *Standard* and the
*Sunday Times* urged their readers to accept each artist's right to
paint according to his own tenets.[42] Although the *Sunday Times* felt
that criticism had so fallen behind practice as to be incapable of
any explanation of it,[43] the *Graphic* critic, like many of his colleagues
two years previously, continued to emphasise the importance of the
written word. 'It will be very necessary for anyone who visits this
exhibition', he said, 'to arm himself with at least a wish to find out
why Picasso paints cubes and pyramids, or what Matisse means by
decoration, and where both think they are going'.[44]

It was their enthusiasm for Picasso which distinguished these
reviews from others which approached Post-Impressionism on its
own terms. Picasso was the only artist whom critics consistently
found wanting, although Lewis's work was occasionally included
in harsh pronouncements because he was seen by most critics as
the British artist closest to Picasso. These four reviewers, however,
expressed their admiration for all the work in the show. The *Sunday
Times* agreed with many less favourable reviewers that Picasso was
difficult to understand, but regarded that as a fault of inadequate
explanation and not of execution.[45] Hind found Picasso's Cubist
work 'unintelligible' and science rather than art, but he effectively
withdrew the criticism by calling him a 'great innovator'.[46] The
*Graphic* reviewer dubbed Picasso a 'master', and asserted that it
was foolish to inveigh against him, since 'not one person who looks
at Picasso's work knows as much about form and colour as he'.[47]

While several critics still regarded Post-Impressionism as a
matter for either complete rejection or complete acceptance, the
remaining reviewers judged each painter individually. The critic of
*The Times* went so far as to rebuke those who 'ask what is the value
and intention of the movement, and condemn or approve of the
artists wholesale'. What was important, he said, was that 'some
Post-Impressionists are gifted while others are not'.[48] This resulted
in a piecemeal approach to the show. Other writers who adopted
*The Times'* stance were the critics of the *Art Chronicle*, the

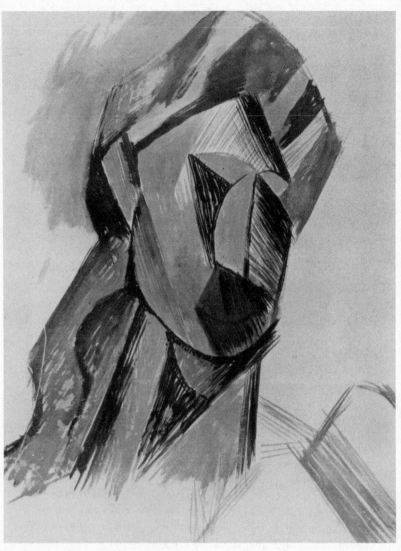

Picasso, *Tête de femme*. Ink wash.

*Connoisseur*, the *Daily Mail* the *Observer*, the *Evening News*, the *Globe*, the *Illustrated London News*, the *Pall Mall Gazette*, the *Tatler*, the *Westminster Gazette* and the *World*. These publications catered to a wide range of aesthetic and political opinions. Some had been harsh attackers and some enthusiastic defenders of the First Post-Impressionist Show. The *Art Chronicle*, the *Connoisseur*, the *Globe*, *The Times* and the *World* had come out firmly against the 1910 exhibition, while the *Illustrated London News*, the *Pall Mall Gazette* and the *Westminster Gazette* had declared in its favour.

The starting point for the appreciation of the Second Post-Impressionist Show was the acceptance of the ideas around which the first show had been based. Critics emphasised the sincerity of the artists involved in Post-Impressionism, their desire for self expression, their search for truth to essence rather than aspect and their right to distort or 'create' form for those ends. These desires were accepted as legitimate even if the products which resulted from them were unsuccessful. So Claude Philliips, who had accused Matisse of 'fumisterie' in 1910, now declared the effort to be 'earnest and in the main sincere', even though he was still in doubt about the quality of the work.[49] Similarly, the critic of the *Pall Mall Gazette* emphasised that Picasso was serious even while he dismissed him as incoherent.[50] Finally, Konody, who had been lukewarm about the first show, now capitulated to one of its major tenets. He declared that the purpose of art was the communication of emotion. While he criticised Picasso, he did so not on the grounds that the Spaniard's work failed to transmit any ideas, nor on the grounds that it was divorced from contact with nature, but on the grounds that it failed to communicate any emotion. Because of this, he said, Picasso's paintings did not 'justify their existence as works of art'.[51]

Along with approval of the Post-Impressionist aesthetic went approval of those painters who had illustrated it most prominently in 1910 – Van Gogh, Gauguin and Cézanne. The *Pall Mall Gazette* called Cézanne 'an Old Master who recognised form as the means of expression',[52] while the *Illustrated London News* praised Matisse's *Les Poissons* (cat. no. 37) as 'one of the fruits of Gauguin's genius'.[53] The critic of the *Connoisseur* baulked at Picasso and Lewis, but asserted that 'the contemplation of such eccentricities must not blind the visitor to the high merit of the less extreme work in the exhibition: Cézanne for instance'.[54] In the 'Apologia' which he

wrote in the *Nation*, Fry himself noted that 'this year Cézanne is always excepted from abuse. He, at least, is a great master.' But he went on to complain that 'whatever advantage might be given by this concession is instantly taken back by the statement that he is not a Post-Impressionist, and has nothing to do with the rest'.[55]

In his introduction Fry had sought to establish the connections between all the artists in the show by highlighting their desire to 'make images which by the clearness of their logical structure, and by their close knit unity of texture, shall appeal to our disinterested and contemplative imagination with something of the same richness as the things of actual life appeal to our practical activities'.[56] This was a declaration of common purpose. Most critics accepted that common purpose because they accepted the Post-Impressionist premises. What many refused to concede was a common level of achievement. Picasso was judged, not upon intention, but upon execution. Here critics followed Fry scrupulously, because Fry had said that it was 'too early' to decide whether Picasso was 'successful'.[57] The distinction which writers made between painters like Cézanne and Picasso was thus a direct consequence of Fry's own unease.

Reviewers did not follow Fry's lead in aesthetics alone. They picked up and echoed other points of emphasis in the catalogue – Bell's distinction between Lewis and the Bloomsbury painters, for instance – and they publicised them in the language which the introductions gave them. By such means Post-Impressionist vocabulary became familiar to far greater numbers than those who actually attended the exhibition, in particular people in the provinces. It is likely that, by 1912, many people who had never seen a Picasso had read Roger Fry's conclusions upon his work, and many people who had never seen a Duncan Grant had noticed Bell's praise of him. Some of these perhaps bought Bell's *Art* when it appeared. Press attention thus helped secure a very wide audience for Post-Impressionism before any rival groups tried to publicise their own aesthetic.

D. S. MacColl said that the critics of the 1912 show were 'practising, a little asthmatically, the phrases of an unknown tongue'. But most of those who had, as he put it, 'declared for the new aesthetic, or religion', displayed considerable linguistic agility in their use of both the phrases of 1910 and the combinations of 1912.[58]

Some writers were still most at home within the terminology and associations of 'Manet and the Post-Impressionists'. The *Connoisseur*, for instance, announced its approval of Cézanne's *Le Dauphin du jas de bouffon* (cat. no. 4) by describing its 'elaborate and crowded composition' as 'spaced out with the nicety of a Persian carpet'.[59] Most reviewers, and perhaps many of the audience, however, had by this time abandoned direct reference to the associations between the Arts and Crafts Movement and the language of Post-Impressionism. But they were increasingly fluent in using that language in its new application. Konody praised Matisse as 'a real master of superb decorative colour, rhythmic line and expressive simplification',[60] while the writer of the *Pall Mall Gazette* said that Matisse's designs, 'even his wildest distortions, live apart, beautiful in colour, of swinging and rhythmical pattern'.[61] The *Globe's* reviewer, echoing Fry's notice of Gill's show in the *Nation*, declared that the sculptor's garden statue was an 'enchanting example of purity of line', and revealed 'the possession of an astonishing technique'.[62] Even the hostile *Illustrated London News* showed its acceptance of the 1910 Post-Impressionist language in its judgement of Matisse's *La Danse* (cat. no. 185). This huge canvas, the first of the painter's two versions of the subject, now in the Museum of Modern Art, New York, was the most widely discussed and most highly praised work in the show. The *Illustrated London News* did not like it, but it did use Post-Impressionist vocabulary to say so. Matisse, said its critic, had 'thrown himself upon rhythm, and torn it to shreds trying to learn and make use of its secrets'.[63]

Reviewers of the Second Post-Impressionist Show also began to combine the language of 1910 with the new adjectives which Fry and Bell had introduced in their catalogue introductions. As a result, like Fry and Bell, they began to shift their emphasis from the intention of the artist to his results, and thus to concentrate more upon form and technique. Phillips, for example, said that Matisse was striving for 'the expression of the essential in man and nature', but he described the essential in formal terms. It was, he said, 'the expression of mass combined with the expression of movement'.[64] Other writers also stressed the formal qualities of Post-Impressionist painting. Writing in reply to the notice in the *Saturday Review*, O. Raymond Drey, a critic associated with the *Rhythm* group, defined Post-Impressionism as 'a new sort of

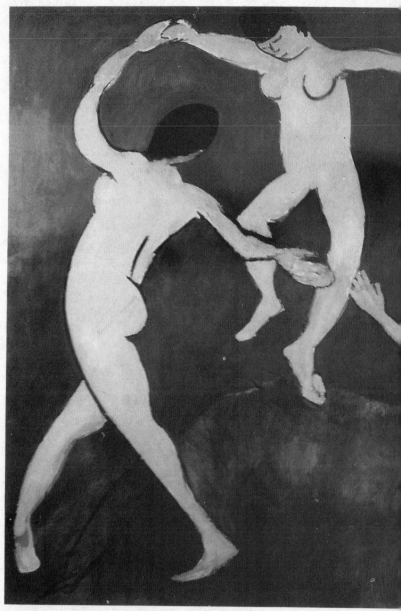

Matisse, *La Danse* (first version), 1909. Oil on canvas, 259.7 × 390.1
cm. (Reproduced by permission of The Museum of Modern Art, New
York. Gift of Nelson A. Rockefeller in honour of Alfred H. Barr, Jr.)

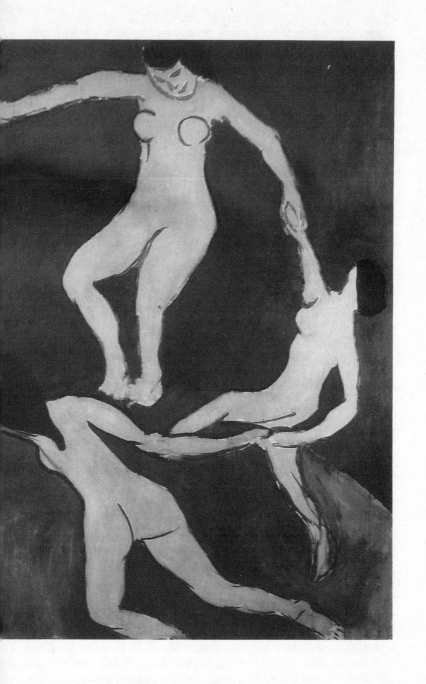

aesthetic statement' which was created by 'relations of colour, line and mass'.[65] The critic of *The Times*, chastising the English contingent for their tendency to 'sacrifice mass to colour', said similarly that a vital component of a good Post-Impressionist painting was 'a strong underlying sense of mass and form'.[66]

Writers who were at ease with the new language took the opportunity to apply it beyond the specific examples presented in the catalogue introductions. Bell said there that Fry and Grant were 'plastic artists'. Thus Drey, developing Bell's idea of plasticity, declared that 'by means of dominant rhythmical relationships', the Post-Impressionists had discovered the means to express their emotions in truly plastic form.[67] Konody took up Bell's notion of significance. In the *Observer* he described the aim of Cézanne, Van Gogh and Gauguin as the achievement of 'a more intense and significant expressiveness than could be found in representation'. He praised *La Danse* because it showed 'all the significant movement, the broad simplification, the swinging rhythm, but passionately intensified, that are found in the figures painted on Greek vases'.[68] But his most imaginative language, however, he reserved for the *Daily Mail*. There, he showed his enthusiasm – in marked contrast to his dismissiveness of two years earlier – for the dancers by calling attention to 'their inimitable rhythm of significant line'.[69]

If one consequence of the critics' acceptance of the Post-Impressionist aesthetic was the development and dissemination of this language, another was a change in the kinds of charges which were levelled at the Post-Impressionist painters. Inevitably, once the enterprise itself was seen as legitimate, many of the issues which had engendered such heated debate two years before were no longer relevant. So they were now ignored, or raised only with regard to particular painters who were found wanting under the Post-Impressionist aesthetic. The writers we are now considering had abandoned 'truth to nature' and had no need to decry the loss of standards, for they had found new ones, which were applicable to new painting. But some artists – Picasso and Lewis in particular – were accused of charlatanry, of the desire to shock and, occasionally, of incompetence.

Any accusation of incompetence or of charlatanry could only be sustained – under a strict interpretation of Post-Impressionist theory at least – by recourse to standards which converts to Post-Impressionism had abandoned. So where charges did appear, they

had necessarily to be without explanation. The critic of the *Pall Mall Gazette*, for instance, admitted that none of the artists were mad, but concluded that they were not 'entirely serious'. At the same time, however, he admired Cézanne and Matisse and Picasso, so his charge could carry little force.

Charlatanry was one of the complaints about the artists represented in the Second Post-Impressionist Show that was carried over from 1910. Other legacies from the first show were the belief that some Post-Impressionists only desired notoriety, and criticism of Fry for allowing them to achieve it. These charges, however, no longer had the prominence or force of two years before. Instead there were new means of showing disapproval. First, critics tried to dismiss painters by a display of indifference. Second, they shifted their attack from the standards by which a painting was evaluated to the means by which it was discussed. Third, they devoted a good deal of space to their unfavourable opinions of the Cubist work of Picasso and Braque.

Those critics who displayed indifference implied that they had no need to take up the issues which the show raised, and revealed that they were unwilling to do so. This apparent lack of concern, so different from the heated argument two years earlier, showed that writers recognised that Post-Impressionism was permanently established in England and that they no longer considered that it was worthwhile combating it. So instead of fighting, hostile critics dismissed the show with as little serious consideration as possible. In so doing, these writers were in fact pointing to the formation of an avant-garde which had its own practice, standards and language, and which was independent of the practice, standards and language which hostile critics still supported.

The critic of the *Evening News* confirmed the existence of these two separate groups and bravely declared that he was 'taking the Philistine view'. 'Those who have got beyond the art of Velasquez or Holbein', he added with ineffective irony, 'see in what are to most of us crude and offensive productions the promise of a great and glorious movement'. But he did not go on either to challenge that view or to defend his own. Instead he contented himself with aphorism. The Post-Impressionists, he said, were either 'those who can paint and like to pretend they cannot', or 'those who cannot paint but like to pretend they can'.[70] Similar levity was displayed by Douglas who, in *London Opinion*, dismissed the show as a

'spoof'.[71] The *Art Chronicle* agreed that 'most people seem to think the exhibition an intentional joke', proceeded to caution young painters who might have been tempted to mimic Matisse or Picasso, but concluded that 'such quantities of ink have been spilled over Post-Impressionism that we feel there is little now to be said about the show'.[72]

The critic of the *Westminster Gazette* shared this view. He said nothing about the show itself, and did not mention one picture by name. Instead he placed himself at a distance from Post-Impressionism with a humorous attack on the catalogue, thus implying that neither he nor his readers need take seriously the issues that were presented there. 'We have lost . . . our cherished friends "the treeness of the tree", and the "good rocking horse" ', he said, referring to parts of the 1910 catalogue which had provoked undisguised animosity from critics. But, he went on, 'there are consolations. Mr Clive Bell enlightens us as to the true sense in which we may 'contemplate emotionally the coal scuttle as the friend of man'.[73]

The writer in the *Westminster Gazette* was one of several who registered their dislike of all or part of the show by an attack on the critical apparatus which accompanied it. Douglas accused Bell and Fry of 'weaving all sorts of subtleties round an orgy of bad painting'.[74] Spielmann complained that 'even if we do not ask what [a picture] represents, the catalogue tells us',[75] while Finberg commented ironically, 'after a careful study of Mr Fry's writings, it is easy to understand how M. Picasso has come to paint this way, and how his admirers have been able to understand such hopeless and dull absurdities'.[76] The *Morning Post* critic was equally vociferous in his dislike of the catalogue.[77]

The critical attention devoted to the catalogue was significant for two reasons. First, it showed how little room critics had for manoeuvre. For those who refused to take the show seriously and who were no longer prepared to defend previous standards of judgment in public, discussion of the paintings was very difficult, because they could not compromise themselves by using the Post-Impressionist terms of reference. The attack on the catalogue was an attempt to undermine the enterprise without making any concessions towards it, because it meant that writers could avoid all discussion of the work displayed.

Second, the attention paid to the catalogue reflected widespread

recognition of the importance of critical theory to the understanding of the works it justified. The reviewer from the *Tatler* conceded this point when he blamed the theory for his inability to understand the canvas. 'After all', he said, 'what is the use of concentrating on the "significance of form" if no intelligent person can make it out even after he has hunted all through the catalogue'.[78] The single satirical contribution to the 1912 reviews served to underline the new attention that was being paid to theory and language, and in particular to the language of form. 'We are threatened', said *Isis*, 'with a new system of aesthetic values. Instead of How Beautiful! And How Fine! We are going to have How Roguishly Rhomboidal! How Tantalisingly Triangular!'[79]

If some of the theory which was offered drew attack, some of it drew incomprehension. In particular, the explanation which Fry gave for Cubism seemed inadequate to the majority of reviewers. Fry implied that Cubism was the logical extension of the search to create, rather than imitate, form. Picasso, he said, was trying to 'create a purely abstract language of form – a visual music'.[80] This statement did not, in fact, contain any theoretical, or even metaphorical, advance upon MacCarthy's 1910 statement that Matisse was searching for 'an abstract harmony of line'.[81] But whereas in 1910 enthusiastic critics had found the application of this theory to Matisse's work perfectly acceptable, two years later they found it an insufficient explanation for Picasso's. The works in the show which particularly bewildered them were the two canvases each entitled *Tête de femme* (cat. nos 64 and 66), *Tête d'homme* (68), *Livres et flacons* (69), *Buffalo Bill* (70) and *Le Bouillon Kub* (16). *Le Bouillon Kub* was the subject of several attempts at a humorous dismissal of Picasso. Along with Braque's *Kubelik* it gave critics the opportunity of punning on Cubism, and thus of trying to dismiss Cubism by refusing to take it seriously.

No less than seven writers, however, condemned Picasso's abstract painting on the grounds that it was not art but science. 'Picasso states science', said Hind, 'and when science swallows art, then goodbye to art'.[82] Douglas said that Picasso was 'a geometrician, not an artist',[83] and Konody agreed that Picasso produced 'abstruse geometrical problems' which were 'surely not art'.[84] Finberg charged that not only the practice but also the theory were 'simply borrowed from the science of geometry'.[85]

Various factors contributed to critical unease about Picasso's

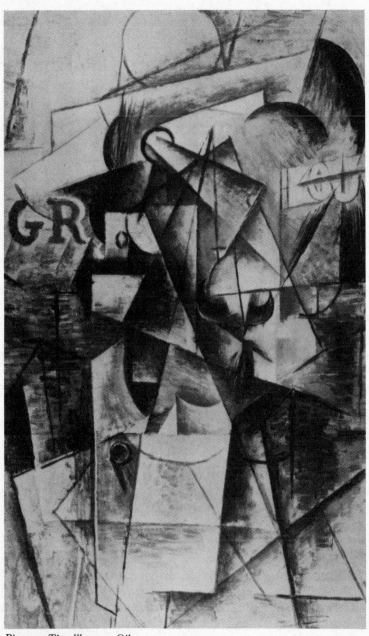

Picasso, *Tête d'homme*. Oil.

abstract painting. It did not appear to conform to the Post-Impressionist dictum that the purpose of art was the communication of emotion. 'To profess that these jigsaw puzzles produce any emotion except hilarity would be hypocrisy', declared Konody.[86] The *Connoisseur*'s critic said that if abstract painting could transmit profound emotion, it should be exhibited without titles. Writers also picked up on Fry's uneasiness about the transmission of emotion. Fry tried to combat accusations against Picasso in the article he wrote for the *Nation*. There, he asserted that Picasso was not a methodical theorist but was rather instinctive and emotional. 'Sensibility is his most salient characteristic', Fry said, and Picasso 'reaches out in any direction which his instinct dictates for the possible expression of his sensibility to natural objects'. But Fry said nothing which would reassure critics about Picasso's products. Indeed, he reiterated his reservations. 'As to the latest works of all', he ruefully admitted, 'I confess that I take them somewhat on trust'.[87]

Finally, because of the geometric forms which Picasso and Braque used in their Cubist work, commentators thought of the paintings as diagrammatic, rigid, mathematical and thus, by extension, scientific. On top of these assumptions they heaped all the negative associations which science held for them, connections with unthinking, unspiritual materialism. It was this materialism, they believed, and the social conditions which resulted from a reliance on materialism, that starved the emotions and the soul. Cubism thus bewildered these critics, for the way they interpreted it clashed with their belief in Post-Impressionism as an anti-materialist, spiritual crusade in which the expression of emotion through form transmitted a hope for a new kind of world where science would have very little place. The writer in the *Saturday Review* tried to reconcile Post-Impressionism and Cubism by bringing science and the communication of emotion together. He said that 'a reasonable definition of Post-Impressionism is an abstruse science for the propagation of passionately emotional diagrams'. But, he continued, 'surely we can find a place for this new movement without incorporating it with art'.[88] Most other critics tried less hard. Those who responded well to Post-Impressionism generally contented themselves with exempting Picasso from their praise and pushing Cubism outside the pale of acceptable new art.

Such equivocation about science also explains critical hostility to

London-based artists who proclaimed their attachment to it.
Hulme's demand for an art based upon mechanical models,
Pound's claim of 1913 that 'the arts . . . are a science, just as
chemistry is a science',[89] or Lewis's suggestion in *Blast 2* that
'European painting today is like the laboratory of the anatomist'[90]
were likely to meet with little favour. This mistrust of much that
was associated with science, then, provides one reason why a work
like Bell's *Art* was so successful. For Bloomsbury shared those
fears. Bell said in *Art* that 'to criticise a work of art historically is
to play the science-besotted fool. No more disastrous theory ever
issued from the brain of a charlatan than that of evolution in art.'[91]

Some critics included Wyndham Lewis in the criticisms they
made of Picasso. Discussing Lewis's *Mother and Child* (cat. no.
112) the *Connoisseur*'s reviewer implied the impossibility of
rendering, not simply an emotion, but a psychological state by
means associated with science. He dismissed the painting because,
he said, 'maternity is represented by what appears to be a compli-
cated architectural diagram'.[92] Konody offered the same reason for
his dislike of Lewis's work as he had for his reaction to Picasso. It
did not, he said, arouse anger or emotion of any kind.[93] Other
writers saw Lewis as Picasso's disciple, and suggested that he was
not only imitative but inferior.

The associations between the two which were made by critics
and public alike may help to explain the virulence of Lewis's later
denunciations of Picasso. In 1919 Lewis made strenuous efforts to
equate Picasso with Bloomsbury in *The Caliph's Design*.[94] This may
have been in part because he held Bloomsbury responsible for the
way in which his work was regarded.

This assessment of Lewis as a weak disciple of Picasso was part
of a wider charge that all the English painters were inferior to
their continental counterparts. This criticism was indicative of an
important shift in attitude towards French painting and towards
the relationship between English and French painting. The xeno-
phobia of 1910 was quite absent from the notices of Fry's second
show. British art was now measured against continental art and
found to be less successful. That meant that French art, and the
art of Matisse in particular, was accepted as the standard by which
British art was to be judged. The frank, bombastic nationalism of
Vorticism must thus be seen against this rapid volte-face by audi-
ence and critics. The success of those painters who took Matisse

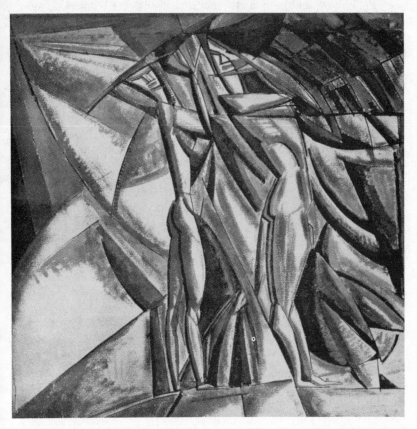

Wyndham Lewis, *Creation*. (Reproduced by permission of the Estate of Mrs G. A. Wyndham Lewis.)

and Cézanne as their models owed a good deal to the *entente* with Paris which Bloomsbury had promoted and endorsed. The comparative failure of art being produced in Germany to capture the esteem of practitioners and public may have resulted in large measure from Bloomsbury's lack of interest in it, and undoubtedly contributed to the subsequent neglect of German art in Britain and British collections for the next seventy years. Kandinsky – Russian-born but based in Germany – had shown at the Allied Artists'

1911 show, and he was also included in the first Grafton Group exhibition, but he was left out of the Second Post-Impressionist Show altogether.

## NOTES

1  Figures taken from Frances Spalding, *Roger Fry, Art and Life* (London: Granada 1980), p. 163.
2  Manson to Lucien Pissarro, 9 December 1912, quoted in Wendy Baron, *The Camden Town Group* (London: Scolar Press 1979), p. 50.
3  'Post-Impressionists and Others Reconsidered', *Athenaeum*, 24 December 1910, p. 801.
4  Laurence Binyon, 'Post-Impressionists', *Saturday Review*, 12 November 1910, p. 610.
5  P. G. Konody, 'More Post-Impressionism at the Grafton', *Observer*, 6 October 1912, p. 6.
6  M. T. H. Sadler, 'Fauvism and a Fauve', *Rhythm*, vol. 1, no. 1, Summer 1911, pp. 14–17.
7  'Second Post-Impressionist Exhibition', *Catalogue* (London: Ballantyne 1912).
8  *Catalogue*, p. 21.
9  *Catalogue*, p. 23.
10  *Catalogue*, p. 22.
11  *Catalogue*, p. 22.
12  Clive Bell, *Art* (London: Chatto 1914), p. 44.
13  *Catalogue*, p. 22.
14  *Catalogue*, pp. 23–4.
15  *Catalogue*, p. 28.
16  *Catalogue*, p. 26.
17  *Catalogue*, p. 27.
18  *Catalogue*, pp. 26–9.
19  *Catalogue*, pp. 26–9.
20  Roger Fry, 'The Grafton Gallery: An Apologia', *Nation*, 9 November 1912, p. 250.
21  Clive Bell, review of C. J. Holmes, *Notes on the Post-Impressionist Painters*, *Athenaeum*, 7 January 1911, p. 20.
22  Clive Bell, review of F. Rutter, *Revolution in Art*, *Athenaeum*, 4 February 1911, p. 135.
23  Clive Bell, letter to the *Nation*, 22 February 1913, pp. 853–4.
24  Roger Fry, 'An English Sculptor', *Nation*, 28 January 1911, pp. 718–9.
25  Roger Fry, 'Plastic Design', *Nation*, 6 June 1911, p. 396.
26  Roger Fry, 'The Allied Artists' Association', *Nation*, 20 July 1912, pp. 583–4.

27  Roger Fry, 'Acquisition by the National Gallery at Helsingfors', *Burlington*, February 1911, p. 293.
28  Irving Babbitt, *The New Laokoon* (London: Constable 1910), pp. 240–1.
29  Anthony Ludovici, *Nietzsche and Art* (London: Constable 1911), p. 19,
30  *The Letters of a Post-Impressionist*, trans. by A. M. Ludovici (London: Constable 1910), p. xxxi.
31  Anthony Ludovici, 'White Roses at the Stafford and Carfax Galleries', *New Age*, 17 October 1912, p. 596.
32  J. B. Manson, 'London Impressionists', *Outlook*, 14 December 1912, p. 794. Manson's use of the word 'modern' in this review, makes it quite clear that he regarded the word as applicable to himself.
33  J. B. Manson, 'Spiritual Experience at the Grafton Gallery', *Outlook*, 26 October 1912, p. 559.
34  J. B. Manson, *Outlook*, 14 December 1912, p. 795.
35  M. H. Spielmann, 'Grotesque Art at the Grafton', *Daily News and Leader*, 4 October 1912, p. 7.
36  *Mayfair and Town Topics*, 30 October 1912, p. 351.
37  James Douglas, 'The Great Art Hoax', *London Opinion*, 19 October 1912, p. 84.
38  'More Post-Impressionism', *Morning Post*, 4 October 1912, p. 4.
39  Anthony Ludovici, 'The Pot-Boiler Paramount', *New Age*, 21 November 1912, p. 67.
40  C. H. Collins-Baker, 'Post-Impressionist Prefaces', *Saturday Review*, 19 November 1912, pp. 577–8.
41  C. Lewis Hind, 'Ideals of Post-Impressionism', *Daily Chronicle*, 5 October 1912, p. 6. 'W.R.', 'Post-Impressionism at the Grafton', *Sunday Times*, 6 October 1912, p. 6; 'E.S.G.', 'Impressions of the Post-Impressionist Show', *Daily Graphic*, 4 October 1912, p. 6.
42  Charles Marriot, 'Post-Impressionism: Remarkable Exhibition at the Grafton Galleries: Pragmatism in Art', *Evening Standard*, 7 October 1912, p. 15.
43  'W.R.', *Sunday Times*, 6 October 1912, p. 6.
44  'E.S.G.', 'Impressions of the Post-Impressionist Show', *Graphic* 4 October 1912, p. 6.
45  'W.R.', 'Post-Impressionism', *Sunday Times*, 6 October 1912, p. 6.
46  Hind, 'Ideals of Post-Impressionism', *Chronicle*, 5 October 1912, p. 6.
47  'E.S.G.', 'Impressions of the Post-Impressionist Show', *Graphic*, 4 October 1912, p. 6.
48  'The Post-Impressionists', *The Times*, 21 October 1912, p. 10.
49  Sir Claude Phillips, 'The Grafton Galleries: The Second Post-Impressionist Exhibition', *Daily Telegraph*, 5 October 1912, p. 9.
50  'G.R.H.', 'Post-Impressionists', *Pall Mall Gazette*, 4 October 1912, p. 10.
51  P. G. Konody, 'More Post-Impressionism at the Grafton', *Observer*, 6 October 1912, p. 6.
52  'G.R.H.', *Pall Mall Gazette*, 4 October 1912, p. 10.

53 'Art Notes', *Illustrated London News*, 12 October 1912, pp. 542–4.
54 'The Post-Impressionist Exhibition', *Connoisseur*, November 1912, p. 191.
55 Roger Fry, 'The Grafton Gallery: An Apologia', *Nation*, 9 November 1912, p. 250.
56 *Catalogue*, p. 26.
57 *Catalogue*, p. 26.
58 D. S. MacColl, *Confessions of a Keeper and other Papers* (London: Alexander Maclehose 1931), p. 202.
59 *Connoisseur*, November 1912, p. 191.
60 Konody, *Observer*, 6 October 1912, p. 6.
61 'G.R.H.', *Pall Mall Gazette*, 6 October 1912, p. 10.
62 'Cubist Comedies: Post-Impressionism and the Public', *Globe*, 8 October 1912, p. 4.
63 *Illustrated London News*, 12 October, 1912, p. 544.
64 Phillips, *Telegraph*, 5 October 1912, p. 9.
65 O. Raymond Drey, letter to the *Saturday Review*, 14 December 1912, p. 735.
66 *The Times*, 21 October 1912, p. 10.
67 Drey, *Saturday Review*, 14 December 1912, p. 735.
68 Konody, *Observer*, 6 October 1912, p. 6.
69 Konody, 'The Comic Cubists', *Daily Mail*, 5 October 1912, p. 6.
70 *Evening News*, 5 October 1912, p. 2.
71 Douglas, *London Opinion*, 19 October 1912, p. 84.
72 *Art Chronicle and Art News*, 8 October 1912, p. 514.
73 'E.S.', 'The Grafton Galleries: Second Post', *Westminster Gazette*, 7 October 1912, p. 3.
74 Douglas, *London Opinion*, 19 October 1912, p. 84.
75 Spielmann, *Daily News*, 4 October 1912, p. 7.
76 A. J. Finberg, 'Post-Impressionism at the Grafton Gallery', *Star*, 5 October 1912, p. 4.
77 *Morning Post*, 4 October 1912, p. 4.
78 'The Post-Impressionists', *Tatler*, 16 October 1912, p. 72.
79 'Heard in the High', *Isis*, 19 October 1912, p. 7.
80 *Catalogue*, p. 27.
81 [Desmond MacCarthy], *Manet and the Post-Impressionists* (London: Ballantyne 1910), p. 11.
82 Hind, *Chronicle*, 5 October 1912, p. 6.
83 Douglas, *London Opinion*, 19 October 1912, p. 84.
84 Konody, *Mail*, 5 October 1912, p. 6.
85 Finberg, *Star*, 5 October 1912, p. 4.
86 Konody, *Observer*, 6 October 1912, p. 6.
87 Fry, *Nation*, 9 November 1912, p. 250.
88 Collins-Baker, *Saturday Review*, 19 November 1912, p. 578.
89 Ezra Pound, 'The Serious Artist', 1913, rpt. in *Pavannes and Divisions* (New York: Knopf 1918), p. 220.
90 Wyndham Lewis, 'Review of Contemporary Art', *Blast 2* (London 1915), p. 39.

91  Bell, *Art*, p. 102.
92  *Connoisseur*, Nov. 1912, p. 191.
93  P. G. Konody, 'More Post-Impressionism at the Grafton', *Observer* 6 October 1912, p. 6.
94  Wyndham Lewis, *The Caliph's Design. Architects Where is your Vortex?* (London: *Egoist* 1919), pp. 67–9.

# 6

# DEBATES AND DISPUTES AFTER THE SECOND POST-IMPRESSIONIST SHOW

The Second Post-Impressionist Show had several important results. First, the great majority of reviewers accepted and publicised the aesthetic which Fry put forward and the limits of tolerance that went along with it. In so doing, they confirmed Fry as the leader of the avant-garde and thus helped him to consolidate the position which he had established as a result of the first show. As MacColl noted, 'the critics were disconcerted, but nervously determined, this time, to be on the winning side. . . . Mr Roger Fry had declared for the new aesthetic, or religion, and the impressionable could but wheel after him.'[1]

Fry also took several painters with him. The Matisse paintings in the show, particularly *La Danse* and *Le Panneau rouge*, were crucial in the formation of British Post-Impressionist style. The thin, brushed paint of both the sketch and *Le Panneau rouge* crop up again and again in pre-war English Post-Impressionist painting, attempting to reproduce the spontaneity which supporters of Post-Impressionism believed was encapsulated in Matisse's style. *La Danse* of course, represented naturalness, freedom, (abandon almost) and spontaneity in its very subject matter, and these, too, were to become enduringly attractive subjects for English Post-Impressionist painters. Grant, in particular, painted dancers over and over again in the coming years.[2]

When Fry secured the critics he went a good way towards securing the readers whom they addressed. The reviews of the Second Post-Impressionist Show suggest that as it became fashion-

able, so Post-Impressionism drew an audience from an increasingly wide social spectrum. Whereas the first show had found adherents mainly amongst liberals – self-educated or university educated – the second won support from those both further up the social scale and further to the right politically. The *Connoisseur*, the *Daily Telegraph*, *The Times*, the *Pall Mall Gazette*, the *Observer* and the *Sunday Times* were all prepared to print notices which accepted the premises on which the show was built. This suggests that the second show drew more of its audience from the upper classes and from those who tended to follow the upper classes in matters of taste. This change was partly achieved because support for Post-Impressionism had become socially acceptable. But it was also due to the role which Clive Bell played in its promotion. Bell not only set out to court the upper classes, he also emphasised the new art's exclusivity by giving it an elitist colouring which had not been in evidence in 1910.

In his writings Bell appealed directly to this audience. He did so in such a way as to suggest that those who appreciated Post-Impressionism, and the art which fitted into the great tradition which culminated in Post-Impressionism, had a monopoly upon sensibility. Soon after the 1912 show closed he wrote that 'sensitive people' seemed to agree that all great works of art generated aesthetic emotion.[3] This suggested that those who disagreed were without taste and of no consequence. Of course many early Modernist writings – those of Lewis, Pound, Nevinson, Aldington and Eliot, for instance – adopted more or less aggressively hostile attitudes towards an uninitiated public. But Bell never went so far as to alienate his potential public – although he obviously limited it to those who counted themselves among the sensitive. Instead he succeeded in combining initiation and fashion, the aesthetically exclusive with the socially exclusive. This combination, so important for operations like the Omega Workshops, was already in evidence in 1912. Arnold Bennett noted acerbicly in his diary a few days after the opening of the Second Post-Impressionist Show that, 'One reason for the popularity of shows like this is that they give the grossly inartistic leisured class an opportunity to feel artistically superior'.[4] Just as importantly, the presence of the leisured class gave Post-Impressionism an added attraction for its socially aspirant supporters.

The second consequence of the 1912 show was the recognition

of the avant-garde as a group separated from other practitioners, and as a group which had a language, theory and version of the past which seemed to pertain only to itself. It was not only critics of the 1912 show who saw that painting had become separated into two distinct kinds of endeavour. Painters and theorists who had attacked the first show saw it too. They acknowledged their separation by ignoring Fry's second exhibition and thus by removing themselves from the issues which it raised.

Neither the painters Phillip Burne-Jones, W. B. Richmond, Charles Ricketts and Arthur Severn, nor the critics C. J. Weld-Blundell, T. B. Hyslop or E. Wake Cook, made any public stand on the second show. All these men tacitly recognised that Fry had secured a forum for the new painting. That meant that they also accepted that this painting could be judged according to standards which were inimical to their own. As long as their practices and standards remained free from assault they were reconciled to Fry's new position and to their own consequent diminution of standing.

But this uneasy peace did not last for long. Towards the end of the show's run, Fry mounted a strong challenge to 'official' art. He published an attack on the recently deceased Alma Tadema in the *Nation*. He described Alma Tadema as a painter who catered for 'an extreme of mental and imaginative laziness'.[5] He also used the same kind of class-based argument against him as the opponents of the First Post-Impressionist Show had used against the painters represented there. Alma Tadema's work, said Fry, 'finds its chief support among the half-educated members of the lower-middle classes. Its appeal to them is irresistible because it gives them in another "line" precisely the kind of article they are accustomed to buy and sell.'[6]

Neither Burne-Jones nor Richmond could tolerate such an attack on a man so closely connected with their own practice and both wrote to the *Nation* in support of Alma Tadema.[7] But the way in which they tried to defend themselves was by attacks upon Fry and the Post-Impressionist painting he promoted. In so doing they lost the opportunity of explaining their own standards and practices. Fry, and those who wrote in his defence, seized the chance thus presented to them of advertising Post-Impressionism. Clive Bell, Lytton Strachey and Edward Wadsworth (then a member of the Friday Club) all endorsed Fry's views.[8] Bell underlined the separate nature of the avant-garde, and equated the avant-garde with

Bloomsbury, by dividing views on art into two opposed kinds, the 'official' and the 'aesthetic'. According to the official view, he said, the value of a work was dependent upon 'representation' and 'prettiness'. According to the aesthetic point of view it was dependent 'solely upon its power of provoking a peculiar emotion, called "aesthetic" '.[9] With this distinction Bell added another polarity to the series of polarities by which early Modernism defined itself. 'Aesthetic' came to share in the positive overtones carried by the other definitions. It came to be associated with the classic as opposed to the romantic, the expressive rather than the scientific and above all with the work that was worthy of consideration and criticism rather than the work that was beyond the critical pale.

Bell's division of art into two camps (like his sister-in-law's division of the novel some years later) left no room for a middle party, and thus highlighted the third consequence of the Second Post-Impressionist Show. It marked the start of the difficulties for the groups and individuals who had either refused to co-operate with Bell or who had been left out of his selection of the English representatives of Post-Impressionism. From this time the position of Camden Town began to get weaker, and Bloomsbury dominated the avant-garde virtually unchallenged until the autumn of 1913.

A few painters showed that they understood the nature of Fry's position in the avant-garde. Spencer Gore, while maintaining his links with Camden Town, began to extend his contacts with the Bloomsbury circle. Not only did he show three major canvases in the Second Post-Impressionist Show, he was also close enough to Bloomsbury in the eyes of the public to be included in the *Daily Mail's* initial offer of the commission for the Ideal Home Exhibition. Sickert, too, perhaps realised that in the polarisation between the avant-garde and 'official' painters, as Bell called them, the Camden Town and Fitzroy Street groups were in danger of being left without adequate linguistic or critical representation. He saw also that Gore and Lewis, the latter by this time an increasingly prominent member of Camden Town, were involved in Bloomsbury-based enterprises. If the painters around Sickert wished to regain some of the ground they had begun to lose at the time of the Second Post-Impressionist Show, and if they wished to remain connected to younger painters, then some kind of alliance with Bloomsbury was advisable. Perhaps for these reasons, Sickert considered a merger between the Camden Town Group, the

Fitzroy Street Group and the Bloomsbury-based Friday Club. The new group would, he said, 'make *the* only interesting crowd in London'.[10] Sickert was planning this amalgamation in the autumn of 1913. It was, however, not put to the test, because in October of that year the 'Ideal Home Rumpus' pre-empted all negotiations and split the avant-garde beyond repair.

The 'Ideal Home Rumpus' led to a total breach between Lewis and Fry, and exacerbated their considerable aesthetic differences. The split between them produced two opposing factions. Among those who took Lewis's side were Sickert and Gore. Their allegiance prevented any co-operation with Bloomsbury, and thus the chance to assert the place of the Camden Town painters in the forefront of the avant-garde was lost.

The 'Ideal Home Rumpus' marked the moment at which a relatively homogeneous and harmonious avant-garde began to fragment. As it broke up, each faction needed critical representatives who could place their ideas before the public. Accordingly, after the rumpus, writers and writings began to play an important part in controversy between rival avant-garde groups. The public face of the avant-garde became far more diverse in consequence. Before the end of 1913 the only English group in which writers, painters and critics had collaborated for their mutual benefit was the *Rhythm* group. The example of the Italian Futurists undoubtedly stimulated Pound and Hulme to similar efforts on behalf of painters and sculptors.

The appearance of the critics was one factor in the breakup of the avant-garde after the end of the Second Post-Impressionist Show, a process which began with the formation of the Grafton Group in early 1913 and ended with the emergence of Vorticism a month before the outbreak of war in 1914. But the most important factors were the growth and spread of Bloomsbury's influence and the growing determination of members of the avant-garde who did not share the Post-Impressionist aesthetic to counter Fry's domination not only of much of the market, but also of younger painters coming out of the art schools. The escalation of strife amongst avant-garde groupings in the last year before the war was an indication of the increasing rewards which could be gained by a share in the market for avant-garde products.

Although the success of Post-Impressionism lay at the back of these disputes, it did not mean that the strong position of the

Bloomsbury circle was the motive force behind every quarrel. It simply meant that Fry had uncovered and brought to light a market for avant-garde art. The conduct of the quarrels between rival individuals and factions made this quite clear.

The 'Ideal Home Rumpus' of October 1913 split the avant-garde into two opposed factions. One was concentrated around the Omega Workshops and the recently formed Grafton Group. The other was based around the London Group. The London Group was formed shortly after the rumpus, and embraced a wide variety of aesthetic and stylistic standpoints, from Camden Town to the Omega secessionists.

The London Group was perhaps too heterogeneous to remain united and peaceable for long. But the internal dissension which split it was prompted more by the reaction to Lewis's increasing dominance in the Group than by any desire to counteract Fry and his circle. In March 1914 Pissarro left the Group and then Sickert quarrelled with Lewis. At the same time the reaction to Ginner's 'Neo-Realism' article provoked a split between both Ginner and Sickert and Ginner and Hulme.

Shortly after his difference with Sickert, Lewis established the Rebel Art Centre. Initially he had Hulme's support, but within a few weeks he had quarrelled with Hulme as well. The final break with all other avant-garde groupings came in June 1914 when Lewis parted company with Nevinson and Marinetti. It was from this quarrel that Vorticism emerged.

None of these disputes had any direct connection with Bloomsbury. Lewis's progressive dissociation from other groups was prompted by his desire to establish a style and aesthetic of his own, and was fuelled by his own irascibility. Nevertheless, the style and aesthetic which emerged was a deliberate challenge to Post-Impressionism. Similarly, the disputes between Ginner and Sickert and Ginner and Hulme over Neo-Realism were nothing to do with the Bloomsbury circle. But Neo-Realism was a concerted attack on Post-Impressionist theory and practice.

The common denominator between Neo-Realism and Vorticism was the determination of their creators that they should be seen by the audience for modern art as different from, and independent of, Post-Impressionism. Neo-Realism was Ginner's first and last attempt to dissociate himself from the Post-Impressionist cause. Vorticism was the culmination of Lewis's campaign for indepen-

dence and followed his espousal and then rejection of alternatives to Post-Impressionism.

In late 1913 the only possible alternatives to Post-Impressionism were Cubism and Futurism. Although he was equivocal about them, Lewis exhibited – along with other artists, including the Omega rebels – under both titles immediately after the break with Fry. Between October 1913 and January 1914, Lewis, along with Etchells, Wadsworth, Nevinson, Hamilton and Epstein made up 'The Cubist Room' in the Brighton exhibition 'English Post-Impressionists, Cubists and Others'. Lewis contributed an essay on 'The Cubist Room' to the catalogue. In it he seized the opportunity – a month after the rumpus – of calling Post-Impressionism 'an insipid and pointless name invented by a journalist'.[11] His adoption of the name of Cubist was hardly enthusiastic, however, and he made no specific links between the work of painters in 'The Cubist Room' and Parisian Cubism.

Lewis's equivocation about a title was evident in the naming of another exhibition 'Post-Impressionists and Futurists' which was organised by Frank Rutter in October 1913 at the Doré Gallery. There, Lewis, Etchells, Hamilton, Wadsworth and Nevinson were classed, apparently with their agreement, as Futurists.[12] Until the quarrel with Marinetti some six months later, Lewis was content to remain a Futurist in the eyes of the public – at any rate that part of the public which recognised that he had broken with Post-Impressionism. This was perhaps because he recognised the advantages of the publicity which Marinetti could secure, and perhaps because of his growing dissatisfaction with Cubism. The entrenchment of Post-Impressionism as an orthodoxy within the avant-garde and the growing market for avant-garde products helped, then, to explain the reasons for the fragmentation of the avant-garde. The content of the debate which accompanied this fragmentation was also largely determined by these factors. But it should also be seen against the more specific background of the two Post-Impressionist shows. Many of the articles, essays and letters published in 1914 referred directly to the assumptions upon which the two shows rested. Not until Lewis attacked Futurism did the theoretical debate leave the premises of Post-Impressionism.

Members of the Bloomsbury circle, however, did not participate directly in any of these debates. Bloomsbury's major contribution in 1914 was Bell's *Art*, published early in the year. In *Art*, Bell

restated and strengthened the Post-Impressionist case, but made no reference to any other aspect of production or theory. So, rather than attempting to discredit their rivals, the Bloomsbury critics and painters concentrated on publicising Post-Impressionism and winning supporters, which proved a far more effective way of bringing about a change of taste. For this reason Fry and Bell never had any need to issue a manifesto of their own.

Those opposed to Post-Impressionism laboured at a disadvantage. The theory they put forward necessarily ran counter to that of Bloomsbury, and so Bloomsbury had to be disavowed before their own theory could gain credence. Thus theoretical discussion between rival factions served two related ends. First, it was intended to publicise a distinct aesthetic – a version of the history of modern art, a language of discussion and a means of evaluation – which would sanction production. Second, it was intended to capture all or part of the market and support which Bloomsbury commanded. Without public support artists like Lewis, Wadsworth, Bomberg or Gaudier could not hope either to secure commissions and earn a living, or to bring about any widespread change in taste. Articles like those of Ginner or Hulme in the *New Age*, no less than a bulky production like *Blast*, were directed both inwards to other members of the avant-garde and outwards to a wider general audience. Such manifestos have a pedigree within the history of art itself, connections with both Futurist manifestos and earlier effusions like Whistler's *Gentle Art of Making Enemies*. But the audience could also have seen them in a broader context as tracts, advertisements for and defences of causes. In a movement like Post-Impressionism, which had some of the trappings of a religious movement, each sect put out its own tracts. It was a kind of publication very familiar to late Victorians. Despite the hostility which many practitioners displayed towards the public, the very existence of these manifestos and articles reveals that the avant-garde was ultimately dependent upon it. It is no surprise that the quarrel between Lewis and Fry centred upon the matter of a public commission. The 'Ideal Home Rumpus' was the beginning of Lewis's struggle to secure a market, and the commission itself was evidence of the hold which Bloomsbury had over that market.

In the attempt by any group or individual to establish an aesthetic and practice different from Post-Impressionism, the critic became increasingly important. Not only did he have to explain paintings

or sculpture which bewildered the audience, he also had to provide that audience with the means of distinguishing those works from all other avant-garde productions. To Bell, writing in 1913, the critic's role was simply to distinguish between works which lived up to Post-Impressionist standards and works which did not. So he could say, with reference to the Futurists, that 'the critic of art has only to note that the forms and colours are in themselves insignificant and in their relations commonplace'.[13] The critic's job, then, was to provide a formal analysis and to evaluate what he saw.

Hulme and Pound, however, saw their job differently. While Hulme admitted that 'the appreciation of a work of art must be plastic or nothing', he declared that he was also 'engaged in the more negative and quite justifiable business of attempting to protect the spectator from certain prejudices'.[14] The immediate cause of Hulme's outburst was the 'prejudice' displayed by Ludovici in his review of Epstein's one man show at the Twenty-One Gallery in late 1913.[15] But Ludovici was, in the context of modern art, an insignificant and marginal opponent. Gradually it was the 'prejudices' of Bloomsbury which began to engross him. So the choice of examples by which Hulme illustrated his theory and defended his friends was often made with Bloomsbury in mind. In December 1913, for instance, he defended Epstein's use of primitive models on the grounds that, regardless of time, similar forms would be produced by the need to express similar emotions. Form, he said, followed attitude. He illustrated this statement by saying, 'I am moved by a Byzantine mosaic . . . because it expresses an attitude I agree with'.[16]

This example was a direct challenge to Bloomsbury. For Bloomsbury writers had frequently used the example of Byzantine art as a backup for the idea of significant form and thus for Post-Impressionism. Indeed, Fry had used Byzantine art as a yardstick of excellence and as an historical precedent even before he had formulated a Post-Impressionist aesthetic. As early as 1904 Fry was using Byzantium to praise Blake.[17] (Arts and Crafts writers had, in just the same way, used medieval art to proclaim Blake's greatness.) Fry had gone on to invoke Byzantine art at the time of 'Manet and the Post-Impressionists', Anrep had included the Russians in the second show by claiming kinship with Post-Impressionism through Byzantine models, and Bell made the connection between Byzantinism and Post-Impressionism explicit

in *Art*. 'Since the Byzantine primitives set their mosaics at Ravenna', he said, 'no artist in Europe has created forms of greater significance unless it be Cézanne'.[18] When Hulme used Byzantine art as an example for his theory he was challenging all the connections which Bloomsbury writers employed it to create.

One of the salient features of avant-garde writing after the 'Ideal Home Rumpus', then, was that explanation and attack were very often synonymous. If Hulme was apologetic about their use (though in the course of 1914 he became less so), Lewis was not. Lewis said later of the months before the First World War that 'as to those methods of the mob-orator, they really had to be used . . . one was surrounded – one was hemmed in – by mob-orators'.[19] He had used them to great effect. What made Lewis famous before the First World War was not a painting but a publication. It was *Blast* which opened the doors of the drawing rooms of Mayfair to him, not his draftsmanship. Indeed, many of his pre-war paintings remained unsold and are now lost.

What was important about the oratory of 1913 to 1914 was that it was built around the premises on which the First and Second Post-Impressionist Shows had been based. The purpose of these premises was twofold: to establish criteria by which Post-Impressionism could be judged and to place the movement in a historical framework which would make it acceptable to the audience. The purpose of attacks upon these premises was obviously to undermine those criteria and that version of the past. The reason that these issues were the subject of debate was because opponents of Bloomsbury were close enough to Post-Impressionism to need to assert their own criteria and version of the past and because the audience was already familiar with these issues as a result of the intense debate about them since 1910.

Avant-garde dispute centred around three connected issues, any one of which might be approached through the other two. The first issue was the importance of nature in the creation of form or, in other words, the relative importance of representation and abstraction from nature. This debate referred both to the question of 'truth to nature', which had been so prominent in 1910, and to the meaning of aesthetic emotion. The second issue was the version of the history of art promulgated in 1910 and developed two years later into the idea of a 'great tradition' which culminated in Post-Impressionism. The third issue was the division of artists and

movements into classic and romantic which Fry had made in 1912. This related to Bell's notion of a great tradition, for it was a version of the past which posited a tradition of classicism.

Within these areas of discussion the immediate past was of especial importance. The meaning and antecedents of Impressionism were hotly debated because it was generally agreed that however the modern movement was characterised, it was both dependent upon Impressionism and a reaction away from it. In every construction of the immediate past Cézanne also played a pivotal role. But again, all discussion of Cézanne was set against the position he occupied for Fry and Bell. As Cézanne grew in importance for them, so he became to the public and to other members of the avant-garde almost synonymous with Post-Impressionism. By 1912, as the reviewers of the Second Post-Impressionist Show revealed, he was widely hailed as a great innovator and a master of rhythm and form. So it was a tremendous advantage for any avant-garde group to present Cézanne as a forebear and model. But, equally, that was extremely difficult while Cézanne was so closely connected with Post-Impressionism. It was for this reason that Cézanne became the subject of such debate.

One faction which was absent from the theoretical crossfire was the Futurists. Futurist manifestos were widely circulated, their meetings were well attended and by 1913 Futurism had become synonymous with *outré* upper-class fashion. But although the Futurists were tremendously important as an example and catalyst for Lewis, Pound and Hulme, no members of the avant-garde engaged in prolonged discussion of the premises of Futurist art. Lewis did consider Futurism in *Blast 1*,[20] partly because, after the break with Marinetti, he wanted to confirm his repudiation of Italian Futurism and partly because he needed to justify the label of Futurist which he had been content to apply to himself in much of the magazine. But neither Fry, Bell, Sickert, Pound nor Hulme entered into any prolonged dispute with Marinetti, Nevinson and their supporters.

So, despite its fashionable appeal, Futurism was not regarded as a serious threat by other members of the avant-garde. The key to their equanimity lay in the Futurists' repudiation of the past. With the exception of Hulme as he presented himself in the last months before the war, the British avant-garde of all persuasions based its claim to be taken seriously upon careful constructions of the immediate – and even the distant – past. Many of them – and

obviously Hulme before he repudiated both romanticism and classicism comes into this category – explained their work by making a series of parallels with this past. Any movement which was based upon a denial of the past was not likely to win long-lived favour. In their 'Vital English Art Manifesto', Marinetti and Nevinson launched Futurism at 'The British public, who stupidly adore the pretty-pretty ... the Garden Cities ... the Maypole Morris dances, Aestheticism, Oscar Wilde, the Pre-Raphaelites, Neo-Primitives and Paris'.[21] Fry had won an audience for Post-Impressionism by appealing to a considerable number of these loyalties. It was unlikely that Marinetti and Nevinson could win themselves an audience by denouncing them. 'The Futurists', Pound reminded his readers, 'are evidently ignorant of tradition'.[22]

The constant references to the past and to tradition by the avant-garde served two purposes for the general audience. It meant that those who espoused Post-Impressionism had no need to reject what they already admired and, perhaps, owned. Post-Impressionism could be fitted in with existing preferences or art collections by the invocation of a great tradition which encompassed all the best art of the past. It also meant that new art could be justified partly by using the accumulated reputations of accredited masters.

The absorption of the past on behalf of the present did not extend only to painters. Criticism as well as painting could be incorporated within a tradition. Those who had approached Post-Impressionist painting through Arts and Crafts language and precepts may well have been familiar with the works of Ruskin (the early works at least), even though they may have moved away from many of his standards of judgement. A reconciliation between Ruskin and Post-Impressionism was not undesirable, and Fry achieved just that by 1914. In his review of Bell's *Art*, he said that Bell's reading of the history of art was 'in a way a complete vindication of Ruskin's muddle-headed but prophetic intimation of the truth'.[23]

Even Lewis and Pound, both sworn enemies of 'provincialism',[24] of the judging of English things by anything other than a global standard, addressed themselves to an audience familiar with late nineteenth-century English criticism. Lewis declared that he would 'have undoubtedly played Turner' to Hulme's Ruskin, if his colleague had lived.[25] If Bell's Ruskin was the historian of the

Gothic, Lewis's Ruskin was the champion and defender of the genius whose 'vortex' had, as Lewis put it, 'rushed at Europe with a wave of light'.[26] Pound, who stood closest of all early Modernists to Ruskin, was, perhaps for that reason, the least willing to acknowledge him. He chose instead another nineteenth-century critic as the 'ancestor' of Vorticism, and set him in opposition to Ruskin. Writing about Vorticism in the *Egoist* of June 1914, he said that 'when Ruskin was telling Oxford and the wives of Oxford dons about the effects that could be got with the palette-knife, Pater was learning 'that all the arts approach the condition of music'.[27] Pound's attack on Ruskin was a rephrasing of many asides from Whistler's *Gentle Art*. It was useful in the context, because Whistler was being presented as another figure in Vorticism's 'ancestry'.

These statements by Fry, Lewis and Pound have a common denominator. All of them invoke what their authors elsewhere forcefully rejected. For behind Ruskin, as he was understood in 1910, lay 'truth to nature' and Pre-Raphaelitism. Behind Pater were the 1890s, symbolism and what Pound called 'the Paterine sentimentalesque Hellenism'.[28] (Although Pound did find agreeable aspects of the 1890's and symbolism to serve as forerunners to Imagism.) This recall of what was elsewhere spurned serves to remind us of the 'other face' – the Victorian face – of early Modernism in England that we discussed in the context of the Arts and Crafts Movement. Like many of their audience, Fry, Lewis and Pound had grown up in the last years of the nineteenth century. Ruskin and Pater had probably – in the cases of Fry and Pound, undoubtedly – helped to form their judgments of art. While they reacted against their mentors later, Fry, Lewis and Pound did not utterly reject them. Instead they incorporated them gradually into the new movement.

Reliance upon the past also provided an index of and a contribution to the elitist notion of art entertained by some of the avantgarde and its sympathisers. Ginner assumed some knowledge of European painting from the fifteenth century onwards, but, like Lewis and Hulme, he was interested primarily in the ways in which the past could illuminate the present. Bell and Pound, however, purported to assess the past without recourse to the present, although they wanted to judge both past and present by the same criteria. While Bell's version of the history of art was essentially teleological – that is, it led up to Cézanne and Post-Impressionism

– Pound's was not. But both men wanted to provide a global history, and their attempts demanded either a tremendous amount of knowledge from their readers, or a good deal of pretension. So Pound said in 1914 that 'Ibycus and Liu Ch'e presented the "Image". Dante was a great poet by reason of the faculty, and Milton is a wind-bag because of his lack of it.'[29] Bell, likewise, spanned centuries and continents in his comparative criticism. 'The slope at the head of which stand the Buddhist masterpieces of the Wei, Liang, and T'ang dynasties', he said, 'begins a good deal higher than the slope at the head of which are the Greek primitives of the Seventh Century, and higher than that of which early Sumerian sculpture is the head'.[30] Readers derived from these allusions not only information but the sense that they were participating in a process that was reserved for the initiated.

Once again, then, the appeal to the past was useful for securing an audience. But, at the same time, all avant-garde theorists, with the exception of Ginner, called for an art that was outside chronology. This appeared to be in conflict with a version of the past that necessarily used chronology. So too did the insistence placed upon breaking the bonds with that past. Lewis called all artists futurists who showed 'a tendency to rebellion before the domination of the past',[31] while Bell called Post-Impressionism 'a deliberate rejection of certain hampering traditions of modern growth'.[32] And yet for Bell in particular, the past justified the present. The way out of this impasse was to posit what T. S. Eliot called 'an ideal order', a great tradition of artists, both past and present, which existed outside the limits of time and space.[33] The great tradition could thus constitute a past without a chronology, and its members did not exist in evolutionary relationship to one another, but on terms of equality.

There was a broad agreement amongst avant-garde writers about a general version of the past. As has been seen, it was already familiar to many of their sympathisers because it tallied with the Arts and Crafts version, albeit on a global scale. Before the war the two fullest accounts of the history of art were presented by Bell in *Art* and by T. E. Hulme in 'Modern Art and its Philosophy'. Bell and Hulme shared a belief that art was a reflection of a state of mind, and both structured their histories around the processes of gradual decline and renewal. Decadence set in for both of them with the beginning of the Renaissance and renewal began with

Cézanne. For Hulme, the decadence was initiated by the espousal of notions of empathy between man and his environment and the consequent development of philosophies of which man was the centre. Bell, likewise, noted in Giotto's painting a human element (he called it, significantly, a 'commonness') which had nothing to do with art and which betokened an already advanced decay.[34] Renewal for Bell lay in the 'return to first principles',[35] which meant the creation of significant form. For Hulme renewal meant the re-emergence of geometric art and the tendency to abstraction.

This broad similarity masked certain crucial differences between the two men, which can be explained by their different motives for studying the past. Hulme was interested by 1914 in what he called 'the breakup of the Renaissance attitude'.[36] He regarded art as illustrative of that change. His interest in the forms on the canvas or in the stone was that they provided evidence that their creators were bearers of a new attitude. Moreover, by 1914, Hulme had rejected a version of the past which was constructed along essentially western lines. In place of the polarity between romanticism and classicism, between Roman and Byzantine, Impressionist and Post-Impressionist, he had substituted a far more embracing polarity: that between East and West, between the 'religious' and 'humanist' attitudes to life. So Hulme was not trying to justify the modern movement. Its art was, to him, not an end in itself, but the illustration of this new proposition.[37]

This was the exact reverse of Bell's standpoint. Bell said, 'I am not a historian of art or of anything else. I care very little about when things were made, or why they were made; I care about their emotional significance to us'.[38] His task was to explain and justify art within the terms set out by Post-Impressionism. But he constantly looked forward in his history to Cézanne and the modern movement, so that, despite intention or first apearance, his history served a teleological end. Hence the importance to Bell of a great tradition, which Hulme had no need of. While denying the notion of progress, the great tradition linked the past to the present.

This invocation of a great tradition seems at first sight to be in direct contradiction to the premises of Post-Impressionism. The hub of Post-Impressionist theory in 1910 was that the artist was the repository of truth and value and that art was the expression of self-consciousness. If many of the audience added an ethical or cultural gloss onto the Post-Impressionist prescriptions this was

due to the associations which Fry's language held for them rather than to any larger ethical scheme into which Post-Impressionism had been fitted. But in the notion of tradition, the opposite of expressionism began to come increasingly to the fore, and the face of Post-Impressionism was gradually turned. This was especially true as Bell began to impose his aphorisms on Fry's theories, for he embodied and put forward the tensions in their most extreme form. If on the one hand there was a push towards the individual, there was, on the other, a push towards his regulation, towards a hierarchical idea of art and its appreciation, and towards, above all, tradition. And it was in the notion of the great tradition that this fusion of mutually exclusive ideas about art was achieved.

In the nineteenth-century socialist thought of which the Arts and Crafts Movement formed a part, the clash between individual self-expression and a collectivist society was resolved in the notion of a communist – or socialist – state in which order was dissolved away in favour of an amicable collection of individuals free to express themselves. The same kind of urge for order, for a construct to give a context to individual endeavour, was apparent from the beginnings of Post-Impressionism, and was to prove an enduring component of Modernism as a whole. But, quite obviously, Post-Impressionism lacked the social focus of the Arts and Crafts Movement in which to resolve such contradictions. Its solution had necessarily to be in the aesthetic domain. Gradually Post-Impressionism developed a theory of order and a normative terminology which implicitly denied the inherent value of personal expression. (A similar theory was developing among the Post-Impressionists' literary counterparts and culminated in Eliot's 'Ideal Order' of 1917.) Bell and, to a lesser extent Fry, began to constrain the personality to the expression of one thing: significant form. The way in which this constraint was squared with self-expression was to suggest – implicitly – that the creation of significant form *was* the highest form of self-expression, that all the best artists expressed themselves thus, and that they therefore formed a 'great tradition' of the creators of form discernible through the ages. By such sleight of hand the self-expression of 1910 was incorporated with the tradition of classicism of 1912 onwards.

The increased prominence of tradition, however, although it represented a crucial shift of emphasis in Post-Impressionist theory, was by no means an innovation. Tradition had been used by Fry

as a way of praising and justifying modern art even before 'Manet and the Post-Impressionists'. In 1908 he wrote a long letter to the *Burlington* in response to a review of the International Society's show at the New Gallery which had exhibited, among others, works by Cézanne, Gauguin, Matisse and Signac. In it he stressed not only that these artists (called at that time Neo-Impressionists) sought to recover the 'organs of expression' from the aridity of Impressionism, but that they maintained a tradition. There was, he said, 'a great distinction between French and English art... namely, that the French artist never quite loses hold of the thread of tradition. However vehement his pursuit of his new aims, he takes over what his predecessors have handed to him as part of his new formula.'[39] Nearly three years later he used tradition again to defend the same artists, along with many others (who were now called Post-Impressionists). They were, he said, 'in reality the most traditional of any recent group of artists'. But this time he did not mean that they had developed what was useful in Impressionism. On the contrary, they were now to be seen as in revolt against the 'photographic vision' of the nineteenth century which had culminated in Impressionism.[40] Two years later he was defending many of the same artists yet again, this time as part of a classic tradition into which they were being incorporated.

As far as Bell was concerned, those artists who were part of the great tradition were all working towards the creation of significant form during an era which neglected it. 'Poussin, Claude, El Greco, Chardin, Ingres, Renoir, Giotto and Cézanne were such men of genius.'[41] Later in his survey Bell provided another list composed of 'El Greco, Rembrandt, Velasquez, Vermeer, Rubens, Jordaens, Poussin, Claude, Wren and Bernini'.[42] Some of these artists were in the 'classic tradition' which Fry had put forward in 1912, and many were used to illustrate his lectures on the character of French art some twenty years later.[43]

Obviously, this tradition was flexible. By 1919, Bell's list of painters who had risen above the general slide into decadence had grown to include Raphael and Piero della Francesca. Cézanne, he said, would one day 'fit neatly into that tradition of which he is as much a part as Ingres or Poussin, Raphael or Piero della Francesco'.[44] It is possible that these additions to the list owed as much to the continued popularity of Raphael and the recent enthusiasm for Piero as to a change of taste or aesthetic on Bell's part.

Bell also placed Velasquez in the great tradition. Velasquez had been one of the most popular painters for the preceding two generations and had received an enormous amount of attention from critics and painters of many persuasions. The National Gallery had recently purchased the Rokeby Venus, and a dispute which had subsequently arisen about the painting's authenticity had brought Velasquez to general attention. Painters as far apart as Whisler, Furse, Clausen and Sickert all claimed him as a technical master. The monograph by R. A. M. Stevenson, published in 1895, had argued that technique lay at the bottom of Velasquez' art, and that, moreover, it was in technique that the essence of art lay.[45] It was both easy and useful, then, for Bell to recruit Velasquez into the great tradition, because the step from technique to significant form was a manageable one, particularly by 1914, when the ethical overtones of form had diminished in favour of the emphasis on spatial relationships.

Bell's list also overlapped considerably with Ginner's 'great tradition of Realism' which was constituted of Van Eyck, Les frères de Nain, El Greco, Rembrandt, Chardin, 'Courbet and the Impressionists', Cézanne and Van Gogh.[46] Even Lewis, who insisted that 'the chemistry of the Present is different from that of the Past', compared Vorticism to what he saw as previous great changes in painting. 'The Rembrandt Vortex', Lewis said, 'swamped the Netherlands with a flood of dreaming. The Turner Vortex rushed at Europe with a wave of light'.[47]

Lewis did not go so far as to suggest a Vorticist tradition. But he did claim an association between Vorticism and Rembrandt and Turner. Ginner was – more directly – claiming kinship between his own work and that of the artists he called Realist. Bell argued that El Greco, Rembrandt, Chardin and Cézanne were occupied in the creation of significant form. Ginner said that they were Realists. They could not, according to Ginner, be both, because Ginner's theory of Realism was deliberately opposed to significant form. If part of the purpose of a great tradition was to establish the legitimacy of its proponents, then its appropriation by a rival could undermine that legitimacy. It thus became a means of attack. For the most part, this attack remained very general. It only became detailed and highly theoretical in the case of Cézanne. That was because Cézanne was the most important justificatory figure for all factions of the avant-garde.

Between late 1910 and early 1913, most people in England associated Cézanne with Post-Impressionism as it had been defined and developed by Fry and Bell in the two Grafton Gallery shows. But from the time of the second show he was also associated with Cubism. As we saw earlier, Fry did not stress this connection in his introduction to Picasso's Cubist work at the 1912 exhibition. But Gleizes and Metzinger, whose *Cubism* was translated into English in 1913, explicitly linked Cézanne with Cubist experiments.[48] For some, perhaps, Cézanne could be regarded as the founder both of Post-Impressionism and Cubism, but most would still have connected him with Post-Impressionism and with Fry. So to deny that Cézanne was a Post-Impressionist was to undermine the basis on which Post-Impressionism was constructed.

In *Art*, Bell discussed 'the debt to Cézanne', and confirmed (as late as 1914), that all those who followed Cézanne were Post-Impressionists. Despite the attention given to Cubism and Futurism in England when *Art* came out, Bell said disingenuously, 'it is sensible to call the group of vital artists who immediately followed the Impressionists by that name' – that is, Post-Impressionist.[49] In saying this, he implied, although he did not say so, that an artist like Lewis, who was among the group he cited, was, like Cézanne, searching 'to capture and express significant form'.[50] Bell made it clear to the readers of *Art* that Lewis was a Post-Impressionist and this could only have hampered Lewis's drive for independence.

In order to become dissociated from Fry and his circle, artists had thus to sever their links with the version of Cézanne's achievement that was associated with Post-Impressionism. But they also needed to establish a connection with Cézanne, because he commanded such widespread attention and respect amongst supporters of the avant-garde. By maintaining a link with Cézanne they could hope that some of this respect – the respect for an established tradition that is – would be transferred by their supporters to their own enterprises and thereby increase their own chances of gaining commissions or sales.

The debate about Cézanne was opened at the time of the Second Post-Impressionist Show in *Rhythm* magazine. There, Raymond Drey, while not denying that Cézanne was a Post-Impressionist, simultaneously tried to claim him for those who sought rhythm above all else. Cézanne, he said, 'never spoke of rhythm; probably it never struck him that his pictures were rhythmic. But painters

who studied his work with enthusiasm ... saw in its rhythmic quality the means to a new aesthetic excitement'.[51] Without directly referring to the circle around Fry, Drey was asserting here that rhythm rather than form was the salient characteristic of the modern movement.

Charles Ginner was far more explicit in his 'Neo-Realism' article in the 1 January 1914 issue of the *New Age*. Ginner's article dealt with the same issues which had concerned the opposition to the First Post-Impressionist Show. But instead of using them as a means of castigating Cézanne, he used them as a means of castigating Roger Fry. The purpose of all great painters, Ginner argued, was to interpret life 'by direct intercourse with Nature'.[52] This direct intercourse, epitomised in Cézanne, constituted Realism. Cézanne was thus the supreme Realist. Ginner believed also that Cézanne represented not a reaction to, but a development of, Impressionism. It was this development, said Ginner – following Manson's statement of 1912 – which was being continued by the Neo-Realists. The Neo-Realists, in fact, consisted only of Gilman and himself, although Ginner perhaps hoped for recruits among the Camden Town and Fitzroy Street groups. Ginner implied in his article that if Cézanne was a Realist he could not be a Post-Impressionist. Both Post-Impressionists and Cubists had, in Ginner's view, travestied Cézanne's art and had made formulae out of his insights. Let them, he concluded, 'get entangled in the formulas and fall'.[53]

It was not any of those associated with Post-Impressionism who picked up this challenge, but T. E. Hulme. Hulme came to the defence of those – Epstein, Lewis, Bomberg and Etchells in particular – who in early 1914 had fairly close affinities with Cubism. Ginner's article gave Hulme the opportunity to distinguish between realism and abstraction and to explain that they were illustrative of two different attitudes towards the world. But he also allowed Ginner's criticism of Fry to stand by distinguishing between abstraction that was vital and active, and abstraction that was conventionalised, mannered or decorative, hinting that Post-Impressionism came into the last category. But it was vital and active abstraction that Hulme saw in Cézanne. It was Cezanne's feeling for 'structure' and 'constructive form' that made him an innovator for the modern artists about whom Hulme was writing.[54]

In his reply to Ginner, then, Hulme seized the chance to deni-

grate Bloomsbury's decorative painting and to confront Neo-Realism. A month earlier, in the first of his articles on modern art, Hulme made his charge against Bloomsbury quite plain. Fry, he said, had accomplished 'the extraordinary feat of adapting the austere Cézanne into something quite fitted for chocolate boxes'.[55] Having dispensed with both Neo-Realism and Post-Impressionism, he could proceed to claim Cézanne as the forerunner of a new geometric art.

Soon after this Sickert came into the debate. He was not, of course, claiming Cézanne as a model for his own painting. Sickert had aired his low opinion of the Frenchman – and his belief that dealers were partly responsible for Cézanne's popularity – in a review of Bell's *Art* some weeks before.[56] His purpose was to suggest to the *New Age* readers that it was Gore, not any other of the avant-garde painters, who was following Cézanne's example correctly. Fry, Lewis, Gilman and Ginner were successively disavowed. First Sickert derided Fry's 'discovery' of the geometric basis of Cézanne's art. It had, he said, only produced a naive simple-mindedness amongst the younger, Cubist painters, who 'propose to have founded a new art on this fact, on which their grandfathers were suckled'.[57] This was a reproach to Lewis and Epstein, with whom he had just quarrelled, and a reply to Hulme's observations on Cézanne. Sickert went on to deal with Ginner and Gilman. He denied that either of them had inherited any of Cézanne's technique, and asserted instead that Gore was Cézanne's true descendant.[58]

Sickert's other contribution to the debate about Cézanne demonstrated his increasing conservatism in the face of developments within the avant-garde. In his review of Bell's *Art*, he criticised Cézanne on the grounds that he could not draw. That again was one of the charges that had been made most frequently in 1910. Sickert called Cézanne 'perhaps the worst' draftsman 'that ever was', and compared him unfavourably with Poynter (then President of the Academy) in whom he discerned the 'excellent Ingres tradition'.[59] It was in *Art* that Bell made Ingres and Cézanne part of the same tradition. Sickert was thus flaunting his disagreement by severing the link which Bell had forged, and uniting Ingres with a figure who was representative of a great deal that Bloomsbury despised.

Sickert's tactics, however, were not so sophisticated as Lewis's

in his treatment of Cézanne. Lewis used Cézanne in order to make a direct link between Parisian Cubism and English Post-Impressionism. This performed the double function of dissociating himself from Cubism and making a comparison of which Bloomsbury could not wholly approve. Lewis had publicly declared his dissent from Cubism by the time of *Blast 1*. There he said that Cubism was essentially 'Natures-mortes', by which he meant that Cubist still-life was the dead interpretation rather than the living creation of nature. With an eye on his readers, perhaps, he also 'Blasted' *Le Bouillon Kub* 'for being a bad pun', thereby siding himself with those who had dismissed the painting in the same way at the time of the second Post-Impressionist show.[60] In *Blast 2*, Lewis developed his theory of the creation of nature considerably further, and in the light of this theory dubbed Picasso an imitative realist. But the most 'abject, anaemic and amateurish manifestations' of 'this deadness and bland arrangement' were, he suggested, to be found at the Omega Workshops.[61] In this way, Fry and Picasso were linked. Lewis then proceeded to join both to elements in Cézanne's work which he disliked. He had already called Post-Impressionism an 'insult' to Cézanne, and by the time of *The Caliph's Design*, he had dubbed this 'bland arrangement' 'Cézannism'. Lewis paid full tribute to Cézanne's 'sombre and plain' personality, and love of 'bulk, of simplicity and of constructive wisdom'.[62] Here he echoed T. E. Hulme's pre-war assessment. But he charged Picasso and the Bloomsbury circle with side-tracking the movement which Cézanne had begun into a 'studio game',[63] which was no more than 'amateurish art – naughtiness, scepticism and sham'.[64]

Underlying this charge was Lewis's statement in *Blast 2* that Post-Impressionism was really 'Cambridge Post-Aestheticism',[65] that is, a provincial form of romanticism. This was because he saw the aesthetic movement, as he indicated in 'Futurism, Magic and Life', as the inheritor of the 'stormy flood of Rousseauism'.[66] Lewis's labelling of Post-Impressionism as romantic was a challenge to the way in which Fry had constructed the romantic/classic dualism in 1912. Romanticism was a term of opprobrium just as classicism was a term of praise.

Part of the appeal of these terms was their looseness. As T. E. Hulme candidly admitted, 'they represent five or six different kinds of antitheses, and while I may be using them in one sense, you

may be interpreting them in another'.[67] Hulme wrote his 'Romanticism and Classicism' essay in late 1911 or early 1912, at about the same time that Fry was beginning to develop his own version of classicism. Both had access to European notions of classicism. Fry, of course, was thoroughly familiar with Denis's formulation of classicism in his *L'Occident* article of 1907.[68] Hulme's treatment of the subject was characteristically wide-ranging, and included a consideration of its European variants and its philosophical and literary precedents.

Other writers used the terms with less precision and continued to use them long after Hulme had abandoned the romantic/classic dualism in favour of one between humanism and anti-humanism, East and West. Bell registered his disapproval of those of Rembrandt's works, in which form and design were lost in 'a mass of rhetoric, romance and chiaroscuro'.[69] Pound declared that 'music was Vorticist in the Bach-Mozart period, before it went off into romance, sentiment and description'.[70] Classicism stood for the obverse of these traits. So Lewis declared that Vorticism stated the classic standpoint, as against the romantic, and praised the English because they were the inventors of 'bareness and hardness, and should be the great enemies of Romanticism'.[71] Even Fry, usually remarkably restrained in the linguistic jousting of the avant-garde, used classicism as a way of trying to pull in Gaudier under the umbrella of Post-Impressionism. In an obituary article written a few months after the sculptor's death, he dismissed Gaudier's Vorticist manifesto as 'a rather flimsy and superficial resumé of the history of art wrapped up in a complicated and rather pretentious jargon', and proceeded to use Bloomsbury's own language to claim the sculptor for himself. Gaudier was, he said, 'in common with many contemporary artists of the new school . . . seeking to create a classic art, one of purely formal expressiveness, and this seems to me to have been always a dominant idea with him during his short career as a sculptor'.[72]

Hulme identified romanticism with an extreme form of empathy, or sympathy with the environment. The way in which nature was treated in art thus became for him the manifestation of the romantic or classic standpoint. He branded Neo-Realism as romantic on the grounds that it was based on 'Rousseauism', which held nature to be the 'source of all good'.[73] The discussion of romanticism and

classicism thus also involved the questions of 'truth to nature' and of representation against abstraction.

The debate about 'truth to nature' was briskly continued by the avant-garde after the 'official' spokesmen had ceased to take part in it. Again, much of the avant-garde debate was a response to the premises which Bloomsbury had established. As far as Bell was concerned, there was theoretically an almost complete antithesis between representation of the external environment and significant or pure form. But as he revealed in his review of the first Grafton Group show, Bell was unwilling to countenance the complete demise of the object. He criticised the 'advanced artists' – presumably Lewis and Etchells – and doubted whether it was 'possible to translate plastically a definite emotion or impression by forms which bear little or no resemblance to the object which inspired that emotion in the painter'.[74] By the time *Art* was published, however, he had recovered himself. He found a use for some degree of representation which would not compromise the theory of pure form. If the representative element were present, he said, it could 'be useful as a means to the perception of formal relations and in no other way'.[75]

By late 1913, Fry seemed to have capitulated to Bell's standpoint. He said of Kandinsky's *Improvisations* at the Allied Artists' Association summer salon, 'they are pure visual music ... I cannot any longer doubt the possibility of emotional expression by such abstract visual signs'.[76] But a few months later he had retreated from the brink and asked, 'why must the painter begin by abandoning himself to the love of God or man or Nature unless it is that in all art there is a fusion of something with form . . .?'[77]

Fry's long tussle with the question of morality in art – the equation between art and some kind of absolute – was far from resolved by the time the war broke out. Arguably, indeed, he got no further than reversing the conventional correlation between art and natural or divine truth or beauty. By his late twenties Fry had declared that the most moral kind of art was the art that abandoned morality. He followed that by suggesting that real 'truth to nature' lay in abandoning truth to natural fact in favour of selective distortion and pure form. That was how, he argued, the essence of objects could be revealed. It was not until after the war that he was able to step beyond and out of this debate altogether. Only when he had developed the notions of surface and unity and

equated them with value did he reject the abandonment of representation – and therefore of morality – as a central aesthetic concern.

When other avant-garde writers attacked the Post-Impressionist theory of form before the First World War they were combating Bell's certainty rather than Fry's equivocation. At the furthest extreme from Bell stood Ginner, who adopted a position very close to that of the opponents of Post-Impressionism in 1910. Ginner tied Neo-Realism firmly to representation and to everyday life. It was he said, 'the plastic interpretation of life through intimate research into Nature'.[78] T. E. Hulme steered a middle course between Ginner and Bell. 'I do not think', he said, in response to Ginner, 'that the artist's only business is to reproduce and interpret Nature . . . it is possible that the artist may be creative'.[79] But this did not imply total abstraction, as his criticism of Bomberg's *In the Hold* – which was by no means an abstract work – revealed. Hulme sensed the figure of Bell behind what he called Bomberg's wish to bring forth 'the appreciation of form in itself *tout par*'. Using the same criterion as those who had criticised Picasso in 1912, he said that 'all the general emotions produced by form have been excluded, and we are reduced to a purely intellectual interest in shape'.[80] Hulme argued for an abstraction that produced emotion and was indicative of an attitude towards life. The 'creation' he spoke of amounted to the selection and editing of facts from the external world. 'The first suggestions must always come from some existing outside shape', he said.[81] Aesthetic emotion he dismissed too, declaring that the emotions produced by art were 'the ordinary everyday human emotions'.[82] This was not only an assertion that life and art were inseparable; it was, as the pointed use of 'ordinary' showed, an attack on Bell's elitist notions of aesthetic appreciation.

Lewis's position on representation was similar to Hulme's, although he added to it an aggressive determination not to be humbled by Nature and thus to declare himself the creative equal of great natural forces. 'The best creation', he said, 'is the most highly developed selection and criticism'. Only decorative artists, he concluded, alluding to the Bloomsbury painters, had 'nothing to do with Nature'.[83]

Aesthetic debate of this sort was one way for groups to distinguish themselves from Post-Impressionism on issues with which their readers – for the most part the influential readers of

the *New Age* and the *Egoist* – were familiar. But there was another way, which called for less subtle tactics. This other method involved the stripping away of all the surrounding aesthetic debate to reveal the direct attack underneath. The Bloomsbury writers generally refrained from such disparagement. The nearest Bell came to direct criticism was his assessment of Lewis in his review of the 'Post-Impressionist and Futurist' show, which took place soon after the 'Ideal Home Rumpus'. Bell said of Lewis there that 'he is inclined to modify his forms in the interest of drama and psychology to the detriment of pure design. At times his simplifications and rhythms seem determined by a literary rather than a plastic idea.'[84] But a few months later in *Art*, Lewis had been readmitted to the ranks of the Post-Impressionists.

Fry was even more circumspect than his colleague. After the vitriolic attack on Bloomsbury which Hulme published in the January 1914 issue of the *New Age*, Fry simply wrote privately to a correspondent, 'the Lewis group have got hold of the *New Age* critic and he's written an amazing thing which I send you'.[85]

Opponents of the Bloomsbury group, with less to lose, were less courteous, both to their Post-Impressionist opponents and to erstwhile friends or colleagues. Sickert, suggesting that Lewis and Nevinson were being deliberately naive, wrote in the *New Age* that they were just 'superannuated art students trying to paint like coastguardmen'.[86] Lewis, charged by Sickert with pornography, was no more polite in return. He intimated that it was Sickert himself who was superannuated, a pensioner from the 1890s. 'He sits at his open front door', said Lewis, 'and invents little squibs and contrivances to discomfort the young brigands he hears tales of, and of whose exploits he is rather jealous'.[87] This kind of exchange contained a grain of levity. It was projecting an image of bohemian, cafe dispute for the readers of the *New Age*.

The attacks on the Bloomsbury painters were more in earnest. This was not only because aesthetic and personal differences were sharper, but also because the Bloomsbury group were in a more entrenched position in the art world. Fry and his circle were disliked partly because their central position in the English cultural and professional establishment gave them an artistic handicap over those far more talented, if less well organised, than themselves. Pound, Hulme and Lewis were well aware of this. Criticism of Bell and Fry had a social component, an awareness of their milieu

and of the audience which they commanded. Lewis dubbed them Cambridge Post-Aestheticists. Hulme, reviewing the Grafton Group show of 1914, declared that 'Mr Fry and his group are nothing but a kind of backwater', and went on, 'I feel about the whole show a typically Cambridge sort of atmosphere . . . I know the kind of dons who buy these pictures, the character of the dilettante approach they feel for them'.[88] Nevinson in his autobiography took this approach a stage further. He noted that he was 'given every form of encouragement by most people, with the exception of Tonks, Roger Fry and Clive Bell, who despised me chiefly because I was English and a professional . . . and not an incompetent amateur addicted to aestheticism, cocoa, puritanism or jabbering about sincerity'.[89]

The vehemence displayed towards Fry and Bell was a reflection of the weakness of their opponents. The issues which were raised at the two Post-Impressionist shows dominated avant-garde discussion in the next two years, so the content of the debate never strayed far from subjects associated in the public mind with Fry and his circle. The rest of the avant-garde was also hampered by the close association which had been forged between Post-Impressionism and a language of criticism which incorporated much commonly held vocabulary. A primary need of these other groups was to establish a language of criticism which was not connected with Post-Impressionist standards and preoccupations. Lewis energetically proclaimed his freedom. 'Our Vortex will not hear of anything but its disastrous polished dance', he said in 1914.[90] To be sure, his belligerent, aphoristic prose and his military metaphors were, in England, peculiar to Vorticism, and his diagonal compositions and acidic colouration were as far from external influence as anything produced in England before the First World War. His Vorticist style, cold and hard edged, was, indeed, in direct contrast to the Post-Impressionist soft edge, and his palate was equally divorced from the earth colours favoured by Cézanne's followers. But one reason why Lewis was so badly represented in institutions and so little studied as a stylist before his death was that he failed to come up with a critically coherent aesthetic and language which set him apart from the Post-Impressionists in aesthetic as well as style. Vorticism had a stance but not much of a distinctive vocabulary. That meant that in their description and

Wyndham Lewis, *The Crowd*. (Reproduced by permission of the Tate Gallery, London, and Mr Omar Pound.)

judgement of Vorticist works, critics had no recourse but to fall back upon vocabulary associated with Post-Impressionism.

With the possible exception of Gaudier, all the avant-garde writers opposed to Bloomsbury failed, like Lewis, to develop their own critical vocabulary. They continued to use the language associated with Post-Impressionism. David Bomberg, who remained detached from both Bloomsbury and the Omega secessionists who formed the nucleus of Vorticism, was unable to develop any corresponding linguistic independence. His preface to the one man show he had at the Chenil Gallery in July 1914 made constant use of Post-Impressionist language (though its stance owed more to Futurism and Vorticism). 'I am *searching for an intenser* Expression', he said, making a parallel between his aim and the aims of the Post-Impressionists which MacCarthy had explained in 1910. 'My object is the construction of pure form, I reject everything in painting that is not pure form', he continued, taking his language directly from Bell.[91] Bomberg's work, such as *In the Hold*, may have been dubbed Cubist by many critics, but it could be described, following the painter's own example, in Post-Impressionist terms. Similarly, Pound, praising Edward Wadsworth as a Vorticist, stressed the painter's delight in 'pure form'.[92]

In the same way, Hulme and Ginner used Fry's notion of plasticity to describe art which they fervently wished to distinguish from Post-Impressionism. Hulme, in the course of an attack on Bell, compromised his stance by the application of terminology associated with Fry. 'Plastic art', he said, rested not upon the generation of aesthetic emotion, but upon the 'possibility of our living our emotions, *into* outside shapes and colours'.[93] Similarly, Ginner defined Neo-Realism as 'plastic art', and 'the decorative interpretation and intimate research of Nature'.[94]

Fry and Bell, moreover, had continued to publicise Post-Impressionist vocabulary in the articles which they published between the end of the Second Post-Impressionist Show and the beginning of the war, as well as in lectures in various parts of the country. Fry reviewed the 1913 Allied Artists' Association salon[95] and Bell reviewed Rutter's Post-Impressionist show.[96] Bell also published an article in the *Burlington* called 'Post-Impressionism and Aesthetics', in which he put forward many ideas later expanded in *Art*.[97] *Art* appeared at the beginning of 1914, and received a sympathetic notice from Fry in the *Nation*.[98] In the year before its

publication Fry had gone to some lengths to advertise the virtues ⟨
of Post-Impressionism to provincial audiences. He went to Leeds,
Liverpool and Leicester to give lectures. At Liverpool and Leicester
small shows of Post-Impressionist painting were mounted, giving
audiences there perhaps their first view of the new art. By the time
*Art* appeared, the 'Ideal Home Rumpus' had come and gone,
the avant-garde was irretrievably fragmented, but the provincial
audience had probably very little inkling of the consequences of
the quarrel. *Art* did little to enlighten them.

One reason for *Art*'s importance was that it was the only state-
ment from the avant-garde devoted exclusively to the visual arts
which appeared in book form before the end of the war. It had a
permanence denied to contributions to periodicals, and a nation-
wide circulation denied to a publication like *Blast*. *Blast* was
primarily for London consumption but *Art* was distributed
throughout the nation, thus allowing interested readers in the prov-
inces to take up the lead offered by Post-Impressionism in the
capital. Those readers, moreover, were even less able than their
metropolitan counterparts to distinguish with accuracy between the
work of the different London painters, and so were even more
likely to accept Bell's characterisation of them all as Post-
Impressionism. *Art* also confirmed the growing elitism of the Post-
Impressionist aesthetic. While Fry was consistently interested in
making Post-Impressionism acceptable and comprehensible, Bell
was far less concerned to develop broadly based support for the
new movement, and it was he who eventually produced its book
length justification. Fry was too busy to attempt such a work in the
two years before the War. He was travelling and working tirelessly
in the Post-Impressionist cause, lecturing at the Slade, keeping the
fragments of the Omega together and developing his own weak
Post-Impressionist style. So the task was left to Bell. Fry's subtlety
and thoughtfulness – his guile and equivocation, even – might have
made *Art* a better, if less widely read and less reassuring, book
than the one Bell produced. *Art* was, nonetheless, a great success.
Frank Rutter, no friend of the Bloomsbury circle himself, reported
that 'a dazed world, bewildered by the fantastic and incomprehen-
sible developments of modern art, was proportionately grateful' for
Bell's book.[99]

The publication of *Art* consolidated the position which Fry and
Bell had built in the four years since 'Manet and the Post-

Impressionists'. When war was declared a few months afterwards, and a temporary check was put upon artistic enterprise, no alternative aesthetic had succeeded in ousting Post-Impressionism as the prevailing avant-garde orthodoxy.

## NOTES

1 MacColl, *Confessions*, p. 202.
2 Dancing, from Morris dancing to 'jazz' dancing to the 'classical' recreations of Isadora Duncan and the 'symbolic' effusions of Loie Fuller was, of course, a popular craze, a subject of scholarly research and a middle-class pursuit as well as a painterly subject before the First World War.
3 Clive Bell, 'Post-Impressionism and Aesthetics', *Burlington*, January 1913, p. 226.
4 *The Journals of Arnold Bennett*, 3 vols (London: Cassell 1932–3), II, p. 51.
5 Roger Fry, 'The Case of the Late Sir Lawrence Alma Tadema, O.M.', *Nation*, 18 January 1913, p. 666.
6 Fry, *Nation*, 18 January 1913, pp. 666–7.
7 See *Nation*, 1 February 1913, pp. 743–4 and 8 February 1913, p. 782.
8 See the *Nation*, 8 February 1913, p. 782; 15 February 1913, p. 819; and 22 February 1913, pp. 853–4.
9 Clive Bell, letter to the *Nation*, 22 February 1913, pp. 853–4.
10 Sickert, quoted in Wendy Baron, *The Camden Town Group* (London: Scholar Press 1979), p. 53.
11 Wyndham Lewis, 'The Cubist Room', rpt. in *Wyndham Lewis on Art: the Collected Writings 1913–56*, ed. Walter Michel and C. J. Fox (London: Thames and Hudson 1969), p. 56.
12 Baron, *Camden Town*, p. 55.
13 Clive Bell, 'The New Post-Impressionist Show', *Nation*, 26 October 1913, pp. 172–3.
14 T. E. Hulme, 'Mr Epstein and the Critics', *New Age*, 25 December 1913, p. 251.
15 Anthony Ludovici, 'Art: The Carfax, the Suffolk Street and the Twenty-One Galleries', *New Age*, 18 December 1913, pp. 213–14.
16 Hulme, *New Age*, 25 December 1913, p. 251.
17 Roger Fry, 'Three Pictures in Tempera by William Blake', *Burlington Magazine*, March 1904, pp. 204–6.
18 Bell, *Art*, p. 130.
19 Lewis, in *Lewis on Art*, p. 58.
20 Wyndham Lewis, *Blast 1*, (London 1914), pp. 143–4.

21 Marinetti and Nevinson, quoted in Wees, *Vorticism*, p. 109.
22 Ezra Pound, 'Wyndham Lewis', *Egoist*, 15 June 1914, pp. 233–4.
23 Roger Fry, 'A New Theory of Art', *Nation*, 7 March 1914, p. 938.
24 For Pound's construction of provincialism see his 'Provincialism the Enemy', *New Age*, 12 July 1917, pp. 244–5; 19 July, 1917, pp. 268–9; 26 July 1917, pp. 288–9 and 2 August 1917, pp. 308–9.
25 Wyndham Lewis, quoted in T. E. Hulme, *Further Speculations*, ed. Samuel Hynes (Minneapolis: University of Minnesota Press 1955), p. xxv.
26 Lewis, 'Our Vortex', *Blast 1*, p. 147.
27 Pound, 'Lewis', *Egoist*, 15 June 1914, p. 233.
28 Ezra Pound, letter to the *Egoist*, 16 March 1914, p. 117.
29 Ezra Pound, 'Vorticism', *Fortnightly Review*, 1 September 1914, p. 462.
30 Bell, *Art*, p. 122.
31 Lewis, 'The Melodrama of Modernity', *Blast 1*, p. 143.
32 Bell, *Art*, p. 41.
33 T. S. Eliot, 'Tradition and the Individual Talent', (1917), rpt. *Selected Essays* (London: Faber and Faber 1932), p. 15.
34 Bell, *Art*, p. 147.
35 Bell, *Art*, p. 44.
36 T. E. Hulme, *Speculations*, ed. Herbert Read (London: Kegan Paul, Trench, Trubner 1924), p. 78.
37 For an excellent chronology of Hulme's changing philosophy, see Levenson, *Genealogy of Modernism*, pp. 90–99.
38 Bell, *Art*, p. 39.
39 Roger Fry, 'The Last Phase of Impressionism', letter to the *Burlington Magazine*, March 1908, p. 374.
40 Fry, 'The Grafton Gallery – 1, *Nation*, 19 November 1910, 332.
41 Bell, *Art*, p. 39.
42 Bell, *Art*, p. 169.
43 Roger Fry, *Characteristics of French Art* (London: Chatto 1932).
44 Clive Bell, 'Tradition and Movements', *Athenaeum*, 4 April 1919, p. 142.
45 R. A. M. Stevenson, *Velasquez* (London: G. Bell 1895). For the importance of *Velasquez* see Kate Flint ed., *Impressionists in England. The Critical Reception.* (London: Routledge & Kegan Paul 1984), pp. 15–18.
46 Charles Ginner, 'Neo-Realism', *New Age*, 1 January 1914, p. 271.
47 Lewis, *Blast 1*, p. 147.
48 A. Gleizes and J. Metzinger, *Cubism* (translated) (London: Fisher Unwin 1913), p. 16.
49 Bell, *Art*, p. 200.
50 Bell, *Art*, p. 209.
51 O. Raymond Drey, 'Post-Impressionism', *Rhythm*, January 1913, p. 369.
52 Ginner, 'Neo-Realism', *New Age*, 1 January 1914, p. 271.
53 Ginner, 'Neo-Realism', *New Age*, 1 January 1914, p. 272.

54  T. E. Hulme, 'Modern Art – II', *New Age*, 12 February 1914, p. 468.
55  Hulme, 'Modern Art-1.', *New Age*, 15 January 1914, p. 341.
56  Walter Sickert, 'Mesopotamia – Cézanne', *New Age*, 5 March 1914, pp. 554–60.
57  Walter Sickert, 'Mr Ginner's Preface', *New Age*, 30 April 1914, p. 820.
58  Walter Sickert, 'The Thickest Painters in London', *New Age*, 18 June 1914, p. 155.
59  Walter Sickert, 'Mesopotamia-Cézanne', *New Age*, 5 March 1914, p. 560. The title of Sickert's piece was an ironic reference to *Art*, p. 215.
60  Lewis, *Blast 1*, pp. 13 and 139.
61  Lewis, *Blast 2*, p. 41.
62  Lewis, *The Caliph's Design*, p. 50.
63  Lewis, *The Caliph's Design*, p. 69.
64  Lewis, *The Caliph's Design*, p. 69.
65  Lewis, 'The London Group', *Blast 2*, p. 79.
66  Lewis, *Blast 1*, p. 133.
67  T. E. Hulme, 'Romanticism and Classicism', *Speculations*, pp. 113–14.
68  Maurice Denis, 'Cézanne', 1907, rpt. in *Theories 1890–1910*, (Paris: L. Rouart et J. Watelin 1920). For his definition of classicism see esp. p. 247.
69  Bell, *Art*, p. 172.
70  Ezra Pound, 'Vorticism', *Fortnightly Review*, 1 September 1914, p. 471.
71  Lewis, *Blast 1*, *Wyndham Lewis on Art*, p. 30.
72  Roger Fry, 'Gaudier-Brzeska', *Burlington Magazine*, August 1916, p. 209.
73  Hulme, 'Modern Art – II', *New Age*, 12 February 1914, p. 469.
74  Clive Bell, 'The Grafton Group', *Nation*, 29 March 1913, p. 1060.
75  Bell, *Art*, p. 225.
76  Roger Fry, 'The Allied Artists', *Nation*, 2 August 1913, p. 677.
77  Fry, 'A New Theory of Art', *Nation*, 7 March 1914, p. 938.
78  Ginner, 'Neo-Realism', *New Age*, 12 February 1914, p. 469.
79  Hulme, 'Modern Art – II', *New Age*, 12 February 1914 p. 469.
80  T. E. Hulme, 'Modern Art – III', *New Age*, 26 March 1914, p. 662.
81  T. E. Hulme, 'Modern Art – IV', *New Age*, 9 July 1914, p. 230.
82  Hulme, 'Modern Art IV', *New Age*, 9 July 1914, p. 230.
83  Lewis, *Blast 2*, p. 46.
84  Bell, 'The New Post-Impressionist Show', *Nation*, 25 October 1913, p. 172.
85  *The Letters of Roger Fry*, p. 377.
86  Sickert, *New Age*, 25 June 1914, p. 178. Sickert's reference is to Sunday painters in general and possibly to Douanier Rousseau in particular.
87  Wyndham Lewis, letter to the *New Age*, 2 April 1914, p. 703.
88  T. E. Hulme, 'Modern Art – I', *New Age*, 15 January 1914, pp. 341–2.

89 C. R. W. Nevinson, *Paint and Prejudice* (London: Methuen 1937),
   p. 65. Nevinson's reference to cocoa is not just a thrust at Fry's
   relative 'chocolate' Fry. It is also a dig at his own father, who worked
   as a journalist on one of George Cadbury's papers. Because of
   Cadbury's support for them, the liberal journalism that these papers
   expounded came to be known as 'cocoa journalism'. In a round
   about way, Nevinson is here attacking liberalism in general.
90 Lewis, *Blast 1*, p. 149.
91 David Bomberg, preface to the catalogue for his one man show,
   quoted in William Lipke, *David Bomberg: A Critical Study of his Life
   and Work* (London: Evelyn, Adams & Mackay 1971), p. 118.
92 Ezra Pound, 'Edward Wadsworth', *Egoist*, 15 August 1914, p. 307.
93 Hulme, 'Modern Art – IV', *New Age*, 9 July 1914, p. 230.
94 Ginner, *New Age*, 1 January 1914, p. 272.
95 Roger Fry, 'The Allied Artists', *Nation*, 2 August 1913, pp. 676–7.
96 Clive Bell, 'The New Post-Impressionist Show', *Nation*, 25 October
   1913, pp. 172–3.
97 Clive Bell, 'Post-Impressionism and Aesthetics', *Burlington*, January
   1913, pp. 226–30.
98 Roger Fry, 'A New Theory of Art', *Nation*, 7 March 1914, pp. 937–9.
99 Frank Rutter, *Art in My Time* (London: Rich and Cowan 1933),
   pp. 159–60.

# CONCLUSION

It is not difficult to account for the failure of rival groupings or for the success of Fry and Bell. In the first place, circumstances did not favour the opponents of Post-Impressionism. With the coming of war, the group around Lewis was gradually decimated. Lewis, Wadsworth, Roberts, Bomberg, Gaudier and Hulme were all drawn into the forces, and Gaudier and Hulme were killed. After the war the re-emergence of this group – never as coherent as *Blast* suggested – was impossible. The death of Hulme and the emigration of Pound deprived it of two energetic spokesmen. The remaining members had diverged stylistically during the intervening four years, and Lewis himself had abandoned Vorticist abstraction for a prolonged study of the figure.

The Fitzroy Street, Camden Town and London groups, already riddled with internal dissension, also suffered from losses. Gore died in 1914 and Gilman perished in the post-war influenza epidemic. Gore's death deprived the alliance of a valuable negotiator, peacemaker and cohesive force. With Sickert continuing to maintain his defiant adoption of academic standards, the Fitzroy Street, Camden Town and London groups gradually lost momentum.

Only the circle around Bloomsbury remained intact through the war years. Both Fry and Bell published collections of essays in the early 'twenties and strengthened their positions as leading theoretical spokesmen. In 1917 Fry was elected to the London group and in 1919 he was followed by Grant and Vanessa Bell. Their

election was a confirmation of the changed 'balance of power' amongst avant-garde artists since the group's formation in 1913. Then, these painters had been refused election because of the group's support for Lewis.

The Bloomsbury circle was also helped by its literary associates. In the decade after the war, the emergence of Woolf and Strachey, together with Forster's growing reputation, provided the group with the literary complement to the visual arts which it had hitherto lacked. Their success in the field of literature undoubtedly increased the reputation of the circle as a whole, while Woolf later enhanced Fry's reputation with her laudatory biography of the critic.

By the end of the decade which began with 'Manet and the Post-Impressionists', Post-Impressionism was firmly established. The Bloomsbury group had produced and patronised painters who reflected Post-Impressionist premises and stylistic preferences. It had set up a version of the history of modern art which was quickly enshrined in modern art galleries on both sides of the Atlantic and which went essentially unchallenged for the next half century. Finally, it had provided itself with a critical language and it had successfully won many thousands of adherents. Although the break-up of rival groups may have contributed to the success of Post-Impressionism, it was not a necessary condition of it. At most the decimation of opposition was only a postscript to the gradual increase in authority which we have been discussing in the course of the last four chapters.

Fry and Bell triumphed because they made Post-Impressionism attractive and intelligible to critics and to their audience. By so doing they brought about a change of taste. The key to their achievement lay in an appeal to those who were like themselves. Most of the supporters of Post-Impressionism were either, like Fry, members of the liberal or radical university educated middle classes, or, like Bell, educated liberals who belonged in, or were linked with, the upper classes. By virtue of its early associations, Post-Impressionism also drew support from self-educated radicals and liberals, and by virtue of its fashionable status it drew support from the socially aspiring. New painting was explained to this audience by using language, associations and standards of judgement with which they were already familiar. That is, the language, associations and standards of the Arts and Crafts Movement and

of the early socialism of which Arts and Crafts was a part. As time went on, Fry and Bell developed a language and an aesthetic which pertained to Post-Impressionism alone. But this independence was achieved not by discarding all the early premises of Post-Impressionism but by incorporating some of them within the mature theory. In this way, Fry and Bell lost none of the ground which they established in 1910. Avant-garde groupings before the First World War displayed an intense awareness of this audience, and of the potential power that it wielded. What Fry and Bell did was to engage, court and secure that audience with more understanding, sophistication and dexterity than anybody else.

# BIBLIOGRAPHY

## MANUSCRIPTS

Ashbee, C. R., *Journals*. Cambridge: Kings' College.
Chiswick Papers. Add. Mss 50910–50, 41867–960, 43975–89,
70986–71003. Chiswick Press Papers. London: British Library.
Fry, Roger, Unpublished lectures. Cambridge: Kings' College.
Hutchins, Patricia, BL Add. Mss 57725–6, Patricia Hutchins Papers.
London: British Library.
Jacobi, C. T., 'A Brief and rough chronology . . . mostly relating to
myself during my connection with the Chiswick Press from . . . 1886
to 1922 . . . with a few notes of later years', Box 111.86.DD.London:
Victoria and Albert Museum, National Art Library.
Macmurdo, A. H., 'History of the Arts and Crafts Movement', Typescript
(with addenda), K. 1037, William Morris Gallery, Walthamstow.

## PRINTED MATERIALS, CONTEMPORARY PUBLICATIONS AND OTHER PRIMARY SOURCES

Addison, Julia de Wolf, *Arts and Crafts in the Middle Ages*. London: G.
Bell, 1908.
Aldington, Richard, *Life for Life's Sake*. New York: Viking Press, 1941.
Anon. 'Allied Artists' Association', *Athenaeum*, June 1914, pp. 859–860.
'Art and Artists: Exhibition at the London Galleries: Various Kinds of
Art', *Globe*, 12 March 1915, p. 7.
'Are the Post-Impressionists worth Seeing?', *Public Opinion*, 25
November 1910, p. 528.

'Art Notes: A Mystification and a Moral', *Mayfair and Town Topics*, 17 November 1910, p. 16.

'Art Notes'. *Illustrated London News*, 12 October 1912, pp. 524–4.

'The Book Beautiful: Sangorski and Sutcliffe'. *Bookbinding and Trades Journal*, July 1914, p. 248.

'Cézanne, Gauguin, Van Gogh, etc. at the Grafton Galleries', *Art News*, 15 December 1910, pp. 19–20.

'Cubist Comedies: Post-Impressionism and the Public'. *Globe*, 8 October 1912, p. 4.

'Deventer Tapestry and Collenbrander's Designs'. *Art*, vol. 1, no. 1, June 1903, pp. 60–7.

'Fields of Employment Open to Women: Furniture and Wallpaper Designing'; *Spinning Wheel*, 26 April 1893, p. 403.

'Fine Arts: Manet and the Post-Impressionists'. *Athenaeum*, 12 November 1910, pp. 598–9.

'French Post-Impressionists at the Grafton Gallery'. *Connoisseur*, December 1910, pp. 315–6.

'The Grafton Galleries', *World*, 22 October 1912, p. 604.

'The Grafton Gallery', *Spectator*, 12 November 1912, pp. 797–8.

'The Haslemere Handweaving Industry'. *Women's Employment*, 4 April 1902, pp. 2–3.

'Heard in the High', *Isis*, 19 October 1912, pp. 6–7.

'Impressionism at its Latest: French Pictures at the Grafton Galleries', *Daily Chronicle*, 7 November 1910, p. 14.

'Jewelled Bindings'. *Connoisseur*, May 1914, p. 44.

'Junkerism in Art: The London Group at the Goupil Gallery', *The Times*, 10 March 1915, p. 8.

'The London Group', *Connoisseur*, May-August 1915, p. 56–7,

'The London Group at the Goupil Gallery'. *Athenaeum*, 13 March 1915, p. 242.

'Manet and the Post-Impressionists', *Tramp*, January 1911, pp. 361–2.

'More Post-Impressionism', *Morning Post*, 4 October 1912, p. 4.

'Of Ourselves', *Arts and Crafts*, 27 September 1890, p. 1.

'Paint Run Mad: Post-Impressionists at the Grafton Galleries', *Daily Express*, 9 Novembers 1910, p. 8.

'Post-Impressionism', *Globe* 9 November 1910, p. 8.

'Post-Impressionism', *Westminster Gazette*, 21 November 1910, p. 3.

'The Post-Impressionist Exhibition', *Connoisseur*, November 1912, pp. 188–92.

'A Post-Impressionist Exhibition', *The Times*, 4 October 1912, p. 9.

'Post-Impressionist Problems', *Punch*, 23 November 1910, p. 368.

'The Post-Impressionists', *Tatler*, 16 October 1912, p. 72.

'The Post-Impressionists', *The Times*, 21 October 1912, p. 10.

'Post-Impressionists and Others Reconsidered', *Athenaeum*, 24 December 1910, p. 801.

'The "Post-Impressionists" at the Grafton Galleries', *Academy*, 3 December 1910, pp. 546–7.

'The Post-Impressionists at the Grafton Galleries'. *World*, 15
   November 1910, p. 726.
'Post-Impressionism: Problems for Visitors at the Grafton Galleries',
   *Daily News*, 7 November 1910, p. 3.
Review of 'The Second Post-Impressionist Exhibition', *Art Chronicle
   and the Art News*, 8 October 1912, p. 514.
Review of 'The Second Post-Impressionist Exhibition', *Evening News*,
   5 October 1912, p. 2.
'Topical Criticisms', *London Opinion*, 26 November 1910, p. 323.
'Women's Handicrafts'. *Arts and Crafts*, 14 February 1901, p. 75.
Anstruther, G. Eliot, *The Bindings of Tomorrow*. London: Guild of Women
   Binders, 1902.
Armstrong, Sir Walter, *Art in Great Britain and Ireland*. London:
   Heinemann, 1909.
*Art and Life, and the Building and Decoration of Cities*, A Series of Lectures
   by members of the Arts and Crafts Exhibition Society. London:
   Rivington Percival, 1897.
Art Workers' Guild, *Beauty's Awakening: A masque of Winter and Spring*,
   London: Essex House Press, 1899.
*Arts and Crafts Essays by Members of the Arts and Crafts Exhibition Society*.
   London: Rivington Percival, 1893.
Ashbee, C. R., *The Buildings of Thelema*. London: Dent, 1910.
—, *Craftsmanship in Competitive Industry*. London: Essex House Press,
   1908.
—, *A Description of the Work of the Guild of Handicraft*. Campden, Glos.
   and London: 1902.
—, *An Endeavour towards the Teaching of John Ruskin and William Morris*.
   London: Edward Arnold, 1901.
—, *A Few Chapters in Workshop Reconstruction and Citizenship*. London:
   Essex House Press, 1894.
—, *From Whitechapel to Camelot*. London: Essex House Press, 1892.
—, *Manual of the Guild and School of Handicraft*. London: Cassell, 1892.
—, *The Treatises of Benvenuto Cellini on Goldsmithing and Sculpture (made
   into English from the Italian of the Marcian Codex by C. R. Ashbee)*.
   London: Essex House Press, 1898.
J. B., 'The London Group: The Rock Drill Comes into Art'. *Manchester
   Guardian*, 15 March 1915, p. 6.
Babbit, Irving, *The New Laokoon*. London: Constable 1910.
Bain, James S., *A Bookseller Looks Back*. London: Macmillan, 1940.
Baldry, A. L., *Modern Mural Decoration*. London: George Newness, 1902.
Bell, Clive. *Art*. London: Chatto, 1914.
—, *Old Friends: Personal Recollections*. London: Chatto 1956.
—, *Pot Boilers*. London: Chatto, 1918.
—, 'The Grafton Group', *Nation*, 29 March 1913, p. 1060.
—, 'The New Post-Impressionist Show', *Nation*, 25 October 1913,
   pp. 172–3.
—, 'Post-Impressionism and Aesthetics', *Burlington*, January 1913,
   pp. 226–30.

—, 'Tradition and Movements', *Athenaeum*, 4 April 1919, pp. 142–4.

—, letter to the *Nation*, 22 February 1913, pp. 853–4.

—, Review of Hind, *The Post-Impressionists. Athenaeum*, 8 July 1911, p. 51.

—, Review of Holmes, *Notes on the Post-Impressionist Painters. Athenaeum*, 7 January 1911, pp. 19–20.

—, Review of Rutter, *Revolution in Art. Athenaeum*, 4 February 1911, p. 135.

Bellamy, Edward, *Looking Backward 2000–1887*. Boston: Ticknor, 1887.

*The Journals of Arnold Bennet*, ed. Newman Flower, 3 vols. London: Cassell, 1932–3.

Bennett, T. P., ARIBA, *The Relation of Sculpture to Architecture*. Cambridge: Cambridge University Press, 1916.

Benson, E. F., *Final Edition*. London: Longmans, 1940.

—, letter to the *Morning Post*, 22 November 1910, p. 5.

Binyon, Laurence, *The Flight of the Dragon: An Essay on the Theory and Practice of Art in China and Japan*. London: John Murray, 1911.

—, *Painting in the Far East: An Introduction to the Theory of Pictorial Art in Asia*. London: Edward Arnold, 1908.

Binyon, Laurence, ed., *Pre-Raphaelitism*, by John Ruskin. London: Dent, 1907.

Binyon, Laurence, 'Chinese Paintings in the British Museum – II', *Burlington Magazine*, November 1910, pp. 82–91.

—, 'Post-Impressionism', *Saturday Review*, 12 November 1910, pp. 609–10.

Blanche, J. E., letter to the *Morning Post*, 30 November 1910, p. 5.

Borenius, Tancred, letter to the *Morning Post*, 26 November 1910, p. 4.

Brown, W. N., *The Art of Enamelling on Metal*. London: Scott, Greenwood, 1900.

Bullock, J. M., *The Art of Extra-Illustration*. London: Treherne & Co., 1903.

Burgess, F. W., *Chats on Household Curios*. London: Fisher Unwin, 1914.

Burne-Jones, Sir Philip, Bt., *Dollars and Democracy*. New York: Appleton, 1904.

—, letters to the *Morning Post*, 17 November 1910, p. 3 and 18 November 1910, p. 10.

'C', 'Art and Ugliness', *Morning Post*, 16 November 1910, p. 5.

Carter, A. C. R., 'The Royal Academy, 1897', *Art Journal*, May 1897, pp. 161–184.

Casson, Stanley, *Some Modern Sculptors*. London: OUP, 1928.

—, *Twentieth Century Sculptors*. London: Humphrey Milford, 1930.

Chancellor, E. B., *The Lives of the British Sculptors*. London: Chapman Hall, 1911.

Chiozza-Money, L. G., MP, *Riches and Poverty*. London: Methuen, 1910.

Clutton-Brock, A., *William Morris, his Work and Influence*, London: Williams and Norgate, 1914.

—, 'The Post-Impressionists', *Burlington Magazine*, January 1911, pp. 216–19.

Cobden-Sanderson, T. J., *The Arts and Crafts Movement*. London: Hammersmith Publishing Society, 1905.

—, *Cosmic Vision*. Thavies Inn: Richard Cobden-Sanderson, 1922.

—, *Ecce Mundus: Industrial Ideals and the Book Beautiful*. London: Hammersmith Publishing Society, 1902.

—, *Journals 1879–1922*, 2 vols. London: Richard Cobden-Sanderson, 1922.

Cockerell, Douglas, *Bookbinding and the care of Books*. London: John Hogg, 1901.

—, *A National Scheme for Vocational Training*. London: Arts and Crafts Exhibition Society, 1918.

—, *A Note on Bookbinding*. London: W. H. Smith and Son, 1904.

Coke, Desmond, 'Our London Letter', *Isis*, 19 November 1910, p. 78.

Collins-Baker, C. H., ed., *The Art Treasures of Great Britain*. London: Dent, 1914.

Collins-Baker, C. H., 'Dry Bones', *Saturday Review*, 20 March 1912, pp. 577–8.

Cook, E. Wake, *Anarchism in Art and Chaos in Criticism: with some notes on the Purpose and Future of Art*. London: Cassell, 1904.

—, *Retrogression in Art*. London: Hutchinson, 1924.

—, letter to the *Morning Post*, 19 November 1910, p. 4.

—, letter to the *Pall Mall Gazette*, 10 November 1910, p. 7.

Cournos, John, *Autobiography*. New York: Putnams, 1935.

Crane, Walter, *The Claims of Decorative Art*. London: Laurence and Bullen, 1892.

—, *Decorative Illustration*. London: G. Bell, 1897.

—, *Line and Form*. London: G. Bell, 1900.

—, *William Morris to Whistler: Papers and Addresses on Arts and Crafts and the Commonwealth*, London: G. Bell, 1911.

—, 'The Work of W. Crane', with notes by the author. *Easter Art Annual*, 1898.

—, Letter to the *Morning Post*, 18 November 1910, p. 10.

Cunninghame-Graham, R. B., letters to the *Morning Post*, 18 November 1910, p. 10 and 22 November 1910, p. 5.

Dalton, O. M., *Byzantine Enamels in Mr. Pierpont Morgan's Collection, with a note by Roger Fry*. London: Chatto, 1912.

Day, L. F., *William Morris and his Art*. London: Virtue, 1899.

—, *Nature in Ornament*. London: Batsford, 1908.

—, *Pattern Design*. London: Batsford, 1903.

—, *The Planning of Ornament*. London: Batsford 1887.

—, *Some Principles of Everyday Art*. 1886 rpt. London: Batsford, 1894.

Denis, Maurice, *Theories 1890–1910*. Paris: L. Rouart et J. Watelin, 1920.

—, 'Cézanne', *Burlington Magazine*, January 1910, pp. 207–19, and February 1910, pp. 275–80.

Denver, Frank, 'The London Group', *Egoist*, 1 April 1915, pp. 60–1.

Dolmetsch, H. *Historic Styles of Ornament*. London: Batsford, 1898.

Douglas, Alfred Lord, *Autobiography*. London: Secker, 1929.

Douglas, James, 'The Frock Coat', *London Opinion*, 26 November 1910, p. 324.

—, 'The Great Art Hoax', *London Opinion*, 19 October 1912, p. 84.

Drey, O. Raymond, 'Post-Impressionism: the Character of the Movement', *Rhythm*, January 1913, pp. 363–9.

Drey, O. Raymond, letters to the *Saturday Review*, 23 October 1912, p. 634, and 14 December, p. 735.

Eliot, T. S., *Selected Essays*, London: Faber and Faber, 1932.

*The Sculptor Speaks: Jacob Epstein to A. L. Haskell: A Series of Conversations on Art*. London: Heinemann, 1931.

Epstein, Jacob, *Let There Be Sculpture: an Autobiography*. London: Michael Joseph, 1940.

Everett, Katharine, *Bricks and Flowers*. London: Constable, 1949.

Finberg, A. J., *English Water Colour Painters*. London: Duckworth, 1905.

—, *Turner's Sketches and Drawings*. London: Methuen, 1910.

—, 'The Latest Thing from Paris', *Star*, 8 November 1910, p. 2.

—, 'Post-Impressionists at the Grafton Gallery', *Star*, 5 October 1912, p. 4.

Ford, Ford Madox, *The Critical Attitude*. London: Duckworth, 1911.

—, *Thus to Revisit*. London: Chapman Hall, 1921.

Fry, Roger, *The Architectural Heresies of a Painter: A Lecture*. London: Chatto, 1921.

—, *Art and Commerce*. London: Hogarth Press, 1926.

—, *Cézanne: A Study of his Development*. London: Hogarth Press, 1927.

—, *Characteristics of French Art*. London: Chatto, 1932.

[Reynolds], *Discourses delivered to the Students of Royal Academy*, with an introduction and notes by Roger Fry. London: Seeley, 1905.

Fry, Roger, *Henri Matisse*. London: Zwemmer, 1931.

[Fry, Roger], *Omega Workshops: Prospectus*. 1915.

Fry, Roger, *Transformations: Critical and Speculative Essays on Art*. London: Chatto, 1926.

—, *Vision and Design*. 1920 Chatto & Windus: rpt. London: Allen Lane 1937.

—, 'Acquisition by the National Gallery at Helsingfors', *Burlington Magazine*, February 1911, vol. XVIII, p. 293.

—, 'The Allied Artists', *Nation*, 2 August 1913, pp. 676–7.

—, 'The Allied Artists at the Albert Hall', *Nation*, 20 July 1912, vol. XI, pp. 583–4.

—, 'The Art of Pottery in England', *Burlington Magazine*, March 1914, vol. XXIV, pp. 330–5.

—, 'The Artist as Decorator', *Colour*, April 1917, pp. 92–3.

—, 'The Artist in the Great State', In *Socialism and the Great State*, ed. H. G. Wells, Lady Warwick and G. R. S. Taylor. London: Harper & Brs., 1912, pp. 251–72.

—, 'The Case of the Late Sir Lawrence Alma Tadema, O.M.', *Nation*, 18 January 1913, pp. 666–7.

—, 'English Embroidery at the Burlington Fine Arts Club', *Athenaeum*, 20 May 1905, pp. 632–3.

—, 'An English Sculptor', *Nation*, 28 January 1911, pp. 718–19.
—, 'The Exhibition of Decorative Art at Turin', *Athenaeum*, 11 October 1902, p. 492.
—, 'Gaudier-Brzeska', *Burlington Magazine*, August 1916, pp. 209–10.
—, 'The Grafton Gallery', *Athenaeum*, 3 February 1906, pp. 144–5.
—, 'The Grafton Gallery – I', *Nation*, 19 November 1910, pp. 331–2; and 'The Grafton Gallery – II', *Nation*, 3 December 1910, pp. 402–3.
—, 'The Grafton Gallery: An Apologia', *Nation*, 9 November 1912, vol. XII, pp. 249–51.
—, Introduction to Maurice Denis, 'Cézanne', *Burlington Magazine*, January 1910, pp. 207–8.
—, 'The Last Phase of Impressionism', letter to the *Burlington Magazine*, March 1908, pp. 374–5.
—, 'A New Theory of Art', *Nation*, 7 March 1914, pp. 937–9.
—, 'Plastic Design', *Nation*, 6 June 1911, p. 396.
—, 'Post-Impressionism', *Fortnightly Review*, January–June 1911, pp. 856–67.
—, 'A Postscript on Post-Impressionism', *Nation*, 24 December 1910, pp. 536–7.
—, 'The Royal Academy', *Athenaeum*, 24 May 1902, pp. 664–5.
—, 'The Royal Academy – Sculpture', *Athenaeum*, 8 June 1901, pp. 731–2.
—, 'Sculptures of Maillol', *Burlington Magazine*, April 1910, vol. XVII, pp. 26–32.
—, 'Three Pictures in Tempera by William Blake', *Burlington Magazine*, March 1904, pp. 204–6.
—, 'Wedgwood China', *Athenaeum*, 15 July 1905, p. 89.
—, Review of Mrs Walker, *Instructive and Ornamental Paperwork*, *Athenaeum*, 19 October 1901, p. 529.
[Roger Fry, Clive Bell, Boris Anrep], Catalogue: 'The Second Post-Impressionist Exhibiton', London: Ballantyne. 1912.
E. S. G., 'Impressions of the Post-Impressionist Show', *Daily Graphic*, 4 October 1912, p. 6.
Gaudier-Brzeska, Henri, 'Allied Artists' Association Ltd. Holland Park Hall', Egoist, 15 June 1914, pp. 227–9.
*Henri Gaudier-Brzeska*, Scottish National Gallery, August 1972. Introduction by Roger Cole.
Gill, Eric, *Art and a Changing Civilisation*. London: John Lane, 1934.
—, *Autobiography*. London: Jonathan Cape, 1947.
—, *Letters*, ed. Walter Shewring. London: Cape, 1947.
—, 'Arts and Crafts: Sculpture'. *Highway*, June 1917, pp. 143–7.
—, 'Church and State', *Highway*, December 1910, pp. 45–7.
—, 'The Failure of the Arts and Crafts Movement', *Socialist Review*, December 1909, pp. 289–300.
—, 'Masters and Servants', *Highway*, November 1910, pp. 23–4.
—, 'A Preface to an Unwritten Book', *Highway*, October 1910, pp. 5–6.
Ginner, Charles, 'Neo-Realism', *New Age*, 1 January 1914, pp. 271–2.

Gleizes, Albert and Metzinger, Jean, *Cubism* (trans). London: Fisher Unwin, 1913.

Goldring, Douglas, *Life Interests*. London: Macdonald, 1948.

—, *Odd Man Out*. London: Chapman Hall, 1935.

—, *South Lodge*. London: Constable, 1943.

Gronau, Georg, *Masterpieces of Sculpture*. London: Gowans & Gray, 1909.

G.R.H., 'Gallery and Studio: Oscar Wilde's Tomb', *Pall Mall Gazette*, 6 June 1912, p. 7.

—, 'The Revolt in Painting: An Extraordinary Exhibition: Post-Impressionism and What It Means', *Pall Mall Gazette*, 7 November 1910, pp. 1–2.

—, 'Post-Impressionists', *Pall Mall Gazette*, 4 October 1912, p. 10.

Haliday, Henry, letter to the *Nation*, 24 December 1910, p. 539.

Hardie, Martin. *John Pettie, R.A., H.R.S.A.* London: A & C Black, 1910.

—, letter to the *Morning Post*, 18 November 1910, p. 10.

Hatton, R. G., *Design*. London: Chapman & Hall, 1902.

von Herkomer, Sir Hubert, *My School and my Gospel*. London: Constable, 1908.

Hiatt, C., 'Oxford University Press Bindings', *Poster and Art Collector*, January 1901, pp. 9–13.

von Hildebrand, Adolf, *The Problem of Form in Painting and Sculpture* 1893, trans. Meyer and Ogden. London: Stechert, 1907.

Hind, C. Lewis, *Adventures among Pictures*. London: A & C Black, 1904.

—, *The Consolations of a Critic*. London: A & C Black, 1911.

—, *From My Books*. London: Collins, 1927.

—, *The Post Impressionists*. London: Methuen, 1911.

—, 'An Adventure Among Pictures', *Art Chronicle*, 5 November 1910, pp. 5–6.

—, 'The Consolations of an Injured Critic', *Art Journal*, May-Dec. 1910, pp. 71–6, 103–9, 135–42, 177–85, 193–8, 265–70, 293–8, 352–9.

—, 'Ideals of Post-Impressionism', *Daily Chronicle*, 5 October 1912, p. 6.

—, 'Maniacs or Pioneers? Post-Impressionists at Grafton Galleries', *Daily Chronicle*, 7 November 1910, p. 8.

—, 'The New Impressionism', *English Review*, December 1910, pp. 180–92.

—, 'A New Movement in Art: Reflections and a Discussion', *T.P.'s Magazine*, March 1911, pp. 684–9.

—, letter to the *Morning Post*, 17 November 1910, p. 3.

Hitchcock, F. H., ed., *The Building of a Book*. London: Werner Laurie, 1908.

Holme, Charles, ed., *Arts and Crafts*. London: The Studio, 1916.

Holmes, C. J., *Notes on the Post-Impressionist Painters*, London: Philip Lee Warner, 1910.

—, *Notes on the Science of Picture Making* London: Chatto, 1909.

—, *Self and Partners*, London: Constable, 1926.

—, 'The British Medical Association', letter to *The Times*, 23 June 1908, p. 16.

Horne, Herbert P., *The Binding of Books*. London: Kegan Paul, 1894.

Housman, Laurence, *The Unexpected Years*. Indianapolis: Bobbs-Merrill, 1936.

Hulme, T. E., *Speculations: Essays on Humanism and the Philosophy of Art*, ed. Herbert Read. London: Kegan Paul, Trench, Trubner, 1924.

—, *Further Speculations*, ed. Samuel Hynes. Minneapolis: University of Minnesota Press, 1955.

—, 'Contemporary Drawings', *New Age*, 2 April 1914, p. 688.

—, 'Mr Epstein and the Critics', *New Age*, 25 December 1913, pp. 251–3.

—, 'Modern Art – I', *New Age*, 15 January 1914, pp. 341–2.

—, 'Modern Art – II', *New Age*, 12 February 1914, pp. 467–9.

—, 'Modern Art – III', *New Age*, 26 March 1914, pp. 661–2.

—, 'Modern Art – IV', *New Age*, 9 July 1914, pp. 230–2.

Hyslop, Theo B., *The Great Abnormals* London: Philip Allan, 1925.

—, *Mental Handicaps in Art* London: Balliere, Tindall & Cox, 1927.

—, 'Post-Illusionism and Art in the Insane', *Nineteenth Century*, February 1911, pp. 270–81.

Jackson, Holbrook, *The Eighteen Nineties*. London: Grant Richards, 1913.

—, *All Manner of Folk*. London: Grant Richards, 1912.

—, *William Morris*. London: A. C. Fifield, 1908.

—, 'An Impressionist of Sculpture', *T.P.'s Magazine*, March 1911, pp. 1753–7.

—, 'A Plea for a Revolt in Attitude', *Rhythm*, Winter, 1911, pp. 6–10.

Jacobi, Charles T., *Gesta Typographica*. London: Elkin Mathews, 1897.

—, *On the Making and Issuing of Books*. London: Elkin Mathews, 1891.

—, *Some Notes on Books and Printing*. London: Charles Whittingham, 1892.

Jerrold, Douglas, *Georgian Adventure*. New York: Scribners, 1938.

John, Augustus, *Chiaroscuro*. London: Jonathan Cape, 1952.

H. A. K., 'The Royal Academy', *Sunday Times*, 2 May 1897, p. 2.

Kandinsky, Wassily, *Concerning the Spiritual in Art*. trans. M. T. H. Sadler. London: Constable, 1914.

Konody, P. G. *Artistic Illustration versus Photography*. London: Press Art Schools, 1912.

Konody, P. G. and Dark, Sidney, *Sir William Orpen*. London: Seeley Service, 1932.

Konody, P. G., 'The Comic Cubists', *Daily Mail*, 5 October 1912, p. 6.

—, 'English Post-Impressionists', *Observer*, 27 October 1912, p. 10.

—, 'More Post-Impressionism at the Grafton', *Observer*, 6 October 1912, p. 6.

—, 'Post-Impressionists at the Grafton Galleries', *Observer*, 13 November 1910, p. 9.

—, 'Shocks in Art: "Post-Impressionists" in London', *Daily Mail*, 7 November 1910, p. 10.

Lanteri, Edward, *Modelling*. London: Chapman Hall, 1902–4.

[Lawrence, D. H.], *Phoenix, the Posthumous Papers of D. H. Lawrence*, ed. with an introduction by E.D.M. London: Heinemann, 1936, rpt. 1961.

Lethaby, W. R., *Architecture, Mysticism and Myth*. London: Percival, 1892.
—, *Art and Workmanship*. 1913 rpt. Birmingham: Birmingham School of Printing, 1930.
—, *Beauty*, Birmingham: Birmingham School of Printing, 1928.
—, *Medieval Art*. London: Duckworth, 1904.
—, 'Art, the Crafts and the Function of the Guilds', *Quest*, no. 6, 1896, pp. 95–100.
*Wyndham Lewis on Art: Collected Writings 1913–1956*, ed. Walter Michel and C. J. Fox. London: Thames and Hudson, 1969.
Lewis, Wyndham, ed., *Blast 1*. London: 1914, and *Blast 2*. London: 1915.
—, *Blasting and Bombadiering*. London: Calder and Boyars, 1937.
—, *The Caliph's Design: Architects! Where is your Vortex?* London: *Egoist*, 1919.
—, *The Letters of Wyndham Lewis*, ed. W. K. Rose. London: Methuen, 1965.
—, 'The London Group,' *Blast 2*. London: 1915, pp. 77–9.
—, 'The Melodrama of Modernity', *Blast 1*. London: 1914, pp. 143–4.
—, 'Our Vortex', *Blast 1* London: 1914, pp. 147–8.
—, letter to the *New Age*, 2 April 1914, p. 703.
*The Letters of a Post-Impressionist, translated by A. Ludovici*. London: Constable, 1912.
Ludovici, Anthony, *Nietzsche and Art*. London: Constable, 1911.
—, *Personal Reminiscences of August Rodin*. London: John Murray, 1906.
Ludovici, Anthony M., 'The Carfax, the Suffolk Street and the Twenty-One Galleries', *New Age*, 18 December 1913, pp. 213–4.
—, 'The Pot-Boiler Paramount', *New Age*, 21 November 1912, pp. 66–7.
—, 'White Roses at the Stafford and Carfax Galleries', *New Age*, 17 October 1912, p. 596.
Lunn, Richard, *Pottery*. London: Chapman Hall, 1903.
'E.M.', rev. of 'Manet and the Post-Impressionists', *Illustrated London News*, 19 November 1910, p. 798.
[MacCarthy, Desmond], *Manet and the Post-Impressionists*. London: Ballantyne, 1910.
MacCarthy, Desmond, 'The Art-Quake of 1910', *Listener*, 1 February 1945, pp. 123–9.
MacColl, D. S., *Confessions of a Keeper and Other Papers*. London: Alexander Maclehose, 1931.
—, *Nineteenth Century Art*. Glasgow: J. Maclehose, 1902.
McKenna, Ethel M., ed., *The Woman's Library: Some Arts and Crafts*. London: Chapman Hall, 1903.
Mackmurdo, A. H., *The Gold Standard and other Diseases*. London: Desmond Harmsworth, 1932.
—, *Pressing Questions*. London: John Lane, 1913.
Macnamara, Francis, 'The London Group at the Goupil Gallery', *New Age*, 1 April 1915, pp. 591–4.
Manson, J. B., 'London Post-Impressionists', *Outlook*, 14 December 1912, pp. 794–5.

—, 'Spiritual Experiences at the Grafton Gallery', *Outlook*, 26 October 1912, p. 559.

Marks, Montague, ed., *Home Arts and Crafts*. London: C. Arthur Pearson, 1903.

Marin, F. S. and Clutton-Brock, A. F., *Art and Civilisation*. Oxford: OUP, 1928.

Marriott, Charles, 'Post-Impressionism: Remarkable Exhibition at the Grafton Galleries: Pragmatism in Art', *Evening Standard*, 7 October 1912, p. 15.

Masterman, C. F. G., *The Condition of England*. London: Methuen, 1909.

Matthews, Brander, *Bookbindings Old and New*. London: G. Bell, 1896.

May, J. Lewis, *John Lane and the Nineties*. London: John Lane, 1936.

Meier-Graeffe, J., *Modern Art*. London: Heinemann, 1908.

Meyer-Riefstahl, R., 'Vincent Van Gogh I – II', *Burlington Magazine*, November 1910, pp. 91–99, and December 1910, pp. 155–62.

Middleton, B. C., *A History of English Craft Bookbinding Technique*. New York: Hafner, 1963.

Miller, Fred, *Art Crafts for Amateurs*. London: Virtue, 1901.

—, 'George Frampton, A.R.A., Art Worker', *Art Journal*, November 1897, pp. 321–4.

Moody, F. W., *Lectures on Decorative Art*. London: G. Bell, 1908.

Moore, George, 'A Communication to Book Collectors', *Fleuron*, vol. 4, 1925, p. 49.

Morley, Robert, *Guide to Midhurst and Neighbourhood*. Midhurst, 1903.

—, letter to the *Nation*, 3 December 1910, p. 406.

*The Collected Works of William Morris with Introductions by his Daughter May Morris, Volume XXII: Hopes and Fears for Art, Lectures on Art and Industry*. London: Longmans Green, 1914.

Morris, William, *The Ideal Book*. 1893, rpt. London: LCC Central School of Arts and Crafts, 1908.

—, 'The Arts and Crafts Today', 1889, rpt. in *Art and its Producers and the Arts and Crafts of Today*. London: Longman, 1901.

*Political Writings of William Morris*, ed. A. L. Morton. London: Lawrence and Wishart, 1973.

Nevinson, C. R. W., *Paint and Prejudice*. London: Methuen, 1937.

Nordau, Max, *Degeneration: Translated from the 2nd Edition of the German Work*. London: Heinemann, 1895.

—, *On Art and Artists*, trans. W. F. Harvey, MA. London: Fisher Unwin, 1907.

Orage, A. O., 'Politics for Craftsmen', *Contemporary Review*, June 1907, pp. 782–794.

Omega Workshops, *Prospectus*, 1915.

Parkes, Kineton, *Sculpture of Today*. London: Chapman Hall, 1921.

Penty, A. J., *The Restoration of the Guild System*. London: Swan Sonnenschein, 1906.

Peters, Charles, ed., *Home Handicrafts*. London: Religious Tract Society, 1890.

Phillips, Sir Claude, *Emotion in Art*, ed. M. W. Brockwell. London: Heinemann, 1925.

—, *Sir Joshua Reynolds*. London: Seeley, 1894.

Phillips, Claude, 'Grafton Galleries: The "Post-Impressionists" ', *Daily Telegraph*, 11 November 1910, p. 5.

Phillips, Sir Claude, 'Goupil Gallery: The London Group', *Daily Telegraph*, 13 March 1915, p. 5.

—, 'Grafton Galleries: The Second Post', *Daily Telegraph*, 5 October 1912, p. 9.

Pound, Ezra, *The Cantos*. London: Faber & Faber, 1964.

—, *Drafts and Fragments of Cantos CX-CXVII*. London: Faber & Faber, 1970.

—, *Gaudier-Brzeska: A Memoir*. London: John Lane, 1916.

—, *Pavannes and Divisions*. New York: Knopf, 1918.

—, *Selected Prose 1909–1965*, ed. with an introduction by William Cookson. London: Faber & Faber, 1973.

—, *The Spirit of Romance*. London: Dent, 1910.

—, 'Affirmations I: Arnold Dolmetsch', *New Age*, 7 January 1915, pp. 246–7.

—, 'America: Chances and Remedies . . . VI', *New Age*, 5 June, 1913, p. 143.

—, 'Wyndham Lewis', *Egoist*, 15 June, 1914, pp. 233–4.

—, 'The New Sculpture', *Egoist*, 16 February 1914, pp. 67–8.

—, 'Preliminary Announcement of the College of Arts'. *Egoist*, 2 November 1914, pp. 413–4.

—, 'Provincialism the Enemy', I–V. *New Age*, 12 July, 1917, pp. 244–5; 19 July 1917, pp. 268–9; 26 July 1917, 288–9; 2 August 1917, pp. 308–9.

—, 'Vorticism', *Fortnightly Review*, 1 September 1914, pp. 461–71.

—, 'Edward Wadsworth, Vorticist', *Egoist*, 15 August 1914, pp. 306–7.

—, letter to the *Egoist*, 16 March 1914, p. 117.

—, Preface to the *Poetical Works of Lionel Johnson*. London: Elkin Mathews, 1915.

Priestman, Mabel T., *Handicrafts in the Home*. London: Methuen, 1910.

'Quex', 'Round About London', *Evening News*, 10 March 1915, p. 4.

W. R., 'Post-Impressionism at the Grafton', *Sunday Times*, 6 October 1912, p. 6.

Rhead, G. W., *Modern Practical Design*. London: Batsford, 1912.

—, *The Principles of Design: a Textbook for Teachers, Students and Craftsmen*. London: Batsford, 1905.

Richmond, W. B., *Art and its Purposes*. Birmingham: Birmingham & Midland Institute, 1908.

—, *Democracy, False or True*. London: Cecil Palmer, 1920.

—, *Leighton, Millais and William Morris*. London: Macmillan, 1898.

—, *The Silver Chain*, London: Cecil Palmer, 1916.

—, 'Monumental Painting'. In *Lectures in Art: Delivered in Support of the Society for The Protection of Ancient Buildings*. London: Macmillan, 1882.

—, 'What are the Prospects for 1911', *London Magazine*, January 1911, 551.

—, 'letter to the *Morning Post*, 16 November 1910, p. 5.

—, letter to the *Nation*, 1 February 1913, p. 744.

Ricketts, Charles, *Pages on Art*. London: Constable, 1913.

—, letter to the *Morning Post*, 9 November 1910, p. 6.

Roberts, William, *Some Early Abstract and Cubist Work, 1913–20*. London: A Canale Publication, 1957.

—, *The Vortex Pamphlets 1956–58*. London: Canale Publications, 1959.

Robins, W. P., *Etching Craft* London: Bookman's Journal, 1922.

Rodin, Auguste, *Art*, trans. Mrs Romilly Feddon, from the French of Paul Gsell. London: Hodder, 1912.

Ross, Robert. *Masques and Phases*. London: Arthur Humphries, 1909.

—, 'Post-Impressionism at the Grafton: The Twilight of the Idols', *Morning Post*, 7 November 1910, p. 3.

Rothenstein, William, *Men and Memories, Recollections 1872–1938*, ed. Mary Lago. London: Chatto, 1978.

Ruskin, John, *Modern Painters*, with an introduction by Lionel Cust, MA, 5 vols 1843–60, rpt. London: Dent, 1906.

Rutter, Frank, *Art in My Time*. London: Rich & Cowan, 1933.

—, *Evolution in Modern Art*. London: Harrap, 1926.

—, *Since I was Twenty-Five*. London: Constable, 1927.

—, *Some Contemporary Artists*. London: Leonard Parsons, 1922.

—, 'Round the Galleries', *Sunday Times*, 13 November 1910, p. 14.

'E. S.', 'The Post-Impressionists'. *Westminster Gazette*, 10 November 1910, p. 3.

—, 'Grafton Galleries: Second Post', *Westminster Gazette*, 7 October 1912, p. 3.

Sadler, Michael, letter to the *Nation*, 3 December 1910, pp. 405–6.

Sadler, M. T. H., 'Fauvism and a Fauve', *Rhythm*, Summer 1911, pp. 14–17.

Sanford, Frank G., *The Art Crafts for Beginners*. London: Hutchinson, 1906.

Sargent, J. S., letter to the *Nation*, 7 January 1911, p. 610.

Scott-James, RA, *The Influence of the Press*. London: Partridge, 1913.

Severn, Arthur, letter to the *Morning Post*, 22 November 1910, p. 5.

Short, E. H., *A History of Sculpture*. London: Heinemann, 1907.

Sickert, W. R., 'Drawing from the Cast', *New Age*, 23 April 1914, pp. 781–2.

Sickert, Walter, 'Mesopotamia – Cézanne', *New Age*, 5 March 1914, pp. 559–60.

—, 'Mr. Ginner's Preface', *New Age*, 30 April 1914, pp. 819–20.

—, 'On Swiftness', *New Age*, 26 March 1914, pp. 655–6.

—, 'Post-Impressionists', *Fortnightly Review*, January-June 1911, pp. 79–89.

—, 'The Thickest Painters in London', *New Age*, 18 June 1914, p. 155.

Simmonds, T. C., *The Art of Modelling in Clay and Wax*. London: George Allen [1893].

Skeaping, Emily J., *The Art of Dainty Decoration*. London: Windsor and Newton n.d. [1914].

Spielmann, M. H., *British Sculpture and Sculptors of Today*. London: Cassell, 1901.

—, *Sir Hamo Thornycroft, RA*. London: Fine Art Society 1926.

—, 'British Sculpture of Today', *Journal of Royal Institute of British Architects*, 3 April 1909, pp. 374–94.

—, 'Grotesque Art at the Grafton', *Daily News and Leader*, 4 October 1912, p. 7.

Stegman, Dr Hans, *The Sculpture of the West*. London: Dent, 1907.

Stevenson, R. A. M., *The Art of Velasquez*. London: G. Bell, 1895.

Symon, J. D., *The Press and its Story*. London: Seeley & Service, 1914.

[Symonds, John Addington], *The Life of Benvenuto Cellini, newly translated into English by John Addington Symonds*. London: J. C. Nimms, 1888.

Thomas, Margaret, *How to Understand Sculpture*. London: G. Bell, 1911.

—, *How to Judge Pictures*. London: Anthony Treherne, 1906.

Thompson, W. G., 'Hispano-Moresque Carpets', *Burlington Magazine*, November 1910, pp. 100–111.

Toft, Albert, *Modelling and Sculpture*. London: Seeley, 1911.

Waldstein, Sir Charles, *Greek Sculpture and Modern Art*. Cambridge: Cambridge University Press, 1914.

Walenkamp, A., 'Jan Eisenloeffel's Metal Work', *Art*, vol. 2, no. 10, 1904, pp. 92–5.

Ward, H. Snowden, *Profitable Hobbies*. London: Danbarn & Ward, 1907.

Ward, H. Snowden, ed., *Useful Arts and Handicrafts*. 3 vols, London: Danbarn & Ward, 1901.

Wedmore, Sir Frederick, *Some of the Moderns*. London: Virtue & Co., 1909.

Weld-Blundell, C. J., *Are We Stupid People?* London: Kegan Paul, 1908.

—, *The Party Spirit and How to Wean It*. Privately printed, 1912.

—, Review of 'Manet and the Post-Impressionists', *The Times*, 7 November 1910, p. 12.

Weller, Herbert P. *Nature and Design*. London: Charles and Dible, 1914.

Wells, H. G., Lady Warwick and Taylor, G. R. S., eds, *Socialism and the Great State*. London: Harper & Bros., 1912.

Winans, Walter, *Animal Sculpture*. London: Putnams, 1913.

Wilenski, R. H., *The Meaning of Modern Sculpture*. London: Faber & Faber, 1932.

Woods, J. J., 'The Post-Impressionists', *Art Chronicle*, 19 November 1910, pp. 35–7.

Woolf, Virginia, *Roger Fry: A Biography*. London: Hogarth Press, 1940.

—, *Walter Sickert: A Conversation*. London: Hogarth Press, 1934.

Worringer, Wilhelm. *Abstraction and Empathy*, trans. Michael Bullock. 1908. London: Routledge & Kegan Paul, 1940, rpt. 1953.

# CONTEMPORARY PERIODICALS AND NEWSPAPERS

Academy
Art
Arts and Crafts
Arts and Crafts Magazine
Arts and Crafts and Technical
    Instructor
Art Chronicle
Art Chronicle and the Art News
Art Journal
Art News
Art Work
Bond
Bookbinding Trades Journal
Booklover Magazine
Bric-a-Brac
Caxtonian Magazine
Caxtonian Quarterly
Century Guild Hobby Horse and the
    Hobby Horse
Collecting
Collector and Art Furnisher
Collector's Magazine
Colour
Connoisseur
Contemporary Review
Daily Chronicle
Daily Express
Daily Graphic
Daily Mail
Daily News
Daily News and Leader
Daily Telegraph
Dyer, Calico Printer, Bleacher,
    Furnisher, and Textile Review
Egoist
English Review
Evening Standard
Expert
Fashionable London
Fleuron
Fortnightly Review
Furnisher
Globe
Granta

Hearth and Home
Home Handicrafts
Illustrated London News
Imp
Imprint
Isis
Journal of Decorative Arts
Ladies' Cutter
Ladies' Fancy Work Magazine
London Opinion
London Magazine
Magazine of Taste
Mask
Mayfair and Town Topics
Morning Post
Nation
Needle
New Age
New Freewoman
Nineteenth Century and After
Observer
Outlook
Pall Mall Gazette
Poster and Art Collector
Printseller and Collector
Potter
Public Opinion
Punch
Quest
Rhythm
Saturday Review
Sculptor
Spectator
Spinning Wheel
Star
Sunday Times
Tatler
The Times
T.P.'s Magazine
Tramp
Westminster Gazette
Women's Employment
World.

## MODERN MONOGRAPHS AND OTHER SECONDARY ACCOUNTS

*Dictionary of National Biography*
*Who's Who*
Arnold, Bruce, *Orpen, Mirror to an Age*. London: Cape, 1981.
Ashworth, W., *An Economic History of England, 1870–1939*. London: Methuen, 1960.
Aslin, Elizabeth, *The Aesthetic Movement: Prelude to Art Nouveau*. London: Elek, 1969.
Aslin, Elizabeth, and Atterbury, Paul, *Minton 1798–1910*. London: V& A, 1976.
Baron, Wendy, *The Camden Town Group*. London: Scholar Press, 1979.
—, *Sickert*. London: Phaidon, 1973.
Beattie, Susan, *The New Sculpture*. London: Yale University Press, 1983.
Bell, I. F., *Critic as Scientist: The Modernist Poetics of Ezra Pound*. London: Methuen, 1981.
Bell, Quentin, *Roger Fry*. Leeds: Leeds University Press, 1964.
Bell, Quentin and Chaplin, Stephen, 'The Ideal Home Rumpus', *Apollo*, October 1964, pp. 284–90.
Bowness, Alan, *Modern European Art*. London: Thames & Hudson, 1972.
Bowness, Alan, ed., *Impressionists and Post-Impressionists*. New York: Grolier, 1965.
Boyce, George, Curran James, and Wingate, Pauline, eds, *Newspaper History from the Seventeenth Century to the Present Day*. London: Constable, 1978.
Bradbury, Malcolm and Macfarlane, James, eds, *Modernism*. London: Penguin, 1976.
Buckle, Richard, *Jacob Epstein, Sculptor*. London: Faber & Faber, 1963.
Buckman, David, *James Bolivar Manson*. London: Maltzahn Gallery, 1973.
Bullen, J. B., ed., Fry, Roger, *Vision and Design*. Oxford: OUP, 1981.
Bürger, Peter, *Theory of the Avant-Garde. Translation from the German by Peter Shaw. Foreword by Jochen Scutte-Sasse*. Manchester: Manchester University Press, 1984.
Bywater, W. G., Jr., *Clive Bell's Eye*. Detroit: Wayne State University Press, 1975.
Callen, Anthea, *Angel in the Studio. Women in the Arts and Crafts Movement, 1870–1914*. London: Astragal Books, 1979.
Campbell, Margaret, *Dolmetsch, the Man and his Work*. London: Hamish Hamilton, 1975.
Camrose, Viscount, *British Newspapers and their Controllers*. London: Cassell, 1947.
Canaday, John, *Mainstreams of Modern Art*. London: Thames and Hudson, 1959.
Catleugh, John, *William de Morgan: with essays by Elizabeth Aslin and Alan Caiger-Smith*. London: Trefoil Books, 1983.

Causey, Andrew, *Harold Gilman*. London: Arts Council, 1981.
Clarke, Peter, *Liberals and Social Democrats*. Cambridge: Cambridge University Press 1978.
Clarke, Tom, *Northcliffe in History*. London: Hutchinson, 1950.
Cole, Roger, *Henri Gaudier-Brzeska*. London: Mercury Graphics, 1971.
—, *Burning to Speak: the Life and Art of Henri Gaudier-Brzeska*. Oxford: Phaidon, 1978.
Collins, Judith, *The Omega Workshops*. London: Secker & Warburg, 1983.
Cooper, Douglas, *The Courtauld Collection*. London: Athlone Press, 1954.
Cork, Richard, *Vorticism and Abstract Art in the First Machine Age*. London: Gordon Fraser, 1976.
*Craftsmanship*, London: Crafts Council, 1974.
Dangerfield, George, *The Strange Death of Liberal England*. London: Constable, 1936.
Davie, Donald, *Ezra Pound: The Poet as Sculptor*. London: Routledge & Kegan Paul, 1965.
Diamond, Pamela, *Some Recollections and Reflections about the Omega*. Unpublished typescript, London: c. 1968: photocopy, Victoria and Albert Museum.
Dolmetsch, Mabel, *Personal Recollections of Arnold Dolmetsch*. London: Routledge & Kegan Paul, 1958.
Dunlop, Ian, *The Shock of the New: Seven Historic Exhibitions of Modern Art*. London: Weidenfeld & Nicholson, 1972.
Ede, H. S., *A Life of Gaudier-Brzeska*. London: Heinemann, 1930.
—, *Savage Messiah*. London: Heinemann, 1931.
Ellmann, R., ed., *Edwardians and late Victorians*. New York: Columbia, 1960.
Ellmann, R. and Feidelson, S., ed., *The Modern Tradition*. New York: OUP, 1965.
Elsen, Albert, E., *Pioneers and Premises of Modern Sculpture*. London: Arts Council, 1973.
Emmons, Robert, *The Life and Opinions of Walter Richard Sickert*. London: Faber & Faber, 1941.
Falkenheim, J. V., *Roger Fry and the Beginnings of Formalist Art Criticism*. UMI Research Press, 1980.
Flam, J. D., *Matisse on Art*. London: Phaidon, 1973.
Franklin, Colin, *The Private Presses*. London: Studio Vista, 1969.
Goldwater, R. J., *Primitivism in Modern Painting*, New York: Harper, 1936.
Greenberg, Clement, *Art and Culture*. Boston: Beacon Press, 1961.
Fine Art Society, *British Sculpture 1850–1914*. London: Fine Art Society, 1968.
Hall, Fairfax, *Paintings and Drawings by Harold Gilman and Charles Ginner in the Collection of Edward le Bas*. London: privately printed, 1965.
Handley-Read, Lavinia, *British Sculpture 1850–1914*. London: Fine Art Society, 1968.
Harrison, Charles, *English Art and Modernism 1900–1939*. London: Allen Lane, 1981.

Henderson, Philip, *William Morris, his Life, Work and Friends*. London: Thames and Hudson, 1967.

Holroyd, Michael, *Augustus John*, 2 vols. London: Heinemann, 1974.

Hone, Joseph, *The Life of Henry Tonks*. London: Heinemann, 1939.

Hunter, Jefferson, *Edwardian Fiction*. Cambridge: Harvard University Press, 1982.

Hutchins, Patricia, *Ezra Pound's Kensington*. London: Faber & Faber, 1965.

Hynes, Samuel, *Edwardian Occasions*. London: Routledge & Kegan Paul, 1972.

—, *The Edwardian Turn of Mind*. London: Princeton University Press, 1968.

Jaus, Hans Robert, *Toward an Aesthetic of Reception. Translated from the German by Timothy Bahti. Introduction by Paul de Man*. London: Harvester, 1982.

Jones, Alan R., *Life and Opinions of T. E. Hulme*. London: Gollancz, 1960.

Jones, Peter d'A, *The Christian Socialist Revival 1877–1914*. Princeton: Princeton UP 1968.

Lambourne, Lionel, *Utopian Craftsmen: The Arts and Crafts Movement from the Cotswolds to Chicago*. London: Astragal Books, 1980.

Lester, John A., Jr., *Journey Through Despair 1880–1914*. Princeton: Princeton University Press, 1968.

Levenson, Michael H., *A Genealogy of Modernism: A Study of English Literary Doctrine 1908–1922*. London: CUP, 1984.

Levy, Mervyn, *Gaudier-Brzeska Drawings and Sculpture*. London: Cory, Adams and Mackay, 1966.

Lewison, Jeremy, ed., *Henri Gaudier-Brzeska*. Cambridge: Kettles Yard, 1983.

Liddington, Jill and Norris, Jill, *One Hand Tied Behind Us: The Rise of the Women's Suffrage Movement*. London: Virago, 1978.

Lipke, William. *David Bomberg, a Critical Study of his Life and Work*. London: Evelyn, Adams & Mackay, 1971.

Martin, Wallace, *The New Age under Orage*. Manchester: Manchester University Press, 1967.

Massingham, H. J., ed., *H. W. M*. London: Jonathan Cape 1925.

Materer, Timothy, *Vortex: Pound, Eliot and Lewis*. Ithaca: Cornell University Press, 1979.

Meyers. Jeffrey. *The Enemy: a Biography of Wyndham Lewis*. London: Routledge & Kegan Paul, 1980.

Michel, Walter, *Wyndham Lewis, Paintings and Drawings*. London: Thames and Hudson, 1971.

Moffett, Kenworth, *Meier-Graefe as Art Critic*. Munchen: Prestel-Verlag, 1973.

Nairne, Sandy, and Serota, Nicholas, eds, *British Sculpture in the Twentieth Century*. London: Whitechapel Art Gallery, 1981.

Naylor, Gillian, *The Arts and Crafts Movement: A Study of its Sources, Ideals and Influence on Design Theory*. London: Studio Vista, 1971.

Nicholson, Benedict, 'Post-Impressionism and Roger Fry', *Burlington Magazine*, January 1951, pp. 11–15.

*Omega Workshops 1913–19: Decorative Arts and Bloomsbury*. London: Crafts Council 1984.

O'Day, Alan, ed., *The Edwardian Age: Conflict and Stability 1900–1914*. London: Macmillan 1979.

Pierson, Stanley, *British Socialism: the Journey from Fantasy to Politics*. Cambridge, Mass: Harvard University Press, 1979.

Pondrom, Cyrena, *The Road from Paris*. Cambridge, Cambridge University Press, 1974.

Poggioli, Renato, *The Theory of the Avant Garde*. Cambridge, Mass.: Harvard University Press, 1968.

Read, Donald, *Edwardian England*. London: Harrap, 1972.

Read, Donald, ed., *Edwardian England*. London: Croom Helm 1982.

Read, Herbert, *Art Now: an Introduction to the Theory of Modern Painting .and Sculpture*. London: Faber & Faber, 1933.

—, *A Concise History of Modern Painting*. 1959 rpt. with new material by C. Tisdall and W. Feaver. London: Thames and Hudson, 1974.

—, *The Philosophy of Modern Art: Collected Essays*. London: Faber & Faber, 1952.

Reitlinger, Gerald, *The Economics of Taste*. London: Barrie and Rockliff, 1961.

Rewald, John, *Post-Impressionism: Van Gogh to Gauguin*. New York: Museum of Modern Art, 1956.

Robinson, Alan, *Poetry, Painting and Ideas, 1885–1914*. London: Macmillan 1985.

Ross, Margery, ed., *Robert Ross, Friend of Friends: Letters to Robert Ross, Art Critic and Writer, together with Extracts from his Published Articles*. London: Cape, 1952.

Rothenstein, John, *Modern English Painters*. London: Eyre & Spottiswood, 1952.

Royal Academy, *Post-Impressionism: Cross Currents in European Painting*. London: Royal Academy and Weidenfeld & Nicholson, 1979–80.

Sadleir, Michael T. H., *Michael Ernest Sadler*. London: Constable, 1949.

Selver, Paul, *Orage and the New Age Circle*. London: Allen & Unwin, 1959.

Seymour, F. W., *William de Morgan*. Chicago: The Bookfellows, 1920.

Shone, Richard, *The Century of Change: British Painting since 1900*. Oxford: Phaidon, 1977.

—, *The Post-Impressionists*. London: Octopus Books, 1979.

Small, Ian, *The Aesthetes, a Sourcebook*. London: Routledge & Kegan Paul, 1979.

Smith, Chris, *Signs for the Times: Symbolic Realism in the Mid-Victorian World*. London: George Allen & Unwin 1984.

Spaulding, Francis, *Roger Fry, Art and Life*. London: Granada, 1980.

Speaight, Robert, *The Life of Eric Gill*. London: Methuen, 1966.

Spender, Stephen, *The Struggle of the Modern*. London: Hamish Hamilton, 1963.

Stirling, A. M. W., *The Richmond Papers, from the Correspondence and Manuscripts of George Richmond R.A. and his son Sir William Richmond* London: Heinemann, 1926.

Stock, Noel, *The Life of Ezra Pound*. London: Routledge & Kegan Paul, 1970.

Stonehouse, John Harrison, *The Story of the Great Omar*. London: Picadilly Fountain Press, 1933.

Stranz, Walter, *George Cadbury*. Aylesbury: Shire Publications, 1973.

Sutton, Denys, *Walter Sickert: a Biography* London: Michael Joseph, 1976.

Thompson, E. P., *William Morris: Romantic to Revolutionary*. 1955, revised ed. New York: Pantheon, 1976.

Thompson, Paul, *The Edwardians: The Remaking of British Society* London: Weidenfeld 1975.

Watney, Simon, *English Post-Impressionism*. London: Studio Vista, 1980.

Wees, William C., *Vorticism and the English Avant-Garde*. Toronto: Toronto University Press, 1972.

Woodeson, John, *Spencer Gore*. Colchester: The Minories, 1970.

Yeo, Stephen; 'A New Life: The Religion of Socialism in Britain 1883–96, *History Workshop Journal*, 1977.

# INDEX